Montmartre and the Making o

❧ Montmartre
and the Making of Mass Culture

Edited by

G A B R I E L P. W E I S B E R G

Rutgers University Press
New Brunswick, New Jersey, and London

Library of Congress Cataloging-in-Publication Data

Montmartre and the making of mass culture / Gabriel P. Weisberg, editor.
 p. cm.
 Includes bibliographical references and index.
 ISBN 0-8135-3008-3 (cloth : alk. paper) — ISBN 0-8135-3009-1 (pbk : alk. paper)
 1. Montmartre (Paris, France)—Civilization—20th century. 2. Paris (France)—
Civilization—20th century. 3. Montmartre (Paris, France)—Social life and customs—
20th century. 4. Paris (France)—Social life and customs—20th century. 5. Popular
culture—France—Paris—History—20th century. 6. Montmartre (Paris, France)—In art.
7. Leisure—France—Paris. I. Weisberg, Gabriel P.

DC752.M7 M66 2001
944'.36—dc21

 2001019290

British Cataloging-in-Publication information is available from the British Library.

Manufactured in the United States of America

"Drink so that Montmartre, the capital of Paris, can shine brightly just like the Eiffel Tower which is its phallus, just as the Chat Noir is its brain, and just as the Moulin de la Galette is its soul!"

Rodolphe Darzens, *Nuits à Paris*, 1889

Contents

Illustrations

❧

Americans in Paris

Montmartre and the Art of Pop Culture

K A R A L A N N M A R L I N G

In August of 1944, the liberation of Paris began. For reasons of diplomacy, the Free French, in the person of Charles de Gaulle, led the column. The next day, the Americans arrived, urged on by Ernest Hemingway, who promptly left the parade and headed for the artists' quarter to liberate Picasso (and later, the Ritz Bar) in person. That Paris had survived the war was something of a miracle: Hitler had promised to burn the place to the ground if he could no longer possess the fabled city of light. That modern art was on the minds of the GIs who soon followed Hemingway to Picasso's studio speaks to the strong connection in the popular imagination between Paris, the avant-garde, and a certain—possibly naughty—artiness. Paris meant art, style, je ne sais quoi, and, above all, liberation from the strictures of life back home, in Kankakee and Kalamazoo, where pert mademoiselles with berets and loose morals were seldom observed sipping apéritifs at sidewalk cafés on Main Street.

In the years between the wars, Americans uncomfortable with what they took to be the unreformed Puritanism of their fellow citizens had taken up residence in France with a vengeance. Hemingway and Fitzgerald migrated to Montparnasse, smoked and argued over syntax at La Coupole and Les Deux

Magots, and looked over the latest crop of homegrown fiction at Shakespeare & Co. Hemingway, who set most of the action in *The Sun Also Rises* on the terrace of La Closerie des Lilas, wrote the book there between drags on countless Gitanes in six weeks' time.

Along with other pilgrims, they climbed the steep streets and staircases that rose abruptly behind the Moulin Rouge to the heights of Montmartre and the too-big domes and turrets of the gleaming new Sacré-Coeur. But they did not come in search of divine solace. Instead, they toiled upward seeking Pablo Picasso, Gertrude Stein, Juan Gris, Josephine Baker, and a thousand other free spirits who haunted the district where la vie bohéme and modern art were born. Vincent van Gogh, the tourist soon learned, once lived on the third floor of a squalid building at No. 54 Rue Lepic. The infamous Bateau-Lavoir, where Picasso created cubism and *Les Demoiselles d'Avignon* in 1907, still stood in shabby splendor not far away. Here, within sight of the crowded Place du Tertre, within hailing distance of le Lapin Agile, with its saucy signboard rabbit jumping out of the sauté pan, was the epicenter of sophistication, wit, and an intoxicating liberté.

In the 1950s, this love affair with Paris resumed in earnest. American teenagers bought cobalt blue bottles of "Evening in Paris" cologne at the dime-store: the bottle, if not the scent, was the last word in high-school seductiveness. "I Love Paris in the Springtime," a hit song of the day, became the theme for the decorations at a thousand junior proms. Robert Doisneau's famous snapshot of a pair of lovers kissing in a sidewalk café in front of the Hôtel de Ville, published in *Life* in 1950, merely confirmed the equation between Paris and unfettered romance. Meanwhile, the last word in department-store chic was a circle skirt decorated with Eiffel Towers, artists' palettes, and poodle dogs. The poodle cut— the gamin look—was all the rage. The small shapely head complemented the ballerina skirts of the New Look that came straight from Gay Par-ee (Degas reborn as Dior), via the local Bon Ton. To Americans in the fifties, Paris signified every new thing, everything missing from the drab uniformity of the previous decades. Love and lust. Style. Art and artfulness. Romance on a grand scale. And above all, liberation.

The meaning of Paris was Montmartre, or what Hollywood and the department store and the dimestore and the tourist trade took to be Montmartre. It was still possible, in the 1960s and 1970s for instance, to bring back from a package tour of the great monuments of Europe a postcard-size picture of the Moulin Rouge, with chic Parisiennes scurrying across a rain-slick Boulevard de Clichy in the fabled month of April; printed on canvas and tacked to a little stretcher, the

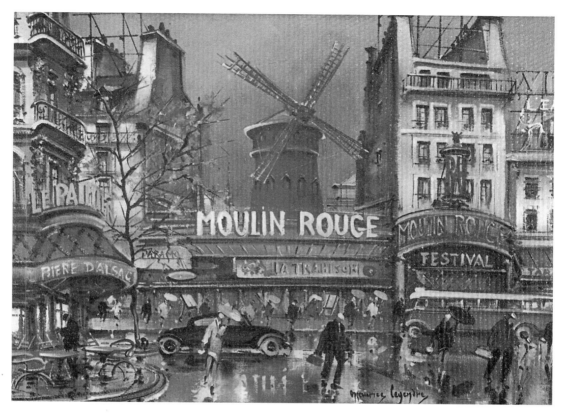

Figure F.1 "Montmartre in the Rain." Postcard-size, simulated oil-on-canvas souvenir of Paris, ca. 1960. Private Collection.

image was a kind of talisman of art, a miniature version of the sidewalk painters' wares displayed on the steep stone parapets of the butte. The topography of Paris had been compressed to a single place, redolent with associations.

An American in Paris, the 1951 musical starring Gene Kelly and the French dancer Leslie Caron, concluded with a celebrated, eight-part ballet in which a young American painter studying on the GI Bill (Kelly) pursues his lady love through the famous landmarks of Paris. The sequence ends with a shot of the couple racing to meet one another during the revelry of a Beaux-Arts ball, on a grand staircase leading to the heights of Montmartre (where the hero displays his own canvases of rain-slick streets). The scenes of the ballet cover the city, from Place de L'Opéra and Place de la Concorde to the Pont Neuf. But every spot is seen through the eyes of an artist: Dufy, Renoir, van Gogh, Rousseau, and Toulouse-Lautrec. The treatment serves to reduce all of Paris to a single, made-for-tourists picture—a colorful, blurry reflection of the artfulness of

Montmartre, wafting over the city like the cloying fragrance of "Evening in Paris." In the consciousness of *An American in Paris,* Paris is Montmartre. And Montmartre, on the magical night of the ball, is art and freedom and love.

The third member of the cinematic triangle that includes Kelly and Caron is a famous French music-hall headliner. His big production number has the star climbing an on-stage staircase in time to the music, surrounded by beautiful showgirls in various states of undress. It is, in other words, a pop culture riposte to the climb of the young lovers at Montmartre. And both staircases, as the lyrics of the Gershwin songs suggest, lead in the end to paradise.

This collection of essays is not about Gershwin or Gene Kelly or Americans in Paris, but it does offer fascinating clues about the origin of our mental landscape of the city in the posters, the exhibitions, the performances, and the attitudes of the fin-de-siècle denizens of the butte. The book, in fact, describes the rapidity of the process by which an elite, somewhat insular culture of art became a mass culture, promoted by tourism and the other burgeoning media of a modern, mobile civilization. As Vincente Minnelli's wonderful film suggests, the line between commercial culture and art—between the illusions of popular culture and what reality still attaches to the vineyards and the pancake bistros and the ready-framed "art" of Montmartre—was hopelessly fuzzy in 1951. Perhaps, as this volume argues, the line had always wavered and blurred, like the whirling dancers in Renoir's *Moulin de la Galette,* painted on Montmartre in 1876. Paradise, like Montmartre, is always a half-remembered dream.

One thing is certain. By the time Hemingway set out to find Picasso, the image of Montmartre crafted at the end of the nineteenth century had become the basis of a thriving popular culture industry devoted to the dissemination of its own icons. Apache dancers in striped tee-shirts, a soulful Edith Piaf, and Maurice Chevalier all headlined the *Ed Sullivan Show* in the 1950s. In *Moulin Rouge* of 1953, José Ferrer (scurrying about on his knees) played Lautrec abroad in the cabarets of the fin de siècle. *Can-Can:* taken to see the Hollywood set during the filming of a spicy dance number in 1959, Nikita Khrushchev decided that the scandalous goings-on were a sure sign of capitalist decadence. *Vogue's* color spread on Dior's Paris townhouse showed a drawing room done up like a bordello, in red velvet and fringe. At Woolworth's, the new rage was a matching set of ready-framed reproductions of Utrillo streets-of-Montmartre scenes (or Degas ballerinas) for milady's boudoir. Frank Semme's Los Angeles nightclub, called the Moulin Rouge, was the place to see and be seen. Hallmark Cards distributed free datebooks adorned with Bernard Buffet views of Sacré-Coeur in the rain. *Gigi, The French Line, Paris Blues, Paris Follies, Paris Holiday*: in a plot derived

from French farce, Doris Day (*April in Paris*) pretended to be a wholesome American chorus girl abroad in Montmartre, where nude models and semi-nude showgirls were the only other women in evidence.

It is clear what American consumers of the 1940s and 1950s had to gain from a dreamworld Montmartre, from a paradise of sexual and expressive freedom, artfully disguised as high culture. In this fascinating work, we finally learn what its inventors took to be paradise—the liberty and the beauty that glimmered at the very top of the butte for the artists who created the symbols of Montmartre in the first place.

Montmartre and the Making of Mass Culture ❧

Montmarte's Lure

An Impact on Mass Culture

GABRIEL P. WEISBERG

Montmartre. The name has a long tradition and a fabled resonance. It was the seat of the government of the Commune—a heterogeneous assemblage of radicals who came to power following the disastrous defeat of the Franco-Prussian War. Today's public considers Montmartre a desirable tourist site, a place which still generates excitement. The Moulin Rouge, the Place Clichy, and the Sacré-Coeur retain a powerful mystique, still capable of stimulating excitement. The community on the hill is revered as a "sacred site" where some artists achieved fame, and many others struggled for recognition. Only a few of the establishments and inhabitants of the bohemian community were systematically canonized and remain intimately connected to Montmartre in the mind of the public— those chronicled by Henri de Toulouse-Lautrec and Théophile-Alexandre Steinlen. The posters of Le Chat Noir, Aristide Bruant, and Jane Avril stand out today as visual markers of the butte, and each tourist who returns from Montmartre with reproductions of famous works believes he has preserved for himself the essence of the pilgrimage through the image. The famous posters have lost their original purpose as advertisement—a beginning point to lure an audience to the cabarets and dance halls—and instead have become an end in and

of themselves. The plight of the poster is similar to that of many of the traditions of Montmartre that have been glossed over by the passage of time and the rise of the tourist industry, which eventually forced artists to abandon the area for Montparnasse. Many innovations in the visual arts, in entertainment, in literature, and in the world of nightclubs had their beginning in Montmartre. This is the location where avant-garde creators struggled to visualize something new, to find an effect that was novel, and where—in the process—the origins of a popular mass culture was born. The challenging innovations of a small band of creators—working from the1880s until the beginning of World War I—had a lasting impact on the world that was not fully recognized at the time.

Scholarly interest in Montmartre has increased significantly in the past ten years with the recognition that the seeds of postmodernism, initiated by Marcel Duchamp early in the twentieth century, had been introduced even earlier by Alfred Jarry, Aristide Bruant, Rodolphe Salis, and others. There have been exhibitions dedicated to the avant-gardism of those who frequented the area, and especially to the achievements of Toulouse-Lautrec, Théophile Steinlen, Jules Chéret, and Pablo Picasso, with increasing interest focused, for the latter, not only on his own work but on that of his Spanish compatriots on the butte. The outrage caused by the combination of unbridled sexuality and scatology in Alfred Jarry's *Ubu Roi* has been analyzed repeatedly for its contribution to Dada manifestations and the development of a "Theatre of the Absurd." Frequently, however, the appreciation of modernity indicated by these studies has focused on the achievements of a very select group of individuals and in no way is that truer than in the case of the work of Toulouse-Lautrec. However, the examination of the achievements of these individuals has been heavily reportorial and often devoid of the larger context of the very culture of Montmartre—of the pervading social environment that encouraged and rewarded experimentation. There have been, however, a number of fine publications that have emphasized the social history of the area and have attempted to re-create the ways in which avant-garde creativity existed in Montmartre. These include *Le Chat Noir, 1881–1897* (published by the Musée d'Orsay, 1992) and *The Graphic Arts and French Society, 1871–1914* (Zimmerli Museum, Rutgers University Press, 1988). In fact, the Zimmerli Art Museum has maintained a consistent interest in the art and culture of Montmartre, with a series of exhibitions and accompanying publications devoted to promoting their collection. While these catalogues and articles have focused on the butte and its creators they have not used this site as the basis for rumination on the future, and as a means of exploring a series of issues that have affected how culture emerged for the masses in the twentieth

century. Even the witty *The Spirit of Montmartre: Cabarets, Humor, and the Avant-Garde, 1875–1905* (Zimmerli Art Museum, 1996), while expanding the parameters of discussion toward literature and music in order to explore an interdisciplinary model, has maintained a documentary methodology, which does not allow larger interpretive issues to be addressed.

As interest in the larger cultural sphere of Paris at the end of the nineteenth century has evolved, so has a more imaginative basis for considering the ways in which mass culture emerged at the end of the century. Vanessa Schwartz, in her *Spectacular Realities: Early Mass Culture in Fin de Siècle Paris* (University of California Press, 1998), has used contemporary methodology to see modern urban culture as a set of spectacular questions. She sees reality as "spectacle" leading to the creation of a sense of shared experiences, where people find themselves increasingly involved and participating in the creation of a type of metropolitan culture. She argues that increasing discussion of shared experiences stimulated the formation of mass culture. Schwartz's publication (and others that tried to examine how mass culture evolved), has led us to a consideration of Montmartre, but not from the perspective of nostalgic retelling of past events, or even a fuller contextual reconstruction of the era. Rather we approach the lessons of Montmartre for what they held for the future—our own present.

As has been noted above, the ways in which the earliest moderns on the butte systematically dismantled the world around them, only to reconstruct it in a new way, has only been partially addressed by prior publications. The larger issue of the cultivation of a community on the "fringe" and its ability to forge the earliest example of what could be termed a mass popular culture has remained largely unexplored. The conference "Montmartre and the Making of Mass Culture," held at the Minneapolis Institute of Arts in March 1999, set out to examine this aspect. The collection of essays presented here represent both the preservation and elaboration of the symposium's goal to probe the nature of popular culture as it was cultivated in Montmartre and to question its continued significance in the postmodern period.

The essays contained in this book demonstrate how and why Montmartre became a breeding ground for what today is termed popular culture. Literally on the fringes of Paris (and thus not subject to the strict enforcement of its laws), Montmartre became an arena where traditional boundaries were blurred (one of the primary conditions considered today to be indicative of postmodernism). The compromised boundary between "fine art" and "popular illustration" was inherent in the colorful posters, which originally intended to promote the personalities and establishments of the area. They disappeared as quickly as they

were displayed—stolen to decorate the homes of those who could not afford paintings. The decoration of the cabarets themselves was highly eclectic, blending styles from the world over. A form of graffiti became a popular mode of interior design, as artists doodled and scrawled messages on the walls and furniture of their favorite drinking establishments. Similarly the traditional boundary between the "artist" and "audience" was obscured and occasionally removed in Montmartre performances, prefiguring postmodern "happenings" and "performance art." Cabaret owners would accost their customers; dancers would "perform" in order to stimulate the crowd to dance and drink. Religious traditions fell under the pressure of prostitution, alcohol, and other forbidden pleasures and were further subverted by a variety of "alternative" religious practices promulgated by Rodolphe Salis and others. Gender divisions were similarly obscured as a penchant for "transvestism" encouraged cross-dressing. Bisexuality among the female performers became yet another attraction that drew together a wide collection of social types. Perhaps the most consistently apparent way that Montmartre "blurred boundaries" was between the traditional class divisions as "high life" and "low life" became indistinguishable from each other. Here the workers mixed with the bourgeoisie; radical anarchists mixed with moderates and conservatives, and the prostitutes masquerading as barmaids or performers served them equally. The area profited significantly from the members of the middle classes who were compelled to experience the perverse pleasures of Montmartre, and it was their presence that stimulated a quest to provide ever more shocking entertainment, frequently at their own expense—both morally and financially.

The construction of the Sacré-Coeur on the butte during the height of Montmartre's popularity added another layer of boundary-blurring and mixed messages. Not unlike the contemporary practice of announcing special "Jubilee Years" by the Roman Catholic Church in an attempt to stimulate pilgrimage and the monies it generates, the construction of the Sacré-Coeur was a publicity stunt—a method of visual "spin control" in the form of a huge white church that could be seen from every section of the city. Its placement on the butte served as a huge advertisement for the Catholic religion, which had been under various forms of assault for more than a century and was experiencing a deep crisis in membership. Completed just ten years after the Eiffel Tower, the Sacré-Coeur became a monument determined to efface the secularity gaining ground in Montmartre and the city of Paris. Its placement suggested that Montmartre was a site for pilgrimage and set up a sharp dichotomy between what was "sacred" and what was known to be the "profane" nature of the area and its favored activities. However, the Church itself soon participated in the commer-

cialism promoted by the 1889 and 1900 world's fairs and itself became a destination for tourism rather than religious pilgrimage. The fact that a souvenir store was part of the original plan (and remains there today) attests to the succumbing of the monument to the nature of the butte, rather than the salvation its appearance originally suggested.

With these concepts embedded as guidelines for the blurring of social and artistic boundaries and the resulting emergence of popular culture it is possible to see how the various essays in this book isolate differing strains of thought, from the general tenets of bohemianism to the specific contributions of its constituent members. The themes that the authors have addressed provide a deeper understanding of the way Montmartre functioned at a moment when radical change was in the air and mass popular culture was born.

———

In the first part Montmartre is examined within a broad social context in order to reveal a variety of themes that had particular resonance in Third Republic France. Montmartre was from the beginning a "delinquent community"—a position argued by John Kim Munholland. It was a location that would not follow the normal ideas of the Third Republic; it was a site where individuals banded together to challenge the mores of the era and to try to push for new liberties and points of view despite a restrictive attitude from those who were in control of the government. Within time, those who led the country recognized that Montmartre had its own vision—that it was an uncontrollable site—and that the only way it could be dealt with was by allowing its existence. This tolerance for the new, for the different, was a remarkable first step in allowing the origins of a popular culture to emerge with its original shocking impact and freshness, without tempering that would have lessened its impact.

Montmartre was also a site where pleasure and vice were equated, especially through the visualization of different types of women. The moral questions raised by a virtue or vice duality are the issues examined by Elizabeth K. Menon in her essay, "Images of Pleasure and Vice: Women of the Fringe." Depictions of women dressed in the latest fashions formed a visual map or matrix by which the region could be understood. Montmartre's artists could also conjure up ideas of danger and enticement through their visual representations of the area's female population. The popular press (illustrated journals and books) in which the images appeared served as the voice of the Montmartre artistic community and consistently challenged the mores of a bourgeois society. The agitations by Parisian feminists (who took morally upstanding, anti-prostitution stances)

were subverted by Montmartre artists who promoted "their woman"—the Montmartroise—as superior both in dress and sexuality. Her "danger" was a positive attribute which contributed to the atmosphere of the butte, which thrived on the juxtaposition of vice and virtue. Montmartre heightened a newer and more profound picture of what women were capable of achieving irrespective of religious or moral considerations. Artists enjoyed manipulating their audience by the blurring of the sexual and the sacred in the Montmartroise, a feat accomplished by frequent visual referencing to Eve and her virtuous replacement, the Virgin Mary.

The picture of an intemperate society on the butte is effectively examined by Jill Miller, whose "Les enfants des ivrognes: Concern for the Children of Montmartre" reveals that despite a bourgeois appreciation for the importance of the child as an individual, substance abuse prevailed at home. Montmartre, similar to other sections of Paris, responded to the necessity of improving the environment and the lives of the poor. These conditions were addressed by the posters and prints of Théophile Steinlen, many of which, ironically, were advertisements for specific products. Steinlen became, in effect, a consciousness-raising advocate who wanted conditions improved and was able to harness the power of advertising for social as well as commercial aims. Steinlen focused on issues that affected all Paris using the symbolic setting of the butte as his pulpit. Montmartre also became the prototypical example for regeneration issues—for the improvement of society in general—providing a foundation for examining social issues that have become paramount in mass culture since the 1890s.

The tensions in Montmartre that existed between visitors and inhabitants on the butte and conflicting groups are examined in different ways by Raymond A. Jonas in "Sacred Tourism and Secular Pilgrimage: Montmartre and the Basilica of Sacré-Coeur" and Richard D. Sonn in his essay, "Marginality and Transgression: Anarchy's Subversive Allure." Both authors see the butte as a location rife with conflicting ideologies, where differing tendencies vied with one another but successfully recognized that each needed the other to survive. In seeing the construction of the Sacré-Coeur as a means of France's reestablishing its traditional identity and reasserting moral order following the Franco-Prussian War, Jonas recognizes that the creation of a modern pilgrimage site emphasized a new way in which tourists could contribute to the financial betterment of the country. In seeing the butte as conflicted Jonas rightfully argues that diversity was one way to survive. Montmartre provided a model for collective action—especially those involving the ways in which religion was being molded and modified for a new century.

Richard Sonn's essay moves in another direction. In seeing Montmartre as headquarters for radical organizations—especially anarchists—he notes that these cells gave the district a "seductive allure." The bourgeoisie came to rub shoulders with those who had been marked as dangerous both through their word (equal distribution of wealth and the dissolution of class divisions) and deed (terroristic behavior, especially bombing). What Sonn argues is that Montmartre became the home for another type of culture: those who were rebellious and oppositional found a home in this district. Radical writers, performers, singers created the image of the disenfranchised but productive group able to function effectively because they created a cohesive solidarity. Hope and revolution existed here; revolution on a broader basis was stressed. Artists were clearly aware of what was happening, representing various outspoken types in posters and prints. Sonn's essay brings one further around to the underlying historical messages in this series of essays. Contestation as represented by anarchists moved from an elite to a popular culture status. Sonn notes that grunge rock groups of the 1990s used the "transgressive look" and sound in spreading the new idiom to those who felt helpless, anguished, and empty. This remains one of the ways in which popular culture has appropriated the directions and implications of an earlier time.

Each of these essays demonstrates various historical strains present in Montmartrian life and suggests ways in which they prefigured the future of mass culture. These tendencies existed in an uneasy cohesion creating an environment that was unlike any other. The effect on various artistic segments is examined further in the second collection of essays.

———————

The essays in this segment focus on the ways in which specific artists or groups created images that reflected the environment in which they lived and ways that aspects of Montmartre culture could be transported elsewhere. Howard G. Lay, in "Pictorial Acrobatics," argues that elements of "low culture" were employed by artists as a means of destabilizing a hierarchical construction. Since Montmartre was the natural habitat of *le peuple*, Lay argues that much that was created was irreverent and oppositional in form and style. In focusing on the signboard of Le Lapin Agile, Lay identifies the unpretentiousness of the image and the ability the artist had in subverting established hierarchical ways of creativity. Since the tone of the work—the signboard itself—stressed misbehavior, it was no wonder that the bohemian community valued both the "sign" and the location—the cabaret that it served—as significant contributions to creativity. In identifying links with the Commune and the political climate of the era, Lay

also identifies several layers of meaning in a popular icon revealing that one image could contain references that were understood, simultaneously, by different sections on the butte. In moving onto the consideration of Seurat's painting titled *Chahut*, Lay elucidates how an image or a location (such as the setting of a dance hall) can be used to suggest new modes of advertising that refer to the world of Montmartrian commercial entertainment at the same time as the image is engaging in a language of promotion necessary to bring people to a higher level of awareness. Lay sensitively demonstrates new ways at looking at images, which lie at the heart of a creative revolution and the utilization of popular culture. He comments effectively on a society that was emphasizing modes of entertainment and popular enjoyment as a way of involving artists in recognizing these areas of creativity.

Michael L. J. Wilson, in his "Portrait of the Artist as a Louis XIII Chair," moves away from the examination of single works of art toward a reevaluation of the entire community, as an extension of the Romantic doctrine of bohemianism. All of creative life was organized around *cabarets artistiques* where spaces were controlled and manipulated by bohemians who were dedicated to presenting their "creative labors" to the public. The Chat Noir became the most popular of these environments where parody, carnivalesque humor, and experimentation with language were the order of the day. At the heart of Wilson's argument is the nature of bohemian identity. The qualities that the cabarets preserved so well, he believes, were consistently challenged by the influx of bourgeois "tourists" who remained largely unable to grasp the significance of each performance. Importantly Wilson's text, whether examining Le Chat Noir or other cabarets such as Le Mirliton or the Taverne du Bagne, addresses how the shocking nature of these performances were destined to be short-lived. The initial strength afforded by imagination and the "shock" that was generated would be tamed through repetition. This led to the cultivation of spontaneous creativity and a romanticizing of the "creative moment." Wilson suggests that much of Montmartre's popularity hinged on the cultivation of the unique time and space of a creative act continually reattempted in other bohemian sites inspired by the butte. Two major recipients of this heritage were the Dadaists who practiced similar spontaneity and disjointedness in their famous "soirées" and the professionalizing of "performance art" as a medium in the 1960s.

Two other essays examine significant aspects of creativity that were developed most fully in Le Chat Noir by its owner/operator Rodolphe Salis. Janet Whitmore's "Absurdist Humor in Bohemia" examines the ways in which artists and writers in the circle of the Chat Noir viewed the so-called "sacred cows" of

France's literary past. Whitmore skillfully suggests that within a series of publications, titled the Contes du Chat Noir, history, religion, and morality were frequent targets for satire and parody either in a literary mode or through visual puns. In this way, Whitmore suggests that the Chat Noir publications were prefigurements of "bohemian" literature, cult magazines, as popular writings that were available for the public to study or use as they saw fit. Elena Cueto-Asín, in "The Chat Noir's Théâtre d'Ombres," argues that although the content of the famed shadow plays has been studied, their impact on their audiences (in terms of reception theory) has not been examined. Cueto-Asín sees the shadow theaters as spaces where the public was being introduced to new forms of popular culture, and the love for moving images as a type of prefiguration of the cinema. Whether drawn from the Far East or from Symbolist sources, the shadow plays destroyed the demarcation between audience and creative space, effectively eliding the physical barriers of creativity. The reactions of the audience were critical to the success of each performance. Cueto-Asín rightfully acknowledges that the spaces of performance, those individuals that occupied it, and the performances themselves were all part of the drive associated with the consumption of entertainment central to creative experimentation on the butte.

Gabriel P. Weisberg's essay, "Discovering Sites: Enervating Signs for the Spanish *Modernistas*," examines ways in which outsiders were absorbed into the bohemian community and how they reacted to the atmosphere cultivated on the butte. The Spanish painters from Barcelona, most of whom were financially independent, came to Montmartre because of the lure of excitement and the belief that this was the current seat of creativity. They recognized that qualities of bohemian creativity were all-consuming and then imported their impressions of the environment to Spain with "art as the only religion." They demonstrated that bohemian life could be transported and that ideas could be understood apart from the blatant commercialization of Montmartre's nightlife. They were determined to transmit what they had gleaned from their experience to a new generation of young artists, thus cultivating their own "Modernista" revolution. Rusiñol and his group became model purveyors of artistic culture spreading the visions of Montmartre to younger communities eager to promote artistic ideals. Through their efforts they demonstrated how inspiration from the Montmartre community could become the basis for a popular culture movement in another country.

———————

What remains most persuasive about the culture in Montmartre is the fact that the origin of the mass culture developed and promoted there began with a

small, elite group. The ability to challenge preconceptions began with a radical few; the compromising of cultural taboos similarly was practiced by a close-knit society. The infusing of artistic culture, specifically the practice of fashioning color lithographic posters into advertisements replete with symbols that could be interpreted one way by the artist and another way by the masses, changed forever the elitist status of the area. In the end the area thrived by the influx of the middle classes to the entertainment establishments, for they were the ones with money to spend. However, the popularity gained by the unconventional performances, through their attacking of the "sacred cows" of religion, of politics, of so-called "bourgeois respectability," changed forever the nature of the butte. No hierarchies remained in the atmosphere of deconstruction. The new became the order of the day and Montmartre's culture triumphed.

While innumerable books and articles have been published about Montmartre, including those that were written in the nineteenth century, any examination of this literature demonstrates that one important aspect has been overlooked in these publications—Montmartre contained the seeds of popular and mass culture as society emerged into the twentieth century. Beyond the well-charted interest in the Chat Noir, the creativity of Toulouse-Lautrec, the early paintings and contacts of Pablo Picasso at the Bateau-Lavoir, our current series of essays provides something new and vital. They examine Montmartre as the starting point for much of what we take for granted about mass culture. They posit that it was in Montmartre that the seeds of what has been defined as mass culture were planted, where audience responses were taken into account, and where new types of creative auteurs challengingly appeared. These tendencies are addressed in the various essays in this book as the authors have demonstrated how the sense of creative license on the butte helped stimulate innovative ideas that eventually became the basis for popular culture in our century.

What had been important to only a few has become the visual culture of the masses. Even experimental music, often dissonant and discordant, initiated by Erik Satie, for example, has triumphed in our century; the stream of consciousness expressed in writing and in cabaret performances inspired not only the Surrealists of the 1930s, but opened the way for today's standup comics to reveal their innermost thoughts to their audiences. Bohemia, which once frightened the establishment and attracted only a few among the young, involves a greater number of youths who push the envelope ever further to establish the norm. A century or more has passed and the ability to shock is not as easy to achieve as in 1896 when *Ubu Roi* was first performed. However, doing the unusual, challenging preconceptions, has become the standard way for popular culture to cre-

ate the new. Once the new enters the mainstream it is co-opted by many, consumed, commercialized, eventually trivialized and passed onto the masses as the avant-garde begin their search for the "new new." It is this cycle of change that was first heralded in the community on the butte around 1900.

Is Montmartre unique in its appeal and in its influence on popular culture? Can we identify other locales and other times when a similar attraction existed? Berlin in the teens and twenties when commercialization was rampant and experimental theater reigned comes to mind, as does the New York of the late 1940s, and 1960s London. Both of these latter periods saw society adopting previously held experimental means as a basis for the making and expansion of a culture for society at large. The end of the twentieth century has seen the globalization of popular culture through the Internet. Still, the questions of true democratization remain and money still determines the degree to which the "masses" have access. Popular culture remains transcendent, the masses continue to be influenced by the elite (often unbeknownst to them). In the process a culture that is transportable has been created. The impact of Montmartre appears in every mall, in each small cabaret or nightclub performance, on the Internet and especially in the contemporary fad of "reality T.V." Mass culture is everywhere and the nature of the revolution created in Montmartre remains significant for its ability to so effectively prefigure the tenets of postmodern society.

Part I

એત

The Historical Context

Republican Order and Republican Tolerance in Fin-de-Siècle France

Montmartre as a Delinquent Community

J O H N K I M M U N H O L L A N D

The young republican politicians who gained control of the Third Republic at the end of the 1870s did not know what to do about the turbulent eighteenth arrondissement of Paris, or Montmartre. These republicans set out to construct a republican civil society that would be progressive, secular and moderate, avoiding the extremes of clerical reaction on one side and the dangers of revolutionary upheaval and disorder on the other. Montmartre seemed to embody both extremes. Montmartre had been at the heart of the Commune, the desperate revolutionary uprising that led to the establishment of a radical, revolutionary government in Paris in the spring of 1871. The Commune had ended in bloodshed when Adolphe Thiers, head of the Provisional Government, sent regular French troops into the capital to repress the uprising. In the "bloody week" of May 21–28 an estimated twenty thousand perished in the fighting. In the aftermath the Provisional Government deported many Communards from Montmartre to the penal colony on the distant island of New Caledonia in the South Pacific. The Mur des Fédérés in Pére Lachaise Cemetery, where 147 Communards had been executed, became a site of memory under the Third Republic. Montmartre became a code name for both the revolutionary uprising and its brutal repression.

At the other extreme the basilica of Sacré-Coeur symbolized the reactionary, counter-revolutionary Right. In July 1873 the government of Moral Order, which ruled France from 1872 to 1875, voted funds to begin construction of a basilica devoted to the Sacred Heart on the heights of Montmartre, the very center of Communard resistance. Sacré-Coeur stood in memory of the clergy, including Monsigneur Darboy, the archbishop of Paris, who had been killed by the Communards. The Communards had their symbolism of martyrdom, and the Church had another. Sacré-Coeur was intended to serve as a site of expiation for the sins of the revolutionaries. The building and then the presence of Sacré-Coeur became, as one historian has observed, "a permanent insult [and] a challenge" to republican secular values throughout the life of the Third Republic.[1] At the same time, the moderate republicans wished to avoid embracing the violence of the Communards' revolutionary tradition and distanced themselves from its memory. At the same time they opposed the Church's attempts to rechristianize France and save the country from the pernicious doctrines of 1789. This would be a moderate, anti-clerical republic committed to gradualist, reformist politics.

At least symbolically there seemed to be little room in Montmartre for a moderate republicanism between the two extremes represented by Sacré-Coeur and the Commune. What developed at the end of the nineteenth century was a tension between the Third Republic and the butte that revealed both the limits and the extent of the Third Republic's tolerance of Montmartre's deviation from republican norms. This essay explores the way in which moderate republicans responded to the often critical and irreverent attacks upon the Third Republic and its civic order that could be heard in the cabarets, read in the literature, and seen in the images coming out of this area. The thesis argued here is that the republicans of the early Third Republic came to view Montmartre as a kind of "delinquent community," and the question is how much delinquency did or could the republican leaders tolerate.

What is a "delinquent community" in the context of French values? An imaginary scene from a boy's primary school, an "Ecole des Garçons," may illustrate the concept. The teacher turns his back to write on the board. Immediately the air behind him is filled with spitwads and other flying objects. Sensing disorder, the teacher turns around and the commotion ceases. A stern gaze indicates disapproval. The hierarchy has been challenged by a band of *copains* engaging in a moment of freedom and self-expression until order is restored and the lesson continues. This imaginary uprising, or momentary defiance of established authority, illustrates the behavior of what the sociologist Jesse Pitts identified

several years ago as a "delinquent community." Classroom scenes such as the one described revealed the ways in which students would, however briefly, turn the classroom into occasions for "entertainment or cheating" in defiance of a hierarchy that insisted upon order and obedience and left little room or opportunity for the formation of informal peer groups. Despite official disapproval these *copains* would seize opportunities to defy authority and deviate from expectations of correct behavior in a way that amounted to a gratification and fulfillment of forbidden pleasures.[2]

Montmartre became "delinquent" and a challenge to the new republican order in four ways. First it became the site of the Church's reproach to the immorality of the revolutionary tradition. Then it was remembered as the locale of the Commune, which embodied the violent side of that revolutionary legacy. It became fertile ground for a populist, nationalistic attack from the radical right in defiance of moderate republican values at the time of the Boulanger affair. Finally, it served as the place with a reputation for pleasure, amusement, imaginative freedom, and a degree of sexual license that challenged republican values of work, discipline, rationality, and the role of women within the republican family. Could republican moderates tolerate deviation from bourgeois norms, and what were the limits of republican patience with a defiant or "delinquent" community in search of pleasures outside republican proprieties?

When the republicans gained full control of the institutions of the Third Republic at the end of the 1870s, they set about creating a republican "moral order" to replace the monarchist, pro-Catholic government of Moral Order that had characterized the Third Republic's early years. The republican generation that came to power in the late 1870s tended to be philosophical materialists and freethinkers in religious matters. They all had entered politics in the last days of Napoleon III's Second Empire as members of an opposition committed to replacing that empire with a democratic republic. They were not radical libertarians, since they believed in the virtues of discipline, order, and patriotic loyalty to the Third Republic's institutions. They formed a positivist generation of political leaders who had faith in science, material progress, the improvement of humanity, and the rights of the male citizen as embodied in the Rights of Man and Citizen proclaimed during the Revolution of 1789. They believed that secular education was the way to develop the good citizen and promote the values of a civic culture.[3]

The republican leader who personified these moderate republican ideals was Jules Ferry, the author of the Third Republic's laws that created a secular, free state education system based upon humanistic and scientific principles. Ferry

believed that the republican state had a "moral mission" of civic education that should instruct students on their political rights and duties.[4] While students would be taught how to be good citizens, they would also be exposed to the arts, but only for a useful purpose. Culture would become a weapon in the construction of republican unity and advancing social peace.[5] During his tenure as prime minister and minister of education and fine arts, Ferry proclaimed that the arts would be a means of civilizing the workers of France. The arts in a democratic society would introduce workers to aesthetic ideas that would improve them and would provide greater satisfaction in their work as artisans. The purpose of arts education was to be pragmatic and socially useful. Ferry did not want, as he put it, to "increase this scourge" of starving artists, of painters trying to live by their brushes, or of sculptors condemned to a life of misery and begging.[6] He wanted happy artisans committed to the improvement of goods produced for the benefit of a republican community.

The republicans sought to implant their values in public spaces as well as within the confines of the classroom. In the 1870s and 1880s the symbolism of the new Republic took form. In 1879, just at the moment of the republican political triumph, the Municipal Council of Paris decided to build a monument on the Place de la République just north of the Place de la Bastille (Fig.1.1). The symbol of republicanism was a gigantic figure of Marianne, wearing a Phrygian hat, placed in the center of the square.[7] In Paris the city halls of the twenty arrondissements became decorated with a new, republican art, including paintings and murals that extolled ideals of patriotism, uplifting morality and civic virtue, including civil marriage. These new decorations were intended to reinforce republican values, including allegories that extolled the benefits of fidelity, chastity, and family reproduction in the secular *salles de mariage*. Scenes of industry, labor, and the triumphs of civic virtue adorned the hallways, staircases, and *salles des fêtes* of all arrondissements, including the eighteenth.[8] Symbolism was all-important. Busts of Marianne greeted visitors as they entered these halls of republican authority.

The new official art was monumental, triumphant, and served as a way of reinforcing and propagandizing the new order in the popular arrondissements of eastern Paris as well as in the villages of the countryside where the slogan, "Liberty, Equality, Fraternity," graced the portals of all official buildings. On the other hand, the Commune was demonized in these allegorical scenes as seen in the sketch of Urbain Bourgeois for the ceiling of the stairway of the twelfth arrondissement that equates the Commune with anarchy.[9] Secular, patriotic festivals further served these colonizing aims. After lengthy debate, much dispute,

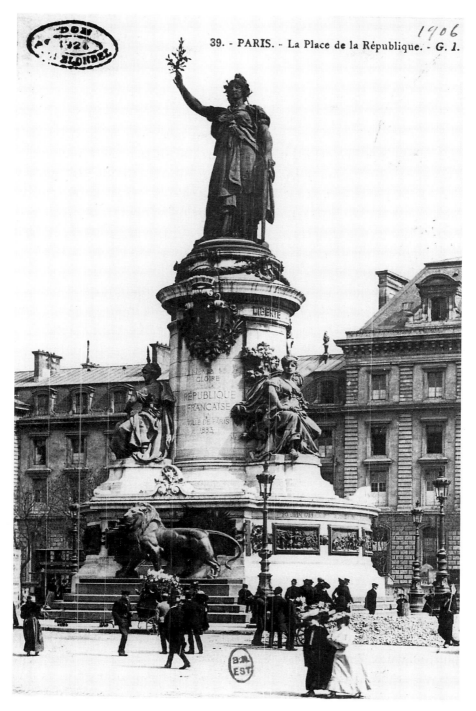

Figure 1.1 Léopold and Charles Morice, *The Republic,* 1883. Bibliothèque Nationale de France, Paris.

and first designating June 30 as the date of national celebration, political leaders settled upon July 14, Bastille Day, as the national holiday to commemorate the triumph of republicanism over the old order and as a manifestation of national pride and unity.[10] In 1879 the Third Republic adopted "La Marseillaise" as the national anthem, again asserting an image of a politically progressive state and community linked to the liberating moment of the Revolution of 1789. But the extremes of the revolutionary era were studiously ignored. Friezes around the base of the statue of Marianne in the Place de la Républic showed republican moments from 1789, 1792, 1830, 1848 and the declaration of the republic in 1870, but left out the Terror of 1793–94 and the Commune of 1871.

The decade of the 1880s opened with growing republican confidence. In a gesture to the Communards, after nearly a decade of hesitation and debate, 1880 brought amnesty for those who had been deported to Algeria and New Caledonia following the suppression of the uprising, and many came home to Montmartre after nearly a decade of exile. The two most famous of these Caledonian deportees were the journalist Henri Rochefort, who actually escaped from New Caledonia, and Louise Michel, the "red" schoolteacher who had led a women's battalion during the Communard resistance. In a further move toward an open and free society, Jules Ferry pushed through a liberal press law of July 29, 1881, that virtually, but not completely, eliminated press censorship in what one historian has described as "a fine example of liberal legislation."[11] No longer were newspapers required to obtain prior approval before publication nor were they required to post caution money. Yet publishers could be prosecuted for certain offenses, such as provocation to military desertion, incitement to commit a felony, insults to the president of the Republic or to members of the government, or defamation of individuals.

This was limited liberalism and not absolute freedom of the press. Still, the law enabled a profusion of new publications to appear, and it also opened the way for a massive production of posters and advertisements that quickly plastered the walls and adorned a growing number of kiosks and Morris columns decorating the urban landscape of Paris. The stricture forbidding the posting of bills under the law of July 29, 1881, which may still be seen on the walls of Paris today, was frequently violated. The government itself encouraged the spread of street posters and advertisements by auctioning approximately 140,000 square feet of wall space to advertisers, which brought in 15,000 francs each year to the municipal government of Paris (Fig.1.2).

The cultural entrepreneurs of Montmartre quickly exploited these new opportunities for advertisement and street art, but some republicans were shocked at

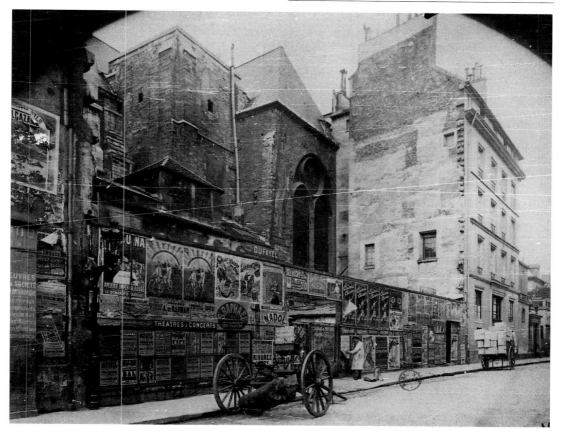

Figure 1.2 Atget, photograph of rue de l'Abbaye, 1898. Bibliothèque Nationale
de France, Paris.

what they saw. The use of seductive images of women in these posters caused
Senator Bérenger in 1896 to push through a law against posters as well as plays
and cabaret performances that were deemed shocking to public morality. Further-
more, the "Union for Moral Action," a private group, joined Senator Bérenger's
morality campaign. They tried to limit what they saw as indecency in the
posters, particularly those advertising the pleasures to be found in the cabarets
of Montmartre, and they tried to replace these "lightly pornographic" posters
with more serious ones designed to have an edifying, not a seductive, effect
upon the viewer.[12] Here was a limitation of republican tolerance.

In another area the advent of the republicans brought liberalization. When
they gained control of the Third Republic in 1879 they moved quickly to limit
the power of the prefects over the cafés and cabarets of the city. Within a year
the new regime passed laws guaranteeing expression of political opinion in all

cafés. This legislation reflected a belief by such republican stalwarts as Leon Gambetta that cafés were, in his phrase, "salons of democracy," reflecting his own youthful experience challenging the repression of the Second Empire in the cafés of the Latin Quarter in the 1860s. A law of 1880 forbade closing any café for political reasons, but authorities could shut down establishments for reasons of prostitution or other "disturbing" behavior.

The new legislation brought a dramatic expansion of drinking establishments. By 1895 there were 30,000 cafés located in Paris, many in Montmartre.[13] Not that the republicans favored drink, and indeed they worried about the effects of increased alcoholic consumption among the working class and upon the health of the family. They believed reports that the excesses of the Commune resulted from debauched Communards and drunken members of the National Guard rampaging through the city. The trouble here, as Susannah Barrows notes, is that the regular troops sent from Versailles to repress the Commune in 1871 ransacked the cafés in search of liquor or became frequent clients at those establishments that remained open. In the aftermath of the Commune, temperance societies advocated control over drinking establishments, seen to be centers of debauchery and threats to political order and family stability.[14] Middle-class republican fears focused upon café life as a threat to the social order, both in a moral and a political sense. The time of the Commune represented working-class café culture at its apogee.[15] Nevertheless, the Third Republic relaxed controls over such places. This was a relatively open, but not necessarily a completely permissive Republic. Much of the fear of alcoholic consumption reflected middle-class concerns about its effects upon the working class and their children.

Confronted with a bourgeois, conservative, and somewhat stuffy republican ideology or ethos, Montmartre saw itself as a world apart from the mundane demands of civic ethics and republican instruction. The district's long tradition of independence and defiance of all forms of authority now turned against the Third Republic and began to make fun of republican ideology. Satires and mockery of bourgeois republicanism and the mundane and increasingly corrupt politics of the Third Republic permeated the cabarets and found expression in the art of the 1880s. The wits of the butte shared, curiously, a conservative critique of the new republic as expressed by Daniel Halévy, who regretted the passing of an era of notables, an elite of distinction and talent. In Halévy's judgment politics of deference and the leadership of men of social and intellectual stature had given way to a regime that he declared to be "mediocre" and little more than a "school for cowardice."[16]

From a populist, rather than Halévy's elitist perspective Montmartre stood against prosaic, republican qualities and values that admired material progress, praised reason and science, honored hard work above the imagination, and promoted family stability. In their opposition, chansonniers and writers expressed a sense of play, imagination and idle pleasure. They denounced republican monuments to scientific technology, exemplified by the newly constructed Eiffel Tower, as signs of vulgarity rather than progress. From the perspective of Montmartre, science, sobriety, and reason left little room for aesthetics, humor, or the creative spirit.

Montmartre refused to take politics seriously, which the republicans certainly did. Plays, performances, poetry, cartoons, and satires in the *Chat Noir* or Aristide Bruant's *Le Mirliton* lampooned the earnest politicians of the Third Republic in a spirit of *fumisme* and in defiance of the newly established, if still somewhat uncertain, authority and official orthodoxy of republicanism.[17] The Chat Noir cabaret stood in opposition to the "seriousness" and pretensions of what was becoming the established republican generation, now subjected to ridicule and offering occasions for amusement and entertainment. Republican claims to have brought a new era of virtue and civic responsibility contrasted with the reality of what Eugen Weber has described as a long series of political crises running through fin-de-siècle France.[18]

The politics of the Third Republic during the 1880s and 1890s provided many opportunities for satire and mockery. What began as a republic of virtue appeared to degenerate into a "republic of pals" in the eyes of critics from both the left and right sides of the political spectrum. Scandals, such as the sale of awards and honors out of the office of the president of the Republic, revealed corruption in high places. The early 1890s produced more scandals such as the Panama Affair in which leading politicians, financiers, and high-profile engineers, including Gustave Eiffel, became implicated in the bankruptcy of a company that had been formed to build a canal across the isthmus of Panama. The collapse of the Panama Canal Company added to the discredit of several republican politicians, including Georges Clemenceau, a former mayor of Montmartre at the time of the Commune. Such scandals inspired a number of satirical images of political life, as can be seen in Steinlen's image of *The Deputy* (Fig. 1.3).

Anarchists and conservatives alike heaped criticisms upon what appeared to be a regime more notable for hypocrisy than virtue, and it was this hypocrisy of political life and the smugness of didactic republicans that elicited the sarcasm of the poets and the illustrators of the quarter. Although claiming to be against politics, the cabarets represented a kind of perpetual "fronde" against the system.

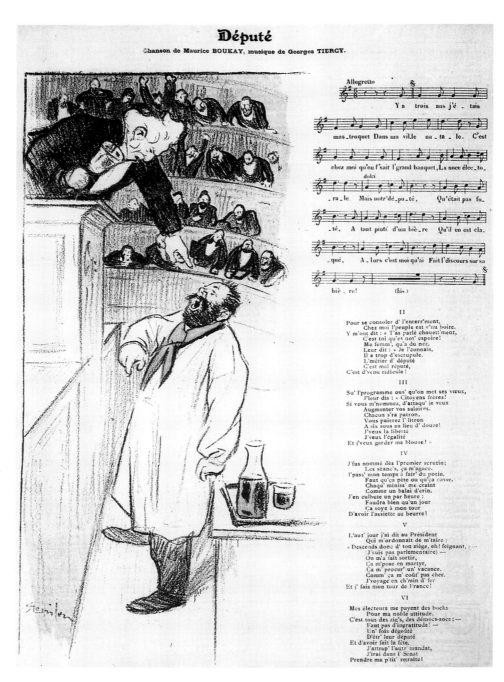

Figure 1.3 Théophile-Alexandre Steinlen, *Député* (*The Deputy*), 1901. Lithograph. Bibliothèque Nationale de France, Paris.

In some ways this mocking of bourgeois, republican virtue in the music halls and print literature anticipated a similar critique of staid, bourgeois republicanism that would appear during the 1920s in Weimar Germany. Unlike Weimar, the Third Republic, beset with crises and lampooned by its irreverent critics, was able to survive. In the final analysis Montmartre's popular culture was provocative, troublesome, and irritating to the republicans, but not a serious threat to the regime.

There was little that was sacred in the eyes of inhabitants and visitors to the butte. Republican festivals, such as Bastille Day, became transformed into moments of revelry, less a moment to celebrate the triumph of republicanism than a time to escape from the grim reality of everyday life. The national holiday even took on an ironic twist in the hands of Steinlen whose portrait of a working-class father and his two daughters showed Bastille Day as a hollow festival for those whose daily lives were harsh. Ordinary people welcomed a day off and took their pleasure and leisure without regard for the political significance of the occasion. Bastille Day offered opportunity for drinking, dancing, and a moment of amusement. But Steinlen's images of popular celebrations of the

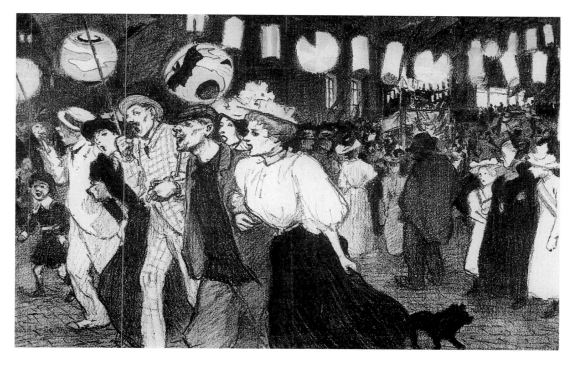

Figure 1.4 Théophile-Alexandre Steinlen, *14 Juillet (July 14)*, 1901. Lithograph. Bibliothèque Nationale de France, Paris.

national holiday also carried a suggestion of potential revolution amid the festivities, as seen in his *14 juillet* (Fig. 1.4).

While the national holiday became transformed from an official to a popular festival to suit the tastes of the people, republican attempts to generate moments of memorial often fell flat or seemed ponderous and failed to attract crowds. The centenary of the first republic in 1892 attracted a sparse crowd. Such ceremonies seemed more contrived than popular or spontaneous. A grandiose, official republican Bastille Day commemoration may be seen in Edouard Detaille's painting of the military review at Longchamp on July 14, 1880, the first official Bastille Day. Ironically the review of the troops following the suppression of the Commune in 1871 occurred on the same site (Fig.1.5).

While the national anthem, the Marseillaise, was sung on these occasions, it also was used ironically, as seen in Steinlen's print *Un Electeur (jour de boire est arrivé)* (*Voter [Drinking Time Has Arrived]*) (Fig. 1.6). In the colored print of this image, published in an inexpensive volume of 100 reproductions of Steinlen drawings taken from *Gil Blas Illustré, Chambard,* and *Mirliton,*[19] the caption read, "Allons, enfants de la partie [game, not country],/Le jour de boire est arrivé!" Eric Satie parodied "La Marseillaise" in one of his earliest cabaret songs, composed for the satirical review of Vincent Hyspa, *A Dinner at the Elysée.* The show

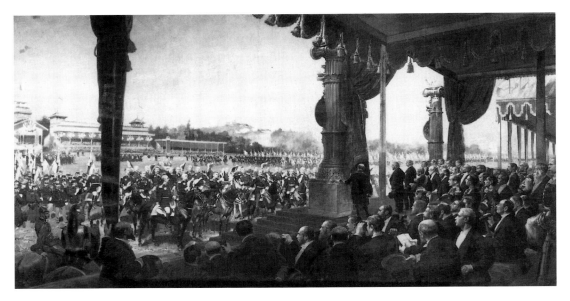

Figure 1.5 Edouard Detaille, *La Distribution des drapeaux à Longchamp, le 14 Juillet, 1880 (Presentation of the Flags at Longchamp, July 14, 1880)*, 1881. Oil on canvas. Musée de l'Armée, Paris.

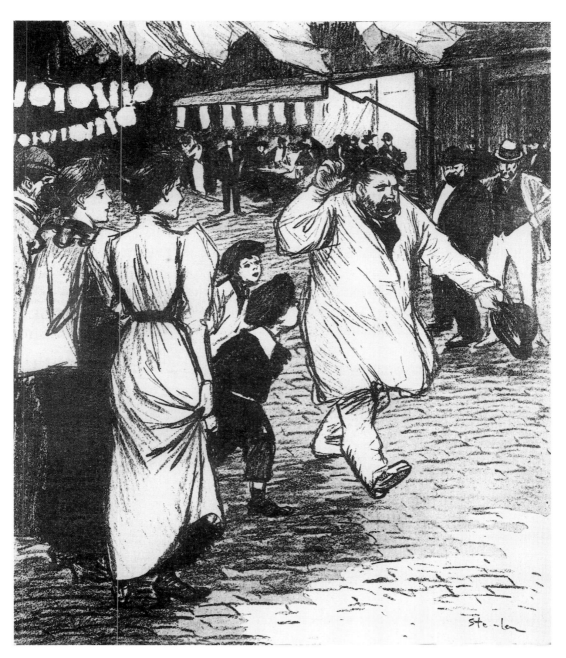

Figure 1.6 Théophile-Alexandre Steinlen, *Un Electeur (jour de boire est arrivé)*,
Voter (*Drinking Time Has Arrived*), 1901. From *Dans la Vie,* Paris, 1901.
Bibliothèque Nationale de France, Paris.

was produced to parody President Loubet's invitation to various artistic boards to attend an official dinner at the Presidential Palace during the time of the annual salon. In the production, a military band serenaded the guests between each course with the "Marseillaise" played as an off-tune march.[20]

In the 1880s Montmartre also played out of tune with republican political orthodoxy. The popularity of General Georges Boulanger, called "General Revenge" for his strongly anti-German sentiments, was a popular figure in Montmartre. Quite literally a military hero on horseback, Boulanger gained popularity throughout France for his implied criticism of the weakness and cowardice of the Third Republic's political leadership. Boulanger's message of nationalism, combined with a critique of the weaknesses and corruption of parliamentary institutions, won him popularity with a variety of political constituencies on the left and on the right. Initially radical Left republicans thought that he might be a force to revise the constitution of the Third Republic to make it more democratic through the elimination of the more conservative upper house of parliament, the Senate. Other Boulanger advocates found in his sense of outraged nationalism and anti-German sentiments a parallel to the defiance first of Paris under siege during the war of 1870 and then of the Commune in 1871. Among the Montmartrois he had a reputation as a nationalist and a "general of the people."

Among Boulanger's initial supporters was the radical republican Georges Clemenceau, who later withdrew his support for the general when he realized that the backers of Boulanger came from the other end of the political spectrum, the anti-republican right. Boulanger received financial backing from various anti-parliamentary groups, including royalists who detested the republic and saw in him a strong leader who would clean out the parliamentary stable and prepare for a royal restoration, or at least put an end to the maneuvers of self-serving politicians. The dashing general, backed by royalist money, launched a modern, "American"-style political campaign, using songs, banners, and ashtrays to advertise the cause. He would run for vacant parliamentary seats in by-elections and had considerable success. As a serving military officer, he was not allowed to take his seat in parliament and would always resign after his elections. The campaign, though, became a kind of referendum against the republic and an occasion for well-publicized attacks upon what the Boulangists claimed were the Third Republic's mediocre and corrupt politicians.

Boulanger's message found enthusiastic support with local cabaret singers and praise in the pamphlet literature. In civilian dress the general became a frequent visitor to the cabarets where the general's campaign song, "In Returning

from the Parade," regularly would be sung. Spectators at the Divan Japonais would shout "Vive Boulanger," and would wear pink carnations, a symbol of the movement. Boulanger himself preferred the Chat Noir.[21] An electoral committee met at the Moulin de la Galette to plan local strategy for his campaign in Paris, presumably the center of republican loyalty. To the consternation of solid republicans, Boulanger won a parliamentary by-election in January 1889, carrying the district against his republican opponent.

Boulanger's campaign and the possibility that he might ride his popularity to seize power and overthrow the Third Republic thoroughly frightened republican politicians. They threatened to try him for treason, while his supporters urged that he march on parliament and take over. The general turned out to be a chocolate soldier. He fled the country rather than risk a trial, and the threat collapsed, putting an end to what was a serious threat to the republican government. But Montmartre's support for Boulanger confirmed the district's reputation as a center for extremist politics and defiance of established authority. The Boulangist moment also revealed a populist political current, laced with a strong dose of nationalism that was critical of stuffy, bourgeois republican electoral politics. Here was a new challenge to the republic at once nationalist, anti-Semitic, and anti-parliamentarian that would reappear during the Dreyfus Affair in the 1890s. Despite the failure of Boulangism, issues raised in the campaign persisted as the regime continued to be denounced as corrupt, inefficient, and mediocre.

The attacks upon the republic came from anarchists to political reactionaries. Among the latter was the curious, aristocratic figure who wrote under the penname "Gyp." She began to frequent the Chat Noir in 1882 where she met fellow anti-republican nationalist writer Maurice Barrès, encountered the former Communard and deportee turned ultra-nationalist Henri Rochefort, and collaborated with the anti-Semitic journalist Paul Déroulède.[22] Gyp began to write publicity for *Chat Noir*, and her work reflected her conviction that Jewish influences had corrupted the Third Republic's political life. By the time of the 1890s and the explosion of anti-Semitism during the Dreyfus Affair, currents of anti-Semitism in its modern guise had already begun to swirl through the cabarets and street life of the butte. Political anti-Semitism appeared in the unsuccessful attempt of the cabaret owner Aristide Bruant to win a seat in parliament in 1898. He ran on a platform of strident nationalism, socialism, and anti-Semitism, the heady mixture that first surfaced during the Boulanger crisis and that some historians claim anticipated twentieth-century fascism or at least a new radical right.[23]

From Boulanger to Dreyfus by way of the Panama Scandal, a series of crises kept the republicans on edge. A certain panic developed with a surge of anarchist violence and police repression in the 1890s. The explosion of Auguste Vaillant's bomb in the Chamber of Deputies at the end of 1893 provoked the government into toughening the 1881 press law by passing a series of "scoundrel laws" or *lois scélérates* holding the press liable for even "indirect" incitement to violence.[24] Armed with these laws, the police cracked down on the anarchist press and arrested several suspected terrorists. Cabarets were closed, and police informers kept up a constant surveillance of deviant political behavior. The limits of republican tolerance became apparent in the 1890s with these measures. Under attack, the republic closed ranks. The censor became more active, and even republican politicians known to be sympathetic to a free press complained of excesses, or at least those transgressions considered to be politically unacceptable and in bad taste.

Increasingly radical republican politicians demanded that the police and the censors impose "good taste" upon the music halls and cafés. A nationalist attack upon a prominent republican politician, Camille Pelletan, and his wife during a show staged at La Scala music hall caused radical politicians, normally defenders of press liberty, to insist that their minister of interior enforce the state's censorship laws. In his own newspaper, *L'Aurore*, which had staunchly defended the rights of Captain Dreyfus, Clemenceau asked why the "reactionary filth" of the music halls and the cabarets was permitted. This complaint marked Clemenceau's political trajectory from mayor of Montmartre during the Commune to the apostle of law and order during his tenure as prime minister from 1906 to 1909, when he became known as a strike breaker and the nation's "number-one cop." The posters advertising the pleasures of Montmartre came under attack from the director of primary education for the city of Paris who denounced the "abominable imagery" that had appeared on the walls of the city, claiming that it had a corrupting effect.

A sharp contrast between a republican ethos and the environment of Montmartre emerges from images of female roles in society. For male republicans, as the historian Philip Nord has noted, women were expected to be sober-minded, literate, and "to find fulfillment in the absorbing and serious business of domestic life."[25] Republicans assumed that reading would provide a defense against clerical influences. Enlightenment for women was at best a partial liberation from the past and anti-republican influences, however. As a number of historians have noted, the inward turn directing women toward domesticity and the decorative arts was the male republican's way of deflecting increasing demands

from both middle-class and working-class women to have a public space, particularly in the political sphere.[26]

Republicans shied away from such demands, claiming that women, despite their reading of self-improving literature, were too much influenced by the Church and to grant women votes would be readmitting clericalism into the body politic. The debate over France's declining birthrate led to a male, natalist argument assigning women to the domestic sphere. In the home women had a responsibility, amounting to a national duty, to raise their children to become good citizens. Motherhood became a civic responsibility. In the realm of fashion a republican style for women reflected classical austerity in reaction to the sumptuousness and excesses of women's fashion during Napoleon III's "decadent" Second Empire. Juliette Adam, whose salon had attracted the founding generation of republicans, argued that women should dress in an austere manner and read serious literature. Images of soberly dressed, serious republican woman may be found in the avant-garde painting of the day, such as that of Mary Cassatt's *Femme lisant* (*Woman Reading*), a portrait of her sister with whom she lived in Montmartre for three years in the 1870s (Fig.1.7).

The women of Montmartre, certainly in their artistic representation, were quite different from this republican ideal, as can be seen in the painting by Toulouse-Lautrec, *A Corner of the Moulin de la Galette* (Fig. 1.8). The variety of cultural encounters gave Montmartre its distinction. Not all of Montmartre, nor the world of entertainment to be found there, was that of "vice and crime," in Louis Chevalier's phrase. In her history of the radical republicans Judith Stone notes that Montmartre and the music halls of the turn of the century provided an environment of "ambiguity and indeterminacy." Different social classes mixed in this permissive environment and women could be found in "intimate proximity with men in a public setting." She has cited Jean Renoir's memoir of life with his father and a family visit to a music hall where women were with their husbands, men were with women who were not their wives, where there were women alone as well as women who were in part-time or full-time prostitution. This was, she concludes, a new cultural terrain that challenged the traditional middle class in search of a cultural identity.[27]

Montmartre offered a bourgeois temptation, a place to escape republican austerity in search of pleasure and the release from work that leisure provides. This was the lure, the temptation of the delinquent community for the republicans. The experience brought a mixture of classes. The working classes and the petty bourgeoisie, the ordinary people of Paris seeking amusement in Montmartre, might find themselves in the company of the Prince of Wales or the elegant,

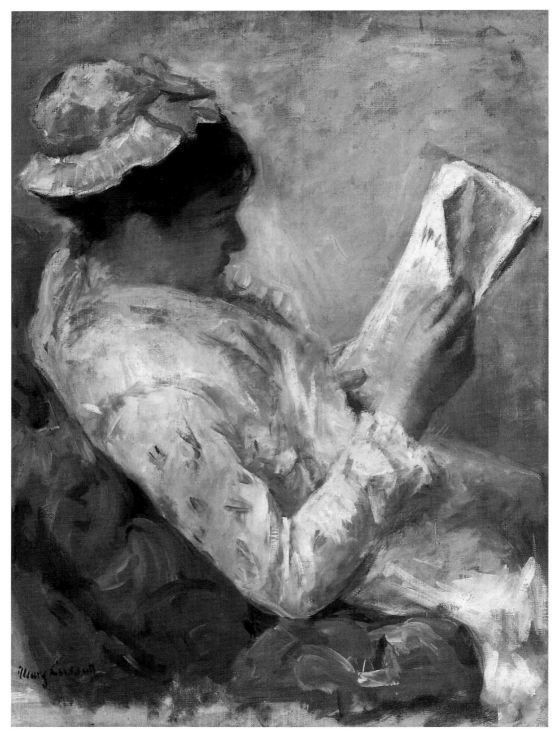

Figure 1.7 Mary Cassatt, *Femme lisant* (*Woman Reading*), 1878–79. Oil on canvas,
32 x 23 1/2" (81.3 x 59.6 cm). Joslyn Art Museum, Omaha, Nebraska.

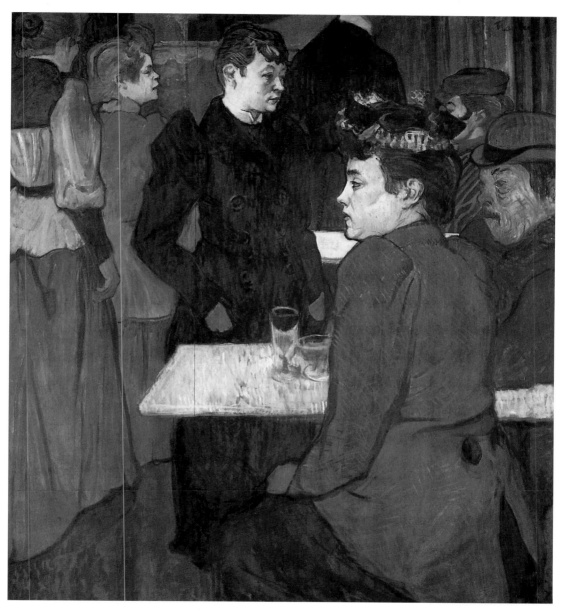

Figure 1.8 Henri de Toulouse-Lautrec, *A Corner of the Moulin de la Galette*, 1892. Oil on cardboard, 39 3/8 x 35 1/8" (100 x 89.2 cm). National Gallery of Art, Washington, D.C., Chester Dale Collection.

decadent aristocrat, Robert de Montesquieu. Montmartre had its attractions for the solid republican middle class of the political system as well. Clemenceau began his political career in Montmartre. Other future ministers enjoyed Montmartre's delinquent pleasures in their youth. René Waldeck-Rousseau, the eminently solid prime minister who had the task of forming a government of republican defense to liquidate the Dreyfus Affair, in his youth joined the merry throng that accompanied Rodolph Salis when he moved the locale of the Chat Noir from upper Montmartre to the boulevards below.

Despite fin-de-siècle alarms and fears, the republic survived and showed a remarkable resiliency. Montmartre was to be watched. The republic's police regularly rounded up prostitutes in the quarter to the derision of all concerned. Even as a site for "vice and crime,"[28] despite official disapproval, Montmartre did not pose a fundamental threat to the regime. And fin-de-siècle Montmartre's image as a hotbed of revolutionary activity began to change. Revolutionary desires of left and right had been contained and sublimated into entertainment and spectacle. The culture of anarchism gradually became domesticated in the new entertainment industry, and the district became better known as a site of leisure, pleasure, and tourism than a center of revolutionary violence. Construction of new buildings between 1890 and 1914 filled open spaces and altered the butte's image as a village haven from the urbanism and formality of Haussmann's Paris. Sacré-Coeur became less a symbol of the ongoing Church-State quarrel than a dramatic, exotic backdrop to the urban landscape, an additional part of Paris as an ongoing spectacle. Nor by the turn of the century did Montmartre evoke such vivid memories of the revolutionary Commune.

As Paris became less revolutionary, more conservative, so did Montmartre, although from time to time fears and claims of Montmartre as a "commune" would surface after the Great War.[29] The masses of the streets seemed less taken by revolutionary politics than attracted to the lures and pleasures of spectacles.[30] The area's revolutionary contribution was to a cultural revolution that the republicans learned to accept and tolerate and perhaps encourage, even if it was a delinquent pleasure. With the exception of the stern measures against the anarchists in the 1890s, republican efforts to contain Montmartre amounted to harassment rather than repression.[31] The republicans failed to colonize Montmartre with their lessons in civic virtue. Moderate republicans may have prevailed in the political sense when they emerged triumphant from the Dreyfus Affair, overcoming perceived threats from the army, the Church, and anti-Semitism; independent Montmartre prevailed in the realm of commercial entertainment and popular culture, a commodification of delinquent pleasure.

NOTES

1. François Loyer, "Le Sacré-Coeur de Montmartre," in *Les lieux de mémoire*, vol. 3, *Les France*, ed. Pierre Nora (Paris: Gallimard, 1992), 451–452.

2. Jesse R. Pitts, "Continuity and Change in Bourgeois France," in *In Search of France*, ed. Stanley Hoffmann (Cambridge, MA: Harvard University Press, 1963), 254–257.

3. Philip Nord, *The Republican Moment: Struggles for Democracy in Nineteenth-Century France* (Cambridge, MA: Harvard University Press, 1995), 137, 191–192; Claude Nicolet, *L'Idée républicaine en France (1789–1924): Essai d'histoire critique* (Paris: Gallimard, 1982), 189.

4. Claude Nicolet, *La République en France: État des lieux* (Paris: Seuil, 1992), 74, 76–78.

5. This theme is developed in Miriam R. Levin, *Republican Art and Ideology in Late Nineteenth-Century France* (Ann Arbor, MI: UMI Research Press, 1986).

6. "Les Beaux-Arts d'une société démocratique," speech of 23 April 1881 to the Society des Beaux-Arts, in Odile Rudelle, *Jules Ferry: La République des citoyens*, vol. 2 (Paris: Imprimerie Nationale, 1996), 95, 98.

7. Maurice Agulhon, "Paris: A Traversal from East to West," in *Realms of Memory: The Construction of the French Past*, vol. 3: *Symbols*, ed. Pierre Nora, trans. Arthur Goldhammer (New York: Columbia University Press, 1998), 539.

8. *Le Triomphe des mairies: Grands décors républicains à Paris 1870–1914* (Paris: Musée du Petit Palais, 1986), 58–59. The decorations for the mairie of the eighteenth arrondissement came relatively late, after the turn of the century.

9. Ibid., 59.

10. Christian Amalvi, "Bastille Day from *Dies Irae* to Holiday," in *Realms of Memory*, vol. 3, 204–205.

11. Irene Collins, *The Government and the Newspaper Press in France 1814–1881* (Oxford: Oxford University Press, 1959), 181.

12. *Le Temps de Toulouse-Lautrec* (Paris: Réunion des Musées Nationaux, 1991), 10, 44–45.

13. Susanna Barrows, "Nineteenth-Century Café Aromas of Everyday Life," in *Pleasures of Paris: Daumier to Picasso,* ed. Barbara Stern Shapiro (Boston: Museum of Fine Arts, 1991), 24.

14. Susanna Barrows, "After the Commune: Alcoholism, Temperance, and Literature in the Early Third Republic," in *Consciousness and Class Experience in Nineteenth-Century Europe,* ed. John M. Merriman (New York: Holmes & Meier, 1979), 208.

15. W. Scott Haine, *The World of the Paris Café: Sociability among the French Working Class, 1789–1914* (Baltimore, MD: Johns Hopkins University Press, 1996), 219–221.

16. Judith F. Stone, *Sons of the Revolution: Radical Democrats in France 1862–1914* (Baton Rouge: Louisiana State University Press, 1996), 8.

17. Jerrold Seigel, *Bohemian Paris: Culture, Politics, and the Boundaries of Bourgeois Life, 1830–1930* (New York: Viking, 1986)

18. Eugen Weber, *France Fin de Siècle* (Cambridge, MA: Harvard University Press, 1986), 107

19. Théophile-Alexandre Steinlen, *Dans la vie* (Paris: Sevin et Rey, 1901) sold for 3.50 francs and had a wide distribution.

20. Philip Dennis Cate and Mary Shaw, eds., *The Spirit of Montmartre: Cabarets, Humor and the Avant-Garde, 1875–1905* (New Brunswick, NJ: Rutgers University Press, 1996), 174–175.

21. Philip Nord, *Paris Shopkeepers and the Politics of Resentment* (Princeton, NJ: Princeton University Press, 1968), 341.

22. Gyp's full name was Sibylle-Gabrielle Marie-Antoinette de Riquetti de Mirabeau, comtesse de Martel de Janville. Willa Z. Silverman, "Female Anti-Semitism during the Dreyfus Affair: The Case of Gyp," in *Gender and Fascism in Modern France,* ed. Melanie

Hawthorne and Richard J. Golsan (Hanover, NH: University Press of New England, 1997), 13; and Willa Z. Silverman, *The Notorious Life of Gyp: Right-Wing Anarchist in Fin-de-Siècle France* (Oxford: Oxford University Press, 1995).

23. See the arguments in William D. Irvine, *The Boulanger Affair Reconsidered: Royalism, Boulangism, and the Origin of the Radical Right in France* (New York: Oxford University Press, 1989).

24. Richard D. Sonn, *Anarchism and Cultural Politics in Fin-de-Siècle France* (Lincoln: University of Nebraska Press, 1989), 68–69.

25. Nord, *Republican Moment*, 229, 226.

26. See Debora L. Silverman, *Art Nouveau in Fin-de-Siècle France: Politics, Psychology and Style* (Berkeley: University of California Press, 1989), 63ff.

27. Stone, *Sons of the Revolution*, 371.

28. The alarmist view of Montmartre's criminality is explored by the urban historian Louis Chevalier, in *Montmartre du Plaisir et du Crime* (Paris: Laffont, 1980).

29. Priscilla Parkhurst Ferguson, *Paris as Revolution: Writing the Nineteenth-Century City* (Berkeley: University of California Press, 1994), 228–229.

30. This claim is based upon Vanessa Schwartz's provocative assertion that "Paris remained a revolutionary space, but in the last third of the nineteenth century, its revolutions were cultural, as the political order of the Third Republic—threatened, challenged and contested—managed to bend but never break." Vanessa R. Schwartz, *Spectacular Realities: Early Mass Culture in Fin-de-Siècle Paris* (Berkeley: University of California Press, 1998).

31. The Third Republic applied more relaxed standards to the cabarets of Montmartre than to the cafés of the Latin Quarter, where impressionable youth required greater protection. Richard Sonn notes that during the crusade of Senator Béranger in 1895, police argued for a lesser standard of propriety for Montmartre than applied on the Left Bank. Sonn, *Anarchism and Cultural Politics*, 74.

Images of Pleasure and Vice

Women of the Fringe

E L I Z A B E T H K . M E N O N

During the last quarter of the nineteenth century women made significant progress; they also played a variety of roles within modern society. But in popular illustrated journals—an area where there was a profusion of possibilities—male artists preferred to reposition the visibility of contemporary women by focusing on an intriguing duality: the visualization of vice and virtue. This interest focused on a diverse variety of thematic "types": barmaids, dance hall performers, singers, delivery girls, and others that provided a thinly disguised network for unregulated prostitution.[1] The prostitute became the primary focus of male fantasies of female sexuality fueled by the ambiguous nature of the prostitute's attraction. She became a mixture of pleasure and danger, the "known" and the "unknown." Since prostitutes literally existed on the "fringes" of society, their presence in Montmartre was widely exploited by artists and writers alike.

Adolphe Willette (1857–1926), Henry Somm (1844–1907), Henri Gray (1858–1924), Henri Gerbault (1863–1930), Alfred Grévin (1827–1887), and Ferdinand Bac (1859–1952), all inhabitants of the district, actively commented on the increasing mobility of women suggesting that societal morals were changing.

Since the work of these artists was extensive—albeit little known—they were quite literally in charge of visualizing contemporary society, its mores and responses, on a daily basis with works that appeared in the popular press. Their visualizations also implied that certain pitfalls could befall a man who looked to Montmartre to find a female companion. The "modern woman" was seen as impudent, challenging, and even dangerous. Many of these themes and popular images of women interconnect in Montmartre, itself a capital of pleasure and vice, where a sense of danger could also be experienced. All of these qualities were found in a broad range of popular images, including studies for interiors of cabarets, that often satirically used the various female "types" to create imagery that had a moral to tell or a humorous anecdote to relate for an ever ready audience.

With *La Dernière Tentation de Saint Antoine et de son cochon* (*The Last Temptation of Saint Anthony and His Pig*) (Fig. 2.1), Adolphe Willette focuses on two publications that frequently examined the representation of women: *Le Chat Noir* and *Le Courrier Français*.[2] In his print these have symbolically replaced the saint's Bible, becoming, in effect, the material that was partially tempting the hermit. These publications, especially *Le Courrier Français* where this image appeared, are further linked because of common goals: to publicize Montmartre's intellectual and social activities and to identify political aims, especially the freedom of the press. They provided a very effective way in which the artist could reveal his contemporary narrative.[3] Saint Anthony was known for living an austere life in the desert where he tried to overcome temptations (which he called "demons"). Adolphe Willette, in selecting the saint as representative for mankind, has also included two other specific aspects to his visual narrative: the pig, representative of sensuality and gluttony (symbolic of Anthony's triumph over weaknesses of the flesh), and the satyr, who as one of the temptations, tried to provide direction for his travels.[4] But here the resemblance to the original tale ends, for the saint is also "tempted" by a semi-nude barmaid—the black stockings underneath her apron suggesting prostitution and the black cat's tail linking her directly to the sensual atmosphere at the cabaret Chat Noir.[5] The satyr, in this context a companion to the barmaid, assaults the pig with a spray of selzer, providing a high (low) comic motif of the type that one would have found in some cabaret performances. Recognizing that the refreshing drink has not been sent by the devil, the saint asks the barmaid to provide a name for it. The barmaid suggests "vin tonique Dubonnet"—a reference to a famous wine (apéritif) first introduced in 1846—to which the saint replies "c'est parfait!" Undoubtedly, even with an assurance, the saint is being duped and is giving in to his temptations especially since the barmaid remains so seductive.

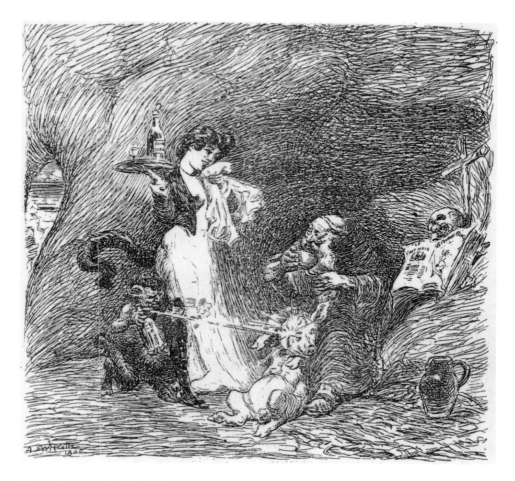

Figure 2.1 Adolphe Willette, *La Dernière Tentation de Saint Antoine et de son cochon* (*The Last Temptation of Saint Anthony and His Pig*),1906. Cover, *Le Courrier Français*. Wilson Library, University of Minnesota.

When the print was published in 1906, Adolphe Willette had long played a strong role in the district as an amateur politician and designer of the red windmill for the Moulin Rouge. He was an extremely active and vocal member of the artistic community.[6] His 1897 cover for the *Le Courrier Français* (Fig. 2.2) further suggests the ease with which women could obfuscate the boundaries between vice and virtue.[7] A nude model, in an artist's studio, strikes a pose while a cigarette dangles from her mouth. She asks the artist in the background: "Should I pose for Vice or Virtue?" This image points out an important truth for the period: that the female nude itself was not a "new" subject. Whether an image was considered "classical" (i.e., virtuous) or "pornographic" had to do with the

particular accoutrements added by the artist in a composition. The fact that this nude is smoking points up another reality—that the models who posed for artists were both low-paid and came from the lower class, often also dabbling in prostitution to make ends meet. A name was ascribed to a woman living in the district who was often associated with poets, musicians, and artists—she was called the Montmartroise. The word montmartrois was used by other individu-

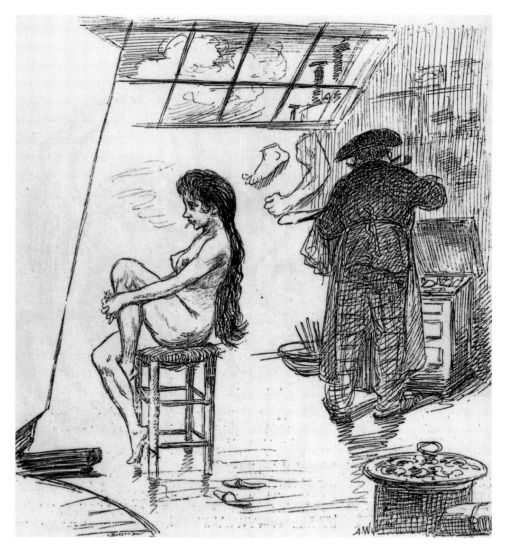

Figure 2.2 Adolphe Willette, *"Vais-je poser pour le Vice ou pour la Vertu?"* (*"Should I Pose for Vice or Virtue?"*), 1897. *Le Courrier Français*, Wilson Library, University of Minnesota.

als such as Eugène Lemercier, in his *Autour du Moulin, Chansons de la Butte* (1898), as a descriptive term relating to the activities undertaken in Montmartre, that is, "plaisirs montmartrois" or "cabarets montmartrois." The use of Montmartroise to describe the women who inhabited this area, and who served as artist's models, was an extension of terms applied to designate French citizens from various regions of the country.[8] But Montmartre was considered less of a "region" than the outskirts of Paris or the red-light district. Appropriately the magazine *La Vie Parisienne* described the Montmartroise as cunning, possessing loose morals, and attractive in an "irregular" way. She was said to be "more Parisienne than the Parisienne."[9]

What Adolphe Willette has cleverly created with this print is another way in which to utilize the theme of the artist's model while drawing a viewer toward recognition of the sitter. It was the artist who could place his young woman in whatever guise possible in order to modify her origins or to disguise her true inclinations. This print suggests that it is the artist's humor that is put to the test every time he sets out to create a new image that can be used to underscore a theme germane to the way in which this district and its inhabitants were actually viewed. The model's pose and manner, her cunning expression reveal her to be the Montmartroise who existed on the fringe and who made additional money by posing in whatever way an artist wished to control an audience through a popular print.

Another image titled *Voilà le plaisir*, by an illustrator known as Carl-Hap (Karl Happel, 1819–1914), was published in the journal *Le Chat Noir* (1894).[10] It demonstrated one popular role that the Montmartroise would play: the personification of the sensuality associated with the district. In this illustration a woman announces herself as "pleasure" and the presence of a black cat signals that this pleasure is sexual in nature. As the official organ associated with Rodolphe Salis's cabaret by the same name, articles and illustrations which appeared in this magazine pertained to life in Montmartre in general, but most specifically to activities linked to Salis's establishment. In addition to sex, another pleasure to be found in Montmartre was alcohol as indicated by Carl-Hap's *Les Boissons* (*Drinks*) also for *Le Chat Noir* (Fig. 2.3).[11] Here three women personify popular beverages. On the left, representing red wine, is a woman dressed in revolutionary sans-culottes. A placard behind her links her with Le Lapin Agile. In the center, in modified "classical" garb, is the personification of beer. At right, freshly popped, is the triumphant champagne. This figure seems to be a "modern" woman, replete with black stockings and a long feather boa draped over her shoulders. The metaphor is persuasive; Carl-Hap has used

Figure 2.3 Carl-Hap (Karl Happel), *Les Boissons (Drinks)*, 1894. *Le Chat Noir.*

seductive women to captivate his audience while reminding them of the asso-
ciative pleasures that drink can create. An image by Willette, titled *La Chanson
(Song)*, indicates yet another enjoyment to be had in Montmartre. In this cover
for the *Le Courrier Français* (Fig. 2.4),[12] Willette shows a bare-breasted female per-
former whose dress is linked to the spiral of a spider web. In the background
Father Time sits transfixed, his feet sprouting mushrooms. The sand has run out
in his hourglass. The amusing suggestion here is that Montmartre performers

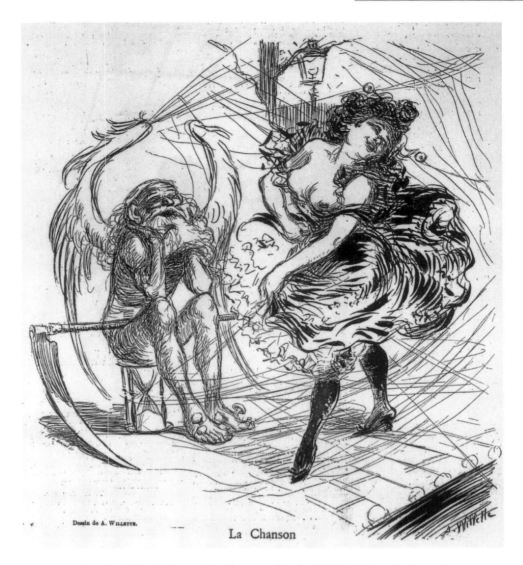

Dessin de A. WILLETTE.

La Chanson

Figure 2.4 Adolphe Willette, *La Chanson* (*Song*), 1898. *Le Courrier Français,*
Wilson Library, University of Minnesota.

have literally spun a web over their audiences, making time stand still. The audience in front of the stage lights, albeit not visually represented, has been transfixed by the performances in cabarets upon which Willette is focusing.

Willette took his publication of the pleasures and vices available in Montmartre even further when he undertook a stained-glass window design for the Chat Noir cabaret. The maquette (Fig. 2.5), or preliminary design, for the window, which has since disappeared,[13] features a woman holding a cat over her

Figure 2.5

Adolphe Willette, *La vierge verte*
(*The Green Virgin*), n.d. Oil on canvas.
78 1/4 x 22 3/8" (198 x 57 cm).
Photograph courtesy of Hazlitt,
Gooden & Fox.

head in a pose reminiscent of the raising of a religious icon to be revered by a congregation. The full moon indicates not only the hours when the cabaret did most of its business, but also suggests—as do many of the other details—that the woman is the priestess of an alternative religion, a form of witchcraft. Placed in the bow around her waist is a lily—traditionally associated with the purity of the Virgin Mary—but here subverted by the rest of the symbolism. The woman's dress is covered not with fleur-de-lis, but with beetles associated with death through their feeding on carrion. References to the window are found in other illustrations depicting the Chat Noir, such as in an image for the journal *La Vie Parisienne* (1887) by an artist named Sahib. The reproduction of the window in several illustrations of the time demonstrates how significant Willette's image was in identifying the nature of the Chat Noir.[14] The symbolism of the black cat and the merging of religious elements (which are very apparent in Steinlen's famous poster for the cabaret) were integrated, furthering the idea that Salis operated an alternative religious society on the premises that united art with spirituality.

Willette's maquette reiterates a basic theme: woman and cat are united. He underscores this point through the sinuous bodies of both; the bell around the woman's neck amusingly echoes the metaphor. Mice scurry about on the platform below, seemingly startled by the commotion. Willette uses the bell as a ringing warning about the attractive sensuality of both women and the feline form. The detail of the lily added to the woman's waistband is tantalizing as it increases the notion of virtue being challenged by vice. This flower also links Willette's work to other depictions of women popular at the time, such as Henri Gerbault's "Ah les 1/2 vierges" for *Gil Blas Ilustré* (1896).[15] The semi-virgin was a desirable state for a woman to occupy as it increased her sense of mystery. This combination of purity and sexuality is symbolized in Gerbault's work through the linking of an angelic bride with a satyr. One author for *Le Chat Noir*, sensing the validity of this theme at an earlier moment, had penned an article entitled "Contemporary Virgins" where he posed the rhetorical question of where exactly virginity began and where it ended.[16] A similar idea was posited in Louis Gautier's image "A Modern Léda," which appeared in *Le Chat Noir* (1893).[17] This image recast the mythological story of Zeus taking the form of a swan to impregnate the mortal maiden Leda. But here, the role of the swan was played by a black cat; the woman had wings that could be interpreted as either swan's wings or angel's wings. An 1894 article featured in *Le Chat Noir* titled "Leda" described her as being "perverse in her desire and subtle in her caress,"[18] or, in other words, containing both positive and negative characteristics that furthered the nature of the duality running through the era.

This theme of sexuality was used by poster designers busily promoting popular performers such as the chanteuse Yvette Guilbert.[19] Henri Dumont-Courselles, the artist responsible for *Tous les Soirs aux Ambassadeurs. Yvette Guilbert* (*Every Night at the Ambassadeurs. Yvette Guilbert*) (ca. 1890) (Fig. 2.6), shows the singer emanating, similar to a magical genie out of a bottle, from the tail of the black cat. The cat "rubs the bottle" as it grooms itself, releasing the image of Yvette Guilbert, complete with her signature black gloves. The cat grasps a three-dimensionally projected line beneath Guilbert's name, completing the relationship. The cat, now a symbol for the sensuality associated with Montmartre itself, is here to heighten the mood of pleasure associated with performers who were active in cabarets other than the Chat Noir. The cabaret atmosphere also strongly influenced the ways in which other artists viewed the dualities of the district. Henri Rivière (also closely associated with the Chat Noir) revealed in one of his illustrations that the realm of the cabaret environment spilled out into the streets around an establishment, suggesting that the dance-hall environment was having its effect on loosening moral restrictions.[20] The street provided a more direct expression of available sexual pleasures through the presence of a great number of prostitutes. Articles and poems published in *Le Chat Noir*, over a period of years, also linked prostitution to the heightened condition of modernity.[21] But, significantly, the attitude of the prostitute had also changed. For instance, Jean Lorrain contributed the following verse to *Le Chat Noir* publication:

Modernity, Modernity
come the cries, the hoots,
the impudence of the prostitutes,
resplendent for eternity.[22]

There can be little doubt that prostitutes in the district became more open, more brazen as they made use of their heightened visibility and their increasing power over men.

The popular illustrators living in the district sensed a change. They were quick to visualize the heightened duality of the locale and the shifting of the balance of power between the sexes. In a cover for *Le Courrier Français* (1897) Willette positions the action squarely in Montmartre through the presence of the symbolic window of the Chat Noir and a sandwich board, carried by a down-and-out male, advertising the Moulin de la Galette (Fig. 2.7).[23] In the caption the vagabond says to the shocked passerby, "Trust me . . . it's not love, it's a wild ride!" The demeanor of the man, the fact that he is walking the streets near the sandwich-board carrier, as well as the facelessness of the well-dressed

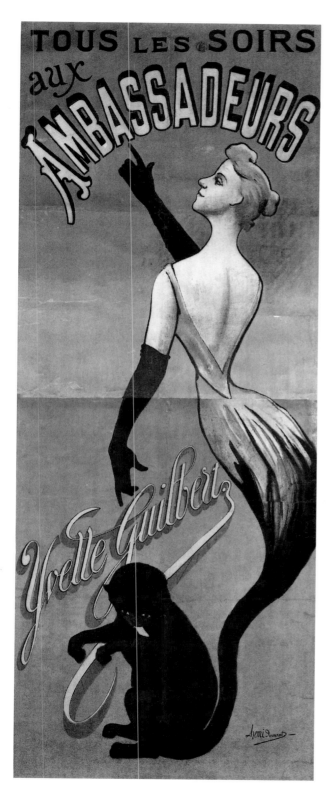

Figure 2.6

Henri Dumont-Courselles,
Tous les Soirs aux Ambassadeurs.
Yvette Guilbert (Every Night at the
Ambassadeurs. Yvette Guilbert),
ca. 1890. Lithograph.
Courtesy Cabinet des Estampes,
Bibliothèque Nationale
de France, Paris.

woman they encounter, suggests that there is something threatening about this meeting. Willette is positing a wily warning through his distressed male, that to become involved with a fashionable prostitute will bring with it perils that are not worth the encounter. Other images such as a cover for the *Chat-Noir Guide* by Georges Auriol stresses the potential for danger represented by a woman. Here a hangman's noose dangles from the silhouette of an attractive female. Her

Figure 2.7 Adolphe Willette, *"Méfie-toi, camarade, c'est pas de l'amour, c'est la vache enragée!"* (*"Trust Me . . . It's Not Love, It's a Wild Ride!"*), 1897. *Le Courrier Français*, Wilson Library, The University of Minnesota.

particular features can be found in many works by Henry Somm, notably a watercolor titled *The Rights of Woman*.[24] Somm was another "founding" member of the ancient Chat Noir, belonging to a secret society within the cabaret community that is as yet not completely understood.[25] Many of his works blend a variety of quickly observed (impressionistic) techniques with macabre subject matter. In *The Rights of Woman* the scales of justice have empowered a woman to dole out her own brand of justice, by murdering a collection of tiny men with a pistol. This type of "feminist-movement" bashing was not uncommon during a period of increasing visibility and agitation by women's rights activists. The politically motivated illustrator André Gill, for example, furthered this notion by depicting the feminist writer Maria Deraismes as a crazed absinthe drinker on the cover of *Les Hommes d'Aujourd'hui*.[26] Alfred Le Petit, who also was best known for his political caricatures, showed feminist activist Hubertine Auclert leading an assault on "the bastille of man's rights" on the cover of *Les Contemporains*.[27] Thus, the illustrators were intimately aware of the changes in society and a number of them remained uneasy about the way in which women were positioning themselves in the world of the cabaret district.

While feminist agitators supported the notion of the family and decried prostitution, sex workers were nevertheless viewed as more "liberated" and therefore suspect—even dangerous—to the patriarchal French nineteenth-century society. Prostitutes were feared for the diseases many of them carried as well as for the power they were wielding over clients. Unlike the images of specific women's rights agitators, the effect of increasing freedoms for the "average" or "mythical" woman, known as the Montmartroise, referenced a set of ambiguities inherent in the prostitute's position. In Henri Gray's image *Guerre éternelle* (*Eternal War*) for the *Le Courrier Français* (Fig. 2.8), a woman who wears a contemporary Parisian hat and an Egyptian-style skirt and a band beneath her bared breasts suggests both a prostitute and the *amazone*.[28] The verse explains the scene:

> Love is an eternal combat between men and women
> Which enslaves the vanquished to the victor.
> Tenderness and sensuality, they say!—Infamous struggle!
> One and the other eats each other's heart!

The image suggests that in this war woman remains victorious; the man will find his heart "eaten." Here a woman cracks a whip at a winged, flaming heart as she stands atop a skull—representative of her domain—complete with references to Baudelaire's *Fleurs du mal*. In the background looms a heart-shaped shadow, suggestive of a rising moon. Multivalent references to Egypt (specifically

Cleopatra, a powerful and particularly sexually active and dangerous woman) and contemporary Paris are indicative of the complexity of images which appear as popular illustrations. Images like this one suggest that some kind of identifiable system for drawing the line between pleasure and danger (vis-à-vis women) was needed.

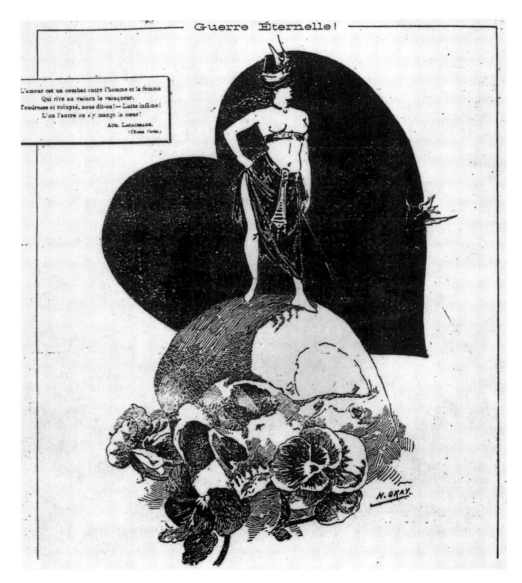

Figure 2.8 Henri Gray, *Guerre éternelle* (*Eternal War*). 1885. *Le Courrier Français*, Wilson Library, The University of Minnesota.

Figure 2.9 Ferdinand Bac, *Femmes automatiques: Ce qu'on y met, ce qu'il en sort*
(*Automatic Women: You Get What You Pay For*), 1892. *La Vie Parisienne.*
Library, Notre-Dame University.

An example of this is Ferdinand Bac, in his *Femmes automatiques* (*Automatic Women*) (Fig. 2.9) for *La Vie Parisienne* (1892), which suggests a museum setting where customers can animate various women by introducing a coin. The subtitle reads, "You get what you pay for."[29] Several of the images are linked to the district including a dancer, a chambermaid, a famous actress, and a barmaid reflected in a mirror, not unlike the woman depicted in Edouard Manet's *Un Bar aux Folies-Bergère* (*Bar at the Folies-Bergère*) (1882) (Courtauld Institute, London). The latter implies that these women had dual roles: a sex worker masked by a "legitimate" profession. The "level" on which they existed was based partially upon social class and the perceived rarity of the second profession (the famous actress "costs" much more than the barmaid, who can be had for a package of cigarettes, reiterates the caption). Also featured in Bac's image is a dancer from the Moulin Rouge. The male consumer is informed that at the Moulin Rouge he needs "considerable dexterity to be able to throw to her three or four coins because she doesn't keep still for one moment. One has to know how to handle her because she is always in a bad mood. If you cannot land on the sensitive spot,

you might as well forget it." The specific costumes of the men shown approaching the women indicate that the "consumption" of these various feminine types was often accomplished by members of the bourgeoisie or the military.

Gerbault suggested another way to gauge the level of virtue versus vice in a woman by how she lifted her skirt. One such work was published in *La Vie Parisienne* in 1897 (Fig. 2.10).[30] Included are the delivery girl and amateur prostitute (called a *trottin*), who positioned herself in front of potential male "clients" on the sidewalk while hitching up her dress.[31] Gerbault also includes the dancer of the *chahut* (specific to Montmartre) and the lowest form of streetwalker who raises her skirt only slightly while glaring at the customer. Positioned from "high" to "low" (left to right), the women are linked to different areas of Paris. The trottin is situated in the middle, indicative of her special attraction as men did not know how "experienced" she was, and their excitement was stimulated by a belief that they would be her first lover. The text associated with the image indicates that she was in search of a specific type of man, for whom she would lift her skirt to indicate availability. "And it is as she returns the merchandise to the customers, that she gains a small clientele of her own." The dancer (iden-

Figure 2.10 Henri Gerbault, *Comment elles retroussent leur robe* (*How They Hitch Up Their Dress*), 1897. *La Vie Parisienne*, Library, Notre-Dame University.

tified in the text specifically as from the Moulin Rouge) occupies the next "lowest" position. The contorted, erotic movements produced during the dance are equated with more specialized sexual pleasures. Accompanied by a dark shading indicative of a change in atmosphere, the action of one woman is deemed "as horribly tucked up!" The text poses the question, "What charitable being will be tempted?" The answer is fueled by desperation and the continued downward spiral of women caught in the cycle of prostitution. An artist named Job, also working for *La Vie Parisienne*, went even further than these selections in two series of images called "Pronostics et Résultats" (1893).[32] To him, the easiest way to see what you might get was to show the women with and without clothes. In this estimation, the trottin fares well and the barmaid yields an ugly truth once her corseted costume is removed.[33] Job's images carefully link specific items of clothing with class level and societal position.

Perhaps the most encyclopedic female types were undertaken by George Montorgueil, author of several books about cabarets and theaters in Montmartre. He collaborated with Henry Somm on *La Parisienne peinte par elle-même* (1897). Somm created illustrations of different types of women, many of whom fell into the general section called "galanterie," typifying loose morals.[34] The trottin, or delivery girl (who appears in a section of the book called "La Mode et L'Art"), was described by Montorgueil as extremely young. No longer a child, but not yet a woman, she remained charming, aspiring to freedom and mobility drawn from this particular job.[35] According to Octave Uzanne, the trottin formed an important segment of the demi-monde; elsewhere she was described as having an irregular beauty with a pert little face, vaguely perverse to the delight of "modern fauns" who liked to chase after the charm of an "unripened fruit."[36] The demi-mondaine was older, more expert at deceit, and possessing fantastic desires that had the duality of being both "gentle [and] cruel."[37] Montorgueil indicated the special role fashion played in these women's lives: "Fashion—this despotic divinity—decides on who will be famous by virtue of some obscure reasons."[38]

Montorgueil thought *La Fille (Girl)* (Fig. 2.11) was of great concern, since his text indicated her primary habitat included cabarets—those "Musical Edens"—such as the Moulin Rouge.[39] She used provocative language to entice clients and wore her "professional" smile like a mask. Montorgueil calls her a "flower of the asphalt" to indicate her attractiveness and where she might be found if she was not in the dance hall or on the street in front of it.[40] Montorgueil explains this aspect "Love is the most democratic of all absolute sovereigns. He offers to the poor the same feast than to the rich. Only the table setting is different. Plates and dishes are sometimes mediocre, and the tablecloth is often dirty."[41] The role of

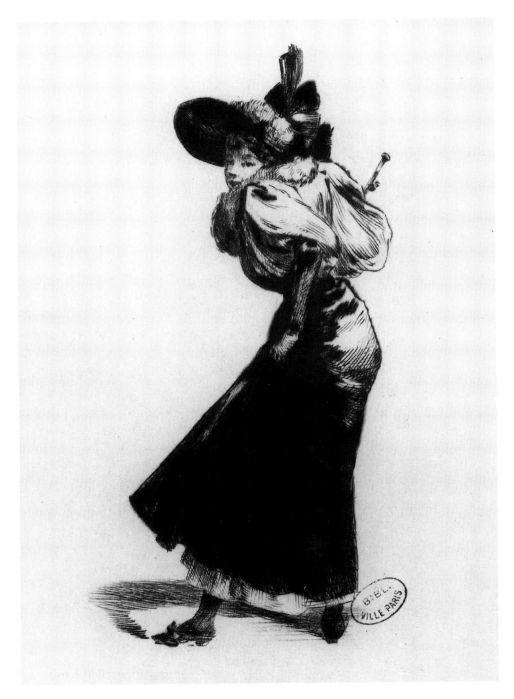

Figure 2.11 Henry Somm, *La Fille* (*Girl*). Illustration from *La Parisienne peinte par elle-même* by George Montorgueil (1897). Courtesy Bibliothèque Historique de la Ville de Paris. Photograph Jean-Loup Charmet.

the *filles* of Montmartre, as well as their attitude, was predetermined. They "came to pleasure instinctively, and not always for pleasure. Some are ungracious, ill-tempered, sullen, and less than engaging when it comes to fulfill an engagement. They amuse themselves as others are bored."[42] The companions that they "conquered" found their words provocative clichés and their ambitions directed toward lascivious nighttime behavior. Montorgueil explained the filles as typical of the virtue/vice dichotomy that made Montmartre such a seductive arena:

> This is depravity! The reproach is paradoxical on such lips. This is depravity! For them it is not depravity. Depravity is when one is conceited enough to give oneself for the superfluous. They forget that the smallest effort would have conjured up their deplorable state and that only a slight nuance separates them from the women whose trade they censure.[43]

Even if they found a man assuring a leisurely life, says the author, they ultimately returned to the streets. As a "bohemian of love" the fille could be swayed by material possessions; but she would eventually become nostalgic for illicit love, thereby sealing her fate. Montorgueil presented her as "Eve"—the original temptress.[44]

The last two types included in the book are *La Bicycliste* (*The Bicyclist*) (Fig. 2.12) and *La Perverse* (*Perverse*) (Fig. 2.13). While at first glance this seems an unusual pairing; they are definitely linked. The bicycle is presented as a brutal revolution that has changed morals (for the worse). This was due to the costume, according to Montorgueil, that was neither masculine nor feminine.[45] The bicycle and the costume are linked directly to the idea of temptation, stressing that this activity was seen as prompting a woman toward lasciviousness.[46] While feminists hailed the contraption for providing a way to combat muscular weakness, and the development of the body was considered useful to fight "moral weakness, . . . timidity, indecision," Montorgueil understands it "to be or not to be a bicyclist" issue by noting the equivalent of "Will I ape this?"—indicating an evolutionary regression (both physically and morally) associated with this mechanical device.[47] The costume was criticized because of its pants-like appearance as much as the suggestive motion of the woman's genitals against the seat, an observation that was increasingly associated with sterility. The woman with the bicycle was

> emancipated, more than emancipated, they move among men, their hands in their pockets with the look of depraved street-boys, and they wonder why men have become disrespectful and less tender—as if they regretted not finding in the impudent comrade in breeches the charming and discrete woman wearing skirts of long ago.[48]

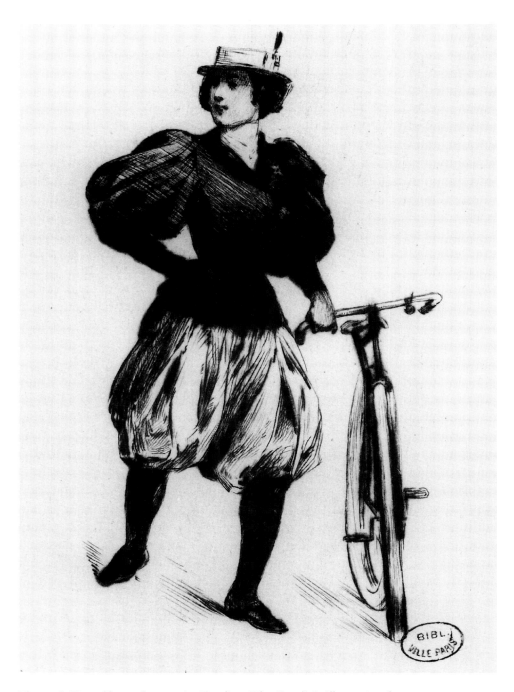

Figure 2.12 Henry Somm, *La Bicycliste* (*The Bicyclist*). Illustration from
La Parisienne peinte par elle-même by George Montorgueil (1897).
Courtesy Bibliothèque Historique de la Ville de Paris.
Photograph Jean-Loup Charmet.

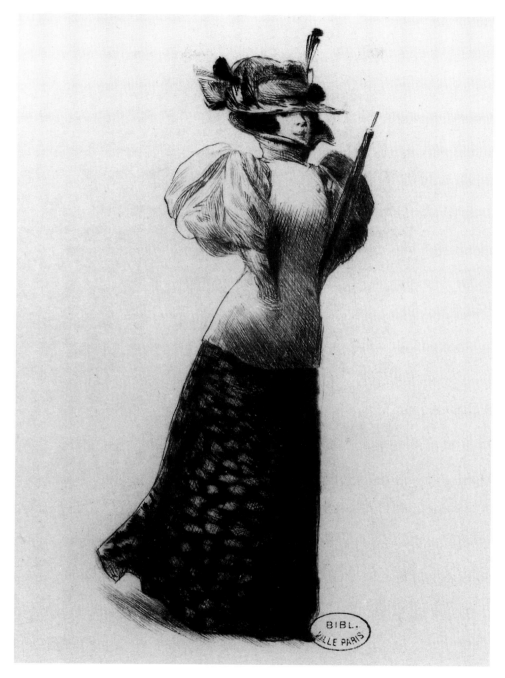

Figure 2.13 Henry Somm, *La Perverse* (*Perverse*). Illustration from
La Parisienne peinte par elle-même by George Montorgueil (1897).
Courtesy Bibliothèque Historique de la Ville de Paris.
Photograph Jean-Loup Charmet.

Part of the problem with both was the idea of increasing mobility seen as a threat to the male population since it represented a move away from the home and maternity. Art critics Camille Mauclair and Marius-Art Leblond identified three dangerous characteristics, calling the "New Woman" independent, critical, and mobile.[49] The mobility and moral ambiguity of the bicycle helps explain the frequent appearance of illustrations of women with their two-wheelers in the pages of *Le Chat Noir*. An illustration by Carl-Hap shows a woman attending a funeral on a bicycle while in full mourning dress; a second has a virtue/vice combination (a figure with angel's wings but clad in the nineteenth-century equivalent of hot pants) posing near her "mount."[50]

The virtue diatribe against the bicycle (which, not coincidentally, was directly linked to the women's rights movement) continues in the chapter on the Perverse. Here the bicycle has created a third sex, resulting in women's abdicating the power of charm for that of liberty.[51] The Perverse, then, has also benefited from this liberation, and it has done her harm. Montorgueil calls her a "perverted Eve," and a "precocious marauder," implying that the bicycle was used to deliver the apple to an unsuspecting Adam.[52] Pushing even further, Montorgueil says that she is a sorceress of disasters and is loyal to black masses of Satan. She has become a demi-vierge who, with her demonic practice, has intensified vulgar desires.[53]

This inhabitant of the world of prostitution was repeatedly described by Montorgeuil as being toxic, a poison, a source of destruction. Her sirenlike voice was capable of weakening the conscience and her instinctive duplicity clothed a desire to watch others suffer, making her the most dangerous of the women in Montorgueil's manual. He implied that she maintained her youth through the realization of her victories, stopping just short of characterizing her as a vampire. While initially examining "real" women of contemporary society, the final section on the various levels of prostitution demonstrated the easy elision between the worlds of fantasy and reality.

Montorgueil's connection of the "Perverse" to Eve links his book to a larger trend within French society.[54] Eve was a popular symbol used by both feminists and antifeminists. Agitator Maria Deraismes drafted a number of documents, including her 1868 tract, titled *Eve dans l'humanité*. She used Eve as a powerful symbol, the mother of humanity. Anti-feminists focused on the "sinful" aspects, especially Eve's responsibility for mankind's fall. An antifeminist image by Grévin for the *Journal Amusant* (1879), humorously comments on the appearance of the New Woman, linking her to the first woman.[55] Connected to the devil directly by the presence of a serpent bearing an apple in its mouth, the

central woman reveals sensual abandon. Her body is encircled by the snake's coils; they share a kiss mediated by an apple of "dangerous knowledge." Grévin's illustration, titled *Filles d'Eve* (*Daughters of Eve*), is proposed as a sculptural entry for the next Salon emphasizing the importance of public exhibitions of the piece to give it broad currency. He adds further details. The central woman, stripped to the waist, holds a glass of champagne from an opening-night party and a fashionable fan; she indulges the serpent's kiss. Below, a second woman in similar *deshabillé* expires following a similar embrace—although she clutches a lifeless snake. The fashion half-worn by both of the women has a serpentine appearance, loose about the hips and gathered in twists about the ankles; the central woman's skirt is falling off similar to a snake shedding its skin. A large crowd of people swarm around the sculpture. Grévin does not visualize whether the woman on the bottom of the sculpture has killed the snake or if the snake has killed her. In any event, the missing head of the second serpent seems a reference to the Virgin Mary as the "New Eve" who eventually crushes the serpent. Grévin's supposition suggests that the serpent is crushed by the Filles d'Eve for a different reason—not to atone for sins but rather to assume masculine phallic power. The connection of the snake to the champagne glass and the fan highlights where the activity takes place, creating a playful aura as well as strengthening the serious undertone of the image. Thus a shift in power is accomplished in favor of woman; she has been given more responsibility than the snake.

Similar use of this type of imagery appears in José Roy's cover for Josephin Péladan's *Femmes honnêtes* (*Honest Women*) (Fig. 2.14), suggesting that they were never to be seen as honest women. Péladan was a symbolist writer based in Montmartre and leader of a religious and artistic/literary group, the Rosicrucians, which achieved cult status. Roy was also a contributor to the Montmartre-based group of artists known as the Incohérents (really progenitors of the Dada movement of the early twentieth century) and a commercial book illustrator. In Roy's cover a woman (one of the contemporary daughters of Eve—identifiable by her negligee, dark stockings, and high-heeled shoes) rides a large serpent, seen, in turn, as a type of substitute phallus. However, the overall relationship is ambiguous—the snake appears threatening; the woman shows no fear. Jack Spector has commented that "for all the menace of the wide-open mouth facing her, she seems in control of the creature, riding it like a witch, and less concerned with dodging it than with flirting with the reader."[56] It is important to take into consideration the nature of the book, which was a continuation of stories Péladan began in 1885 using the same title, but denying his authorship through the pseudonym of Le Marquis de Valognes. The cover by Roy suggests

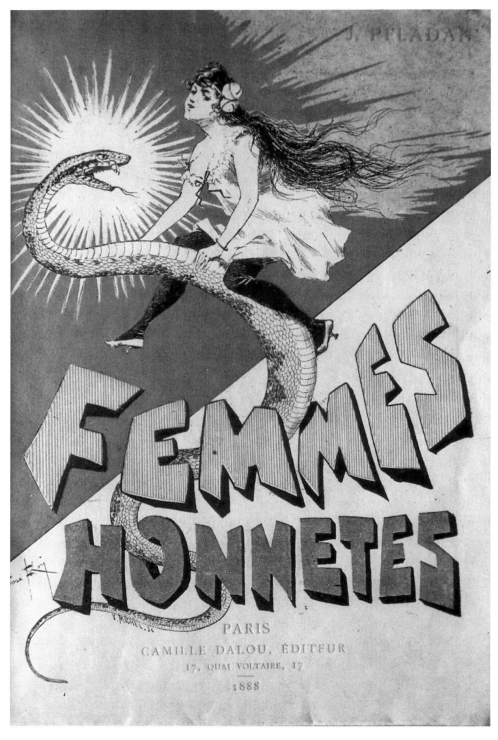

Figure 2.14 José Roy, cover for Joséphin Péladan's *Femmes honnêtes* (*Honest Women*), 1888.

changes within society. The 1885 text contains individual stories about narcissistic women and those obsessed with material goods, especially fashion. They use their feminine wiles to seduce men (and women, in one lesbian example) in a series of unusual sexual adventures. While only some are identified as courtesans, none of them appear as "femmes honnêtes." Péladan suggests through careful wording that the devil is aware of their activities; he also describes aspects of their appearance as "serpentine."[57] In general the women in the second volume remain meaner in spirit; they are more diabolical in their maneuvers—something Péladan associates with the turn of the century. Working together, the twenty-four chapters between the two texts show progressive moral decay and degeneration. There is a change from the crime of opportunity to ones that are carefully plotted and from an attitude of chagrin to one of celebration on the part of the women. In the second volume the women are well aware of their own role in their destinies—something that Péladan connects directly to the feminist movement in the story "Edelburge-Nina":

> When a woman is neither fit for gallantry or marriage, and if she wants to hide her frivolity under the guise of artistic licence or, if driven by necessity she ignores piano playing too much to be able to teach, she will become a woman of letters.
> Blue-stockingism constitutes a "demi-monde among the "demi-monde."

The connection of the snake with a powerful woman appears in Henry Gerbault's "Sa Toute-Puissance la Femme."[58] Here a woman wears an ermine while holding a parasol upside-down like a scepter. A partially blindfolded cupid holds onto the woman, revealing a traditional bow and arrow, which he is not prepared to use. A large snake wraps itself around the woman's knees curling over her head; this serpent creates the simultaneous appearance of becoming the rear of a throne and a halo. The woman's hat is a modification of a tricorn, but with a tiara inserted in the center. The print's caption reveals a powerful alliance forged between a fashionable woman, cupid, and the snake. Similar to other representations, the snake has become an agent of the woman; it can still refer to Eden, but is losing biblical associations. Increasingly the equation is: woman equals snake.

Henri Gerbault visualized this concept on many occasions, including "Eve et son Flirt" from *Le Journal Amusant* in 1900.[59] The scene takes place in a fairly barren landscape with mountains. In a triangle, at the top, an eye watches—the symbol for the "eye of God," which Gerbault created by combining the trinity with Hindu and Buddhist references to a "third eye."[60] Eve's hair—which is tightly bound on the left but suddenly flows free on the right—symbolizes released

sexuality. The flowers and butterflies decorating her dress and hair link her to the transience of nature. The tree stump she sits on is the tree of knowledge—an awareness of good and evil—now cut down. The snake curls behind her, whispering something in her ear, to which she replies in the caption: "You are not serious; you are a snake that talks nonsense." In other words, the snake is making small talk or flirting. While the caption and the title identify the serpent as the flirt, it is clear from Eve's demeanor that the attraction is mutual. The tree, the apple, and all of the narrative of the original story have been replaced by a cunning double seduction scene conducted under the all-seeing, all-knowing eye. Another work by Gerbault, titled "Le Bon Serpent," presents a discussion that one expects to find taking place between a woman and her maid (thus the humor of the phrase "bon serpent," which plays on the idea of a bonne—a maid). The serpent asks a fashionably dressed woman, "—Voyons, mon cher conseiller, deux amants, vous ne trouvez pas cela un peu excessif?" (Don't you think, my dear counsellor, that two lovers is somewhat too much?), to which she replies "—Oh! ma chère enfant! quand il y en a pour un il y en a pour deux." (O! my dear child! when there is enough for one there is enough for two).[61] Jean Floux, writing for *Le Chat Noir*, noted in his poem "Les Eves" that these women were neither spouses nor mothers, but that their kisses were a savory poison. The apples of Eden contained their souls and their friendships were both lascivious and chaste.[62] Thus, even Eve was seen as having a desirable virtue/vice duality. The qualities were very similar to the fictional Montmartroise, who moved with ease from barmaid to dancer to streetwalker to become the symbol of all Montmartre.

In popular illustration and in real life snakes began to be associated with women's dress accessories. While the concept of the Fille d'Eve existed earlier than its appearance in fashion, it is perfectly reasonable that increased discussion of this figure led directly to the adoption of snake motifs in fashion and fashion accessories. Artists, noticing a change, also ridiculed a new fashion trend intimately connected to the Eve revival—the feather boa. One particular motif of historical reference was the story of Laocöon, and the sculptural representation of it. The sculpture was well known; it was used by Carl-Hap, who decided to "spoof" the statue in his commentary on the boa as a fashion accessory for *La Caricature* in 1900.[63] *Les Boas* contains six images with different "types" of boas, including the fur version (described as "Boa . . . titude") and the feather version ("Boa . . . teuse"). In the center of the upper register is the Laocöon composed with women instead of the father and sons; and with the boa as an accessory rather than sea serpents. The text underneath this image consists first of a quote:

When two repulsive boas come out of . . .
I still tremble in horror etc. etc.

Carl-Hap placed the title "Laocöon" next to the image. The original Laocöon statue has within it the association of women with snakes, since it was Athena who sent snakes to attack Laocöon and his sons after Laocöon had warned the Trojans about the wooden horse. But the caption beneath the print turns considerable attention to contemporary fashion:

Help me find the name of the greatest furrier:
Put him in the place of Ténédos and it will become a practical joke.
And, frankly, I don't wish to give him free publicity.

Two of the images in the lower register suggest that the constricting action of the sea serpents sent to torture Laocöon were inherent to this fashion accessory. At the left, two women have their feet entrapped in boas, with the caption: "With the remains of the great boas/Fall had strewn the stone!" In the lower center two women are bound to a man (the women's feet have been raised off the ground through constriction). All three figures have their mouths covered by the boa; both women's waists are encircled. At the right is a figure meant to point up the accessory as blatantly sexual. This African was called a "Hottentot" as both buttocks and breasts are exaggerated. But the encircling boa does not interfere with the viewer's vision of these attributes which are highlighted for amusing sexual emphasis. A final text explains the overall reason:

Great allegorical compositions inspired by Antiquity.—They stand for our poor little women who are in the grip of a cold winter personified by two horrible boas.

The fashion boa inspired other artists working for popular journals, including Draner, who had satirically titled his version of a portrait by L. Amans from the 1890 Salon "Madame Laocöon."[64] The Laocöon is also featured in Ferdinand Bac's illustration "Statues That They Love," in *La Vie Parisienne* (1899).[65] Here a woman is shown wrapped in snakes, standing in front of the classical statue. This concept also appeared in a work by Henri de Toulouse-Lautrec (1883–1901) later that same year in a poster for *Jane Avril* (Fig. 2.15), demonstrating that these ideas were so potent that they could be put to use for advertisements centering on pleasures available in Montmartre. Jane Avril (1868–1943), famous red-haired performer at the Moulin Rouge and Moulin de la Galette and habitual Toulouse-Lautrec painting dweller, wears a fantasy costume based on the "Daughter of Eve" theme. Avril was a dancer of the racy chahut and had a personality with the intriguing duality of being "elegant and discreet" on the one

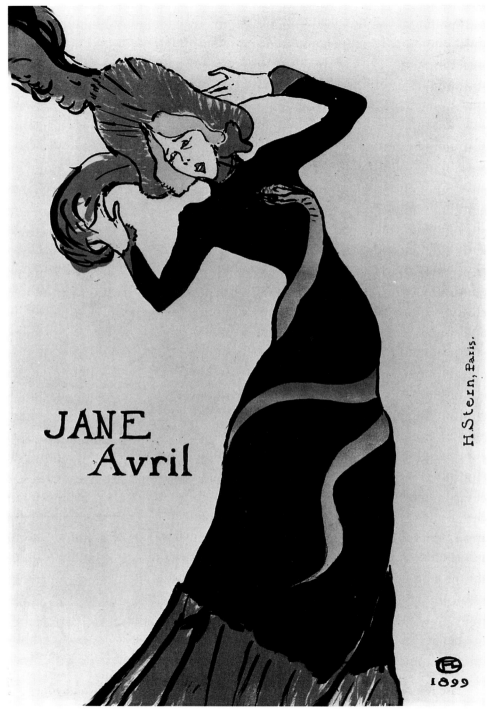

JANE
Avril

H.Stern, Paris.

1899

Figure 2.15 Henri de Toulouse-Lautrec, *Jane Avril*, 1899. Color lithograph
(second stone). Sterling and Francine Clark Art Institute,
Williamstown, Massachusetts.

hand and "endowed with a ferocious energy that earned her the nickname of 'La Mélinite'"—an explosive—on the other.[66] Avril was said to be the daughter of an alcoholic prostitute and a noble Italian and because of her difficult childhood developed tics and phobias—resulting in at least one stay at Salpêtrière. Arsène Houssaye, Arsène Alexandre, and Arthur Symons described Avril in terms of vice and virtue when they ascribed to her "the beauty of a fallen angel."[67] Toulouse-Lautrec's 1899 poster shows Avril in a costume with a snake writhing around it.[68]

It is likely that Lautrec's poster communicated more than simply a striking design, as a similarly dressed woman appears in a detail from a drawing by Hyp published in *La Vie Parisienne* on January 7, 1899.[69] The Hyp work comes from a spread entitled "The Statues They Love," and, similar to Carl-Hap's work examined earlier, parodies the statue of Laocöon.[70] Hyp suggests that the woman who loves the Laocöon is likely a morphine addict prone to excitable states—in this case she has hallucinated the writhing snakes. The text explains:

> After using ether she started using morphine. She suffers from deep anxiety and fright—and at the same time has a morbid taste for terrifying spectacles. All her life she has had a terrible fear of snakes which, because of her addictions, has become dementia.

Given the resemblance between not only the dress of the woman, but also the pose, it seems as though drug use and/or hallucinations were the intended focus for Lautrec's poster. While little is known about the specific evolutionary process of the poster (for instance, it is not known if Avril owned a dress resembling the one used), it is possible to infer some conclusions. Avril's stage performances were partially responsible, since according to Frèches-Thory, she "devised original choreographic routines to show off her lissome figure and the sophisticated elegance of her wardrobe."[71] Arthur Symons's description of Avril's personality suggests further reasons why Toulouse-Lautrec may have depicted her in this way:

> The reflections—herself with her unconscious air, as if no one were looking—studying herself before the mirror . . . [she] had a perverse genius, besides which she was altogether adorable and excitable, morbid and somber, biting and stinging; a creature of cruel moods, of cruel passions; she had the reputation of being a Lesbian; and, apart from this and from her fascination, never in my experience of such women have I known anyone who had such an absolute passion for her own beauty. She danced before the mirror under the gallery because she was folle de son corps. . . . She was so incredibly thin and supple in body that she could turn over backward— as Salomé when she danced before Herod and Herodias.[72]

Another inspiration undoubtedly linked both Avril's and Lautrec's own experiences with psychological disturbances. Both abused alcohol; both were institutionalized at some point in their lives. Lautrec's health had deteriorated significantly by 1898—and it seems as though he utilized his own understanding of nervous disorders (including erratic behavior, obsessional thoughts, and "swatting at invisible flies"). He was prone to hallucinations and "visibly shaking with delirium tremens," which were caused either by alcoholism or by tertiary syphilis. In December 1898 Lautrec was given a prescription for "psychological disturbances" which included Valerian—a common treatment for hysteria.[73] The appearance of Hyp's illustration presumed an additional level linking it to drug-induced hallucinations, which were certainly not a common aspect of poster advertisements for nightclub acts during the period!

Serpents were also featured on the flowing costumes of Loïe Fuller, whose seductive nightclub performances were dubbed "la danse serpentine."[74] Loïe Fuller (who was born in Illinois in 1862 but made Paris her permanent home in 1892) became known for dance performances aided by flowing skirts and colored lights, which she would claim later were inspired by her improvisation of being hypnotized for a New York audience.[75] In her customary act, she occasionally manipulated her skirts with poles, other times with her hands. In this way (through careful staging and lighting) she was able to create a fantasy environment and present herself as an object of desire. The degree to which her "smoke and mirrors" performances enhanced her appearance is evident through a comparison of publicity posters with contemporary photographs and with existing film footage of a performance. Loïe Fuller was consistently advertised in Montmartre publications, and she eventually opened her own dance establishment there.

While Fuller had a variety of costumes and corresponding dances, it was the *danse serpentine* and the Butterfly dance that became her selling points. An anonymous 1893 poster transforms Loïe into a serpent-woman; her head and chest are melded to a serpent. Loïe also posed for publicity photographs in the snake costume and a rubber snake attached to a wire, which she raised to her lips.[76] An article about Loïe published in *Gil Blas Ilustré* in 1892 focused primarily on her use of serpent motifs. It describes the immobilized display of snakes patterned on her dress, that are "awakened" as she begins the dance. As the spirals of cloth move about her body, she appears to be "charming" the serpents.[77] A similar estimation of the sensual movements of Fuller during her performance is contained in a long poem by Georges Rodenbach, including the following stanza commenting specifically upon her appearance during the *danse serpentine:*

Sinuous, on her body, in the shape of snakes . . .
O! column of temptation O! enchantress!
Tree of Paradise around which our servile desires
Entwine themselves as serpents of color . . .[78]

Fuller clearly cultivated the image of the "snake charmer" in her public per-
formances as well as in her publicity photographs and poster advertisements.
She used the popular mythology associated with women in the company of
snakes to her advantage. When Fuller danced the "butterfly"—as preserved on
film—she emerged from a bat creating the disturbing impression that some-
thing beautiful could evolve from a form associated with terror. Fuller's per-
formances made it clear that even within the realm of Eve, snake imagery and
the butterfly, there was something attractive but dangerous—the duality again
became a viable vehicle for advertisements for Montmartre performers.

Through an examination of the range of popular images which proliferated
at the turn of the century in French posters and in illustrated magazines and
books, it is clear that artists were using this popular forum to reveal both the
pleasures and the potential pitfalls of Montmartre, using women as symbols of
virtue and vice. Women were associated with available sex and alcohol along
with the performance aspects of dance and song that took place in the various
cabarets. Frequently women were depicted with the black cat—a symbol partic-
ular to the area—but just as often they could be found with a bicycle or a snake,
which were equally expressive of the dualities of the prostitute. Illustrations that
appeared in journals and in books detailed a network of "types" of women of
easy virtue (sex workers) who could be identified by their secondary (or "cover")
profession, their costume (even the way their skirt was lifted) and with other
attributes. In Montmartre, the world of the performer and the prostitute
revealed that a revolution had taken place bringing to the fore a number of
issues pertaining to sexuality and the power struggle between the sexes. The
revolution in the popular press centered around these images of women who
were seen as containers of virtue and vice. They were collectively vessels of the
seductive dualities that encompassed the very spirit of Montmartrian women on
the fringe of respectability or desire.

N O T E S

1. There has been a persistent interest in prostitution as it existed in French society. Doc-
 uments from the period include A.J.B. Parent-Duchâtelet, *De la prostitution dans la
 ville de Paris* (Paris: Baillière, 1837), Ferrero Lombroso, *La Femme criminelle et prostituée*
 (Paris: F. Alcan, 1896), and Edouard Dolléans, *La Police des moeurs* (Paris: Librairie de

la Société du Recueil Général des Lois et des Arrêts, 1903). Many original documents are summarized in Dominique Dallayrac, *Dossier Prostitution* (Paris: Editions Robert Laffont, 1966). Contemporary studies include Charles Bernheimer, *Figures of Ill Repute: Representing Prostitution in Nineteenth-Century France* (Cambridge, MA: Harvard University Press, 1989) and Alain Corbin, *Women for Hire: Prostitution and Sexuality in France after 1850* (Cambridge, MA: Harvard University Press, 1990) (English translation of the original French). The presence of prostitutes in Montmartre cafes was reported in "Les Cafés des Boulevards," *La Patrie en Danger*, September 22, 1870, 1.

2. This appeared on July 12, 1906.

3. For a discussion of press issues in Montmartre, see Gabriel P. Weisberg, "Louis Legrand's Battle over Prostitution: The Uneasy Censoring of *Le Courrier Français*," *Art Journal* 51 (Spring 1992): 45–50.

4. Georges Ferguson, *Signs and Symbols in Christian Art* (New York: Oxford University Press, 1966), 104–105.

5. On the cabaret, see Rodolphe Darzens, *Nuits à Paris*, illustrations by Willette (Paris: E. Dentu, 1889), ch. 13, "Le Chat Noir"; and Louis Marsolleau, "Le Chat Noir," *Le Chat Noir*, June 20, 1885, 2.

6. See Willette's memoirs, *Feu Pierrot 1857–19—?* (Paris: Floury, 1919) and Luc Willette, *Adolphe Willette: Pierrot de Montmartre* (Paris: Editions de l'Armançon, 1991).

7. This appeared on February 7, 1897.

8. While clearly related to the use of descriptive terms based on regional attributes to refer to various women (e.g., Alsacienne or even the common Parisienne) the use of Montmartroise linked less to the appearance of women, rather to the characteristic pleasures—even vice—associated with Montmartre. Henry d'Erville preferred the term *montmartraise* to describe "des fillettes à l'air étique" and concluded "Sans doute, en veine d'épigrammes, / L'architecte, sur ta hauteur, / Montmartre! rêvait à tes femmes / Quand il bâtit le . . . Sacré-Coeur!" "Montmartraise," *Le Chat Noir*, June 10, 1893, 2.

9. Homodel, "Les Marges de l'histoire du cabaret à la brasserie," *La Vie Parisienne*, July 13, 1895, 404.

10. This appeared on September 1, 1894. Happel was German-born, but nevertheless contributed illustrations to many French journals, including *Le Rire* and *Le Chat Noir*.

11. This appeared on June 30, 1894.

12. This appeared on April 24, 1898.

13. The maquette is currently in a private collection.

14. "Une soirée au Chat-Noir," *La Vie Parisienne*, January 15, 1887, 36–37.

15. "Ah! les Demi-Vierges," Chanson de Xanrof; illustration by Henri Gerbault. *Gil Blas Ilustré*, February 9, 1896, 8. See also the special issue of *Le Courrier Français* titled *La Revue des Demi-Vierges*, August 11, 1895.

16. Debut de La Forest, "Les Vierges contemporaines," *Le Chat Noir*, August 5, 1882, 4.

17. This appeared on October 7, 1893, 3.

18. Lihou, "Léda," *Le Chat Noir*, June 2, 1894, 2.

19. The popularity of Guilbert and her characterization of various Montmartre venues was illustrated by Widhopff, "Au Concert des Ambassadeurs. —Yvette Guilbert dans ses chansons," *Le Courrier Français*, July 3, 1898; see also Huges Delorme's "Pour un camarade," which places Guilbert in the role of "la Divette," who is hailed after her performance by a personification of *Le Courrier Français*, with illustration by Willette. *Le Courrier Français*, April 24, 1898, 3.

20. "L'ancien Chat Noir," *Le Chat Noir*, June 13, 1885, 3.

21. See Raymond Verd'hurt, "Modernité," *Le Chat Noir*, December 23, 1893, 2; and Despailles, "Le monsieur qui connait les femmes," *Le Chat Noir*, May 27, 1882, 1. See

also Léon Maillard, "I. Femme du monde; II. Bourgeoisie; III. Femme du peuple; IV. La Balance," *La Plume* 3 May 1, 1891, 151.

22. Jean Lorrain, "Modernité," *Le Chat Noir*, November 10, 1883, 2.
 Modernité modernité!
 A travers les cris, les huées
 L'impudeur des prostituées
 Resplendit dans l'éternité.
23. This appeared on December 19, 1897.
24. Current location unknown.
25. For more information on Henry Somm, see Elizabeth Menon, "Henry Somm: Impressionist, Japoniste, or Symbolist?" *Master Drawings* 33, no. 1 (Spring 1995): 3–29.
26. *Les Hommes d'Aujourd'hui*, no. 103, ca. 1881 (cover).
27. *Les Contemporains*, no. 15, 1893 (cover). The caricature of Hubertine Auclerc [sic] produced by Alfred le Petit (1841–1909) for *Les Contemporains* suggests that women's rights could only be obtained by compromising male rights. This is why Auclert is depicted on horseback leading a feminine assault upon the "Bastille des droits de l'homme." The accompanying poem claims that it is the "bearded sex" who drafted the "rights of man" and Hubertine, who possesses breasts, might make claims to equal rights, but in the end "les droits les plus sûrs sont les droits du plus fort"— meaning that while she might in theory have an argument, it is in no way as "solid" as the bastille erected by men. Hubertine Auclert was considered one of the *amazones du siècle* by Jehan des Étrivières; she described herself as a "crusader" and equated her taking up of the feminist cause as her "going to war like a medieval knight." Translated in Claire Golberg Moses, *French Feminism in the Nineteenth Century* (Albany: State University of New York Press, 1984), 213. See Jehan Des Étrivières, *Les Amazones du siècle* (Paris, 1882). Auclert was also ridiculed in "A Mlle Hubertine Auclerc et Cie.," a long poem which appeared on the first page of *Le Figaro*, February 14, 1880.
28. This appeared on April 12, 1885.
29. *La Vie Parisienne*, March 19, 1892, 160–161.
30. This was part of a series of three illustrations with commentary which appeared in *La Vie Parisienne*, August 28, 1897: I. Comment elles retroussent leur robe, 492 (general considerations); II. Comment elles retroussent leur robe, (figure 10), 495–495; III. Comment elles retroussent leur robe, 499 (demonstrates the different style of raising the skirt between the left and right banks of the Seine).
31. For an example of how this figure was viewed by Montmartre writers, see Raymondo de Cazba, "Les Trotins" [sic], *Le Chat Noir*, March 11, 1882, 2; M. Irlande, "P'tit Trottin," *Le Chat Noir*, May 5, 1894, 2, and Ferdinand Loviot, "Trottins," *Le Chat Noir*, March 9, 1895, 4.
32. This appeared on June 3, 1893; second series appeared October 14, 1893.
33. The Fille de Brasserie appears in the second series. "Pronostics: La joie des potaches; énorme dans sa robe de soie noire décolletée audacieusement en pointe. Abondantes promesses. Résultats: Tient plus encore qu'elle ne promet, —au point de vue de la quantité, mais non de la qualité, —le corset comprimant et servant également . . . d'ascenseur. Mais les très jeunes gens ne détestent pas ça."
34. Georges Montorgueil, *La Parisienne peinte par elle-même* (Paris: Librairie L. Conquet, 1897). The section titled "galanterie" begins on p. 153.
35. Ibid., 96–97.
36. Octave Uzanne, *La Femme à Paris. Nos contemporains, notes successives sur les Parisiennes de ce temps dans leurs divers milieux, états et conditions* (Paris: Ancienne Maison Quantin, 1894 and 1910), 167.
37. Montorgueil, *La Parisienne peinte par elle-même*, 156.

38. Ibid., 157.

39. Ibid., 163 and 170.

40. Ibid., 164–166.

41. Ibid., 164.

42. Ibid.

43. Ibid., 168.

44. Ibid., 173–174.

45. Ibid., 183. The most complete condemnation of the costume is likely that found in John Grand-Carteret, *La Femme en culotte* (Paris, E. Flammarion, 1899). See especially chapter 10.

46. Montorgueil, *La Parisienne peinte par elle-même,* 187–189.

47. Ibid., 186.

48. Ibid., 190.

49. See Camille Mauclair, "La Femme devant les peintures modernes," *La Nouvelle Revue* 1 (1899): 190–213; and Marius Ary-Leblond, "Les Peintures de la femme nouvelle," *La Revue* 39 (1901): 275–276 and 289–290. For a discussion of these writers views, see Debora L. Silverman, *Art Nouveau in Fin-de-Siècle France: Politics, Psychology and Style* (Berkeley and Los Angeles: University of California Press, 1989), chapter 4.

50. See, for instance, Carl-Hap, "Veuve fin de Siècle," *Le Chat Noir*, November 10, 1894, 3; and Carl-Hap's "Sous le manteau de ma cheminée," *Le Chat Noir*, December 29, 1894, 3.

51. Montorgueil, *La Parisienne peinte par elle-même,* 191–193.

52. Ibid., 192.

53. Ibid., 194–195.

54. This phenomenon is the subject of a book manuscript currently in progress by the author, titled "Evil by Design: The Creation and Marketing of the Femme-Fatale."

55. This appeared on June 14, 1879. For further discussion of this image and the relationship to the femme-fatale, see Elizabeth K. Menon, "Fashion, Commercial Culture, and the Femme-Fatale: Development of a Feminine Icon in the French Popular Press," *Analecta Husserliana. The Yearbook of Phenomenological Research* 53 (1998), *The Reincarnating Mind or the Ontopoietic Outburst in Creative Virtualities*, ed. Anna-Teresa Tymieniecka (Dordrecht: Kluwer Academic Publishers, 1998), 363–379.

56. Jack Spector, "A Symbolist Antecedent of the Androgynous Q in Duchamp's L.H.O.O.Q.," *Source: Notes in the History of Art* 18, no. 4 (Summer 1999): 44. Spector's main concern in the article is to discuss the implications of the phallic cedilla of the "Q" in other works by Roy; in the case of *Femmes honnêtes* he argues that the penetration of the snake through the "O" in *Honnêtes* is similar to the cedilla.

57. For instance, in the story "Bibiane" her walk is described as "à la fois serpentine et contenue" (23).

58. This was reproduced in the album *Bonjour M'sieurs Dames* (Paris: H. Simonis Empis, 1903) and in *Les Maitres humoristes* (Paris: F. Juven, 1905).

59. *Journal Amusant*, July 28, 1900, 16.

60. The motif appears in an illustration by Lami, called "Le Décolletage à travers les siècles; celui de notre mère Eve," which was published in *Le Courrier Français*, January 13, 1901, 10. Gerbault used the motif in a cover illustration for *Le Charivari*, July 6, 1899, where the eye wears a monocle and watches over "Mademoiselle Phryné se rendant à Trouville."

61. *Les Maitres Humoristes* no. 8, *Henri Gerbault* (1905), n.p. Eve's sexuality was the subject of a poem, "Eve moderne," written by Charles Quinel and dedicated to "Mlle. Rose Chagrin." *Le Courrier Français*, July 26, 1891, 2.

62. Jean Floux, "Les Eves," *Le Chat Noir*, March 22, 1890, 2.

63. Carl-Hap, "Les Boas," *La Caricature*, December 10, 1892, 397.

64. Draner, "A Travers le Salon," *Le Charivari*, May 8, 1890, 3.

65. This appeared on January 7, 1899.

66. Claire Frèches-Thory in the section "Stars" of *Toulouse-Lautrec* (New Haven, CT: Yale University Press, 1991), 290.

67. Sophie Monneret, *L'Impressionisme et son époque: dictionnaire international* (Paris: Laffont, 1987) 1, 22–23. The Symons quote is translated and reprinted in Julia Frey, *Catalogue of the Galerie Charpentier Sale* (Paris, 1959), 272.

68. Lautrec's preliminary drawings show the development of the sinuous line and the placement of the snake on Avril's costume. In the first state of the finished poster (for which only twenty-five copies were printed) there is a cobra in the background, suggesting that Avril is either reacting to it, or is transformed by it. (See Jean Adhémar, *Toulouse-Lautrec: His Complete Lithographs and Drypoints* [New York: Abrams, 1964], commentary on plate 323.) According to Anne Roquebert, the poster was never used, and there has been some speculation that it was not completely finished, as was the case with many of Lautrec's works from the last years of his life. ("Late Work," in *Toulouse-Lautrec*, 468). Certainly Lautrec's financial situation (for he was destitute in January of 1899) and his health difficulties contributed to the small numbers of posters printed and possibly as well to their not being displayed. Lautrec's financial situation is detailed in Herbert Schimmel, ed., *The Letters of Henri de Toulouse-Lautrec* (Oxford: Oxford University Press, 1991), 345–347.

69. Which work came first cannot be definitively documented. According to Julia Frey, Lautrec designed his poster in the fall of 1898, but it was not printed until January 19, which would raise the issue of how Hyp could have become aware of the design in order to produce his work which was published on January 7. While Frey has provided documentation for the printing of the poster, she provides none for the date of the design itself (*Catalogue of the Galerie Charpentier Sale*, 449–450). Lautrec, on the other hand, certainly must have read *La Vie Parisienne*. In addition to his general interest as an illustrator of popular magazines, *La Vie Parisienne* published a report on an open house Lautrec held at his apartment in 1897. The open house occurred May 15, 1897; the report appeared on May 22. See ibid., 432–433.

70. Hyp, "Les Statues qu'elles aiment," *La Vie Parisienne*, January 7, 1899, 6–7.

71. Frèches-Thory, "Stars," 290.

72. Reprinted in Frey, *Catalogue of the Galerie Charpentier Sale*, 273.

73. Frey, 441.

74. "La Danse serpentine—Mlle. Loïe Fuller et ses transformations," *L'Illustration*, November 12, 1892, 392. The most complete study of the dancer has been completed by Giovanni Lista, *Loïe Fuller, danseuse de la Belle Epoque* (Paris: Somogy, 1994). Lista is very concerned with the mechanics of the productions, especially with regard to patents on the machinery and the implications for the development of both dance and film.

75. Frank Kermode, "Loïe Fuller and the Dance before Diaghilev," *Theatre Arts* (September 1962): 9.

76. Both this illustration and the previous one were reproduced in Lista, *Loïe Fuller, danseuse de la Belle Epoque*.

77. René Tardivaux, "La Loïe Fuller," *Gil Blas Illustré*, December 18, 1892, 2–3.

78. Georges Rodenbach, "La Loïe Fuller," *Revue Illustrée*, May 1, 1893, 335–336.

Les enfants des ivrognes

Concern for the Children of Montmartre

JILL MILLER

> Steinlen was Swiss. At a young age, he left his calm country to come to Paris to live an existence of fights and of fever. *L'Assommoir* (1877), by Emile Zola, which revealed to him, he said, the people of the poor neighborhoods: pale, anemic, eaten away by tuberculosis, weighted down by tuberculosis and hard work, fodder of sweatshops and barracks . . . here his soul could fully develop.[1]

When Théophile-Alexandre Steinlen (1859–1923) arrived in Paris in 1881, he found a haven in Montmartre. Here he spent his career visualizing the district not as an outsider, but "from the perspectives of the smoky suburbs," and from the position of someone who commiserated, actively, with the poor.[2] Steinlen was captivated by disturbing social themes most would have ignored, writing:

> On my first day here I was seduced by the world of the street, by the workers and errand girls, laundresses and poor people. If instead of arriving in Montmartre, I had been near the big boulevards, I would have tried to paint the nouveau riches or the millionaires. But rich people are not interesting to study. . . . Ordinary people are far more interesting. Deep down, something in me responded to their humble position in life; they suited my temperament.[3]

La Rue (*The Street*) (Fig. 3.1), a monumental poster completed in several segments, was inspired by these firsthand experiences in Montmartre. It presented his daughter Colette, at the center, who, with a nurse, struggles through a crowd composed of workers from various social strata. While Steinlen renders a typical neighborhood scene, the poster also symbolizes bourgeois fears, including those of Steinlen himself who had become, at the time, a member of the middle class. Urban streets were perceived as dangerous places for naive children. A tiny bourgeoise, however, was not the only type of child who was the focus of mass concern at the fin-de-siècle.

Heated debate raged over the condition and treatment of Montmartre's unfortunate children. Popular culture (illustrated journals, posters, and books) offers hundreds of examples that document an interest in and fear about a

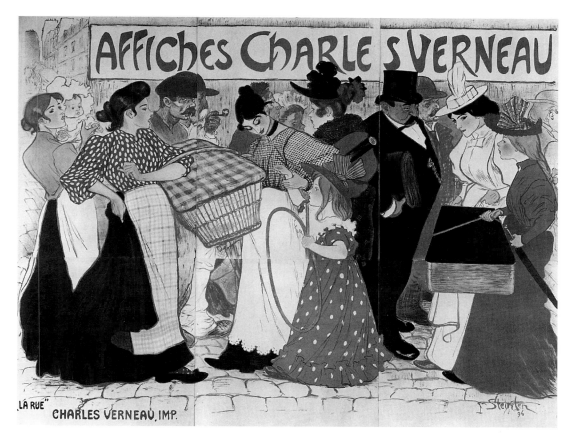

Figure 3.1 Théophile-Alexandre Steinlen, *La Rue* (*The Street*), 1896. Lithograph poster. The Metropolitan Museum of Art, Harris Brisbane Dick Fund, 1932. [32.88.18 (1-3)]

child's condition to the point where it resembles a form of social paranoia. These sources often document disturbing facts and cases, as the tone of some material (and the unrelenting frequency with which they appeared from 1871 to 1914) reveals deep concerns about the physical health of France.

Depictions of charity were particularly popular in middle-class journals. A dispensary became the subject of an 1890 *Le Monde Illustré* image.[4] *L'Hiver à Paris (Winter in Paris)* (Fig. 3.2) is situated in a dispensary in Montmartre. This is a typical scene revealing one of many charitable centers that had been founded in Paris since the early 1880s. At these locations poor mothers could obtain some minimal medical care (represented by the toothache bandages around the children's heads), sterile feeding bottles, food, and, sometimes, fresh milk.[5] Dispensaries were plentiful in areas with strong concentrations of urban poor, such as Montmartre.[6] The most famous one, in Belleville, was founded on the principle that the lives of poor children could be sanitized. Following the code instilled by a dispensary meant a healthy growth was encouraged; by implication it also underscored that improvement would become a way of life for all

Figure 3.2 Marc-Aurèle, *L'Hiver à Paris* (*Winter in Paris*),1890. *Le Monde Illustré*, Wilson Library, University of Minnesota. Photo: Jill Miller.

France. Mothers were taught to value hygiene for their children as well as for their own bodies.

Such services, along with schools and day nurseries for working mothers became sources of considerable pride for the Third Republic.[7] The libertarian, socialist, and anarchist presses, however, were quick to criticize the government's role in the lives of Montmartre children. Radical journalists and artists portrayed bourgeois Republicans as the cause of poverty and alienation, rather than the solution. What emerges from this complex historical situation are a number of critical questions. Why was there such intense interest in the plight of the children of Montmartre in the first place? Why were children at the core of the Third Republic's propaganda industry? And, finally, when children were visualized by artists such as Théophile Steinlen, why did they effectively make the case for improving the life of the impoverished in such sections as Montmartre?

Bourgeois Discourse and the Child

Steinlen's 1912 etching, *La Grande Soeur* (*The Big Sister*) (Fig. 3.3), represents an urchin inspired by types from Parisian streets. The middle class pitied and feared this stereotypical image of Montmartre. The young girl appears extremely vulnerable. Her dress, shoes, and hair are rough and tattered. She has not reached adolescence herself, yet she holds an infant, creating a symbolic reference to a complicated, even distressing, home life. The absence of an adult's presence implicates that one or both of her parents are working, have disappeared, or have left her to beg on the street, while carrying a little sibling. For the bourgeois who doted on their children as pampered treasures, the visibility of urchins was an uncomfortable reality that was being echoed in artwork by those who were sympathetic to the masses.[8]

Middle-class adults kept a wary eye on urchins and on Montmartre. Vice drew people to this section of Paris, an area that seemed more open than others. Popular culture stereotypes reveal that the middle class believed that the working poor and the unemployed who lived in Montmartre were largely promiscuous drunkards. Popular journals and novels perpetuated these views. A stereotypical view of the children of Montmartre also developed: they were lost souls born to drunkards, living lives filled with want and misery. They grew up to be characters similar to those in Emile Zola's *Nana* (1880): lusty, selfish, loutish, and languishing in disease and squalor in prisons and bordellos. An awareness of conditions of the poor in Montmartre, those who lived in penniless squalor on the butte, was effectively used by Steinlen to convey

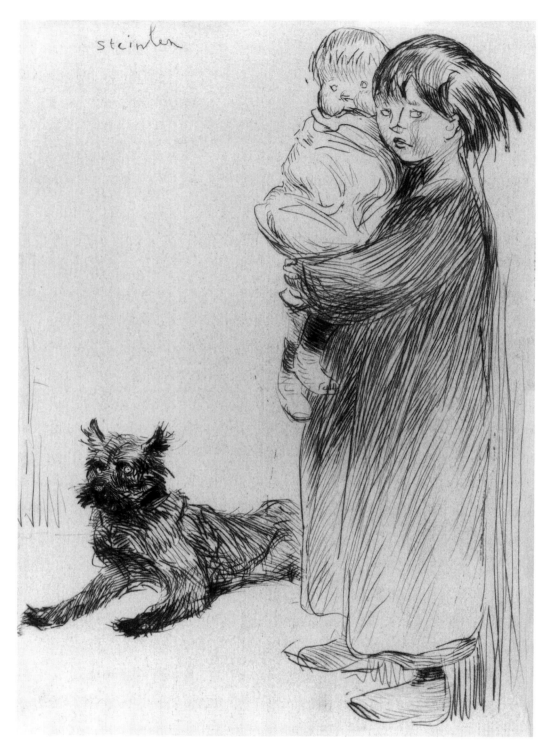

Figure 3.3　　Théophile-Alexandre Steinlen, *La Grande Soeur* (*The Big Sister*),1912. Etching. The Minneapolis Institute of Arts, Gift of S. A. Edwards.

an attitude toward all the poor—that they had to be helped and saved from themselves.

The impoverished girl's plight in *The Big Sister* is underscored by contrasting her with her counterpart: the little bourgeoise. The well-fed middle-class child seems to look over the urchin's shoulders from the new medium of large, brightly colored posters pasted on urban walls. Companies used sleek, pretty children to advertise convenience foods, such as sterilized milk and packaged biscuits for the middle class. These hygienic foods and their tin containers represented the latest in industrial technology.[9] Steinlen was commissioned to create an image for the Quillot Brothers dairy in 1894. He used Colette as a model for *Lait pur stérilisé* (*Pure Sterilized Milk*) (Fig. 3.4). Here a healthy child "type" promoted a product. The child also grew up to be the "beautiful bourgeoise," a glossy, lovely female prototype prevalent in art and literature.[10] Viviana Zelizer, in *Pricing the Priceless Child,* discusses how economic changes related to the perception and treatment of children. With the rise of the bourgeoisie and their disposable income, the child no longer needed to work; one could remain a student. The child also became a priceless jewel at the center of a family's reason for existence. Zelizer refers to this as the "sacralization" of child life.[11] This reverence for the innocent, indulged child became widely apparent, serving as a counterpoint to the urban beggar who wandered the streets in search of food or a sou.

Another powerful element of turn-of-the-century French culture became a subtext to this poster. In the early Third Republic France experienced a slight decline in the birth rate. While the city of Paris (and neighborhoods such as Montmartre) continued to grow, the nation's population slightly decreased.[12] This situation stimulated a desire to strengthen the French "race"; it was coupled with the need to improve France militarily. A desire to stimulate the birth rate and the position of the country in Europe has been richly documented in recent years by social historians. This phenomenon was popularly known under the rubric of "regeneration."[13] Infant mortality, irresponsible sexuality, and a wide array of vices were identified as destructive forces to the state. Whatever helped promote a better lifestyle, improve working conditions, or instill a sense of pride in the worker was seen as helping to "regenerate" society, and was destined to improve the lifestyle in all sections of the city, including Montmartre.

Louis Pasteur had isolated the microbe in 1893, the year before the *Pure Sterilized Milk* poster was created. People were both afraid of and fascinated by this enemy they could not see; a desire to protect the family pervaded popular visual culture.[14] Steinlen's awareness was heightened, since he and Pasteur were possibly acquainted (they both frequented the Chat Noir and other Montmartre

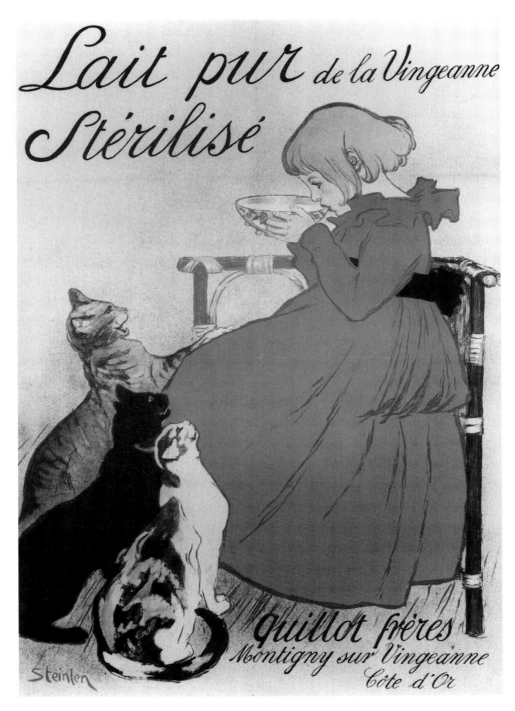

Figure 3.4 Théophile-Alexandre Steinlen, *Lait pur stérilisé (Pure Sterilized Milk)*, 1894. Lithograph. Jane Voorhees Zimmerli Art Museum, Rutgers, The State University of New Jersey, Gift of Herbert D. and Ruth Schimmel.

nightclubs). *Pure Sterilized Milk* promotes sanitation and health. The words used in the name of the product and the clean, spare use of space in the image underscore an openness that can be equated with the need for cleanliness. Colette appears as freshly scrubbed and groomed,[15] embodying the new ideal of the middle-class child. A viewer might understand that a child using this product would ideally grow up to have more children, which would help to repopulate the nation. The use of sterilized milk now became a status symbol and part of one's patriotic duty if one was to raise healthy children. The middle class was at an advantage because its members could afford these relative luxuries, further adding to the belief that a middle-class child was being elevated over others, especially those in the street, and hence would occupy a privileged position.[16]

The working class, remaining somewhat confused about its role in the regeneration effort, became the subject of lengthy discussion. Working-class habits that affected child health and mortality also underwent intense scrutiny. Popular journals regularly reported that excessive licentiousness, as found in Montmartre, often caused sterility and birth defects.[17] Involvement with drink and drugs was debilitating and was detrimental to children's health. Popular journals connected the increasing atmosphere of decadence to the falling birth rate, a pivotal topic in public discourse in early Third Republic France. A great deal of propaganda on this topic was aimed at middle-class audiences as there was a renewed effort to encourage charitable acts as a means of creating a better living environment. The elimination of addiction became the focus of campaigns designed to reinvigorate the nation. Doctors, politicians, and educators sought to protect children (born and unborn) from the problems that were "symbolically" represented by life on the street. One of the most serious of these issues was alcoholism. Regenerationists believed a key factor in the success of their campaign would be the obliteration of alcoholism and other vices that thrived in Montmartre—a center of perceived licentiousness.

Alcohol and the Threats of the Street

The regeneration effort ideally espoused that by raising the birth rate and strengthening the French "race" through the promotion of mental and physical hygiene, a new France would emerge. As artists participated in the campaign, some actively subscribed to the regeneration of the republic. Images implied that drunkenness was Public Enemy Number One. Photographs and graphics of this period by Steinlen, André Gill, and Jean-Jules Geoffroy made alcohol's effect

visible.[18] Montmartre nightclubs were notoriously seen in the press as centers of social destruction.

One image, a cover from an 1880 issue of *Le Journal Illustré*, *L'Homme ivre* (*The Drunken Man*) (Fig. 3.5), was inspired by an original painting by Montmartre regular, André Gill. In it, a man who is presumably a husband and father has stumbled through the door and has fallen. He stares into space, as if in a drunken stupor. There is a bloody wound on his forehead; perhaps he has been in a brawl or has fallen on his way up the steps. The pipe in his hand marks him as a smoker. In public discourse both alcohol and tobacco were now identified as substances weakening one physically and impeding an ability to reproduce. While appropriate to the district, this type of presentation also held implications that were found elsewhere—such as in English genre painting—revealing how widespread was the interest in these themes.

This man's vices have nearly ruined his life and those of others. His family hides behind the door. The woman protects an infant in her arms, while a frightened toddler clings to her. This woman seems disgusted, yet not surprised by the man's behavior. Clearly his drunkenness is disruptive and dismaying. The broken sanctity of the family and their home is emphasized by the cross on the wall, symbolically situated on the woman's side of the room. The tragic nature of alcohol and its effects on the home are underscored by the upturned chair. Gill's visual image contains a narrative that symbolically reveals a common stereotype linked to the poorer Montmartre families. In the popular press French fathers were portrayed as the guardians of their families' physical and moral health. It is not difficult to imagine how *The Drunken Man* (and a host of similar images) would shake middle-class faith in the strong male provider. The subject of many temperance images in French popular culture featured men; the drunken father was a focus in this campaign. After losing a husband and father to drunkenness, women and children often became homeless; the necessity of begging was increased.

The prototypical room in *The Drunken Man* appears repeatedly in images of poor families, particularly those with a drunken parent. Sparse rooms under sloping mansard roofs were usually among the lowest-priced housing available in the city. This is also a type of space inhabited by penniless alcoholics in late nineteenth-century French literature, including characters from Emile Zola's *L'Assommoir*. The use of alcohol, as referenced in literature, was undoubtedly inspired by what was occurring in reality, making another case for the interchangeability of themes, ideas, and actuality.

Children in public schools also learned about the dangers of alcohol. Photographs and documents obtained from all sections of the country and exhibited

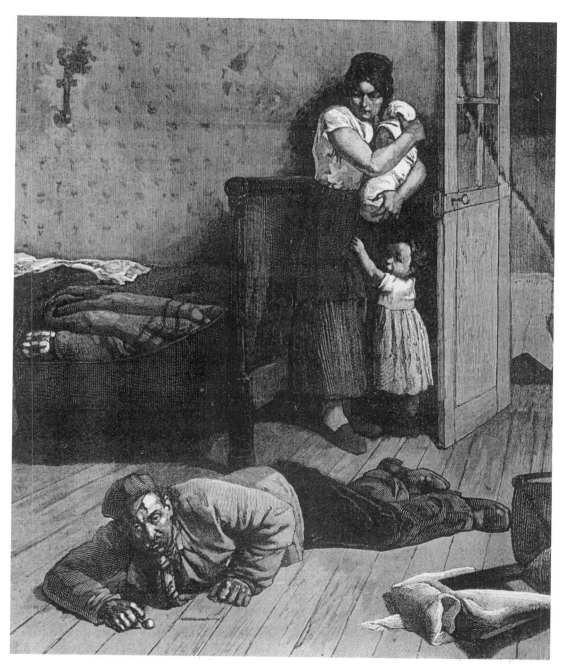

Figure 3.5 André Gill, engraving of Gill's *L'Homme ivre* (*The Drunken Man*), 1880.
From *Le Journal Illustré*, Wilson Library, University of Minnesota.
Photo: Jill Miller.

at the 1900 Paris Exposition Universelle included much temperance propaganda. Schoolboys, in sober rows, are taught from standard-issue schoolroom posters, announcing that "Alcohol poisons slowly." Schoolroom posters and anti-alcohol treatises specifically blamed some of the following social problems on the use of alcohol: poverty, crime, premature aging, epilepsy, mental illness, and high death rates. Alcohol, according to the school posters, robs one of good reasoning skills, happiness, and dignity.[19] Children of alcoholics were portrayed as potential epileptics and victims of diseases such as tuberculosis. In public schools children were taught that it was their patriotic duty to keep their bodies clean and free from alcohol and cigarettes. Children became the most important targets of the regeneration campaign devised by government officials, doctors, and public school educators.

Bringing children into bars became another lamentable, alcohol-related habit of the working class, according to temperance propaganda. Steinlen's untitled illustration for Edouard Pelletan's *Almanach du Bibliophile* (*The Book Lover's Almanac*) (Fig. 3.6) is one of many depictions of workers and their children in nightclubs. Many renditions of this theme emotionalize the situation, although Steinlen reports this family scene in the cabaret rather objectively.[20] Nonetheless, the verity of such images is what frightened temperance activists: the proximity of the children to alcohol and the habitual observation of the parents' drinking by the children on their knees was a frightening and recurring nightmare.

Popular journals at the fin de siècle, including those that were published in or near Montmartre, repeatedly featured warnings about the dangers of alcohol. An 1897 article from the *Revue Encyclopédique*, "Enfants d'alcooliques" (Children of Alcoholics) summarized scientific implications of the effect of alcohol on children.[21] The article stated that children from alcoholic homes interred at Paris's Hospice de Bicêtre were three times more likely to suffer from retardation, epilepsy, or other "degenerative conditions."[22] Middle-class publications increasingly heightened an awareness of alcoholism; they also succeeded in establishing an unfortunate stereotype. The media created an image of the poor as weak drunkards and their children as filthy, diseased, and predisposed to drink.

Tobacco, opium, hashish, and alcohol were identified as sources of a variety of medical problems. Turn-of-the-century medical treatises published studies and heart-wrenching accounts of diseased and dying children. Dr. René Arrivé's book, *L'Influence de l'alcoolisme sur la dépopulation* (*The Influence of Alcoholism on Depopulation*) (1899), was one of them.[23] Arrivé theorized that alcoholism was killing the family. He claimed that half of all pregnancies occurring in alcoholic

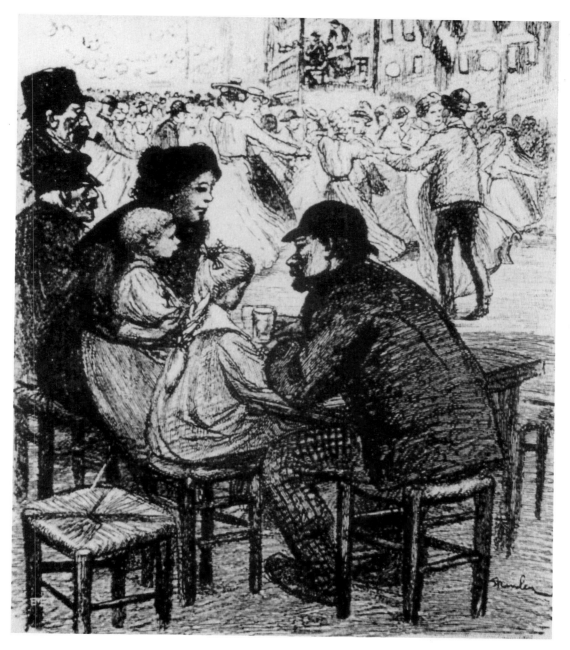

Figure 3.6 Théophile-Alexandre Steinlen, illustration for Edouard Pelletan's
Almanach du Bibliophile (*The Book Lover's Almanac*), 1900.
Photo: Jill Miller.

homes ended in abortion or stillbirth. In a country that was frightened about its birth rate, these figures raised considerable alarm.

Arrivé spoke disparagingly of the "prophylaxie of alcoholism"; he called for a war to be waged against liquor. He, and others, identified alcohol as an obstacle for the regeneration campaign, noting:

> The descendancy of a working class, alcoholic couple is often physically and mentally degenerative. It results in a feebleness of constitution that predisposes alcoholics' children to tuberculosis, diverse malformations, deafness and dumbness, nervous conditions, convulsive tics, epilepsy, hysteria, and retardation. In addition many alcoholics are syphilitic, an additional reason why alcoholism is a threat to repopulation.[24]

Anti-alcohol treatises typically explored the scientific impact of liquor on the human body, but also recounted effects of alcoholism on the moral fiber of France. It is not surprising that those middle-class men and women who read these journals and treatises feared the working classes, especially when they drank. An understanding of the attitudes circulated by the popular press helps contemporary audiences appreciate the prejudices and value an 1890s audience found in Gill's *The Drunken Man* and Steinlen's *The Book Lover's Almanac* illustrations.

Charity, Resentment, and Blame

The regeneration campaign's connection of alcohol to the tuberculosis epidemic emerged as one of many strategies angering the socialist press. The libertarian, neo-Malthusian publication, *Régénération*, was published by the Ligue de la régénération humaine (beginning in 1901). It was not illustrated, printed on inexpensive paper, and was marketed to a working-class audience.[25] The ironically and provocatively titled *Régénération* favored a plan to restructure France without attacking the alcoholic poor. The journal was organized by Paul Robin, who founded the league in 1896. Robin and his controversial group sought to bring the birth control messages of the British Malthusian League to France.[26] As Angus McClaren has noted, Robin's efforts

> elicited an amazing degree of public hostility, not because the limitation of family size was unknown in France, but because it had already been employed by increasing numbers of couples for over a century. Robin's League was immediately met by the creation of a rival Alliance nationale pour l'accroissement de la population supported by powerful elements within the church and military.[27]

Robin and his colleagues admitted that France's population problems were real, but *Régénération*'s editors advocated cooperative solutions that were initiated by the people. Robin scorned the republican government and the conservative medical profession for their interference in people's private lives (although one could argue that Robin was doing the same thing).

Numerous articles in this periodical admitted that there were high rates of alcoholism among the poor, but *Régénération* did not blame working-class health problems on heredity and sloth (as many mainstream middle-class journals did). In 1902, *Régénération* claimed that alcohol should not be seen as the demon of social destruction as it was often made out to be. Drunkenness was only a small, feeble enemy. The editorial staff wrote, "Alcohol has three parents: poverty, procreative irresponsibility, and brutal religious authority." The journal offered alternative solutions to the larger social problems facing children. These vague panaceas were: parental prudence, integrated education, communal living, abundance, joy, and cerebral force."[28] In an article encouraging "Practical Child-Rearing" *Régénération* asked its working-class audience to procreate in July so that babies would have the best chance of surviving when they were born long before the winter months.[29] As McLaren points out, birth control was part of a class struggle in France.[30] Robin's recommendations for working-class families were part of this war. Both the republican and the radical press were anxious to find scapegoats for diseased children, but both expressed genuine concern for the amount of sick and dying children in neighborhoods similar to Montmartre.

Popular republican and middle-class sentiment was that alcohol was at the root of desire and despair that affected Montmartre's children. Socialist factions, on the other hand, saw it differently. Many radical gathering places (the Chat Noir nightclub, for example) were exactly the types of establishments that caused alarm. Socialist journals agreed that alcoholism, depopulation, and child poverty were pressing problems but they disagreed on believing that the "nightclubs" or "hot spots" were totally detrimental.[31] They also did not agree that poverty and the falling birth rate were caused by the poor's dependence on alcohol. Socialists believed that social assistance and charity were, however, "essential to moral solidarity."[32] They saw government officials and public monies as failing to address the roots of the evil. Anarchists were opposed to any type of government interference in children's lives. *La Feuille* editor Jean Grave promoted the destitute child as an "enfant martyr." He insisted that children were not to be treated as property. Laws, he reasoned, make people into slaves and education must not be centrally governed.[33]

With this in mind it is clear that artists with a social conscience, such as Steinlen, found themselves in a difficult position. Bohemian artists were tolerated for experimenting with drink and for developing a personal life style that was unusual. Yet, through the position that Steinlen took in his works, he had to condemn the working classes for being intemperate. It was an ironic position, at the very least. Through his posters, Steinlen helped sell products that promoted hygiene, just as republican regeneration efforts (aimed at the middle class) did. However, in most of his work, Steinlen's ideologies were aligned with those of the radicals with whom he associated in Montmartre. While there is no evidence that Steinlen ever openly declared a specific political affiliation, he often allied himself with the most prominent socialists and anarchists. As late as 1917 he participated in a campaign to obtain a French visa for the Russian revolutionary Maxim Gorky. Steinlen also took a position of visual advocacy for the poor in hundreds of images, particularly in radical journals, such as *Gil Blas Illustré*. Through the poster, it was possible for Steinlen to create images that reached diverse groups—his way of affecting social change. Camille Mauclair said of him, "Steinlen is not a socialist, he is social."[34] He was aware of all aspects of life in urban Montmartre.

While Steinlen usually commented on working-class lifestyles, he seemed to approve of forms of charity by France's middle class. He created an 1896 *L'Illustration* image where females, resembling his wife and daughter, gave alms to a haggard and shabbily dressed woman with two children. Benevolence contrasted with humility on Steinlen's beloved Montmartre streets; he endorsed street charity. Other images, such as his benefit concert program for a soup kitchen in 1895 show Marianne, the personification of France, generously ladling soup to the masses. These are a few of many pictures informed by what certainly must have been an active, compassionate sympathy for those who were dispossessed or whose lifestyle was caught in a downward spiral.

Conservatives and radicals alike agreed that there was a problem. Everyone recognized that poor children needed protection as many were living lives severely damaged by alcoholism. But varying political factions offered independent solutions. What could be done for the children of the street? Despite criticism, doctors, politicians, and educators who advocated regeneration established significant facilities, organizations, and programs to help children who were victims of alcohol and abuse. One great concern was how children with working mothers were cared for during the day. The city of Paris established day nurseries in working-class neighborhoods. Many of these *crèches* were privately funded; some were supported by the government. Steinlen and other artists cre-

ated invitations for benefit functions held at these crèches. The proliferation of these nurseries stemmed from regeneration concerns in another example of institutional safeguarding of the health of small children. Many feared that working mothers would have fewer children and they might not take good care of the ones they had. Efforts were made to keep working mothers' children healthy at little or no expense to the mother.

Articles about middle-class efforts to assist unfortunate children ran weekly in the popular press. With titles such as "L'Hospice des Incurables à Ivry," these heart-wrenching narratives featured photographs and lengthy descriptions of facilities, valiant caretakers and benefactors, as well as the poor children themselves. Articles in which doctors congratulated the government's public assistance program promoted health and an increased birth rate as patriotic issues.[35] *Le Monde Illustré*, one of the more popular bourgeois journals, published a story on *les patronages*, schools organized to train children who had no family or those who had been taken away from their parents. The periodical exclaimed, "If the working family was organized as it should be, that is to say that the father, gainfully employed, would ensure a wage sufficient to guarantee that his wife could give herself exclusively to the care of her children and to raise them in good moral and physical hygiene, then the patronages would have no reason to exist."[36] The Société pour le sauvetage de l'enfance (Society for the Rescue of Childhood) was founded in response to an 1891 law designed to prevent the "moral abandonment" of children. The society's activities were designed to oversee the mental and physical health of children in the poverty-stricken family's environment, as well as providing locally based wet nurses to ensure that children were breast-fed.[37]

Radicals argued that these charitable efforts were simply "blind capricious fantasy." However, criticism did not deter republican efforts to help the children and perhaps to ease some middle-class guilt. France's new first lady Madame Félix Faure took advantage of the spirit of Christmas in 1896 to remember children from poor neighborhoods. Madame Faure, in a fin-de-siècle equivalent of a photo opportunity, appeared in an etching after a photograph printed in *L'Illustration* (Fig. 3.7). Every December the illustrated journals featured images and articles about well-heeled men and women and their charitable efforts. These included such events as the importation of poor children to the Petit Palais to distribute Christmas gifts amid lavishly trimmed trees. Many children were helped by conservative charities, despite radical cries that these efforts were merely materialistic stopgaps that were symptoms of the "moral abandonment" of the poor.

Figure 3.7 T. Haever, *Mme. Faure,* December 1896. Etching after a photograph, from *L'Illustration.* Wilson Library, University of Minnesota. Photo: Jill Miller

Science and medicine affected every aspect of life in Montmartre. Popular culture preserves an impressive amount of civic interest in this section of the city and in the early Third Republic. Obviously, children were at the center of a peculiar patriotism. Identified as the salvation of France, young people were critical mass-culture subjects of concern and pity. Steinlen and other artists noted the disparities between their own bourgeois world and that of the working and middle-class children, bringing patriotic passions and class-based hypocrisy further into the public eye. In some cases, the images created by these artists fed the paranoia of the regeneration campaign. Physical cleanliness transcended daily habits and became a moral value by 1900.

Artists helped to create an awareness of children's health issues and stimulated charitable action. Visual presentations of the child were used to blame and to protect, particularly the vulnerable children of alcoholics. While a great deal of the nation's temperance propaganda was negative in tone, much of it mirrored the child's new centrality to the operations of the family. "The child is the strength of the weak, the wealth of the poor,"[38] wrote Champfleury.

Mass-culture images were central to action, reaction, and argument on the subject of children and the future of France at the end of the nineteenth century. The truly complex circumstances surrounding the production of regeneration imagery should be more widely recognized. Montmartre's "children of drunks," who were often at the heart of visual imagery, emerged as important pawns in political games and strategies designed to engineer France's future. "Selfishness is unpatriotic," wrote one physician in 1875.[39] Whether the selfish ones were the alcoholics or those who refused to help them and their families remained a critical national question. Artists, such as Steinlen, were pulled in several directions at once and their images while reflecting intense social concern, created an ironic conundrum. They were blaming the poor for being weak while they were, themselves, trying to advocate a strategy that improved the conditions of the country. In the midst, in the center of the debate, were the artists themselves whose own lifestyle—especially in Montmartre—could often give rise to similar concerns about dissipation and degeneration. However, it was a quality that was overlooked as the strategies took on a national, patriotic inflection.

NOTES

1. Louis-Frédéric Sauvage, "L'Oeuvre de Steinlen," *La Nouvelle Revue* 26 (1904): 91.
2. Gabriel Mourey, "Steinlen," *Revue Illustrée,* October 1, 1900, 36–47.
3. Steinlen is quoted in Jean Rollin, "J'ai toujours un carnet dans ma poche," *Le Bel Héritage: Th. A. Steinlen Rétrospective 1885–1922* (Montreuil: Musée de l'Histoire

Vivante, 1987), 83, cited by Oscar Ghez in *Théophile Steinlen (1859–1923)* (Geneva: Musée du Petit Palais, 1993), 2. A comprehensive study on Steinlen's voluminous and varied work has yet to be completed. Important preliminary studies include Philip Dennis Cate and Susan Gill, *Théophile-Alexandre Steinlen* (Salt Lake City: Gibbs M. Smith, Inc., 1982) and Susan Gill, "Théophile Steinlen: A Study of His Graphic Art, 1881–1900" (Ph. D. diss., City University of New York, 1982). See also *catalogue raisonné* that was completed in Steinlen's lifetime: Ernest de Crauzat, *L'Oeuvre gravé et lithographié de Steinlen* (Paris: Société de propagation de livres d'art, 1913). Réjane Bargiel and Christophe Zagrodski recently brought Steinlen's poster oeuvre together in *Steinlen affichiste, catalogue raisonné* (Lausanne: Editions du Grand-Pont, 1986).

4. Marc-Aurèle, "L'Hiver à Paris: Un dispensaire d'enfants à Montmartre," *Le Monde Illustré,* December 20, 1890, 528.

5. Dispensaries often served as social and educational centers for working-class families. For a detailed account of the role and growth of the dispensary phenomenon in fin-de-siècle Paris, see Dr. Paul Traverse, *Etude sur les dispensaires pour enfants malades à Paris* (Paris: G. Carré et C. Naud, 1899). Lenard Berlanstein, *The Working People of Paris, 1871–1914* (Baltimore, MD: Johns Hopkins University Press, 1984), 63. Twenty-four dispensaries were created in Paris between 1887 and 1895, as were eight free hospitals in the Seine Department and a network of dispensaries with hygiene workers where mothers could bring children. "The ideal of teaching working-class mothers, dispelling their customary notions about nursing, and retraining them in sound, scientific methods was an appealing one. They contained soup kitchens, milk giveaways, child-rearing classes, and gave money."

6. Berlanstein, *The Working People of Paris,* 61. The author documents the presence of the workforce in the outskirts of Paris in communities such as Montmartre, as well as those further from the center of Paris. Berlanstein demonstrates that 44 percent of the male workforce by 1910 lived outside of central Paris. Employers drew on the lowest rank of urban or rural society, especially the people who were rural emigrants. There were high levels of unemployment, illiteracy, and contagion in the suburbs. As the author points out on page 61, the spread of tuberculosis was particularly rapid in working-class neighborhoods.

7. The Third Republic was founded at the end of great unrest and devastation caused by the Franco-Prussian War (1870) and the Paris Commune (1870–71). It ended with the dawn of World War II

8. The middle class clearly feared the working class and this was not particular to the late nineteenth century. Louis Chevalier has documented many of the roots of bourgeois attitudes toward the urban poor in *Laboring Classes and Dangerous Classes in Paris during the First Half of the Nineteenth Century* (New York: H. Fertig, 1973). The author discusses bourgeois beliefs that moral inferiority was biological and that the working class was responsible for carrying the cholera epidemic of the 1830s. This demonstrates that Third Republic prejudices toward the working class were nothing new. See ibid., 173.

9. For a stimulating discussion of Victorian female icons and the way they were used to sell the new prepackaged foods, see Lori Anne Loeb, *Consuming Angels* (New York: Oxford University Press, 1994). For more information on political issues surrounding milk, see George Sussman, *Selling Mother's Milk: The Wet Nursing Business in France, 1715–1914* (Urbana: University of Illinois Press, 1982).

10. Annemarie Springer, "Woman in French Fin-de-Siècle Posters" (Ph.D. diss., Indiana University, Bloomington, 1971), 114.

11. Viviana Zelizer, *Pricing the Priceless Child: The Changing Social Value of Children* (New York: Basic Books, 1981).

12. For population statistics of modern France, see Brian R. Mitchell, *European Historical Statistics, 1750–1970* (New York: Macmillan, 1978).

13. Hundreds of documents provide proof that the regeneration phenomenon was real and pressing. Among them is Julien Guillemen, *Protection des enfants du premier âge: dépopulation de la France* (Paris: Giard et Brière, 1901). The excessive mortality rate of newborns was particularly worrisome to regeneration activists. The 1874 Roussel law was one of the first of many passed to protect children. This particular act regulated the entire wet nursing industry. M. Frater, "Hygiène: Les microbes," *L'Enseignement ménager* 1 (August 1904): 93–96.

14. Bruno Latour effectively summarizes the French "hero worship" of Louis Pasteur in *The Pasteurization of France* (Cambridge, MA: Harvard University Press, 1988).

15. For analysis of the bowl and the cats in this image, see Anne Ilan Alter's essay in Philip Dennis Cate, ed., *The Graphic Arts and French Society, 1871–1914* (New Brunswick, NJ: Rutgers University Press, 1988), 55–82.

16. Many valuable studies have been published on the *foyer* as a domestic haven in late nineteenth-century France. Among them is Philippe Meyer, *The Child and the State: The Intervention of the State in Family Life* (New York: Cambridge University Press, 1977), 40. Meyer calls the child an "infant monarch" and later describes how social engineering created a private, artificial environment for the urban family as the family withdrew from the dwelling that was located in the back of a street-based business. Although parks and beaches were popularly promoted as healthy alternatives to the home, Dr. Félix Regnault warned fin-de-siècle parents about the dangers of taking toddlers to the park in "Les Jardins publiques et l'hygiène des enfants," *Le Magasin Pittoresque,* August 1, 1893, 243: "Being outside is fraught with hazards. . . . One speaks often of depopulation and of infant mortality, but one does nothing to diminish it. . . . Public fountains should be condemned and stay out of the parks! The park is full of cigarette butts (full of saliva), dust from the souls of feet, animals leaving unspeakable things. Walkways are contaminated. . . . Amused children will put anything in their mouths. . . . A few days later, baby is sick, then baby dies." Zelizer points out that as children lost access to the outdoors, they gained control of large amounts of interior space.

17. Dr. Fauchon, "La Tuberculose: maladie du peuple," *Le Magasin Pittoresque,* September day?, 1906, 392–394. See important statistics related to children of alcoholics who contracted diseases in "Enfants d'alcooliques," *Revue Encyclopédique* (1897): 371–394. Fauchon blames alcoholism and microbes for a variety of public health problems. He expresses concern about clothes which, he suggests, may also contain microbes and cause illness.

18. Jean-Jules Geoffroy, a prominent academic painter, illustrated an anti-alcohol booklet that was published in 1904. *Histoire d'une bouteille*, with text by Jean-Michel Baudrillard, features before-and-after images of a young male drinker, as well as a series of Geoffroy illustrations, "Alcohol and the Family: A Story in Twelve Images." Scientific literature at the turn of the century often cited alcohol as a problem among men and women, particularly of the working class. Alcohol as a cause of sterility is mentioned in this publication.

19. The National Education Museum in Rouen, France, holds an impressive collection of photographs of schoolrooms (such as one in which a temperance lesson is being taught), as well as a collection of didactic posters used in nineteenth-century classrooms.

20. Camille Mauclair, "Steinlen," *L'Art et les Artistes* 5 (April-September 1907): 300, "Steinlen has remained true in his representations of subjects such as alcoholism."

21. Fauchon, "La Tuberculose: maladie du peuple," 371. The turn-of-the-century author applauded efforts of temperance groups and specifically applauded the efforts of La Ligue nationale contre l'alcoolisme.

22. Société de médecine publique et d'hygiène professionnelle, "Enfants d'alcooliques," *Revue Encyclopédique* 7 (1897): 1048. Libertarian critics likened the hospices to prisons.

23. Dr. René Arrivé, *Influence de l'alcoolisme sur la population* (Paris: Jouve et Boyer, 1899), 42–43. Arrivé was on the medical faculty of the Hospitals of Paris.

24. Fauchon, "La Tuberculose: maladie du peuple," 392–394. Fauchon admits that surmenage results from excess of work, but also from excess pleasure. He quotes another physician, Dr. Landouzy, saying that "alcoholism makes the bed of tuberculosis." Alcohol destroys from the inside out, reasons Fauchon. Habitual usage of alcohol "results in a slow degeneration." On page 393 Fauchon claims that 150,000 children suffered annually from tuberculosis and 100,000 of them were children of alcoholics, pointing out that this would result in over one million deaths in ten years. Articles such as "La Tuberculose: maladie du peuple" in *Le Magasin Pittoresque* (1906) stimulated middle-class prejudices against the proletariat by suggesting that hard labor, poverty, syphilis, and alcoholism were the causes of tuberculosis.

25. "L'Oeuvre accomplie," *Régénération* 10 (January 1902): 4. The editors mention recent publications that quoted their articles, notably "Population and procreative prudence" and "Summaries of neo-Malthusian conferences." While Robin advocates social regeneration they do so only by means of responsible and planned procreation.

26. Champfleury [Jules-François-Félix Husson-Fleury], "Les Enfants, richesse de la maison," *Le Monde Illustré*, November 1, 1871, 274. "Malthus, has he destroyed at once the teachings of the legislators, of the philosophers, of the poets of all times? French depopulation must be attributed to modern luxury, to the desire for quick profits, at the same time as the difficulty of life increases in urban centers." For statistics and analysis of French efforts to control its birth rate, see Angus McLaren, "Abortion in France: Women and the Regulation of Family Size, 1800–1914," *French Historical Studies* 10:3 (Spring 1978): 461–485.

27. Angus McLaren, *Sexuality and Social Order: The Debate over the Fertility of Women and Workers in France, 1770–1920* (New York: Holmes & Meier, 1983), 1. Chapter six of this text is devoted solely to Paul Robin. McLaren points out that Robin also angered socialists by advocating that the state be involved in the sex lives of private citizens.

28. See "Les Préventifs," *Régénération* 10 (March 1902): 2–3. This publication regularly featured messages defending the poor, said to be driven to drink by the burden of poverty (rather than by laziness or heredity as many popular journals claimed). The editors called alcoholic mothers "poor martyrs of the hypocrisy of puritans" (referring to temperance activists).

29. "Puériculture pratique," *Régénération* 10 (March 1902): 3.

30. McLaren, *Sexuality and Social Order*, 3.

31. Paul Strauss, "L'Enfance abandonnée," *La Revue Bleue* 22 (August 1891): 252–254. The Hospice des enfants assistés was run by the bureau designed to provide public assistance for children in the Seine region (Le Service des enfants-assistés de la Seine). *La Revue Bleue* reported that more than ten thousand children had been helped by temporary assistance for children (5,558 by milk distribution and another 5,200 by mercenary wet nurses). In interviews, the personnel of the Bureau of Public Assistance bitterly commented on the ironic situation of the government's encouragement of the birth rate and desire to reduce the number of abandoned children. The implication is that the Bureau of Public Assistance was not addressing the sources of these

problems. For more analysis of efforts to assist disadvantaged children, see Rachel G. Fuchs, "Morality and Poverty: Public Welfare for Mothers in Paris, 1870–1900," *French History* 2:3 (September 1988): 288–311.

32. Paul Gaultier, "La crise de la charité," *La Revue Bleue,* August 5, 1905, 187–191.

33. Jean Grave, "Les Enfants," *La Plume,* May 1, 1893, 209–210. Anarchists also used exploitative images of children suffering to make their point.

34. Camille Mauclair, "Steinlen," *L'Art et les Artistes* 5 (April-September 1907): 209.

35. Dr. A. Richaud, "L'Hospice des incurables à Ivry," *Le Monde Illustré,* September 30, 1899, 266–269. See also André Theuriet's series: "Les Enfants assistés: les bureaux et la crêche," *L'Illustration,* March 25, 1882, 195–199, and 210–213 for a discussion of the Hospice des enfants assistés in Montparnasse. For a social history perspective, see Karen Offen, "Depopulation, Nationalism, and Feminism in Fin-de-Siècle France," *American Historical Review* 89 (1984): 648–676. Jacques Bertillon, physician and chief demographer for the Department of the Seine, founded Alliance nationale pour l'accroissement de la population française and wrote about women's roles in repopulation issues in *La Dépopulation de la France* (Paris: Librairie Félix Alcan, 1911).

36. Guy Tomel, "Les Patronages," *Le Monde Illustré,* March 13, 1897, 168. See also Magdalen, "Les Enfants trouvés," *Le Monde Illustré,* January 30, 1909, 74. Magdalen supplies a brief history of organizations that helped foundling children in Paris from the sixteenth through the nineteenth centuries. The author pays particular homage to Dr. Gaston Variot, a well-known physician who opened in Belleville a dispensary for poor women and children. The article also mentions that each year the city of Paris spent 14,500,000 francs to provide medical care to children in hospices. The article appears to have been written to congratulate public assistance on its work.

37. Adrien Mellion, "Académie des sciences morales et politiques: Comptes rendu de séance," *Revue Encyclopédique* 1 (1891): 1106. The work of politicians, doctors, and the Department of Public Assistance had been celebrated in a separate pavilion dedicated to public assistance at the 1889 Exposition Universelle. It was reported on by Henri Lavedan in "Causerie: A.P.," *Revue Illustrée,* August 15, 1889, 155–156. Interest in documenting this work in the mass media seemed to expand after this landmark display of regeneration propaganda.

38. Champfleury, *Le Monde Illustré,* November 1, 1871, 274.

39. Dr. Dupasquier, *La Vie en famille,* June 30, 1875, 1.

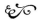
Sacred Tourism
and Secular Pilgrimage

Montmartre and the Basilica of Sacré-Coeur

RAYMOND A. JONAS

The Arrival of the Pilgrim

I have a confession to make. Long before I was the historian of the basilica of Sacré-Coeur, I was a tourist of the Sacré-Coeur. Or was I a pilgrim? Although the distinction seemed clear to me then, on that muggy August afternoon, it no longer seems so now. Let me explain.

It was one of my first visits to Paris. A solicitous friend graciously took me on a tour of historic sites around the city. Montmartre was on our itinerary and we reached it as most tourists do, by leaving the Metro at Anvers, walking northward to the Place Saint Pierre, then ascending the steep stairway to the basilica of Sacré-Coeur, which anchors the Montmartre quartier (Fig. 4.1). As we ascended Montmartre, the form of the basilica and its domes gradually appeared, rising above the crest of the hill, their details taking shape through the brown haze of a Parisian summer day. Toward the top of our climb, we encountered clutches of tourists who had installed themselves on the steps, making the most of the deep August sun. We had to pick our path through the bodies and backpacks and vendors.

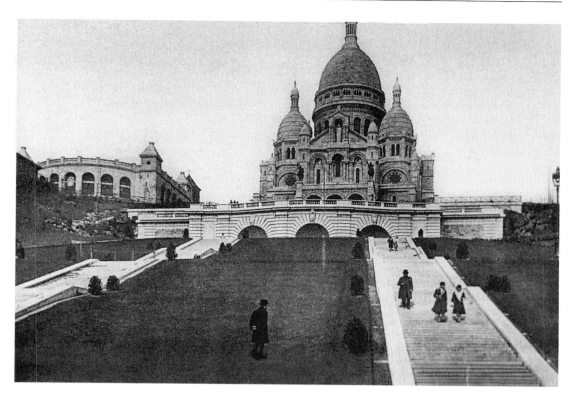

Figure 4.1 Photo postcard of the Sacré-Coeur. Private Collection.

When we reached the basilica my friend stopped and sat down on the steps. I stopped beside him, puzzled. Ours had been no easy ascent, but I could tell that this was not a matter of fatigue. He simply refused to enter. I asked my friend why we weren't going to join the hundreds of tourists milling through the front doors of the basilica. He responded with a brief history of the Sacré-Coeur. I listened attentively. He told me that the revolutionary Commune of Paris had begun on Montmartre in March of 1871 only to be brutally suppressed a few weeks later and the church had been built as a kind of monumental reappropriation of the terrain, the result of a vow taken by a chastened and devout bourgeoisie. My friend's reluctance to enter was a principled statement, a refusal to set foot within a structure that celebrated the defeat of the people of Paris. I admired my friend's moral conviction, but his story only increased my curiosity. With a concerned and earnest tone worthy of the screenplay of an American G.I. movie, I looked reassuringly at my friend then said, "Wait here. I'm going in."

I left Montmartre that day moved by the power of the place and the legends constructed around it. I "made a vow" to return to the basilica and its history.

But when I began work on the project that is now about to become a book, I became convinced that the story that I wanted to tell could not be neatly organized around the basilica of the Sacré-Coeur. It certainly could not be confined to the history of Paris, much less that of the Commune.[1] The basilica could not be understood outside of the context of the devotion to the Sacred Heart of Jesus, itself deeply implicated in the history of modern France.

What had begun as a simple tourist visit had turned into something much more. My friend's attempt to turn our visit to Montmartre into a "teachable moment" raised more questions than it answered and set me off on a journey—not really a pilgrimage, I suppose, although it had some of those searching and contemplative qualities.

Leaving Paris, I learned that the modern devotion to the Sacred Heart began with the visions of a late seventeenth-century nun, a member of the Visitationist Order named Marguerite-Marie Alacoque (Fig. 4.2). Marguerite-Marie experienced visions of the Sacred Heart of Jesus, in which she was told that France was to be consecrated to the Sacred Heart of Jesus, and that France build a church (what would become the Sacré-Coeur de Montmartre) in recognition of the fact.

Leaving Paris, I learned that the emblem of the Sacré-Coeur was the key symbol of counterrevolution during the Revolution of 1789. Wearing the Sacré-Coeur on one's chest protected against harm but also revealed the conviction that the Revolution represented an evil to be combated by force of arms (Fig. 4.3).

Leaving Paris, I also learned that the Sacré-Coeur de Montmartre is but one of several churches built following vows taken during the national crisis of the Franco-Prussian War—better known in France simply as "l'année terrible," the Terrible Year. In the cities of Nantes, Angers, Lyon, Poitiers, and elsewhere, vows were taken to the Sacré-Coeur and churches dedicated to the Sacré-Coeur went up in the 1870s, 1880s, and 1890s, just as the basilica of Sacré-Coeur was being constructed on Montmartre.[2]

I returned to Paris with a deeper understanding of the Sacré-Coeur de Montmartre as the central node in a network of sites and memories constructed across France and on the theme of French identity. What these sites had in common was a vision of French decline following the French Revolution—a decline amply demonstrated, it was held, by the twin tragedies of defeat in the Franco-Prussian War and the bloody civil war known as the Paris Commune. A return to Moral Order became a central theme in the public culture of France in the early 1870s and the Sacré-Coeur of Montmartre would be one of its monuments. The Sacré-Coeur de Montmartre, far from being reduced to a commentary on

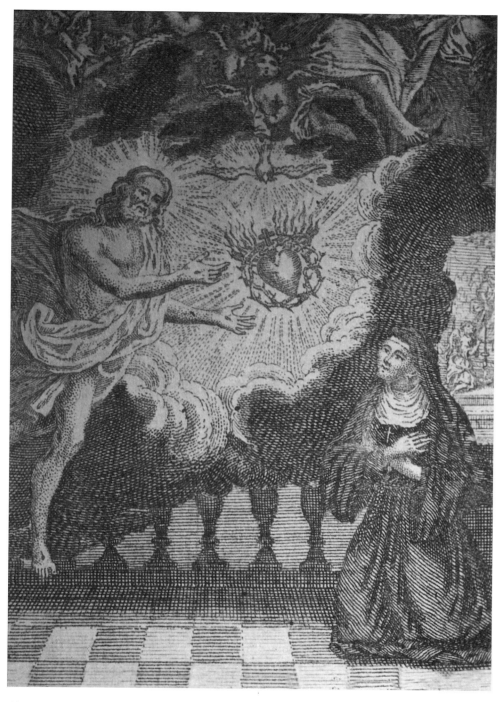

Figure 4.2 The Sacred Heart appears to Marguerite-Marie Alacoque.
From *Instructions, pratiques, et prières pour la dévotion au Sacré-Coeur
de Jésus, l'office, vespres et messe de cette dévotion,*1752.

Figure 4.3 Pierre-Narcisse Guérin, *Henri de La Rochejaquelein*, 1817. Oil on canvas, detail. Musée des Beaux-Arts, Cholet.

the Paris Commune, nevertheless embodied a critical and counterrevolutionary message about France and its past.

But that is not my main message. What I'd like to emphasize are the modernist impulses and techniques driving the construction of the Sacré-Coeur, and the adaptation of the basic features of modern tourism to the ancient practice of pilgrimage.

Montmartre as a Pilgrimage Site

The basilica of Sacré-Coeur was destined to be a site of pilgrimage. When Joseph Guibert assumed his responsibilities as archbishop of Paris, the church that would become the Sacré-Coeur de Montmartre was not among his primary concerns. His immediate predecessor, Georges Darboy, had died a violent death as hostage of the Paris Commune. Indeed his three immediate predecessors, Darboy, Sibour, and Affre, had each died violent deaths in the city of Paris. Sibour was a stabbing victim in the 1860s. Affre died on the barricades of June 1848; he was shot when he attempted to intervene as peacemaker. The evidence was plain enough to Guibert (Fig. 4.4). As the city of Paris had grown, the diocese had failed in its pastoral mission to the new population, especially the working classes of the city of Paris. It was time to correct this error by building parish churches in the new neighborhoods and working-class suburbs of Paris.[3]

But Guibert also was a builder on a monumental scale. In his prior tenure as bishop of Tours, he had undertaken a massive project to rebuild the church of Saint Martin of Tours, the patron saint of France.[4] Moreover, he had successfully exploited the idea of rebuilding this church as a metaphor for the moral reconstruction of France. And he had used the site to revive the practice of pilgrimage in Tours and beyond. Pilgrimage, he understood, was a way to mobilize people in large numbers and thus, by their very numbers, impart value and meaning to the shrines they visited.[5]

A man of such imagination and ambition, once elevated to the position of Archbishop of Paris, would hardly limit himself to the construction of parish churches. When lay sponsors of the Sacré-Coeur church approached him with the proposal to build a church as a symbol of national atonement, Guibert hesitated. His indifference, however, was feigned. He wanted to test the resolve of the project's lay sponsors before committing himself and the prestige of his office to the unprecedented task of building a national monumental church in the city of Paris. "I'll think about it," he promised. "Form a committee of twelve, like the Apostles, and come and see me in a few days."[6]

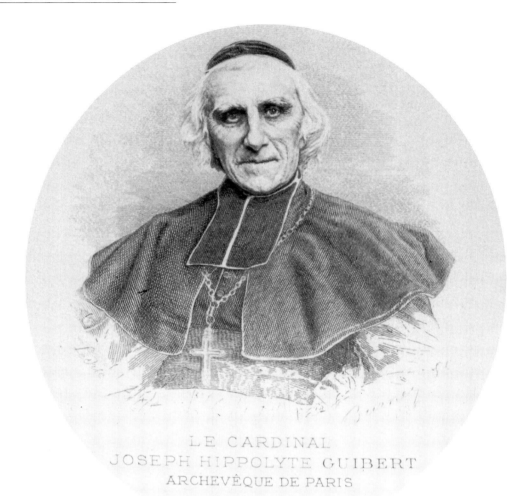

Figure 4.4 Joseph Hippolyte Guibert, Archbishop of Paris, patron of the
Sacré-Coeur de Montmartre. From J. Paguelle de Follenay,
Vie du cardinal Guibert, archevêque de Paris, 1896.

Guibert knew that siting this church of national atonement would greatly
determine its significance as a symbol and its potential as a pilgrimage shrine.
The site for the monumental church remained unspecified, however, and Guibert
entertained a number of proposals before settling on the choice of Montmartre.
Some proposed a site near the center of the city, along the rue de Rivoli; while
others promoted the high ground of the Trocadero. Still others relished the sym-
bolic justice of converting Charles Garnier's still-unfinished Opéra to sacred pur-

poses. The ornate, eclectic, extravagant opera perfectly expressed the unabashed self-indulgence of the Second Empire. What better way to mark the triumph of Moral Order than by making this temple of pleasure into a temple to a just but forgiving God?

The choice of Montmartre was Guibert's and he made the decision during a pastoral visit to the parish church of Saint-Pierre de Montmartre. He was already familiar with Montmartre's reputation as a fiercely independent community with an irreligious bohemian ethos. He also knew that the site had figured prominently in the history of the Parisian revolt of 1871 known as the Paris Commune. Supporters of an independent Paris (the "Commune") had hauled dozens of artillery pieces to Montmartre for safekeeping. When the national French government sent troops to Montmartre to secure the cannon and, in effect, secure the restive city of Paris, it provoked a riot that became the revolutionary Commune. Montmartre, better than any other site, evoked the very ideas—disorder, irreligion, decadence—that Guibert's Sacré-Coeur aimed to combat. But what clinched Guibert's decision was the dialogic potential of this singular site. Montmartre is the strategic high ground in the Paris basin but, during his visit there, as he gazed down from Montmartre a thick fog concealed the city. Then, as the story goes, the fog began to lift and the city came into view. Guibert could see as well as imagine the dialogic relationship between his expiatory monument and the city below. The church of the Sacré-Coeur would address Paris from the high ground above Montmartre.

Pilgrimage as a Form of Collective Action

Ever since the 1970s and 1980s, when the great wave of social history washed over the historical profession, we have been conditioned to think of the working class whenever we imagine the great social movements of nineteenth-century France. In fact, the collective action of the French working class dwarfs in comparison to the collective action of French Catholics. Led by an episcopate determined to revitalize a flagging post-revolutionary faith, Catholics in France participated in a reinvention of the ancient practice of pilgrimage.

Pilgrimage in its medieval form was largely an individual enterprise, part of an ongoing economy of sin, forgiveness, and grace. Individual sinners made pilgrimage journeys to destinations local and remote, in order to remove the stain of sin and to restore their status in the community of believers. During the Revolution, penitential practices of all kinds went underground, but in the processions of expiation held under Restoration, one can discern the revival of pilgrimage

in a new, collective form. The period of the Second Empire was a time of extraordinary development in pilgrimage shrines, largely because of the visions of devout children. The visions experienced by children at La Salette and Lourdes in the 1850s initiated pilgrimages that would build in the 1860s and 1870s into movements truly national in scale.[7]

Pilgrimage as a mass phenomenon depended ultimately, however, upon the development of the transportation technology of the railroad before it could fulfill its promise as a form of collective action. And it required the national penitential mood generated by the Terrible Year of 1870–71 to give pilgrimage on a large scale the politically critical dimension it would acquire. Emmanuel d'Alzon had founded the Assumptionist order in 1845, but the order's most characteristic work came in the early 1870s, when it organized pilgrimages on a large scale in the name of national and social regeneration in the aftermath of the Franco-Prussian War and the Commune. Pilgrimage organizers negotiated group rates on railroad tickets, in some cases taking over entire groups of railroad cars, in order to facilitate pilgrimage as a collective act. Pilgrimages to La Salette, Rome, and Lourdes (Fig. 4.5) in 1872, 1873, and 1874—one of which numbered over forty thousand pilgrims—set the tone for an era.[8] In the modern age, faith would be ostensible, demonstrative, and implicitly critical of a secularized public culture.[9]

Emile Zola, in his novel entitled simply *Lourdes*, describes compellingly the power and scale of these mechanized pilgrimages of the rails. In a powerful passage whose rhythm matches those of the trains, he describes the convergence of trains from all over France at the grotto of Lourdes.[10] And although Zola had great respect for the pilgrims themselves, he could not fail to note the political ambitions of some of their number. Nor could contemporaries, who noted that pilgrims voyaging to shrines or returning from them often manifested overtly political intentions. Pilgrims on a rail car pulling away from the station at Béziers in October 1873 alarmed local authorities by shaking white handkerchiefs (white being the color of the exiled Bourbon dynasty) and singing, "Give us a king in the name of the Sacré-Coeur!"[11] Pilgrims returning to Nantes and Blois wore emblems of the Sacred Heart—a counterrevolutionary sign in France—on their lapels as they left train stations en masse.[12] These were pilgrimages that blended into royalist political demonstrations.

Unlike workers, whose communities and places of work both defined them and served as the locus for their collective action, Catholics were a virtual community defined by belief rather than class and habitat. They constituted a body of believers living apart from one another. Catholics in France felt increasingly

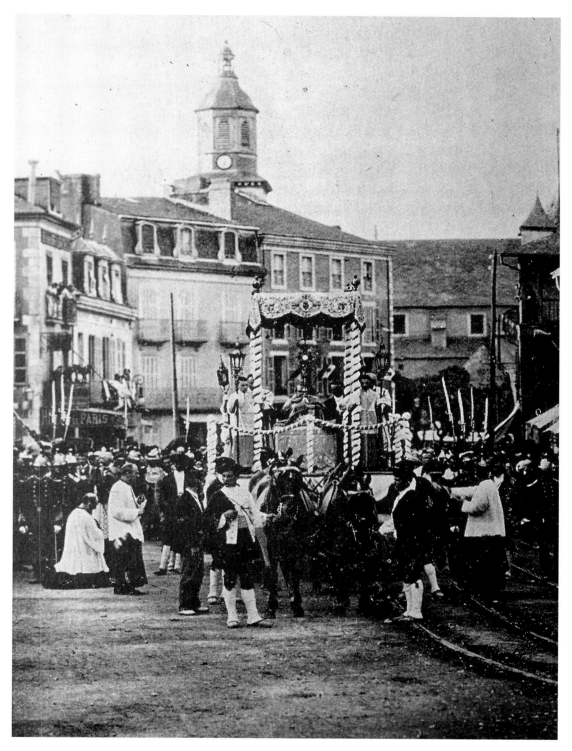

Figure 4.5 Pilgrimage at Lourdes. From P. E. Galtier, *Les Congrès eucharistiques*, 1910.

embattled as the century progressed. They could make their numbers felt only when they gathered together for rituals and at shrines. Pilgrimage fit the bill perfectly. By the 1870s, no one—not the trade unions, not the major political parties—could put more people in the streets of the Republic than the Catholic hierarchy. Pilgrimages became penitential plebiscites and public demonstrations on the moral status of France. Shrines provided the destination, railroads brought them together, and their collective conduct confirmed their status as a meaningful and integrated constituency within France.

Montmartre was also to be a site of such experiments in the possibilities offered by modern transportation and ancient ritual. Prior to the Second Empire, Montmartre had stood apart from the city of Paris.[13] In fact, until its incorporation into the city in the 1860s, it drew every advantage from its situation beyond the tax walls of the city of Paris. Visitors to Montmartre could enjoy drink without the tax built into the price and the local economy thrived on its status as a kind of drinkers' duty-free zone. Entertainment grew up around and within drinking establishments. Add to this the fact that Montmartre offered some of the cheapest housing available in the Paris basin, and one can see why this quarter rapidly became the destination of choice for those willing to live or even just pass a few hours beyond the margins of Parisian life. Little wonder, then, that Montmartre soon acquired its bohemian reputation. From Hector Berlioz in the 1830s to Camille Pissarro, Auguste Renoir, Claude Monet, and Théophile Steinlen two generations later, Montmartre felt comfortable to those most at home on the fringes of conventional society.

With its selection as the site for the new church of the Sacré-Coeur, Montmartre became the locus not only of one of the most important construction projects of late nineteenth-century France, it also became the locus of an ongoing dialogue between the publicly sacred and the outrageously profane. That the Sacré-Coeur would be a pilgrim's church was never in doubt, from the wide aisles the architect Paul Abadie designed for it, to the fact that pilgrimages began almost immediately after the site was chosen, more than a decade before the church itself had assumed anything like a recognizable shape. Archbishop Guibert ordered the construction of a temporary chapel, in order to habituate the faithful to the idea of Montmartre as a pilgrimage site, and to begin the penitential practices deemed necessary for the regeneration of France. This temporary chapel, or "chapelle provisoire" as it was known, was capable of accommodating hundreds of pilgrims at a time.

Contemporary prints reveal this chapel to be a rather spare, wooden structure, as befits its purpose as a temporary building. Unlike other pilgrimage

shrines, it lacked a distinctive natural feature—a grotto, a stony promontory—to set it apart. Indeed, people didn't go there to be healed; they went there to be part of a collective penitential experience truly national in scope. The central experience for the pilgrim to Montmartre was not the immersion or the healing touch, but a sermon about France's catastrophic fall from grace. The Sacré-Coeur de Montmartre was about God's immanence in history.

The pilgrimage to Montmartre also typically featured a visit to the construction site, where pilgrims could observe the progress of the national shrine. There they would hear of how Archbishop Guibert had nearly felt obliged to abandon the location when he learned that mining the Montmartre hill over the years had left the area unstable. Only the setting down of over eighty pilings, each one hundred feet tall, had saved the site for the project (Fig. 4.6). Thus the engineering marvel of a church built on stilts added to the marvel of a church symbolizing national religious renewal. This was a church for the ages.

Figure 4.6 The crypt beneath the dome of the Sacré-Coeur, 1888.
Archives Historiques du diocèse de Paris.

Such visits typically also featured a procession, in which men and women circulated around the foundation, separated by gender with men following women, bearing colorful banners and singing songs on the theme of France and the Sacré-Coeur. "Save Rome and France in the name of the Sacré-Coeur!" was the refrain of one of the most common songs. Workers at the site would pause in their labors as the procession passed by.

Tokens to Leave; Memories to Go

From the very beginning, the builders of the Sacré-Coeur imagined that pilgrimage would have a place in fixing the meaning of the site and the structure on Montmartre.[14] But they also imagined that pilgrimage would advance the project in more tangible ways, too. As a national project, it was important for the organizers to solicit—and be seen to solicit—funds from all over France. Their monthly bulletin, the *Bulletin du Voeu National*, did just that. They also went out of their way to make pilgrimage a national experience, by promoting pilgrimages to Paris and Montmartre from all over France. With the temporary chapel, and the organized processions and site visits, pilgrims were given an experience of Montmartre that would make them feel part of a project larger than themselves.

By participating in a penitential pilgrimage, they were told, they participated in a project of national spiritual renewal. Once on the site, they were encouraged to donate money to the construction of a church that would give tangible evidence of that renewal. The association was a compelling one. Within five years of the laying of the first stone of the Sacré-Coeur, the donations of pilgrims outstripped all other sources of income for the project. Donations varied, but pilgrims donated between 600,000 and 1.5 million francs per year at the Montmartre site.[15]

Much of the appeal of donation to the project had to do with the long-standing pilgrimage practice of the ex-voto. Pilgrimage is about a voyage, a journey, often in fulfillment of a promise. Arrival thus is a special moment, but there comes a time to leave and the pilgrim historically has given in to the desire to leave something behind as a sign of faith and as a token of a vow accomplished— hence, the ex-voto. Ex-votos typically took the form of religious symbols, prayer cards, or personalized marble plaques. Project organizers for the Sacré-Coeur adapted this practice to the larger purpose of erecting the church. They urged pilgrims to leave an ex-voto in the form of a piece of the very building. Pilgrims could "purchase" a personalized stone with their initials engraved for as little as 100 francs (Fig. 4.7). Wealthier donors could purchase more costly pieces of the

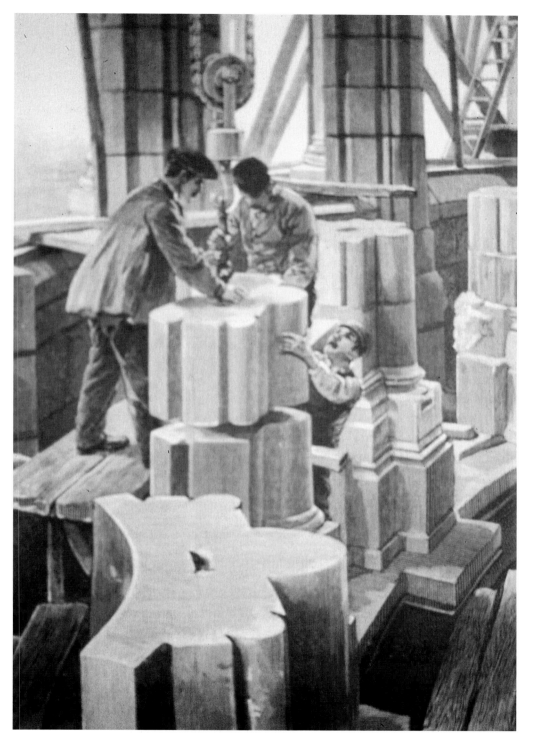

Figure 4.7 The construction of the dome of the Sacré-Coeur, ca. 1894.
Archives Historiques du diocèse de Paris.

church. Pilgrims to Montmartre thus left behind ex-votos as enduring as the structure itself—as if their wishes were incorporated within it.

Pilgrims also typically wish to take something away and here, too, the Sacré-Coeur of Montmartre offered significant innovations. Religious articles of all kinds—prayer cards, necklaces, medals—these made up the inventory of the vendors on site and in the Montmartre neighborhood. In effect, the Montmartre experience was a total experience. From the time they left their parishes and dioceses in provincial France until the moment of their return, every effort was made to make their journey a complete experience. Pilgrims became the object of some of the most innovative and modern techniques of organized tourism and fundraising, including group fares, guided tours, naming opportunities, and souvenir sales.

Pilgrimage as a Form of Leisure

Even though pilgrimage to Montmartre had all of the requisite features of holy pilgrimage, it also blended into a recognizably modern form of organized leisure.[16] This is already evident in the careful management of the pilgrimage experience; indeed, parish clergy typically assumed the role of tour promoter and organizer. They also accompanied their parishioners on their pilgrimage, making parish priests among the first official tourist guides. But the blending of pilgrimage and tourism was also an inevitable consequence of location. Pilgrimage to La Salette or Lourdes, however enjoyable, is unmistakably an excursion organized around a religious destination. No such claim could be made for a pilgrimage to the Sacré-Coeur of Montmartre. However devoted, however well intentioned, pilgrims to the Sacré-Coeur could not have failed to notice the extraordinary appeal of the great city below.

That the Great Babylon of Paris offered certain attractions could not be denied. That pilgrims took advantage of their journey to sample the delights of the city is strongly suggested by the seasonal rhythm of the pilgrims themselves. Pilgrimage is a year round activity—or at least it can be. In fact, in the case of pilgrimage to the Sacré-Coeur, it was overwhelmingly a fair weather activity.[17] No figures were kept on the number of pilgrims, but detailed figures on donations were; inferences about the seasonality of pilgrims from the seasonality of donations shows that the most popular months were June, July, and August.

Moreover, the concurrence of pilgrimage with certain major events confirms the point. Easily the most popular year for pilgrimage to the Sacré-Coeur was 1889, the year of the universal exposition to celebrate the centenary of the Rev-

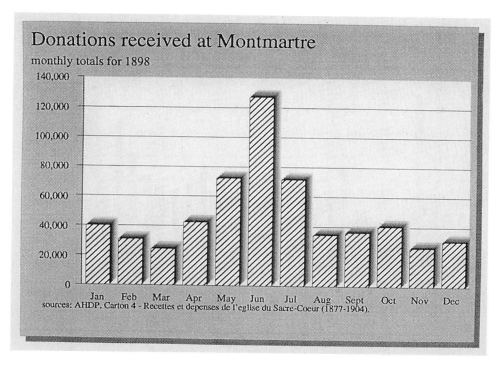

Figure 4.8 Donations received at Montmartre, monthly totals for 1898.
Archives Historiques du diocèse de Paris.

olution of 1789 (Fig. 4.8). It must have made their guides wince, but what could they do when, after hearing sermons on the decline of France after 1789, pilgrims descended Montmartre and made their way to the Champ de Mars to inspect the Eiffel Tower and gape in amazement at marvels of the modern age?

Contesting the Sacred: Tensions between Montmartre and the Sponsors of the Sacré-Coeur

Despite the growing presence of pilgrims to the Sacré-Coeur, or perhaps because of it, relations between the community of Montmartre and the community of the Sacré-Coeur remained conflicted. After all, these were vastly different communities—one devout, prayerful, and convinced of the inexorable decline of France save some dramatic intervention; the other largely secularized and suspicious of authority of all kinds.

Speakers in debates in the National Assembly repeatedly invoked the contrast between the bohemian and anarchic spirit of Montmartre and the spirit of

the project of the Sacré-Coeur. The first serious legislative attempt to halt construction took place in 1881, when republican politicians challenged the decree of eminent domain that had made forcible purchase of the site possible. One speaker deemed the structure a "provocation." "Eh bien," he said, "it's a citadel of superstition. . . . The nature of the establishment under construction at Montmartre . . . is in direct contradiction with the spirit of the population."[18] A similar point was raised by none other than Georges Clémenceau who, as former mayor of Montmartre, knew the neighborhood and community well. In the National Assembly debates of 1882 aimed at halting the project, Deputy Clémenceau protested the structure, noting that it signified "an obligation to ask forgiveness for having fought, as we still fight, for the rights of man—to repent for having made the French Revolution!"[19]

To such challenges, the most effective replies were not political but economic. René Goblet, minister of the interior, simply pointed out that sponsors of the project had already expended between 12 and 15 million francs—well over a million francs a year.[20] Quite simply, these expenditures meant income and jobs for the people of Montmartre. Ever since the crash of 1874, the French and European economies had been mired in a period of economic stagnation and high unemployment that would last until the 1890s and would be known as the European "Long Depression." No politician, confronted with the expenditure figures for the Sacré-Coeur, could confidently propose shutting down the Montmartre worksite on which so many depended. If neither faith nor love nor mutual admiration could unite Montmartre and the Sacré-Coeur, self-interest would.

As the odd, domed profile of the Sacré-Coeur rose over the summit of Montmartre, republican deputies made at least two other attempts to halt the project.[21] On these occasions, too, the challenges faded away as defenders of the Sacré-Coeur added up the figures and showed how much the structure meant to Montmartre and the working people of Paris. By the time the church was completed on the eve of the First World War, some 40 million francs had been expended on it. Like most construction projects of an unprecedented or monumental scale, the Sacré-Coeur was years late and millions over budget, but those years transformed the face of what some fondly remembered as the independent municipality of Montmartre.

And, of course, 40 million was only the nominal figure representing direct investments. Few were ignorant of the fact that for every franc going into the construction of the Sacré-Coeur, many more were left behind by pilgrims to the temporary chapel and to the construction site. It's worth pointing out in this

regard that the 1880s were also the period in which Montmartre developed into a center of commercial entertainment, from the opening of the Chat Noir café-concert in 1881, to Aristide Bruant's Mirliton (1885), to the Moulin Rouge itself (1889)—not that there was any great overlap in clientele with the Sacré-Coeur![22] The point is this: whether dining in bistros and restaurants, drinking in cafés or *estaminets,* buying religious objects or secular art, the thousands of pilgrims who visited Montmartre were tourists like any other, subject to the whims, appetites, desires, needs, anxieties, and longings of any other out-of-towner. The Sacré-Coeur might look as though it had been parachuted into Montmartre. Not only for its exotic architecture but also for its exotic ideology, the Sacré-Coeur truly was an alien object. But that alien object so animated local activity that, over time, Montmartre came to depend upon the Sacré-Coeur as much as the Sacré-Coeur depended upon it.

Tensions between these two communities were inevitable, especially as the scaffolding went up for the Sacré-Coeur, changing the visual profile of the Montmartre butte. But the arrival of hundreds of pilgrims also changed the social and ideological profile of Montmartre. For some, the affront to Montmartre's independent and bohemian spirit was too much. Steinlen, a denizen of Montmartre whose work is featured in this book, made his sentiments clear by drawing an illustration of an imagined revolutionary assault on the Sacré-Coeur (Fig. 4.9).

Willette and Steinlen were not alone. Montmartre has produced more than its share of gadflies and outspoken figures over the years. Most of them were enemies of the project of the Sacré-Coeur. Gustave Téry was among the more notable of these gadflies and he used every means at his disposal to confront the sponsors of the Sacré-Coeur. Téry was a classic radical republican firebrand of the early Third Republic. All the markers are there: former student at the Ecole Normale Supérieure, lycée professor of philosophy, freethinker, anti-capitalist, anti-clerical, and anti-alcohol. In 1901, Téry wrote a lengthy letter to the prime minister of the French Republic on behalf of himself and his Montmartre neighbors. Téry's letter emphasized what we today would call the seismic hazards represented by the Sacré-Coeur. Everyone knew that Montmartre had literally been undermined over the years. Now the sheer weight of the structure, Téry argued, was making Montmartre unstable. The whole structure threatened to slide and collapse on the people of Montmartre. He cited as evidence the fact that cracks appeared in the paving here and there; that despite every attention lavished on them, young trees refused to grow. They merely withered in the unstable soil. Even worse, a lovely clump of irises planted along the rue Ronsard had shifted by "more than a meter."[23]

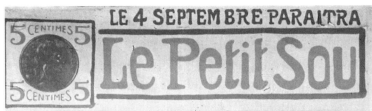

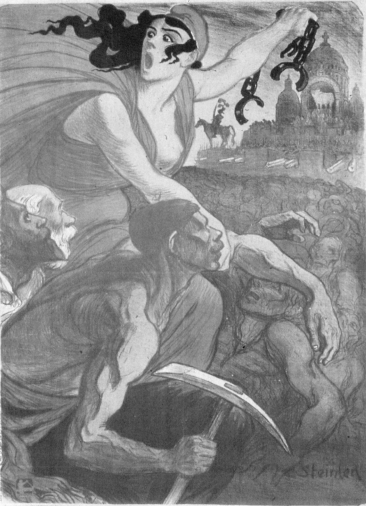

Figure 4.9

Théophile-Alexandre
Steinlen, (Assault on
the Sacré-Coeur),
Le Petit Sou, 1899.
Color lithograph.
Musée de l'Affiche
et de la Publicité, Paris.

Not content to write cranky letters, Téry decided to go undercover. He posed as a devout Catholic and volunteered for participation in nocturnal prayer at the basilica. He then published a small book recounting his experience, in which he described the prayers, canticles, and rituals he observed.[24] During his night of feigned prayer, he noted among the names etched in the stones of the basilica that of the famous liqueur-producing family Noilly-Prat. This put him in a conspiratorial frame of mind and led him to speculate on the similarities between the stultifying effects of liquor and what he regarded as the stultifying effects of religion. He concluded his book with the suggestion that the Sacré-Coeur be muncipalized and converted into a recreational facility, a Maison du Peuple (Fig. 4.10). The nave would be converted into a theater with seating for over a thousand. Chapels along the side aisles would be converted into classrooms. Utility rooms would be remodeled to serve as day-care centers, exercise rooms, baths, and classrooms for learning the art of fencing. Religious art, of course, would be stripped from the basilica, while a monumental figure of Marianne would be placed atop the central dome of the Sacré-Coeur, gazing serenely out toward the city below (Fig. 4.11).

Téry never got his wish to turn the Sacré-Coeur into a community center for Montmartre. This idea failed as had an earlier proposal, fully in the anarchic spirit of secular Montmartre, to turn the basilica into a four-star hotel . . . under the name of the Grand Hôtel du Sacré-Coeur.[25] Although Téry's outrageous schemes never came to fruition, they came close. Support for the separation of Church and State in France grew markedly toward the end of the nineteenth century. The bitterly cold civil war known as the Dreyfus Affair drove public opinion toward the defense of the Republic and the definitive separation of Church and State. The radical republican majority elected in 1902 thrived on the anti-clericalism fueled by the conduct of the Catholic clergy and press during the Affair. The separation of Church and State was voted in 1905.[26]

Its most striking consequence was the seizure and municipalization of churches. At a stroke, the basilica of Sacré-Coeur became the property of the city of Paris. The archdiocese of Paris resisted, claiming that the basilica was not the property of the Church as an institution but the personal property of the archbishop of Paris and his successors; a court decision in 1908 confirmed the transfer of title to the city.[27] The penitential monument was delivered into the hands of the leaders of the new Babylon. Donations to the still-unfinished structure continued, though at a diminished rate. Pilgrimages continued unabated.

But another kind of visit soon surpassed those of pilgrims. In his book on the Montmartre of pleasure and crime, Louis Chevalier describes an episode

Figure 4.10 *The Sacré-Coeur Converted into a House of the People.* From Gustave Téry, *Les Cordicoles*, 1902.

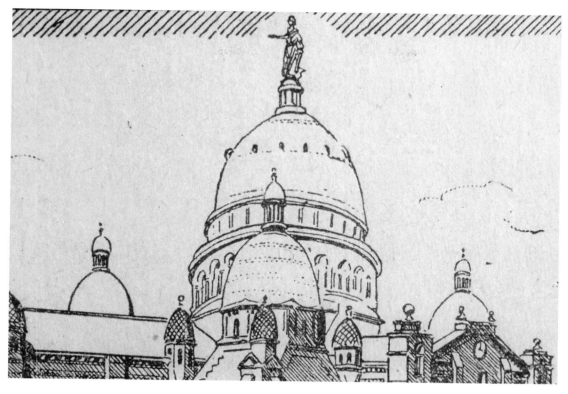

Figure 4.11 *Marianne Atop the Dome of the Sacré-Coeur.* From Gustave Téry,
Les Cordicoles, 1902.

that occurred when he was showing an American friend around Paris and
Montmartre. Toward the end of his stay, the American visitor asked why they
hadn't yet visited the Sacré-Coeur. Chevalier had to admit that "ordinarily,
that's where one begins," adding that Montmartre really has two holy places—
the Sacré-Coeur . . . and the Moulin Rouge.[28] Chevalier and his American visitor
approached the Sacré-Coeur much as my friend and I did on that hot August
afternoon. We are drawn by the exoticism of the Sacré-Coeur and its Oriental
otherness, and we are both fascinated and repelled by what we think it means.

But pilgrims and other tourists have a somewhat different experience. In
effect, the exotic Romano-Byzantine edifice now serves Montmartre as its sig-
nature structure, beckoning to visitors from across the city. They admire the
same view of Paris that Guibert admired and enter the basilica with a mix of
anticipation and awe, as if entering a ride at a theme park. After shuffling
uncomprehendingly through the church, they exit to wander around the Place
du Tertre (Fig. 4.12), buy something to take with them, and descend the hill. As

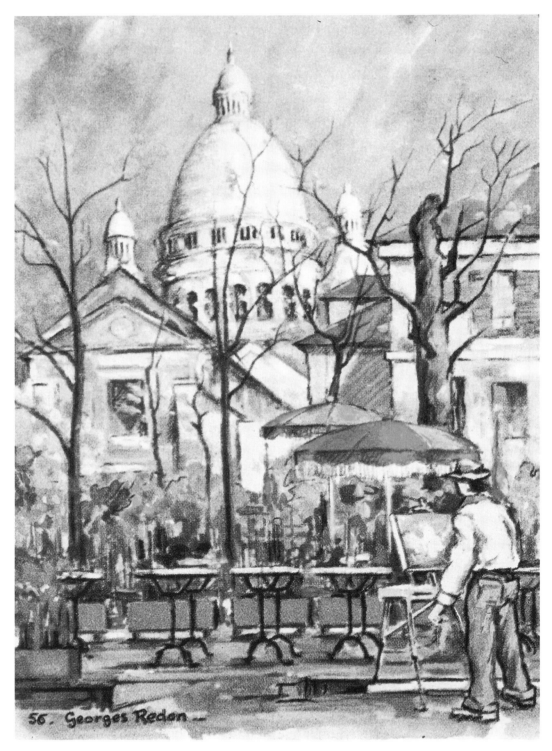

Figure 4.12 Georges Redon, *Place du Tertre, Montmartre*, ca. 1960. RATP Plan.
Private Collection.

one of the top five destinations in the combination museum/city/theme resort that Paris has become, the Sacré-Coeur does for Montmartre what the anchor store does for the shopping mall—it lures visitors, who subsequently find themselves drawn to smaller, incidental pleasures. From the Moulin Rouge to the Lapin Agile, Montmartre thrives in the shadow of the Sacré-Coeur. There, the sober faith of the earnest pilgrim hesitates, then gives in to the pleasures of food and color, music and dance.

NOTES

1. This story has been told and retold in the literature, too, most recently in David Harvey, "Monument and Myth: The Building of the Basilica of the Sacred Heart," in *Consciousness and the Urban Experience: Studies in the History and the Theory of Capitalist Urbanization,* ed. David Harvey (Baltimore: Johns Hopkins University Press, 1985).
2. Raymond Jonas, "Anxiety, Identity, and the Displacement of Violence during the "année terrible": The Sacred Heart and the Diocese of Nantes, 1870–1871," *French Historical Studies* 21 (Winter 1998): 55–75; Raymond Jonas, "L'Année Terrible, 1870–1871," in *Le Sacré-Coeur de Montmartre; Un Voeu National,* ed. Jacques Benoist (Paris: Délégation à l'action artistique de la Ville de Paris, 1995), 31–41; Raymond Jonas, *France and the Cult of the Sacred Heart: An Epic Tale for Modern Times* (Berkeley and Los Angeles: University of California Press, 2000).
3. For Guibert and his predecessors, see J. A. Foulon [Monsignor, Archevêque de Lyon], *Histoire de la vie et des oeuvres de Mgr. Darboy, archevêque de Paris* (Paris: C. Poussielgue, 1889); J. Paguelle de Follenay [abbé], *Vie du cardinal Guibert, archevêque de Paris,* 2 vols. (Paris: C. Poussielgue, 1896).
4. See Archives Diocésaines d'Angers, Pèlerinages, 2K9, "Circulaire de l'Archevêque de Tours aux Religieux et Religieuses de France leur demandant une participation financière en faveur de la basilique de St-Martin-de-Tours," 1863.
5. John Eade and Michael J. Sallnow, eds., *Contesting the Sacred: The Anthropology of Christian Pilgrimage* (London and New York: Routledge, 1991); Sabine MacCormack, "Loca Sancta: The Organization of Sacred Topography in Late Antiquity," in *The Blessings of Pilgrimage,* ed. Robert Osterhout (Urbana: University of Illinois Press, 1990); Mary Nolan Lee and Sidney Nolan, *Christian Pilgrimage in Modern Western Europe* (Chapel Hill: University of North Carolina Press, 1989); Victor Turner, *Image and Pilgrimage in Christian Culture: Anthropological Perspectives* (New York: Columbia University Press, 1978); Victor Turner, "Pilgrimages as Social Processes," in *Dramas, Fields and Metaphors; Symbolic Action in Human Society,* ed. Victor Turner (Ithaca, NY: Cornell University Press, 1974); Pierre Pierrard, "La Renaissance des pèlerinages au XIXe siècle," in *Les Chemins de Dieu; histoire des pèlerinages chrétiens des origines à nos jours,* ed. Jean Chelini (Paris: Hachette, 1982), 295–343; Alphonse Dupront, *Du Sacré; croisades et pèlerinages, Images et langages* (Paris: Gallimard, 1987); Alphonse Dupront, "Pèlerinages et lieux sacrés," in *Méthodologie de l'Histoire et des sciences humaines,* by Raymond Aron et al. (Toulouse: Privat, 1973); Jeannette de Saint-Montan, *Nos pèlerinages en 1900, 15 août-19 octobre; souvenirs, lettres intimes* (Balan-Sedan: Imprimerie du Patronnage, 1901); Pierre-André Sigal, *Les Marcheurs de Dieu; pèlerinages et pèlerins au Moyen Age* (Paris: A. Colin, 1974).
6. Auguste Hamon [S.J.], *Histoire de la dévotion au sacré-coeur de Jésus,* 5 vols. (Paris: Gabriel Beauchesne, 1923–1939), 5:50.

7. On La Salette see Jean Stern, *La Salette; documents authentiques: dossier chronologique intégral: le procès de l'apparition, fin mars 1847-avril 1849* (Paris: Les Editions du Cerf, 1984), esp. 69–70.

8. Alfred Baudrillart [Mgr.], *Dictionnaire d'histoire et de géographie ecclésiastiques* (Paris: Letouzey et Ané, 1930), 4:1135–1138; Adrien Dansette, *Histoire religieuse de la France contemporaine: l'Eglise catholique dans le mêlée politique et sociale* (Paris: Flammarion, 1965), 443; Philippe Boutry and Michel Cinquin, *Deux pèlerinages au XIXe siècle, Ars et Paray-le-Monial* (Paris: Beauchesne, 1980), 182.

9. The rapid growth of the pilgrimage phenomenon following the defeat of 1870 can be traced in the pages of *Le Pèlerin*, a weekly launched in the aftermath of 1870–71.

10. Emile Zola, *Lourdes,* trans. Alfred Vizetelly (Dover, N.H.: A. Sutton, 1993), 17.

11. Archives nationales (henceforth AN) F19 5562 Pèlerinages, unsigned memo, dated 9 October 1873, apparently sent by the Prefect of the Hérault to the Minister of the Interior.

12. AN F19 5562, pèlerinages, copie d'une lettre de M. le préfet du Loir-et-Cher en date du 9 septembre 1873.

13. For Montmartre, see Jean-Paul Crespelle, *La Vie quotidienne à Montmartre au temps de Picasso, 1900–1910* (Paris: Hachette, 1978), Pierre Laligant [Abbé], *Montmartre. La Basilique du Voeu national du Sacré Coeur* (Grenoble: B. Arthaud, 1933), Paul Lesourd, *Montmartre* (Paris: Editions France-Empire, 1973). Charles Rearick's work on the Belle Epoque frequently touches on Montmartre. See Charles Rearick, *Pleasures of the Belle Epoque; Entertainment and Festivity in Turn-of-the-Century France* (New Haven, CT: Yale University Press, 1985).

14. Sermons and devotional literature served to clarify the pilgrimage experience. See, for example, Anonymous, *Faisons pénitence pour le salut de la France* (Paris, 1903); Anonymous, *Souvenirs du sacré-coeur de Paris*, (Tours, 1878); Anonymous, *Guide officiel du pèlerin au sacré-coeur de Montmartre* (Paris, 1892). Sermons were occasionally excerpted in the *Bulletin du Voeu National.*

15. *Bulletin du Voeu National* 7 (1882):19; *Bulletin* 12 (1887):34; *Bulletin* 10 (1885):315–317; Archives historiques du diocèse de Paris (AHDP), basilique du Sacré-Coeur, carton 4.

16. The existing literature in French on leisure says virtually nothing about the relation between pilgrimage and organized experiences of leisure. See Alain Corbin, *L'avènement des loisirs, 1850–1960* (Toulouse: Privat, 1995); Georges Hourdin, *Une civilisation des loisirs* (Paris: Calmann-Lévy, 1961); Jean Fourastié, *Des loisirs, pourquoi faire?* (Paris, 1977).

17. Thus confirming the assertion of the historians of pilgrimage. See Nolan and Nolan, *Christian Pilgrimage in Modern Western Europe,* 56.

18. "Séance du jeudi 29 juin 1882," *Annales de la Chambre des Députés; débats parlementaires* (Paris, 1882), 700.

19. Ibid., 701.

20. Ibid., 697.

21. In 1892 and 1897; see Jacques Benoist, *Le Sacré-Coeur de Montmartre de 1870 à nos jours,* 2 vols. (Paris: Editions ouvrières, 1992), 771–793 and the relevant debates in the *Journal officiel.*

22. Phillip Dennis Cate and Mary Shaw, eds., *The Spirit of Montmartre: Cabarets, Humor, and the Avant-Garde, 1875–1905* (New Brunswick, NJ: Rutgers University Press, 1996); see also Rearick, *Pleasures,* 55–64.

23. AN F19 2371, Eglise du Sacré-Coeur de Montmartre, lettre, le 20 décembre 1901.

24. Gustave Téry, *Les Cordicoles* (Paris: E. Cornély, 1902).

25. AHDP, basilique du Sacré-Coeur, carton 4.

26. See Gérard Cholvy and Yves-Marie Hilaire, *Histoire religieuse de la France contemporaine*, vol. 1, *1800–1880* (Paris: Privat, 1985); Adrien Dansette, *Histoire religieuse de la France contemporaine* (Paris: Flammarion, 1965); Jacques Le Goff and René Rémond, *Histoire de la France religieuse*, 3 vols. (Paris: Seuil, 1988); Louis Chevalier, *Montmartre du plaisir et du crime* (Paris: Laffont, 1980).

27. AHDP, basilique du Sacré-Coeur, carton 6.

28. Chevalier, *Montmartre*, 25.

Marginality and Transgression

Anarchy's Subversive Allure

RICHARD D. SONN

To paraphrase Caesar, Bohemia was composed of three parts in fin-de-siècle Paris: art, pleasure, and social radicalism. Montmartre, celebrated as a center of art and entertainment during the last decades of the nineteenth century, was best known for its cabarets. These were situated at the lower edge of Montmartre, along or near the boulevards Clichy and Rochechouart, so as to be easily accessible to patrons coming from central Paris. These patrons were unlikely to be themselves residents of Montmartre, unless they were artists intent on capturing the ambience of these establishments. Dance halls such as the Moulin Rouge relied upon artists to produce the colorful posters that advertised their joie de vivre, but were much less dependent on their relationship to bohemia than the other major category of cabaret, that called artistique, which advertised its proximity to the artistic avant-garde. Launched in 1881 under the sign of the black cat, the Chat Noir was synonymous with Montmartre's reputation for irreverence and social satire. Steinlen's emblematic poster reminds us that black cats have a long tradition in European folklore of associations with witchcraft and the devil. Another cabaret was called the Chat Rouge, and yet another, the Ane Rouge; red and black were subversive, revolutionary colors. Even songs

could be colored red; Maurice Boukay (pseudonym of Charles Couyba, 1866–1931) sang his at the Chat Noir and the Cabaret des Quat'z'Arts before collecting them in a book in 1896 (Fig. 5.1). Steinlen's illustrations highlighted the political messages that such songs could convey.[1]

Artists—painters, poets, singers, and musicians—provided the second claim to fame of fin-de-siècle Montmartre. The painters generally occupied studios further up Montmartre's steep and winding streets, because accessibility was not an issue for them; low rents, local color, and contact and community with fellow artists attracted them to the neighborhood. From the Impressionists to the Cubists, modern artists challenged the artistic establishment from Montmartre's slopes.

One other group, much less well known, found bohemian Montmartre to be a congenial refuge from the commercial bustle of Paris. The epoch that witnessed the apotheosis of the French cabaret and the domination of Paris over the art world also recorded the sometimes furious and desperate activities of anarchists. The fin de siècle was the highpoint of the anarchist movement in France, when anarchists vied with the socialists for the allegiance of the working classes. Anarchists could be found in many regions of Paris and of France, including the Latin Quarter and many of the working-class neighborhoods in the north and east parts of the city, such as Belleville and St. Denis. Yet in the 1890s, Montmartre became a sort of unofficial headquarters of the movement. We know that the cabarets and the artists functioned symbiotically, the latter bequeathing a bohemian aura in which the former gladly bathed themselves, while providing the audience that sustained the poets, singers, and publicists. Less well known is the manner in which anarchism enhanced Montmartre's subversive allure, sharpening its distinctiveness from the metropolis, and highlighting its combative stance toward the bourgeois public. In the fin de siècle, art and anarchy were parallel avant-gardes, and Montmartre was their mutual home.

Radical politics forms the third part of the cultural ecology of Montmartre. The entrepreneurs, from Oller and Zidler of the Moulin Rouge to Salis of the Chat Noir, who were able to market Montmartre as a pleasure and culture center, relied in part on Montmartre's reputation as a distinct region of the metropolis with its own mores and values. There was a certain *frisson* or thrill attached to leaving Paris's fashionable Right Bank and heading up the slope, the expectation of rubbing shoulders with representatives of the lower depths. Of course, the bourgeoisie was not eager to encounter real toughs; if they had, they could have found plenty of them in Belleville. What they found in Montmartre was the representation of the "social problem," as it was called then, much as they found it

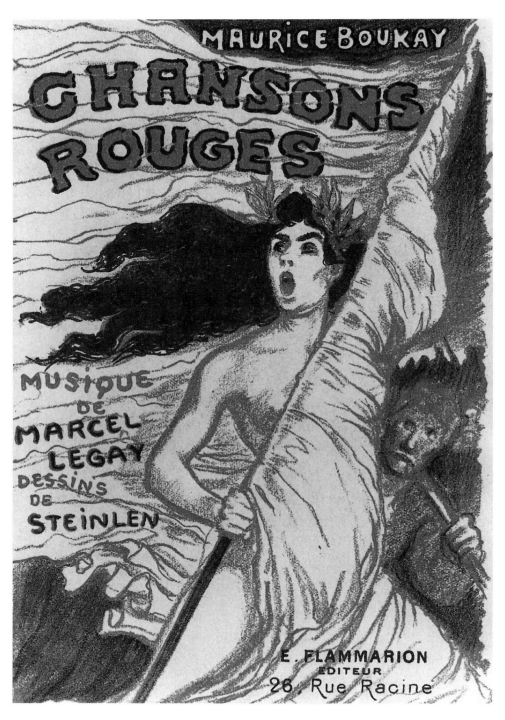

Figure 5.1 Théophile-Alexandre Steinlen, cover for *Chansons Rouges* (*Red Songs*),
by Maurice Boukay, 1896. Lithograph. Jane Voorhees Zimmerli Art
Museum, Rutgers, The State University of New Jersey,
Gift of Norma B. Bartman.

in the novels of Emile Zola. When Aristide Bruant insulted them in the language of the streets at the Mirliton cabaret, when Jules Jouy, Yvette Guilbert, Bruant, and a host of others sang of pimps, streetwalkers, and tramps, tout-Paris got a taste of social reality they couldn't find along the Champs Elysées. But the Montmartrois did not simply market their Otherness; they also functioned as genuine intermediaries between the classes, between St. Denis and the Right Bank. Montmartre functioned as a liminal realm, a borderland in which bohemians and radicals could fashion alternative lifestyles and politics, and project those imagined alternatives in their art and writings. Montmartre's marginality was bound up with transgressing dominant social codes. Art, cabaret, and anarchy thrived together in fin-de-siècle Montmartre, and when this symbiotic mix declined, Montmartre rapidly lapsed into a tourist trap feeding upon nostalgia.

Focusing on Montmartre's social radicalism helps explain why the bohemian quarter should have thrived precisely in this period, from about 1880 to 1895. Montmartre operated as a counterweight to the newly stabilized Third Republic. During the Second Empire and throughout the 1870s, republicanism was itself a combative force struggling with authority; yet after 1880 it quickly turned into the status quo. Montmartre arose to parody this newly ensconced power of the bourgeoisie, and was tolerated by the regime as a sort of safety valve, at once expressing and siphoning off dissent. Montmartrois symbolic inversion of dominant values was preferable to more serious political opposition. Of course, when anarchist terrorism did seriously threaten the power structure, the republic acted energetically by repressing the anarchist media as well as the perpetrators of the violent deeds. By the time that the anarchists regained their footing in 1895 and after, Montmartre itself had changed, becoming tarnished by tourist-oriented commercialism, and began to lose its oppositional edge.

Anarchism, then, fed Montmartre culture in multiple ways. A number of important anarchist militants set up editorial offices in Montmartre, from which they published newspapers and journals that were circulated throughout France. At the same time, many of the Post-Impressionist painters and critics and Symbolist poets were attracted to anarchist doctrines, and contributed their services to these journals. At the level of popular culture, anarchist and socially radical themes pervaded the songs and ambience projected in the cabarets artistiques. While it is often impossible to circumscribe neatly anarchist ideology, there were good reasons why anarchism rather than socialism or simple republicanism should have particularly appealed to many denizens of this bohemian milieu. To understand why this was, we must look briefly at the late nineteenth-century movement of anarchism.

The anarchist movement was particularly strong in the countries of Latin Europe—in Italy, Spain, and France—between 1870 and 1914. It also established roots both in Latin America and in the United States, where it was spread by and largely associated with European immigrants. Anarchism tended to compete successfully with rival socialist movements in completely industrialized regions, and found support among peasants and artisans rather than factory workers. Anarchism exerted a nostalgic attraction for a simpler and more harmonious way of life in areas undergoing rapid modernization. It appealed more to people resisting rather than simply succumbing to change. Anarchists agreed with socialists that capitalism exploited the workers, but rather than organize political parties that encouraged the proletariat to seize control of the state, either through revolution or, increasingly, at the ballot box, anarchists refused to participate in the political process. Anarchists distrusted all leaders, all governments, all authorities. They refused to delegate authority, fearing that necessarily disempowered the individual. Where socialists were concerned above all with economic equality, anarchists valued individual freedom and personal autonomy, while simultaneously longing for human relations within an egalitarian community. They therefore rejected both big government and big business, and idealized the small-scale workshop and the independent craftsman as the source of non-alienated labor. To replace the centralized nation-state, they spoke somewhat vaguely of associations of producers. As the highly individualistic anarchist movement of the nineteenth century evolved into one more focused on organizing workers into anarchist unions in the early twentieth century, anarchist nostalgia for medieval guilds and free city-states abated, and emphasized instead workers' self-management.

The peculiarities of anarchist ideology help clarify why it would have been particularly appealing in fin-de-siècle Montmartre. Where Marx confined those types he disdainfully referred to as *lumpenproletariat* to the dustbin of history, anarchist thinkers such as Mikhail Bakunin considered peasants, vagrants, outlaws, and other socially marginal types to be ideal revolutionary prospects. Marx used *bohemian* as a term of abuse for "the society of disorder, prostitution, and theft";[2] Bakunin realized the transgressive potential of marginality. Socialists idealized labor, especially as performed by workers in factories; anarchists believed in the self-fulfilling creativity of artists and craftsmen. Above all, Marx's dialectic prophesied a communist utopia set in the distant future, after socialism had replaced capitalism and itself had been made obsolescent. Anarchists collapsed revolutionary means and ends; one had to live the revolution, embody anarchist ideals of spontaneity and freedom, and transform society

from within. Montmartre was one approximation of the anarchist vision of utopia—or at least upper Montmartre was, with its narrow, winding streets, gardens and windmills, studios and cafés, where art rather than money determined status and social relations. Lower Montmartre, with its dance halls designed to attract slumming bourgeois and its prostitutes hanging out on the Place Pigalle, was a more equivocal scene, decadent and unequal.

Montmartre was not simply a geographical site for anarchist aspirations; its recent past connected it to rebellion. The revolution known as the Paris Commune originated in Montmartre. On March 18, 1871, after France had sued for peace with Prussia and the besieged city of Paris had surrendered, Adolphe Thiers sent a military detachment to retrieve the cannons emplaced on the heights of Montmartre above the city. The Parisians not only refused to be disarmed, but executed the two generals sent from Versailles, thereby inaugurating the seventy-day experiment called the Commune, when the city of Paris essentially seceded from France. The popular artist Théophile-Alexandre Steinlen, long-time resident of Montmartre, depicted these events repeatedly, casting the famed anarchist Louise Michel as Marianne, symbol of the French revolutionary ideals of liberty, equality, and fraternity. The Paris Commune was the most violent revolutionary episode in a century of uprisings, as the French armies crushed the rebellious city mercilessly in late May, leveling the defenders' barricades block by block. Père Lachaise Cemetery, where the communards made their last stand, rather than Montmartre, became the chief pilgrimage site for annual commemorations of the Commune, but the episode reinforced Montmartre's reputation for revolutionary ardor.

These memories were perpetuated when the Catholic Church decided to build a basilica dedicated to the cult of the Sacred Heart of Jesus, and the National Assembly offered the Church land behind the Church of Saint-Pierre on the heights of Montmartre. Sacré-Coeur was built explicitly to expiate the sins of the highly anti-clerical communards, and was a lasting reproach to the spirit of revolutionary Montmartre. At the Chat Noir, the great leftist singer Jules Jouy complained about this encroachment of Catholic France on Bohemia:

> Since a temple has burdened it,
> Our old Montmartre is much changed
> Thanks to the work that they execute
> On the butte.[3]

Later in the decade, just before his involvement in the Dreyfus Affair, Emile Zola made Sacré-Coeur central to the plot of his novel *Paris*, with anarchists planning

to blow up the church at its dedication ceremony. Steinlen did a large poster advertising the serialization of Zola's novel in the newspaper *Le Journal*, as well as posters for Zola's famous novel of Parisian working-class life, *L'Assommoir* (Fig. 5.2). Sacré-Coeur is shown with its scaffolding still surrounding it; below it a mass of writhing bodies rise in revolt, while Truth towers above in the form of a nude female with flowing hair. Two years later, Steinlen created a more effective revolutionary image based on the same iconographic elements. Sacré-Coeur is now shown bristling with cannons, a golden calf in its portals for the masses to worship. A female Liberty clearly drawn from Rude's sculpture of *La Marseillaise* breaks the shackles binding the people, as the men, armed with their tools, surge forward (Fig. 5.3).[4] This image, done for a leftist publication in 1900, reflects the fervor of the Dreyfus Affair, which polarized feelings between proponents of French revolutionary values of liberty and equality (as found in the armed worker with a pick in the foreground) and supporters of the Church and

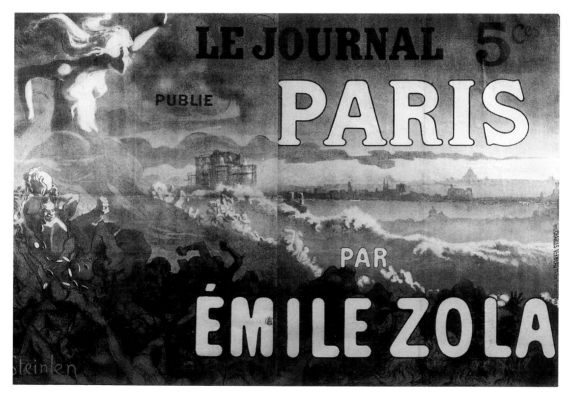

Figure 5.2 Théophile-Alexandre Steinlen, poster for Emile Zola's *Paris*, 1898. Photorelief. Jane Voorhees Zimmerli Art Museum, Rutgers, The State University of New Jersey, Gift of Norma B. Bartman.

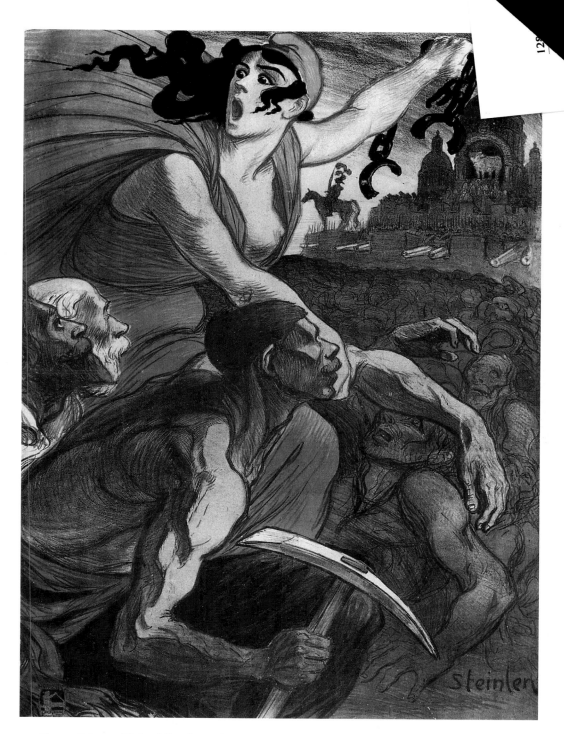

Figure 5.3 Théophile-Alexandre Steinlen, *Le Petit Sou* (*Small Change*), 1900.
Lithograph. Jane Voorhees Zimmerli Art Museum, Rutgers,
The State University of New Jersey, David A. and Mildred H. Morse
Art Acquisition Fund.

the army, leagued together against the Jewish army captain. Sacré-Coeur stands by itself as a symbol of reaction; it is not linked particularly to Montmartre.

Steinlen placed himself within the revolutionary tradition, and envisioned Louise Michel as embodying the great iconic imagery of the French Revolution during the Third Republic. What was meaningful history for Steinlen was ineradicable personal memory for Maxime Lisbonne, one of the most outrageous personalities of fin-de-siècle Montmartre. Deported along with Michel, Henri Rochefort, and many others for his role as a colonel in the Paris Commune, Lisbonne returned from the French penal colony of New Caledonia in 1880, and proceeded to relive simultaneously and capitalize on his tumultuous past in a succession of cabarets that he ran between 1885 and 1895. The best remembered of these theme-cabarets was his Taverne du Bagne, which opened on the boulevard de Clichy in 1885, the same year that Aristide Bruant took over the old site of the Chat Noir and turned it into the Mirliton. Both Lisbonne and Bruant capitalized on the *nostalgie de la boue* (nostalgia for sordidness), as the French called slumming, but whereas Bruant made his name by evoking the lower depths, Lisbonne was always overtly political. No lesser light than Paul Lafargue, Marx's son-in-law, regaled Marx's old sidekick Friedrich Engels with a description of Lisbonne's cabaret, in a letter of November 19, 1885:

> Lisbonne, professional ham, has had the genial idea of opening a café where the doors are barred, where the tables are chained, where all the waiters are dressed as galley slaves, dragging chains. . . . The success has been crazy; one lines up to go drink a bock in the prison of citizen Lisbonne, who makes you pay double on top of it. The society people go in their carriages, and are happy to hear themselves addressed with *tu* and to be ill-treated by the prison guards, who use the academic language of prison to speak to their clients.[5]

As with the Chat Noir and the Mirliton, Lisbonne too had a house publicity paper; this one featured a picture of *Louise Michel* (Fig. 5.4). Later establishments run by Lisbonne included the Taverne de la Révolution Française and the Brasserie des Frites Révolutionnaires. Finally, the Concert Lisbonne opened in 1893 on the site of the Divan Japonais, made famous by Lautrec's poster. Lisbonne made a sort of theatrical history here on March 3, 1894, when Blanche Cavelli performed a little dramatic scene called "Le Coucher d'Yvette," removing as many layers of undergarments as the censors would allow in the process of getting ready for bed. This first striptease generated numerous imitators in the succeeding months.

By the 1890s, Lisbonne was not simply replaying his own radical past, but responding as well to the new currents of anarchist violence then rocking Paris.

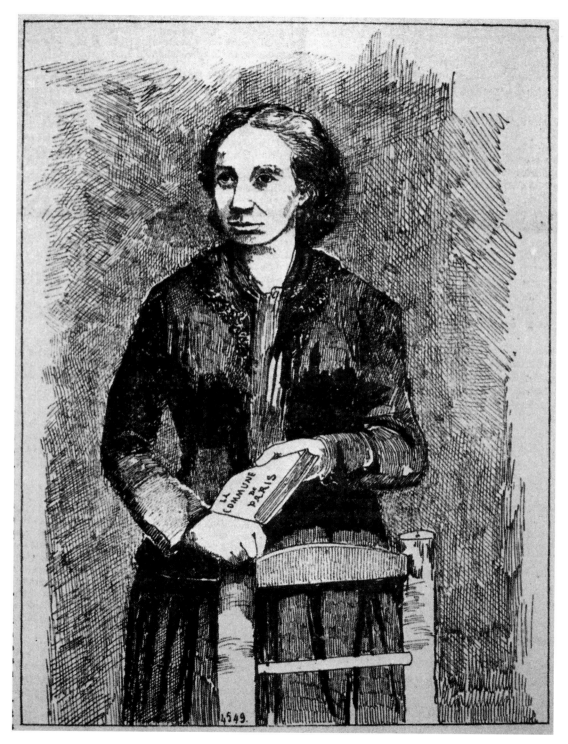

Figure 5.4 *Portrait of Louise Michel* reproduced in *Gazette du Bagne*,
Maxime Lisbonne, editor, November 8, 1895.

The era of "attentats," a term which can be translated as "attacks" or "outrages," began in 1892 with Ravachol's bombs planted in the apartments of judges and prosecutors who had played a role in sentencing workers accused of perpetrating violence on the previous May Day celebrations. Lisbonne placarded Montmartre with offers of insurance policies against dynamite explosions, contracted by a new Committee of Public Safety. Widows and unmarried female proprietors could dispense with such policies simply by marrying an anarchist. This proclamation was printed in the newspaper *La Patrie*, with the comment, "One laughs at everything on the Butte."[6] By 1894, the Concert Lisbonne was being advertised as "the sole Concert sheltered from the Bombs." Police informers kept a careful watch over Lisbonne's activities and filed regular reports on the cabaretier. A lengthy report dated April 30, 1894 was entitled "Le Concert Lisbonne, centre anarchiste," and reported that numerous anarchists of letters frequented the place. Agent "Legrand" cited journalists, printers, students, painters, and sculptors, and made a point of mentioning the presence of young women as well.

The police would frequently suspend a cabaretier's license if they found the program to be overtly insolent toward the authorities; I suspect that part of the reason for Lisbonne's frequent closings had to do with other issues than simply his lack of business acumen. Another landmark similarly suffered both from the authorities and the criminal element of Montmartre.

Frédéric Gérard had his first cabaret, Zut, closed by the authorities because it was a popular hangout for the anarchists affiliated with the newspaper *Le Libertaire*, Sebastien Faure's weekly located nearby on the rue Collin. Frédé's new place became famous as Le Lapin Agile, and stood for the free spirit of Montmartre to the generation of Picasso. Yet as late as 1910, informers were reporting on the anarchist clientele, who still remembered the café's alternative name, the Cabaret des Assassins. Sadly for Frédé, his son Victor was gunned down late one night in 1911 at the Lapin Agile, suggesting that the artistic bohemia was not immune from the other bohemia of crime.[7] The death of Victor Gérard is one of the symbolic finales of the utopian community of Montmartre, and a time when many of the artists began abandoning the butte for other parts of Paris, such as Montparnasse.

So far I have been speaking of Montmartre establishments serving the general public, bourgeois or bohemian, which catered to anarchists or projected their ideals. Anarchists also created social and cultural institutions of their own, designed to increase group solidarity and to spread the doctrine of hope and revolution to a broader base. The most important of these institutions in terms of

propaganda and public visibility were the newspapers, at least ten of which were being published between 1886 and 1896. In fact, the only major anarchist newspaper that did not have its editorial offices in Montmartre at this time was Jean Grave's *La Révolte*, which was published on the Left Bank. Grave's paper was viewed as the official organ of anarchism, but was displaced in popularity and certainly in panache in the early nineties by Emile Pouget's paper *Le Père Peinard*, which reached a weekly circulation approaching twenty thousand copies. Pouget's paper's appeal to its clientele precisely parallels the ways in which cabaret singers such as Bruant appealed to their audiences, identifying with the vitality and values of the lower classes by speaking to them in their own language. It is hard to believe that Pouget, who had a moderately middle-class background, was not influenced stylistically by the *chansonniers* of Montmartre. In any case, his persona was that of the cobbler whose image adorned the masthead of the weekly paper, and *Père Peinard* deprecated the bosses and deputies in the colorful argot of the *menu peuple* of Paris, connecting popular speech with illegality and revolt.

If Pouget's *canard* represented the common people from the inside, as it were, the other most typically Montmartrois anarchist papers stood for the bohemian artistic elements of the movement. *L'Endehors* (*The Outsider*) was the perfectly titled creation of an extreme bohemian who called himself Zo D'Axa. This picture of the editorial staff of *L'Endehors* was included in the 1894 exposé of the contemporary anarchist scene by Félix Dubois called *Le Péril Anarchiste* (*The Anarchist Peril*) (Fig. 5.5). A full-bearded D'Axa stands behind an illustrious assortment of anarchist littérateurs, including the novelist Octave Mirbeau, author of *Diary of a Chambermaid*; Jean Grave, editor of the mainstream anarchist paper *La Révolte*; and Bernard Lazare, soon to play a key role in the Dreyfus Affair.

No less violent than Pouget in his calls for revenge against a heartless society, Zo D'Axa expressed a radically different rationale for violence. He wrote that anarchists "had no need to hope for distant better futures, they know a sure means of plucking the joy immediately: destroy passionately!"[8] Individualist and aesthete rather than spokesman for the people, D'Axa saw terrorist deeds akin to works of art—what might be called performance art today—that irrevocably stamped the personality of the perpetrator on his times. His version of anarchism recalls the phrase uttered by the poet Laurent Tailhade after the explosion in the Chamber of Deputies: "What do the victims matter if the gesture is beautiful?" "*si le geste est beau.*" This phrase immediately became notorious as indicative of a decadent, elitist sensibility that sought in anarchist *attentats* one more refined sensation. *L'Endehors* was shut down by the police

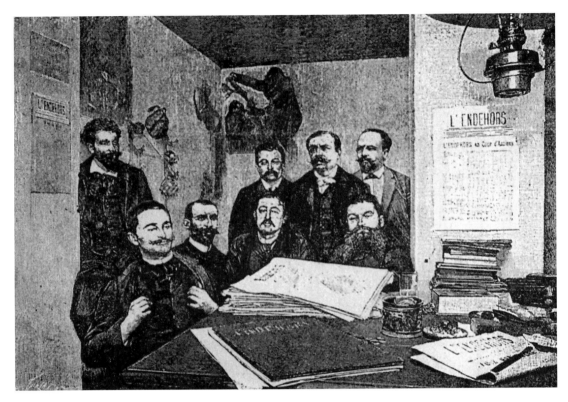

Figure 5.5 The editorial office of *L'Endehors,* ca. 1892. Reproduced in Félix Dubois,
Le Péril Anarchiste, 1894.

even earlier than *Le Père Peinard* for such outrageous incitements to violence,
and its editor spent several years as a vagabond before returning to journalism
with *La Feuille* later in the decade. Whether in jail, on the road, or on the
heights of Montmartre, Zo D'Axa exulted in his outsider status. Steinlen's cover
for *La Feuille* (Fig. 5.6) depicts a stout, elderly bourgeois couple amid a crowd of
the popular class whose demeanor is more joyful than threatening. Perhaps
Steinlen was simply incapable of portraying the people as ominous, or perhaps
they were enjoying the rain of sheets of paper over their heads, a reference to
the title of D'Axa's journal.

The anarchists of Montmartre did not only court publicity; they also spon-
sored libraries, soup kitchens, and workers' centers (Maisons du Peuple) as ways
to encourage social solidarity. Nevertheless, Montmartre anarchists were partic-
ularly conscious of reaching out beyond the butte to communicate their mes-
sage to the wider world. Anarchism at the end of the century was inherently
oriented toward symbolic communication, toward propaganda by all means

possible, including by the noise of bombs, which was not called terrorism but, significantly, "propaganda by the deed."

So far I have had little to say about the artistic avant-garde and anarchism. The works of Steinlen were clearly *populaire* rather than avant-garde. In other cases, a Post-Impressionist artist might contribute a popular image to the anarchist press, as Charles Maurin did with his famous woodcut of the martyred terrorist *Ravachol* (Fig. 5.7). The anarchist's handsome visage is portrayed against the guillotine, the new dawn of anarchy visible on the horizon beyond the horror of his martyrdom. Maurin and Toulouse-Lautrec displayed their works together in a two-man show at the Goupil Gallery in 1893, where Maurin displayed his experiments with spray paint using atomizers, and excited the admiration of Edgar Degas. Lautrec is the artist most closely associated with fin-de-siècle Montmartre, but he is not usually regarded as bearing any political

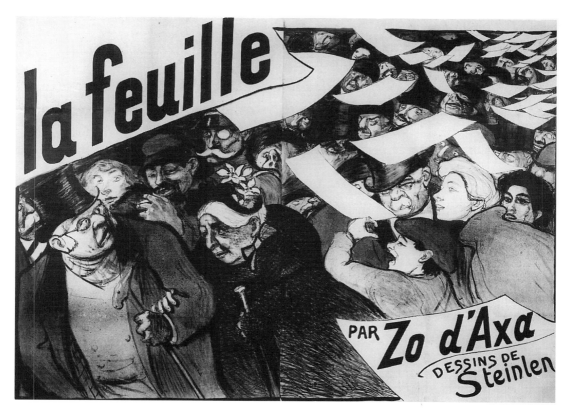

Figure 5.6 Théophile-Alexandre Steinlen, *La Feuille*, 1897. Lithograph. Jane Voohees Zimmerli Art Museum, Rutgers, The State University of New Jersey, Frederick and Lucinda Mezey Purchase Fund.

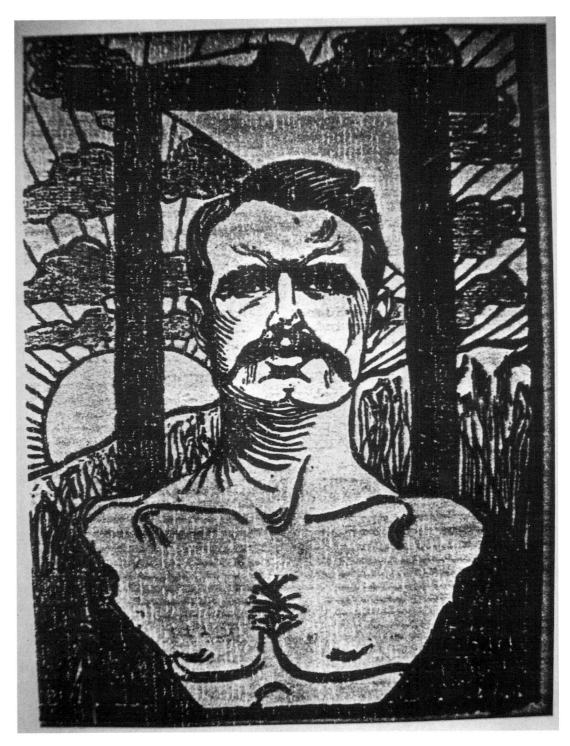

Figure 5.7 Charles Maurin, *Ravachol devant l'histoire* (*Ravachol before History*).
Reproduced in *Almanach du Père Peinard*, 1893.

message in his work. Still, his work was reviewed enthusiastically in *Le Père Peinard* in 1893, which emphasized Lautrec's ability "to catch the face of the decrepit old capitalists with some girls seated on their knees, licking their muzzles to make them shell out."[9] The poster for Reine de joie may be what the anarchist reviewer had in mind, but his paintings of the Moulin Rouge also feature the juxtaposition of wealthy men and dancers. The dispassionate eye of Lautrec may have been more cynical than political, but he was not glamorizing the dance hall as we now may perceive it, but rather showing it as a sordid place of commerce in young women.

Many of Montmartre's artists were sympathetic to anarchism, and in some cases were enthusiastic supporters. Camille Pissarro and his artist son Lucien, Paul Signac, Maximilien Luce, Charles Maurin, and Steinlen contributed images as well as financial support to the anarchist press. A number of Symbolist poets and critics wrote articles praising the movement, both in their own artistic reviews and in the anarchist papers. Compared with socialists, anarchists were relatively tolerant of art that did not convey a particular social statement, because they understood that art that rebelled against the rules of the Academy and the official Salons communicated values of deviance and independence on a different level. They accepted—at least in Montmartre—the idea of the parallel avant-gardes of art and politics, a doctrine that had been voiced by Victor Hugo as early as 1830, when he argued that Romanticism was inherently republican.

Paul Signac wrote on the relation between art and politics: "Justice in sociology, harmony in art: same thing. The anarchist painter is not he who will exhibit anarchist paintings, but he who . . . without desire for recompense, will struggle with all his individuality against bourgeois and official conventions in his personal contribution. The subject is nothing."[10] When he wrote this in 1902, Signac was mostly painting seascapes along the Riviera; maybe he felt a little guilty. He meant that beyond considering the social commitment of the artist as expressed in didactic works, beyond even stylistic experimentation, the untrammeled creativity of the artist stood for freedom to which all should aspire. The implication was that all *true* artists of necessity were anarchists, insofar as they took orders from no one and followed their own instincts. In reality, anarchism demanded a somewhat greater commitment to a social ideal; otherwise, one might end up in complete solipsism or Nietzschean elitism.

Signac's fellow Neo-Impressionist Maximilien Luce painted in a very similar style, but certainly did not restrict himself to radical subjects. Whereas Toulouse-Lautrec captured the ambience of lower Montmartre, both revealing and reveling in its sordid pleasures, Luce was more typically anarchistic in depicting a

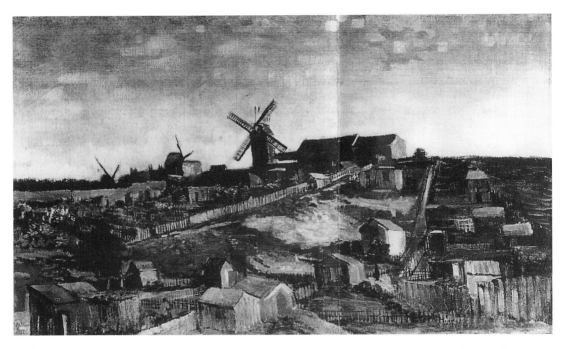

Figure 5.8 Maximilien Luce, *Outskirts of Montmartre*, 1887. Stichting Kröller-Müller Museum, Otterlo, Netherlands.

very different image of Montmartre as a semi-pastoral landscape of windmills and cottages (Fig. 5.8). It is hard to imagine two more disparate images than Lautrec's lithographs of the Moulin Rouge and Luce's painting of a rustic refuge from the urban maelstrom, which lay just a few hundred steps, but seemingly a whole world, away. Luce's landscape may be contrasted with another painting he did a few years later, around 1890, in the much more populaire milieu of the Rue Mouffetard on the Left Bank. Between 1886 and 1890 the artist's style evolved toward the pointillism being employed by his friends Seurat and Signac (Fig. 5.9). He used this new style to show the common people in their urban habitat, in the neighborhood where Jean Grave ran the editorial offices of *La Révolte*. This crowded cityscape highlights Luce's decision to show La Butte Montmartre as the anti-Paris, unpaved as well as unpeopled.

In this symbolic landscape of arcadia and of pleasure, it is tempting to apply the bodily metaphors of higher and lower, of the heart and the genitals, to upper and lower Montmartre. Montmartre was marginal to the main interests of Paris, whether of the brain (the Sorbonne), the belly (Les Halles), or the pocketbook (the Bourse or stock exchange, to stray only slightly from the bodily metaphor—after all, it was commonly reported that the typical republican bourgeois wore

Figure 5.9 Maximilien Luce, *La Rue Mouffetard*, 1889–90. Oil on canvas,
31 5/8 x 25 3/16" (80.2 x 64 cm). Indianapolis Museum of Art,
The Holliday Collection.

his heart on the left and his pocketbook on the right). The authorities tacitly acknowledged Montmartre's marginality in tolerating a certain amount of social and moral license. Beginning with the Chat Noir in 1881, cabarets were expressly released from the censorious watch of the police, though openly revolutionary cabaret owners such as Lisbonne might still get in trouble.[11] The cabarets' carnivalesque disrespect was matched by the artists' revolt against artistic norms and bohemian disregard for propriety. In the process of thumbing their noses at the great body of Paris lying below, they made Montmartre into the very image of the fin de siècle. In this process of inversion, "what is socially peripheral is often symbolically central."[12] The Moulin Rouge and the Lapin Agile have come to stand not just for the Parisian spirit but for the entire Belle Epoque.

Let me summarize the main points of my argument, and then try to suggest what all this has to do with mass culture in our own century. Anarchists found a congenial home in Montmartre because its rustic, bohemian milieu approximated the anarchist utopia of free creativity and small-scale production. Though more anarchists lived in the major working-class neighborhoods to the east and north, Montmartre functioned as a meeting-ground between classes, with artists and singers acting as cultural intermediaries, interpreting the values and way of life of the lower classes for a bourgeois audience. Montmartre was home to a large proportion of the anarchist press because it was a center of publicity, projecting images to the outside world. In fact, fin-de-siècle anarchism was largely a matter of publicity by all means possible, including the bombings that were then known as "propaganda by the deed." So the anarchist publicists of the word fit right in to publicity-conscious Montmartre. Whether bohemian, criminal, or proletarian, anarchists stood for revolt, expressed as disdain for all authority and dedication to the liberation of humanity from church, state, and factory.

As one looks back at the end of another century, one wonders what happened to this nineteenth-century movement that filled the headlines of the era with its violent deeds and utopian dreams? Certainly the active movement of the years before World War I declined in the aftermath of two world wars, of totalitarian governments and especially the rise of communism, as the Bolsheviks showed how to really make a revolution. Yet despite all this, the spirit of *L'Homme Revolté*, the Metaphysical Rebel of whom Albert Camus wrote admiringly at mid-century, lives on.[13] While the social radicalism of the Montmartre cabarets declined after the turn of the century, anarchism remained a force in the modernist avant-garde movements of Dada and Surrealism, and in Abstract

Expressionism. The oppositional mystique of modernism, the scorn for the bourgeois commercial public and for conventional taste, derived in part from art's associations with anarchy.[14]

What is most striking in the postwar West is the way in which this sense of contestation has moved from elite to popular culture, from the small, self-conscious avant-garde to the mass culture of rock music. From the sixties counter-culture with its themes of generational revolt and back-to-nature fantasies; to punk rock whose raison d'être was its shock value; to the contemporary movement called "alternative music": each wave of new musicians has had to establish its own rebellious credentials, its alleged disdain for commercial success and even for its own audience. Some rock icons, such as Jim Morrison of the Doors and Patti Smith, were directly inspired by the example of the *poètes maudits* Verlaine and Rimbaud's own transgressive behavior; others, such as the Sex Pistols, sang in "Anarchy in the U.K." that "I don't know what I want, but I know where to get it." Drawn to the darker, nihilistic aura of anarchy, these latter punks were mostly self-destructive.

More recently, the defining rock band of the 1990s, which rode its way to mass popularity on the transgressive look and sound of "grunge," was the Seattle-based group Nirvana, which catapulted to stardom with the 1991 album *Nevermind* and ended abruptly in 1994 with lead singer and songwriter Kurt Cobain's suicide. By taking the earlier punk idiom and making it accessible, Nirvana spoke directly to teenagers who felt consumed by angst and emptiness. Here's how these "poets of alienation" described the gestation of their satirically titled hit "Smells Like Teen Spirit":

> We were sitting in the apartment when we were making the record, and I was talking about an anarchist high school with, like, black flags, and the cheerleaders have anarchy A's on their shirts, and that whole school spirit, pep spirit. But what if it was, like, anarchy, and it was the school that was espousing it at pep rallies, the whole, like, punk-rock ethos. What kind of world would that be?[15]

Anarchy envisioned as adolescent rebellion will survive as long as youth seek cultural expressions for their disaffection. As Marxist dreams of class-based revolution fade, the anarchist-bohemian appeal of alternative lifestyles and of "Rage Against the Machine" (to use the name of another alternative band of the 1990s) may claim to be equally significant sources of opposition.

The mass appeal of marginality and transgression is as evident today as it was a hundred years ago in bohemian Montmartre. While it may seem that all that is left of anarchism is the spirit of alienation and cultural rebellion, it may be pre-

mature to speak of anarchism entirely in the past tense. The stylized letter "A" was spray-painted around Seattle in November 1999 by anarchists protesting the meeting of the World Trade Organization. Young drifters of our own fin de siè-cle, who go by such pseudonyms as Swamp and Panic, report that they were turned toward anarchism by the music of other punk bands, suggesting that the connection between radical culture and politics is still alive.[16] They are far more likely to be influenced by punk culture than by any traditional spokesmen for anarchist ideology, though they do acknowledge the destructive inspiration of the Unabomber and his anti-technology manifestos.[17] At the same time, the jar-gon of liberation can be co-opted for the most commercial purposes. A recent ad from *Elle* fashion magazine, for example, evokes sixties nostalgia with this cap-tion: "feelin' groovy: A bit of bohemia, a touch of the exotic . . . with their rebel-lious mix of color and texture, spring's new looks—beaded, crocheted, or bursting with prints—are just the thing for a free spirit."[18] If the model portrayed in the ad doesn't look anything like the young punk-anarchists, one might remember that fin-de-siècle Montmartre was home to authentic bohemians, artists, and to a variety of *poseurs* trying to cash in on radical chic. It would be a mistake to assume that the commercial appropriation of bohemia necessarily invalidates that culture, or the spirit of rebellion underlying it.[19]

NOTES

1. For more on Boukay, see Mary Ellen Poole, "Chansonnier and Chanson in Parisian Cabarets Artistiques, 1881–1914" (Ph.D. diss., University of Illinois at Champaign/Urbana, 1994), 164; Richard Sonn, *Anarchism and Cultural Politics in Fin de Siècle France* (Lincoln: University of Nebraska Press, 1989), 126–128.
2. Karl Marx, *The Eighteenth Brumaire of Louis Bonaparte*, in *The Marx-Engels Reader*, ed. Robert Tucker (New York: Norton, 1972), 481.
3. Sonn, *Anarchism and Cultural Politics*, 92.
4. Phillip Dennis Cate and Susan Gill, *Théophile-Alexandre Steinlen* (Salt Lake City: Gibbs Smith, 1982), 125–127.
5. Sonn, *Anarchism and Cultural Politics*, 66.
6. Ibid., 67.
7. See Louis Chevalier, *Montmartre du plaisir et du crime* (Paris: Editions Robert Laffont, 1980), 222.
8. Sonn, *Anarchism and Cultural Politics*, 242.
9. Ibid., 168.
10. Ibid., 148, 149.
11. Ibid., 71–74.
12. Barbara Babcock, *The Reversible World: Symbolic Inversion in Art and Society* (Ithaca, NY: Cornell University Press, 1978), 32. See also Peter Stallybrass and Alton White, *The Politics and Poetics of Transgression*, (Ithaca, NY: Cornell University Press, 1986), who discuss Babcock and also Bakhtin's grotesque realism and carnivalesque upsetting of hierarchies.

13. Albert Camus, *The Rebel: An Essay on Man in Revolt* (New York: Knopf, 1954).

14. David Weir makes this argument in *Anarchy and Culture: The Aesthetic Politics of Modernism* (Amherst: University of Massachusetts Press, 1997).

15. "The Grunge Invasion," *Newsweek*, June 28, 1999, 77.

16. Evan Wright, "Swamp's Last Day on Earth and Other True Tales of the Anarchist Underground," *Rolling Stone*, March 30, 2000, 44–50.

17. Ibid., 49.

18. *Elle*, February 1999.

19. The capitalist co-optation of the sixties counterculture is the theme of Thomas Frank, *The Conquest of Cool: Business Culture, Counterculture, and the Rise of Hip Consumerism* (Chicago: University of Chicago Press, 1997).

Montmartre's Artistic Community

Pictorial Acrobatics

H O W A R D G . L A Y

This essay focuses on a pair of particularly obstinate pictures, both of which issued from the somewhat disreputable context of late nineteenth-century Montmartre. The first, a remarkable *enseigne* (signboard) painted by André Gill in 1880 (Fig. 6.1) was designed to grace the façade of an obscure *montmartrois* watering hole called the Cabaret des Assassins—where it immediately acquired "masterpiece" status among the bohemian clientele that frequented the place.[1] The second, Georges Seurat's *Chahut* (Fig. 6.12), was made to dominate the field at the Salon des Indépendants in 1890, to turn heads with its frozen rendering of a company of dancers, musicians, and spectators endemic to the considerably less refined atmosphere of Montmartre's dance halls, cabarets, and *café-concerts*. On the face of things, these images—a commercial shop sign, an avant-garde tour de force—make for an unlikely comparison, if only because of their obvious functional and thematic dissimilarities. My purpose in bringing them together here is twofold. In keeping with the objectives of the present collection, I want, on the one hand, to examine the dramatic transformation of "popular culture" in Montmartre between 1880 and 1890, a complex historical phenomenon in which these pictures are thoroughly

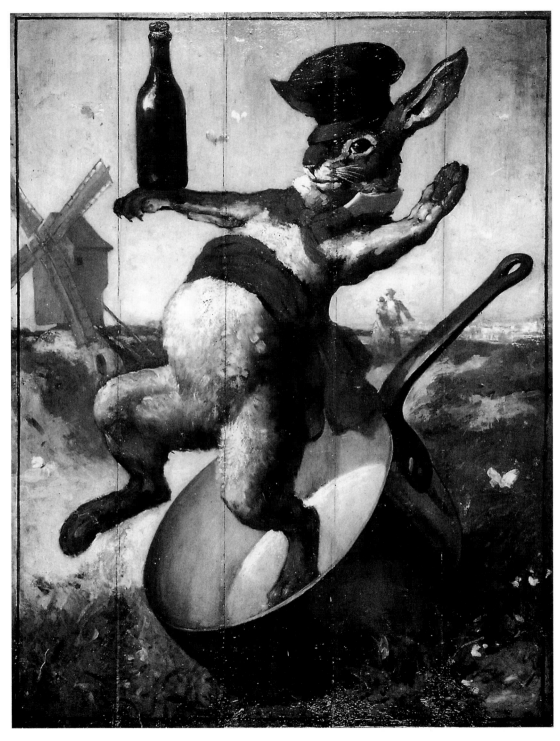

Figure 6.1 André Gill, *Enseigne du Cabaret le Lapin Agile* (*Signboard for the Lapin Agile Cabaret*), 1880. Musée de Montmartre, Paris.

steeped. But on the other hand, I aim to look closely at the means and effects of their mutual dependence on "pictorial acrobatics"—a term by which I mean to refer less to the feats of their nimble protagonists than to the ways in which both images perform significative balancing acts in the face of interpretation. It is my argument in the following pages that these pictures function not only as indices of the contestability of popular culture in fin-de-siècle Montmartre, but also as elaborate mechanisms designed to outmaneuver the normative parameters of the same visual languages they employ.[2] In the process, they lend themselves to the transmission of particularly unstable, even contradictory, sets of figurative meaning in which contestability itself assumes metaphorical significance.

J'aimais les peintures idiotes . . .

By way of a preliminary digression, let me begin with an exquisitely deadpan confession concerning the nature of taste. The voice is Arthur Rimbaud's in *L'Achimie du verbe* of 1873:

> J'aimais les peintures idiotes, dessus de portes, décors, toiles de saltimbanques, enseignes, enluminures populaires; la littérature démodée, latin d'église, livres érotiques sans orthographe, romans de nos aïeules, contes de fées, petits livres de l'enfance, opéras vieux, refrains niais, rythmes naïfs.

> [I loved idiotic paintings, decorative panels over doors, stage sets, carnival backdrops, shop signs, popular illustrations; old-fashioned literature, Church Latin, erotic books with poor spelling, our grandmothers' favorite novels, fairy tales, children's books, old operas, silly refrains, naïve rhythms.][3]

These lines have a familiar ring where modernist art and literature are concerned.[4] For like many of his contemporaries, Rimbaud was inclined to dismiss the established literary tastes of his day by mounting a defense for degraded or otherwise *démodé* forms of culture. The tactic was common in nineteenth-century Paris, and typical of a rather conventional variety of avant-garde and bohemian posturing. It was less common, however, to index in such detail the wide range of objects and practices to be found beyond the scope of conventional "high culture." Carnival backdrops; fairy tales; erotic books: these are divergent cultural forms, none of which operate in some uniform way as a foil to legitimate art or literature. Nor does Rimbaud suggest that they do, despite the liberties he takes by mixing them together in the same elocutionary pot. What he submits in opposition to the cultural canon of his day is his *taste* for the non-canonical,

rather than an analysis of the characteristic behavioral patterns of the particular forms he names. There are significant differences, in other words, between his contentious delight in shop signs or popular illustrations and the performance of such images in cultural situations in which Rimbaud himself was neither involved nor particularly interested.

There are two points to be made here, the first of which I take to be relatively obvious: that the invocation and manipulation of cultural hierarchies are related in some essential way to a given individual's social and cultural aspirations—or, to put it another way, that Rimbaud's love for the non-canonical was inseparable in 1873 from his ambition to distinguish himself in opposition to a dominant concurrence of cultural and aesthetic values. Cultural hierarchies, after all, are a matter of negotiation, of incessant claim-staking, of self-interested appeals—and of equally self-interested challenges—to authority. So it is important to stress straightaway that elements of "low" culture are typically deployed in modernism to function as symbolic bones of contention, as rhetorical maneuvers designed to destabilize an established (and exclusionary) hierarchical construction. They are also a means—and this is my second point—by which a given individual presumably communicates with an audience of similarly marginal orientation, and in so doing contributes to an accretion of signifying practices with which an oppositional collective defines itself in negative relation to institutional and commercial culture. Such modes of communication may or may not have to do with a nostalgic fondness for popular culture. What matters is the oppositional resonance that popular signifiers accrue when they function in implicit dialogue with the same hierarchical constructions that consign them marginal status. I say "implicit dialogue," since the transmission of oppositionality depends on an audience's critical recognition of the contestability of hierarchical structures—as well as the necessarily fugitive path oppositional discourse must follow if it is not inordinately to ruffle the feathers of the agents of authority against whose interests it operates. In the case of *L'Alchimie du verbe*, the fugitive path is one of irony: hence the delectable cynicism informing the phrase "J'aimais les peintures idiotes"; hence also the ploddingly encyclopedic list of idiotic cultural forms that follows (a list that passes from "latin d'église" to "livres érotiques sans orthographe" without a hitch). Rimbaud's rhetorical posturing assumes the existence of readers capable of recognizing irony when they see it—readers, that is, who somewhere share an inclination to greet prevailing cultural authority with similar tokens of disrespect.

Montmartre

Disrespect was the order of the day in late nineteenth-century Montmartre, and low culture the preferred vehicle of communication and self-representation. This is the period that witnessed the emergence along the Parisian outer boulevards of a constellation of artists, poets, singers, political activists, dance-hall performers, and show-business impresarios who tirelessly trafficked in seemingly popular orders of signification, and whose various enterprises smacked of contempt for virtually any form of legitimate culture. In Montmartre—a lower-class *faubourg* with a well-earned reputation for cut-rate diversions and revolutionary intransigence—they found the perfect venue from which to peddle images of marginal collectivity inscribed on the one hand by performative affronts to the routine do's-and-don'ts of correct society and, on the other, by an aura of authenticity owed in great part to the rough-and-tumble neighborhood in which they operated.

Montmartre was the natural habitat of *le peuple*, or at least it had been prior to the migration in the seventies and early eighties of a loose-knit community of Latin Quarter bohemians who coalesced around a succession of new *montmartrois* cabarets. La Grande Pinte, the cabaret de la Canne, and Les Assassins were the first; Rodolphe Salis's Le Chat Noir and Aristide Bruant's Le Mirliton became the most renowned: but they all helped, one way or another, to make of Montmartre a flourishing center of marginal entertainment.[5] Political irreverence; elaborately orchestrated hoaxes and hi-jinx; gritty renditions of popular *chansons* and monologues; bohemian art and poetry of questionable merit; ample quantities of beer: all this was available to bourgeois Parisians looking for round-trip passage to the *faubourgs* for a modest sum with no strings attached.[6] What was also available was a cluster of shabby dance halls, the featured attractions of which included raucous performances of the cancan, the *chahut,* and the quadrille, as well as a cast of professional dancers whose reputations for misbehavior and immodest display began to draw Parisians to Montmartre in droves. If bohemian commercialism opened the neighborhood to a more broadly based clientele, these *bal publics*—or at least those that survived—perfected the techniques of mass publicity. The new means of promoting irreverently lower-class forms of song, dance, and comedy were institutionalized when Charles Zidler's Moulin Rouge—soon to become the stamping ground of stars like La Goulue, Grille d'Egout, Jane Avril, and Yvette Guilbert—opened its doors in 1889.[7] The enormous hoopla manufactured to publicize the event obscured

the quiet disappearance just a few months earlier of the Boule Noire and the Reine Blanche, two of the most venerable of the down-and-out dance halls that had catered to *montmartrois* locals (and slumming Parisians) for years.

So it was that the commercial production of popular culture in Montmartre passed from the hands of a rag-tag team of bohemian interlocutors (whose transparent commercialism was itself the stuff of satire and parody) to those of a more professional caste of producers and publicists (for whom "business was business"). In the process, a system of signification that might have seemed, once upon a time, to be the unique property of *le peuple* was recast within the more persuasive parameters of "mass culture"—replete with high-profile advertising campaigns, profit margins, media coverage, and the usual quotient of sensation and scandal. The rise and fall of fin-de-siècle Montmartre is an old story, a sad tale of appropriation and recuperation in which the neighborhood's indigenous population plays a negligible part, while figures like Salis, Bruant, and Zidler take leading roles. The antics of its protagonists, however, are less significant than the cultural distinctions they helped to produce between the Montmartre we meet at the beginning of the story and the metamorphosed facsimile we encounter at the end.[8] It is reasonable, I think, to imagine a moment back in 1880 when popular forms of signification, deftly deployed, still seemed capable of doing oppositional damage to social, cultural, and political authority; a decade later those same forms of signification, having undergone considerable commercial homogenization, had apparently lost their fangs. This second moment is the determining frame of reference of Seurat's *Chahut*. Gill's *enseigne* for the Cabaret des Assassins belongs to the first.

Le Lapin à Gill

There is no disputing the popular bearing of Gill's *enseigne*. The image was entirely at home above the door of Les Assassins (Fig. 6.2), where its crazy pictorial ensemble—an enormous rabbit performs a balancing act with a bottle of wine and a copper pot—wooed passersby with a clever visual register of the food, drink, and good humor to be enjoyed just across the threshold.[9] As a commercial image, its principal raison d'être was to turn passersby into patrons and patrons into "regulars." Hence the deployment of a visual narrative that implicitly flatters the spectator for imagining a sequence of events leading from the rabbit's balancing act to the spectator's dinner—and for recognizing that, both literally and figuratively, the rabbit acts out the principal meanings of the common idiomatic expression "passer à la cassarole" ("to get fried" or "to be on the

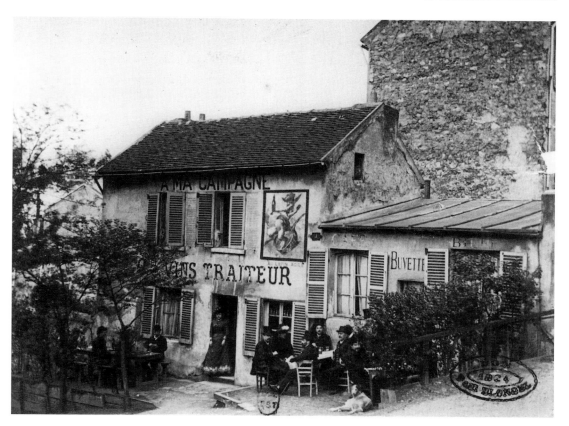

Figure 6.2 Photograph of the cabaret le Lapin Agile (formerly Les Assassins), ca. 1900. Bibliothèque Nationale de France, Paris.

hot seat").[10] This kind of flattery (the customer is congratulated for "getting" a joke or a pun) was standard fare in the world of commercial *enseignes*. When innkeepers, for example, ran their establishments under the sign of the Lion d'or, they fully expected their customers to appreciate the phonetic pun that transforms "au lion d'or" (at the Golden Lion) into "au lit on dort" (one sleeps in bed); shopkeepers operating under the Cygne de la croix similarly expected their clientele to notice that "cygne" (swan) does phonetic double duty as "signe" (sign).[11] In keeping with tradition, the regular clientele at Les Assassins began, in deference to Gill's *enseigne*, to refer to their favorite cabaret as Le Lapin Agile (The Agile Rabbit) a name that had the advantage of describing the demonstrably agile rabbit above the door, while paying phonetic homage—as in "le lapin à Gill" (Gill's rabbit) or "là a peint A. Gill" (A. Gill painted here)—to the artist who made the picture.

Gill, then, was conferred a unique honor by the cabaret's regulars, an honor that attested both to his celebrity as a caricaturist (and high-profile bohemian-at-large) and to the effectiveness of his *enseigne* as a familiar emblem of bohemian collectivity. It also attested to the distinctive environment in which the image operated, for nowhere else could a picture have been so explicitly identified with its author—except, of course, in the considerably more distinguished surroundings of the Louvre, the Musée du Luxembourg, or the up-scale private gallery. In the less distinguished surroundings of Montmartre, Gill's *enseigne* enjoyed a success predicated, I suspect, on the pointed distance it kept from the lofty concerns of serious painting in 1880—on its resolute unsuitability, in other words, for exhibition as an objet d'art. Here, apparently, was the very incarnation of a *peinture idiote*; the Cabaret du Lapin Agile, in turn, was a gathering place for a clientele inclined, like Rimbaud, to treat such images with a reverence defined in no small measure by a disdain for the cultural hierarchies that would relegate Gill's much revered rabbit to the lowly status of *enseigne*.

Une révolte qui ne casse rien

Of course a contentious appreciation for low culture is one thing, and an interest in the significative mutability of vernacular forms quite another, especially when those forms are called upon to evoke divergent sets of meaning in constantly changing contexts. It is important to remember here that while Rimbaud's narrator categorically *names* the objects of his affections, Gill's picture *deploys* its vernacular antecedents, reconfiguring them along the way to address its own culturally and historically specific circumstances. So an informed reading of the *enseigne du Lapin Agile* necessarily involves the spectator's awareness not only of the picture's iconographic (and verbal) sources, but also of the conflicting purposes for which those sources had already been made to serve. Gill's pictorial program, after all, draws quite obviously on a familiar species of bacchanalian imagery, the characteristic attributes of which were liable to turn up in a wide variety of social circumstances.

The most commonplace of these images, at least by nineteenth-century standards, was surely *Le Grand Saint Lundi* (Fig. 6.3), a standard theme (reproduced ad infinitum along with its pictorial twin, *La Sainte Bouteille*) of the Péllerin family workshops at Epinal.[12] The print was originally published in 1834 to commemorate the reestablishment of *très-sainte paye* (Holy Pay), a bimonthly holiday for working people who presumably spent their additional free time at the cafés and wine shops where the image was typically posted. Its narrative program is overtly

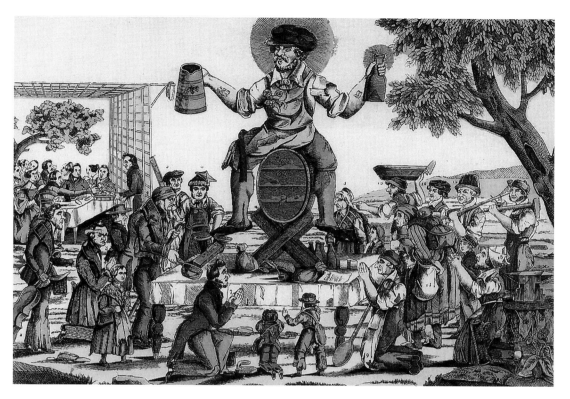

Figure 6.3 Nicolas Wendling, *Le Grand Saint Lundi* (*The Great Saint Monday*), 1834.
Musée départmental d'art ancien et comtemporain, Epinal.

carnivalesque; a lowly cobbler, gargantuan in scale and enthroned on a wine
cask, plays the role of an earthly deity of Dionysian stature who, pitcher in one
hand and carafe in the other, enjoys the devotion of his peers—a devotion he
merits, like Gill's rabbit, by overseeing the distribution of wine. The allusions
here to a symbolic inversion of the social and religious order, to the potentially
disruptive underpinnings of carnival itself, are obvious.[13] Yet *Le Grand Saint
Lundi* evokes containment too, since the bacchanalian hymns that typically
filled the margins in most editions of the print served as warnings about the
effects of various forms of social irresponsibility—from drunkenness and bank-
ruptcy, to loitering and brawling. The confluence of the "carnivalesque" and
secular moralization in these images is no accident; disorder is encouraged in
the fictional world of *Le Grand Saint Lundi*, as long it occurs every other Monday
in an orderly fashion.

Things were not much different in the real world of Parisian cabarets and
wine shops. These were establishments in which misbehavior and orderly

conduct (the former a marketable attraction and the latter a mandate of law, police surveillance, and good business sense) were forced to coexist—sometimes harmoniously, sometimes not.[14] The *enseignes* under which they operated were likely to tell a similar story. In the mid-nineteenth century, for instance, one could drink at the sign of *Le Petit Bacchus* (Fig. 6.4), a classicizing version of *Le Grand Saint Lundi* in which the cobbler's role is assumed by a discretely classless cherub—and the overtones of hierarchical inversion accordingly sweetened. In a late eighteenth-century cabaret *enseigne* (Fig. 6.5), social disorder takes the form of a frolicking drunkard whose most dangerous transgressions are to wear a woman's bonnet and to embrace his bottle of wine. These are images of excess, but of excess within acceptable limits. And it is arguably these same limits that established the boundaries within which oppositional behavior in the Parisian cabarets could transpire without provoking anything more than the usual quotient of police interference.

Back at the Cabaret du Lapin Agile, Gill's *enseigne* apparently toed the same line. The familiar attributes of *Le Grand Saint Lundi* and *Le Petit Bacchus* are reconfigured around a dauntless rabbit whose lowly social status (signified by his working-class *casquette*) is eclipsed by overtures to the folkloric and the comic—to La Fontaine, say, or to Grandville, or to any number of seemingly benign stories and fables in which animals carry on like people. That a diminutive (human) couple looks on in amazement as the rabbit performs his wine-induced miracles hardly does damage to the social and religious order; for despite the topographical accuracy of the image (the Moulin de la Galette appears to the left, and St. Denis in the distant background), the rabbit and his admirers occupy an illusory Montmartre in which allusions to disorder are defused by humor and fictitiousness. A little disorder, however, could go a long way at the Lapin Agile—despite the routine pressures of legality and commerce. Like a handful of other cabarets in the neighborhood, the place would enjoy considerable success throughout the eighties and nineties as bohemia flourished and the police turned a blind eye. Small wonder that in 1897, when the Republic's censors finally began to crack down on the montmartrois cabarets in earnest, a writer for *Le Rappel* would lament the end of a perfectly amenable state of affairs that had lasted for almost two decades: "Nous payons; mais nous chantons: c'est une révolte qui ne casse rien et qui nous suffit" (We pay; but we sing: it's a harmless revolt, and that's enough for us).[15]

Une révolte qui ne casse rien: what better way to describe the chemistry of oppositionality—be it social or pictorial—than to invoke intransigence and containment in the same breath. The amalgam was both safe and marketable

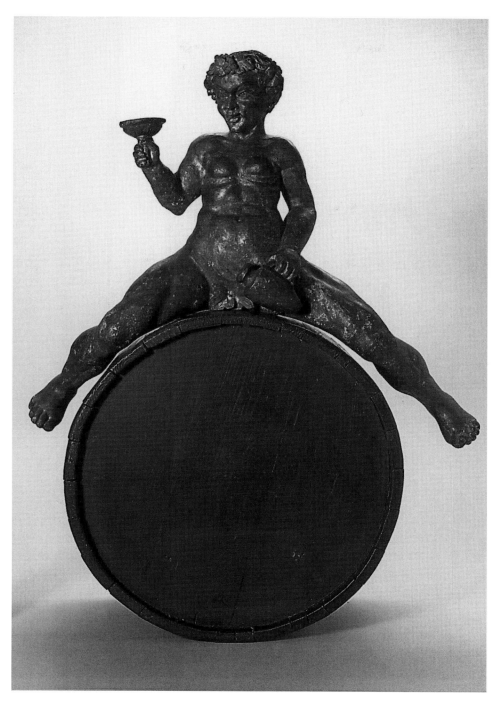

Figure 6.4 Anonymous, *Le Petit Bacchus* (*The Small Bacchus*), 19th century.
Musée Carnavalet, Paris.

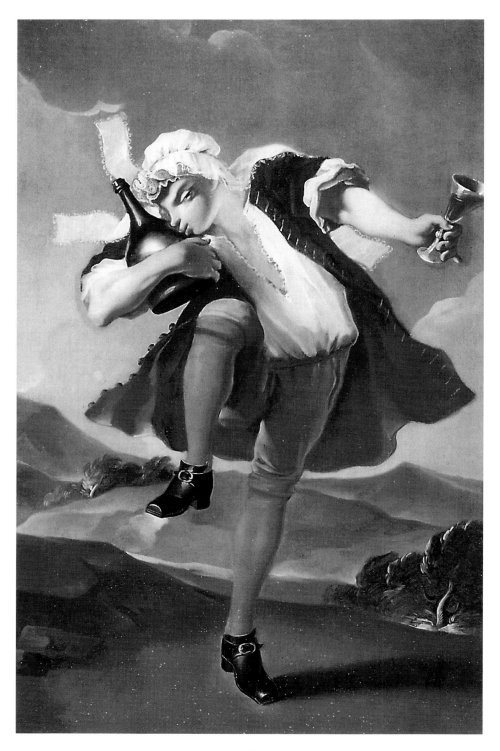

Figure 6.5 Anonymous, *La Bonne Bouteille* (*The Good Bottle*), 18th century.
Musée Carnavalet, Paris.

as long as an appropriate equilibrium was maintained between its constitutive elements. But when the scales were tipped in the direction of intransigence (and the administration of containment accordingly redoubled), the resulting social circumstances could radically change the ways in which pictorial signs of disorder, excess, and hierarchical inversion were deployed and received. Such was the case in the spring of 1871, when the Paris Commune—surely the nineteenth century's high-water mark of collective intransigence—briefly held the capital in open rebellion against a provisional government that had come to power with the fall of the Second Empire a few months earlier. For Adolphe Thiers and the Assemblée Nationale in Versailles, the Commune seemed the very antithesis of social order, a monstrous assault on property and propriety, a *très-sainte paye* gone horribly awry under the direction of the most execrable representatives of the working-class and bohemian Left. For propagandists of similar persuasion, the insurrection's leading celebrities made altogether fitting targets for caricatural programs in which the familiar attributes of a theme like *Le Grand Saint Lundi* could be reconfigured to represent revolution as an unhealthy consequence of popular excess. The bohemian journalist Eugène Vermesch (Fig. 6.6), for example, would find himself obscenely positioned atop the spigot of a wine cask and the inflammatory rhetoric of his widely disseminated revolutionary journal, *Le Père Duchêne*, accordingly likened both to drink and urine; Gustave Courbet (Fig. 6.7), who helped to organize the demolition of the Vendôme column, would see himself transformed into the wine cask itself—as if excess, in his case, had taken human form. These figures were among the earthly deities of an insurgent carnival the Assemblée Nationale wished to suppress, and whose overtures to revolution (Vermesch's *Hébertiste* harangues against the *versaillais*, Courbet's involvement in the destruction of a monument to Napoleonic imperialism) were easily characterized as both seditious and egomaniacal.

À la casserole

The spring of 1871 witnessed a dizzying succession of incidents in which a tenable balance between disorder and containment was destabilized—and to which the Republic duly responded with incendiary artillery, executions, martial law, military courts, press censorship, and mass deportations. The suppression of the Commune was nothing if not thorough. Some twenty-five thousand Parisians died during the so-called "bloody week" in May; by the end of 1871, another forty thousand awaited sentencing in makeshift prisons at Versailles.

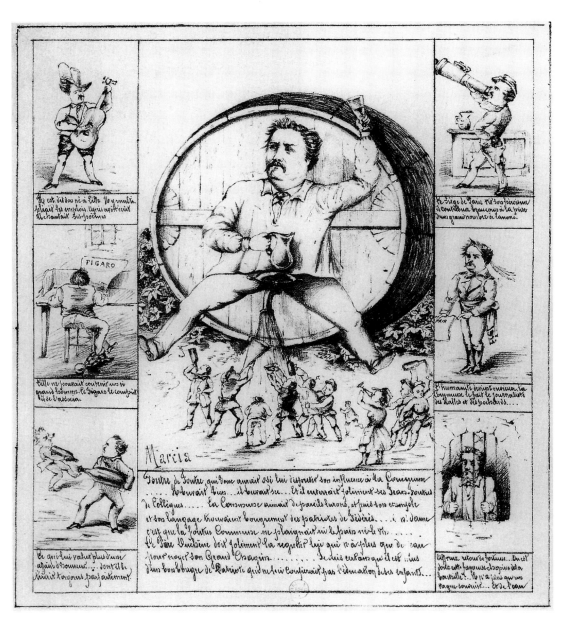

Figure 6.6 Marcia, *Vermesch,* from the series *Les Communards,* 1871.
Bibliothèque Nationale de France, Paris.

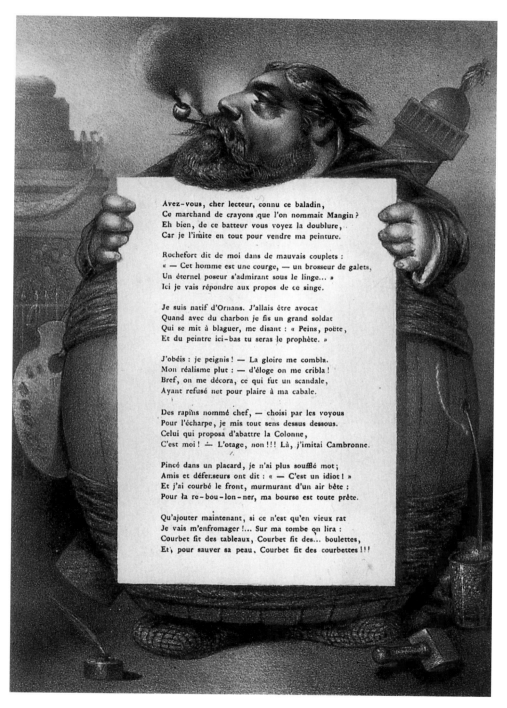

Avez-vous, cher lecteur, connu ce baladin,
Ce marchand de crayons que l'on nommait Mangin ?
Eh bien, de ce batteur vous voyez la doublure,
Car je l'imite en tout pour vendre ma peinture.

Rochefort dit de moi dans de mauvais couplets :
« — Cet homme est une courge, — un brosseur de galets,
Un éternel poseur s'admirant sous le linge... »
Ici je vais répondre aux propos de ce singe.

Je suis natif d'Ornans. J'allais être avocat
Quand avec du charbon je fis un grand soldat
Qui se mit à blaguer, me disant : « Peins, poëte,
Et du peintre ici-bas tu seras le prophète. »

J'obéis : je peignis ! — La gloire me combla.
Mon réalisme plut : — d'éloge on me cribla !
Bref, on me décora, ce qui fut un scandale,
Ayant refusé net pour plaire à ma cabale.

Des rapins nommé chef, — choisi par les voyous
Pour l'écharpe, je mis tout sens dessus dessous.
Celui qui proposa d'abattre la Colonne,
C'est moi ! — L'otage, non !!! Là, j'imitai Cambronne.

Pincé dans un placard, je n'ai plus soufflé mot ;
Amis et défenseurs ont dit : « — C'est un idiot ! »
Et j'ai courbé le front, murmurant d'un air bête :
Pour la re-bou-lon-ner, ma bourse est toute prête.

Qu'ajouter maintenant, si ce n'est qu'en vieux rat
Je vais m'enfromager !... Sur ma tombe on lira :
Courbet fit des tableaux, Courbet fit des... boulettes,
Et, pour sauver sa peau, Courbet fit des courbettes !!!

Figure 6.7 Frédéric Job, *Courbet* (from the series *Les Communeux peints par eux-mêmes*), 1871. Musée Carnavalet, Paris.

Their collective fate, according to a caricature published in *Le Charivari* (Fig. 6.8), likely involved deportation to the labor camps in New Caledonia, where a "native" population of hungry cannibals eagerly awaited the arrival of a ship load of communards doomed to an unsavory existence *à la casserole*. The deportations, in turn, set the stage for years of political squabbling. Between 1871 and 1877, the possibility of granting amnesty to convicted communards was hotly debated in the Assemblée Nationale between radical republicans (for whom amnesty became a cause célèbre) and a monarchist/Bonapartist coalition on the right (for whom amnesty was tantamount to the inauguration of a socialist republic). With the rise of Opportunist republicanism after 1876, however, the "amnesty question" became a matter of political rhetoric in which invocations of justice and mercy were overshadowed by the pragmatics of maintaining power in a parliamentary political system. By the time full amnesty was finally legislated four years later, the Republic had been saved for republicanism—but at the cost of the very principles for which (in the minds of radicals and socialists on the left) republicanism had stood.[16]

This is the tumultuous sociopolitical context in which the *enseigne du Lapin Agile* was born in 1880, and to which its folkloric bearing and carnivalesque visual vocabulary were bound, one way or another, to respond. So it makes sense, I think, to look again at Gill's picture and to wonder about the potential resonance, at the height of the amnesty controversy, of the *casserole*, the working-class *casquette*, and the red sash and tie—particularly as operative attributes of an *enseigne* made for a bohemian cabaret located on the butte Montmartre just a stone's throw away from the site of some of the bloodiest events of the Commune. It also makes sense to look beyond the image's carnivalesque vocabulary for pictorial correspondences of an entirely different order. Alfred Roll's grisly depiction of the execution of a young communard bugle boy (Fig. 6.9) comes to mind, as does any one of the countless illustrations (Fig. 6.10) devoted to the mythic transgressions of the insurgents. These are images of intransigence in which the red sash of the Commune recalls a genuine threat to bourgeois rule, and the familiar joviality of popular carnival is at best a distant memory. We might even compare Gill's *enseigne* to the nineteenth century's most venerable revolutionary painting, Eugène Delacroix's *Liberté guidant le peuple* (1830), if only to open the door to readings that might identify in the agile rabbit an allegory of the Commune, or of the returning *déportés*, or even of *le peuple* itself—still persistent in its revolutionary intransigence despite the violence of the repressions and the disingenuousness of Opportunist politicians.[17]

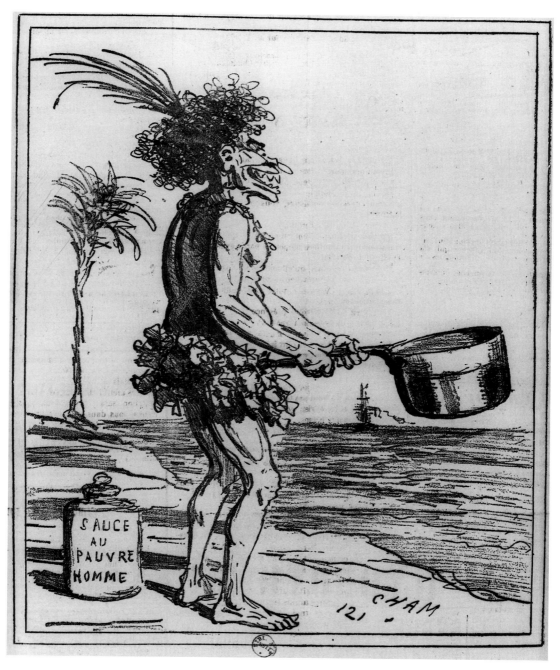

Figure 6.8 Cham, *Les Calédoniens s'apprêtant à gouter de la Commune*
(*The Caledonians Getting Ready to Get a Taste of the Commune*).
Le Charivari, December 13, 1871. Bibliothèque Nationale de France,
Paris.

Figure 6.9 Alfred Roll, *L'Exécution d'un trompette* (*Execution of a Bugler*), 1871.
Musée Carnavalet, Paris.

Figure 6.10 Bertall, *Une citoyenne* (*A Citizen*). From *Types de la Commune*, 1871. Private Collection.

Gill's *enseigne* tempts us with such readings, although fully to indulge them would be to overstate politics and to under-emphasize the degree to which the image leans on its vernacular and commercial antecedents. We are dealing, after all, with a pictorial program in which allegorical signification is already disrupted by promotional overtures to good food and drink. But it is the disruptions that tell the tale, particularly in a political climate in which an officially sanctioned commemoration of the Commune and its participants was virtually inconceivable. For the picture seems to encourage the confusion generated by the simultaneous engagement of incongruous modes of representation. When we ask the rabbit to function allegorically, it coyly invites us to dinner at the Lapin Agile; but when we sit down to enjoy our meal, it serves us the Paris Commune, as well as a pointed reminder that under different circumstances it might well be the rabbit who does the cooking. The comedic bearing of the image, in other words, veils a threat of immanent hierarchical inversion, of violence, of revenge—a threat more openly invoked in the revolutionary tradition by implacable firebrands like Le Père Duchêne (Fig. 6.11).[18] This kind of slippage is at the heart of the matter, for the balancing act Gill's *enseigne* performs strikes me as nothing less than strategic, as if its significative agility were wielded to ensure the survival of a set of oppostional practices that only stood to lose in 1880 by being named. To have named them, of course, would have been to call off the daring acrobatics and to end up permanently *à la casserole*. And it would have meant relinquishing the protective indecipherability that made it possible for a commercial emblem of harmless bohemian disobedience to double as a commemorative monument to the Paris Commune.

La Représentation synthétique

Within a decade, the vogue for harmless disobedience in Montmartre had been eclipsed by the commercial resurrection of the same bals publics that had implicitly served during the eighties to legitimate bohemian claims to popular marginality. Disobedience had in turn become a highly profitable spectator sport, the most fashionable loci of which were frenzied performances of popular forms of dance like the cancan, the quadrille, and the *chahut*. For Zidler, whose Moulin Rouge set new standards among Parisian dance halls for garish extravagance and chintzy glamour, the formula for success was simple: to create an establishment "dont la femme vénale serait la reine, une sorte de luxeux marché d'esclaves, avec cette différence que ces esclaves bénévoles seraient les filles les plus huppées du moment" (in which the venal woman would be queen,

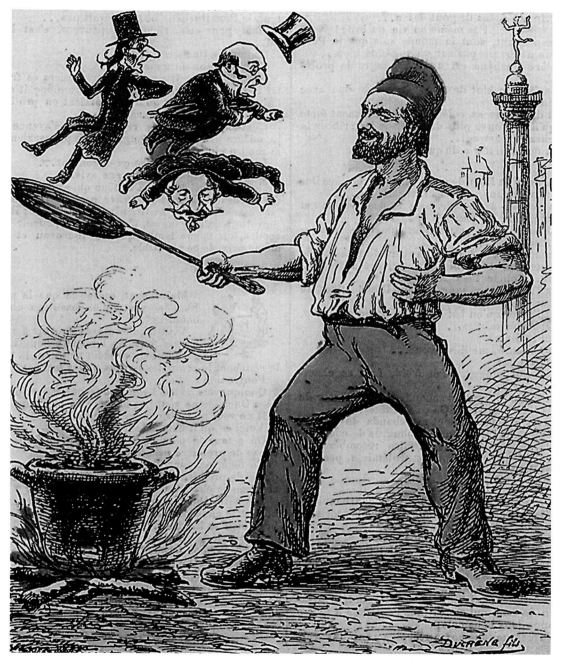

Figure 6.11 Anonymous [Duchêne fils], *"Chaud! Chaud! Les Marrons!"*
("Hot! Hot! The Chestnuts!"), *Le Père Duchêne*, 17 Frimaire an 87
(November-December 1878).

a sort of luxurious slave market, the difference being that these unpaid slaves would be the classiest broads around).[19] *Huppées* or not, dancers of lower-class origin like La Goulue and Grille d'Egout were all the rage, precisely because the frenetic athleticism and impertinent vulgarity of their routines could be reproduced night after night to eager audiences who paid heed more to the apparently spontaneous unleashing of popular *jouissance* than to the generic procedures of production and promotion that made *esclaves bénévoles* of Zidler's most insolent dancing *reines*. This new situation, called for new modes of oppositional representation, which meant that the strategies that had served Gill so well a decade earlier would need reconfiguring. Hence the appearance of the generic procedures of production and promotion in another context, in the pretentious and presumably less commercial context of avant-garde painting—in a context, I want to argue, in which the implications of genericism mutate dramatically.

This is not to suggest that Seurat's *Chahut* (Fig. 6.12) is a "generic" painting. Or perhaps it is, since the picture fairly smacks of mechanical procedures, and since the absence of the article "le" in the title seems to allude to performances of the *chahut* in a generic (rather than a particular) sense.[20] The term "synthetic" also comes to mind, especially because it appears prominently in the artist's so-called *L'Esthétique* (Fig. 6.13) of 1890, as well as in an 1891 article on Neo-Impressionism in which Paul Signac described Seurat's work as "la représentation synthétique des plaisirs de la décadence: bals, chahuts, cirques" (the synthetic representation of the pleasures of the decadence: dance halls, chahuts, circuses).[21] By "synthétique," Signac apparently meant a process of representing the world through operations in which "on réunit des corps simples pour former des composés, ou des corps composés pour en former d'autres d'une composition plus complexe" (one combines simple bodies to form compounds, or compound bodies to form others of a more complex composition).[22] The definition is Littré's, and it corresponds quite accurately to what we know about Seurat's somewhat overblown theories about tone, color, line, and, perhaps most importantly, the behavior of the retina itself when it responds to luminous stimulation. These theories—drawn piecemeal from the likes of Charles Blanc, Ogden Rood, Charles Henry, and Eugène Chevreul—were at the center of Seurat's enterprise, or so it seemed at the time.[23] The underlying assumption then, as it is in much of the literature on Seurat today, was that the artist's "synthetic" methods were scientifically oriented toward the optical re-creation of the Real, and that just the right combination of little dots of paint could stimulate a synthetic interaction on the spectator's retina that might approach, within the

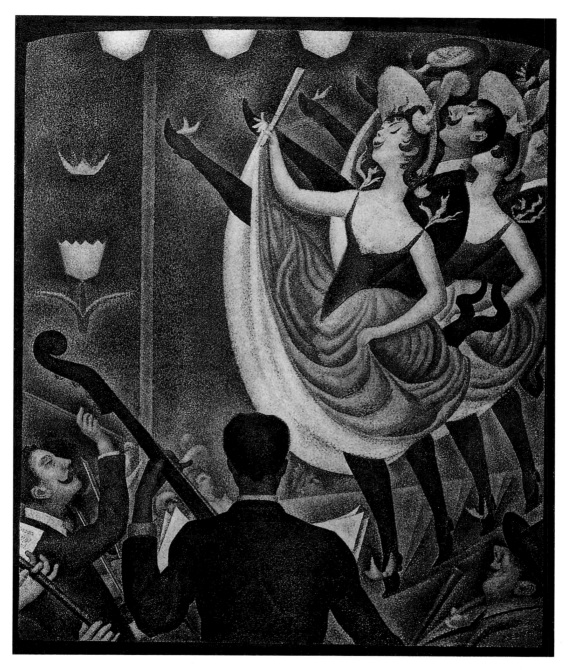

Figure 6.12 Georges Seurat, *Chahut*, 1889–90. Oil on canvas, 66 7/8 x 54 3/4"
(171.5 x 140.5 cm). Rijksmuseum Kröller-Müller, Otterlo.

Le Triste de ton c'est la dominante sombre de teinte
la dominante froide et de ligne les directions
abaissées.

Technique

Étant admis les phénomènes de la durée de l'impression
sur la rétine ~~sont les mêmes~~ lumineuse

~~Le moyen d'expression sera synthétique~~

La synthèse s'impose comme résultante
le moyen d'expression est le Mélange optique
des tons des teintes (de locales et de la couleur
éclairante soleil lampe à pétrole gaz etc) c'est à dire
des lumières et de de leurs réactions (ombres)
suivant les lois du contraste de la dégrada-
tion de l'irradiation.

Le cadre ~~n'est plus~~ ~~comme consent~~
est ~~dans l'~~ harmonie opposée à celle des tons
des teintes et lignes du ~~motif~~ Tableau

Figure 6.13 Georges Seurat, *L'Esthétique* (unfinished letter to Maurice Beaubourg; page three of the fourth draft, 1890). Musée Carnavalet, Paris.

obvious limitations of the medium of painting, a luminous simulation of something seen out there in the world. Yet it seems clear that for all its remarkable visual effects, the one thing a picture like *Chahut* does *not* do is simulate the Real. What it produces instead is an imposed distance from the Real, almost as if the stubborn visibility of all the vibrating dots of paint—not to mention the unnatural coloration and the impossible rigidity of the figures themselves—was devised to provoke a suspension of the spectator's willing suspension of disbelief.

"Disbelief" is the key word here, and it points to the now rather banal celebration of Modernism's self-conscious obsession with "medium," "process," and the "means of representation."[24] Not that the old clichés are worn out or discredited—far from it. But there are ways in which the incredulity engendered by Seurat's work suggests more than a simple question of the primacy of medium and materials relative to the articulation of illusionary space (and of the people or things that occupy that space). What, one might ask, does a picture like *Chahut* want us to disbelieve? Or, to put it another way, how does this painting draw attention to certain modes of representation that warrant our disbelief as much as the visual behavior of the painting itself? The answer has to do with the artist's choice of themes for his last large-scale pictures—apparently the same "plaisirs de la décadence" that constituted the backbone of Montmartre's entertainment industry. It also has to do with the engagement of Seurat's synthetic techniques in relation to his ostensible motif— "ostensible" because the degree of frozen artificiality in *Chahut*, of rigid geometry, pleonastic repetition, and overt caricature, makes it difficult to see the dancers, the musicians, or the spectators without sensing the presence of a mediating agency, of a form of production or packaging, operating somewhere amid the tiny dots of color and the performance they presumably represent. The point is that the picture wants us to see that mediating agency as clearly as we see the spectacle, the applications of paint, and the determining procedures by which spectacle and paint are made (uneasily) to coalesce. Plainly stated, *Chahut* addresses itself to the modes of representation with which the world of montmartrois entertainment had learned to represent itself: promotional posters, commercial hype, the "staging" of presumably popular forms of dance. These modes of representation, the painting seems to tell us, warrant a suspension of our willing suspension of disbelief.

Démonter les moyens d'expression

Chahut was painted in the fall and winter of 1889–90, during the deluge of promotional fanfare that attended the opening of the Moulin Rouge—at precisely

the moment, that is, when public interest in popular dance and bals publics had reached a feverish pitch. Zidler hoped to draw on the crowds already generated by the Republic's extravagant Universal Exhibition, and to lead them to Montmartre in search of a set of diversions that were unavailable on the Champs de Mars. His publicity campaign accordingly included a widely disseminated series of posters by Jules Chéret, whose stock-in-trade nymphs enticingly hawked the popular amusements to be enjoyed at the latest montmartrois nightspot. Daniel Halévy, a long-time denizen of the neighborhood, was unimpressed:

> Une affiche, peinte par Chéret, annonça aux Parisiens les nouveaux plaisirs qui leur étaient offert. Quelle apparition féerique sur nos murs! Une danseuse, une fille rapide enlevée dans ses gazes, les bras ouverts, à peine liée au sol; et ce fond d'ombre et de lumière, ces profondes nuances de crépuscule urbain que notre grand décorateur a si bien vues, fixées. L'affiche était féerique, mais n'annonçait aucune féerie. La Goulue et Grille d'égout, danseuses du *Moulin-Rouge*, savaient, du bout de leurs pieds, basculer les hauts de forme sur les têtes de leurs admirateurs, et à l'art de la danse n'ont ajouté nulle autre figure. C'est peu.

> [A poster by Chéret announced to Parisians the new pleasures available to them. What a mysterious apparition on the walls of our city! A dancer, a sprightly girl wrapped up in translucent gauze, her arms open, barely touching the ground; and this background of shadow and light, these profound nuances of urban twilight that our great decorator saw, and recorded, so well. The poster was enchanting, but what it advertised was not. The Moulin Rouge's dancers, La Goulue and Grille d'égout, knew how to kick the top hats off the heads of their admirers, and contributed nothing else to the art of dance. The contribution was negligible.][25]

What rankled Halévy was the distinction between the goods promised in Chéret's posters and those delivered at the Moulin Rouge; and he was no doubt irritated by the extent to which promotional promises could effect an audience's perception of the goods delivered—especially when the large majority of the audience in question neither knew nor cared about genuine contributions to *l'art de la danse*. But Zidler's productions had less to do with dance per se than with the invocation of specifically popular forms of dance in a context determined by the systematized parameters of mass marketing. The implicit tension between the two—between the complex mandates of commercial promotion and the mnemonic residuum of disorder, transgression, and social inversion associated with popular culture—is what animated the entire operation. Small wonder that the Moulin Rouge attracted the attention of curmudgeonly intellectuals like Halévy, of the vice squad, and of virtually everybody in between.

The contradictions inherent in Zidler's project—and in the larger workings of mass culture in general—were precisely what made it interesting.

They are also what makes *Chahut* interesting, and what saves it from acting out a plodding rehearsal of optical theory or a transparent critique of commercial culture. If nothing else, the picture is an exercise in contradictions, a performative meditation on the incongruities of modern spectacle. Its optical irresolvability—the unrelenting complementary collisions of orange/blue, red/green, and yellow/violet—is only the most obvious of the visual metaphors at work here. For nowhere in the image is the spectator permitted to take refuge in a singular, integral mode of representation. To look for agreements of form, for a logic of geometry, rhythm, and composition, or for (Apollonian) order of any kind is to run headlong into comedic passages of the utmost vulgarity. The erectile cane held by the porcine spectator to the lower right; the hypnotized gaze of the conductor, who looks directly up the skirt of the principal dancer; the diddling little finger of the bassist; the severed hands of a flutist, who fingers a cylinder of indeterminate constitution: these are (Dionysian) passages that bring uncritical celebrations of optical science and aesthetic consonance to a grinding halt. Yet the picture is redolent with order too, so much so that its comedic elements are wholly circumscribed within a pictorial system to which they are entirely foreign, and from which they acquire a bizarre solemnity. The resulting instability is both visual and significative, and it generates a perpetual contrariety informed on the one hand by an elaborate display of representational mechanics and on the other by a mischievous foray into bawdy humor—neither of which sustains meaning independently of its inconsonant counterpart.

Gustave Kahn, whose 1891 analysis of *Chahut* was the most extensive produced by any of Seurat's friends and contemporaries, saw a related set of contradictions at work in the painting: the opposition, as he put it, between "la beauté de la danseuse" (the dancer's beauty) and "la laideur de l'admirateur" (her admirer's ugliness) and between "le faire hiératique de cette toile et son sujet, une contemporaine ignominie" (the hieratic configuration of this canvas and its subject, a contemporary infamy).[26] Kahn's critical system, of course, hinges on a traditional set of binaries (beauty/ugliness, sacred/profane, form/content), as well as a conventional Symbolist conviction that meaning is to be found "dans l'interprétation d'un sujet and non dans le sujet" (in the interpretation of a subject rather than the subject itself). Yet by identifying *Chahut*'s "sujet" in negative terms (as an "ignominie" rather than a *phenomenon*), he performs an interpretive intervention of his own, while at the same time proposing that an authentic set of (allusive) meanings is to be discovered

uniquely in Seurat's "interprétation" of that same "sujet." The inconsistencies at work here are both epistemological and heuristic and they anticipate the critical drift (from hermetic analyses of technique and style, to contextually grounded studies of "subject matter") of a large part of twentieth-century Seurat scholarship. But what I take to be Kahn's most consequential oversight is perhaps the least conspicuous: the implicit assumption that *Chahut*'s subject matter (ignominious or not) is itself simplistic, significatively fixed, and more to the point, self-evident. For everything we know about the production of popular culture in fin-de-siècle Montmartre suggests that its power lay precisely in its complexity, in its abstruse juggling of commerce and carnival, and in the incessant arbitration it enacted between *reines* and *esclaves bénévoles*, between goods promised and goods delivered, between mercantile order and popular *jouissance*. Chahut's subject matter, in other words, was itself a site of mediation and contrariety—well before it underwent the interpretive intervention of the artist.

Nowhere is this more apparent than in Seurat's notorious "borrowings" from Chéret—France's preeminent poster-artist, the winner of a gold medal at the Universal Exhibition of 1889, and the inventor of an erotic feminine stereotype that was surely a component part of *Chahut*'s pictorial program.[27] The painting's central figure, after all, seems like a synthetic composite of any number of the alluring nymphs with which Chéret had populated the streets of Paris (Fig. 6.14). The narrow waist and attenuated legs; the automatic smile; the apparent ability to hover, legs provocatively splayed, in mid-air: these were Chéret's most marketable trademarks, and the focus of a discourse that extended well beyond critical admiration of his dexterous draftsmanship and his innovations in color lithography. According to Yvanhoé Rambosson:

> La production la plus caractéristique de la verve de Chéret, c'est sans contredit sa Femme, cette femme irréelle et pour ce pleine d'attirance, à la taille tendant vers *moins l'infini* et aux jambes vers *plus l'infini*. Cette femme disloquée . . . qui est plutôt une flamme qu'une femme.
>
> [The invention most characteristic of Chéret's wit is surely his Woman, this unreal—and therefore extremely charming—woman, whose waist is as infinitely narrow as her legs are infinitely long. This elastic woman . . . who is more like a fantasy than a female.][28]

Desirability, for Rambosson, issues from an immoderately lithe, nubile body that, well beyond the physical tolerance of human anatomy, has been squeezed, stretched, and compelled to perform impossible contortions. The indices of sexual precocity and masculine authority thus hyperbolized, the typical *chérette* (as

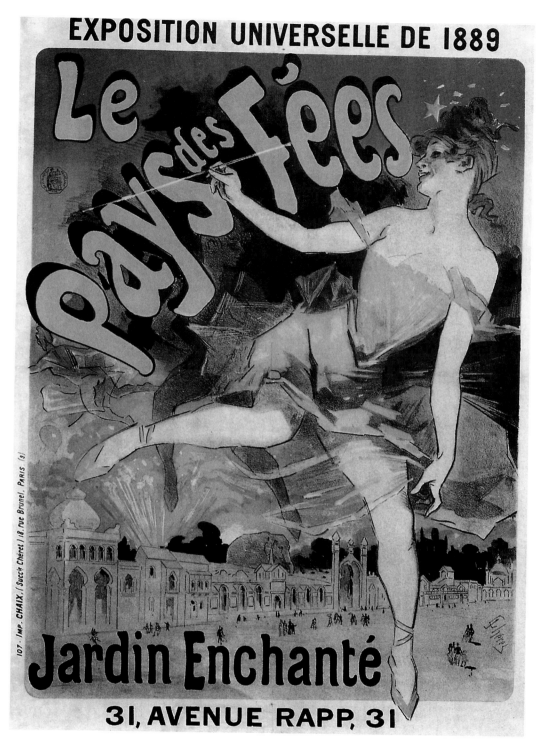

Figure 6.14 Jules Chéret, *Le Pays des Fées* (*The Land of the Fairies*), 1889.
Musée Carnavalet, Paris.

these nymphs came to be called) could cast an erotic glow on virtually any con-
sumer product, from a glitzy tourist attraction at the Universal Exhibition to the
most mundane of household products. That she was overtly "irréele" seemed
only to encourage speculation about her personality, moral character, and social
background. Rambosson continues:

> C'est l'élégante des Watteau qui s'est, dans les Mabiles et les Bulliers
> modernes, encanaillée un peu à fréquenter des calicots et des étudiants. Elle
> n'en a pas moins, pour être devenue *patte-en-l'air* et *forte-en-gueule*, conservé
> cette je ne sais laquelle aristocratie de la fleur et du papillon.

> [One of Watteau's fashionable ladies has gone slumming at the modern-day
> Mabilles and Bulliers in the company of clerks and students. Despite her
> appetite for high-kicking and hollering, she has mysteriously maintained the
> aristocratic grace of a flower and of a butterfly.][29]

The juxtaposition here of contradictory terms—the "patte-en-l'air" who main-
tains the "aristocratie" of a flower or a butterfly—attests both to the erotic
power of Chéret's feminine ideal and to an unstable social identity that fluctu-
ates wildly between virtue and promiscuity, between rococo elegance and the
less seemly environment of the dance hall or the *musette*.[30] Like a Galatea to the
general public's Pygmalion, the *chérette* possesses every imaginable charm, while
hovering tantalizingly between a material world of recognizable social codes
and an illusory realm of pure eroticism.

That she seems somewhat less charming in *Chahut* is to be expected, since
her appearance in the picture is dictated both by the repetitive patterns of lines
and angles that hold her compositionally in place, and by the quivering dots of
color that threaten to dissolve her even as they give her form.[31] This strict regi-
men of pictorial procedures serves to harness the operative erotic signifiers upon
which the *chérette*'s allure (and promotional efficacy) depend, and then to exag-
gerate them: her nubility, with a longer pair of legs, splayed further apart; her
sexual subservience, with the highly orchestrated contortions she now performs
for the sake of admirers and compositional integrity alike. Thus reconfigured,
the evocation of erotic charm in *Chahut* becomes a matter of mechanics, and
seductive illusionism the progeny of transparent artifice. Emile Verhaeren got it
right when he explained in 1891 that Seurat's interest in Cheret's posters was
"démonter les moyens d'expression et surprendre les secrets esthétiques" (to
deconstruct the means of expression and discover the aesthetic secrets).[32] For as
surely as it conjures her up, *Chahut* enacts a piece-by-piece *démontage* of Chéret's
commercial seductress before our eyes—and suspends her, stripped bare, in a

visual world that shifts wildly between aesthetic order and ribald humor, between optical science and the science of promotion, between the dance halls of Montmartre and their eerie pictorial equivalent.

This incessant shifting insulates the picture from the kinds of univalent interpretation that would make of it a zealous celebration of positivism or a venomous critique of capitalism—or any other order of *peinture idiote*. Its slipperiness, however, is more than a matter of pictorial sleight-of-hand, since the pictorial focus in *Chahut* on both the promotional procedures of mass culture and the formal procedures of painting makes it difficult to tell where the "sujet" ends and "l'interpretation d'un sujet" begins. So it is entirely appropriate that the respective domains of commercial and aesthetic production appear in the image as sites of perpetual mediation, as wobbly fabrications built of contraries and inconsistencies, as operative catalysts, finally, of an interpretive incredulity warranted in equal measure by the manufactured clamor of popular culture, by the rarified conceits of art-making, and by a cultural hierarchy that would figure an exclusionary relationship between the two.

La Synthèse

This is not to suggest that *Chahut* breaches some axiomatic barrier between "art" and "life." That would be to simplify both terms in the face of a picture that wants to complicate them. But it is worth noting that Seurat's last three large-format paintings—*Parade de cirque, Chahut,* and *Cirque*—were engaged with the visual culture of the street in a way that was entirely unique among late nineteenth-century realist projects, precisely because they involved an examination of *promotional representations of modern life rather than modern life itself.* And it is also worth noting that after having looked hard at a picture like *Chahut,* it becomes increasingly difficult to breath in the erotic fragrance of the typical *chérette* without catching wind of the unmistakable scent of genericism and cheap effect. It is here, perhaps, that the "synthetic" nature of Seurat's paintings comes to bear on a critical discourse operating outside the walls of the studio or the Salon des Indépendants. One need only imagine the merging of a spectator's visual impressions of a picture like *Chahut* with residual memories of promotional images seen everyday in the street to conceive of a synthetic composite of a cognitive order, one that would potentially involve a reconstruction of consciousness itself. The resulting critical vision might well make disbelievers out of believers, while dismantling the synthetic representations of a commercial culture

for which the reconstruction of consciousness and "good business" are one and the same concern.

This is speculative territory, of course, although consciousness and image-making are perhaps more closely related than we would like to think, especially where promotional interests are concerned. It is in this same speculative territory that we might wonder about the strange convergence in Seurat's *L'Esthétique* of an elaborate plan for the systematization of the art of painting with a quasi-psychological study of automatic human response—the implications of which, in the less aesthetic world of advertising and politics, bring to mind unpleasant notions of persuasion and control. What is *not* speculative is the consistency with which Seurat's last major pictures address simultaneously the visual mechanics of commerce and painting alike. Nor is it speculative to see in fin-de-siècle popular culture a powerful composite of image, myth, and promotion designed to provide its audiences with harmless doses of marginal entertainment. Its strength lay in its capacity to recast the interests of *le peuple* in commercial terms—and in the apparent seamlessness of the resulting representations. A picture like *Chahut*, on the other hand, is replete with seams, and demands conscious reflection to the point that it is virtually impossible, standing before the image, to partake of popular culture without paying heed to the image-makers, or to consider the persuasiveness of mass publicity without remarking upon the synthetic nature of its most powerful illusions.

Coda

Which brings us back to *L'Alchimie du verbe*, and to a refined taste for *les peintures idiotes*. In a world enamored of slick artifice and instant gratification, Rimbaud's love for low cultural forms makes perfect sense, especially since it demands of his readers to conceive of "love" in ironic rather than literal terms—and in so doing to join an exclusive caste of readers who know slick artifice and instant gratification when they see it. Membership has its risks, however, for it is well to remember that the acrobatics performed by pictures like Gill's and Seurat's generate an endless cycle in which the satisfaction of "getting it" necessarily involves the fear of "not getting it," and comprehension itself becomes a matter of contrariety, of incessant doubleness, in which wisdom and foolishness precariously intermingle and the interpreter is made to acknowledge the capacity in human consciousness for both.

For Charles Baudelaire, the general effect of such "phénomènes artistiques" was to make manifest "dans l'être humain l'existence d'une dualité permanente,

la puissance d'être à la fois soi et un autre" (the existence in the human being of a permanent duality, the power to be one's "self" and an "other" at the same time).[33] From within the fraught political context of 1880, this *dualité* emerges in Gill's *enseigne* in the form of a recalcitrant *soi* compelled by an authoritarian political *autre* (of which the former, as citizen, is a constituent) endlessly to negotiate the tensions between Romantic myths of individuality and the dehumanizing power of a parliamentary government that counts people like numbers. In *Chahut*, a reflective *soi* and its guileless *autre* undergo further commingling amid the technical operations (both aesthetic and promotional) of a visual machine that subjects the distinctions between fascination and revulsion, between complicity and critique, to an interminable—and irresolvable— process of synthetic interaction. But in both pictures, it is the persistent instability of ironic figuration itself—and the uneasy significative shifting upon which irony depends—that makes of this same *dualité* a disconsolate effect of seeing, of interpretation, of (in)comprehension. As for the anonymous consumer of fin-de-siècle Monmartre's popular distractions, finally, the specter of disconsolation may well have passed unnoticed, despite the nagging contradictions implicit in a form of entertainment contrived to produce, on a nightly basis, *un révolte qui ne casse rien.*

NOTES

1. On Gill, see especially Charles Fontane, *Un Maître de la caricature: André Gill, 1840–1885*, 2 vols. (Paris: Editions de l'Ibis, 1927). See also Armand Lods et Véga, *André Gill: sa vie, bibliographie de ses oeuvres* (Paris: Léon Vanier, 1887); Jean Valmy-Baysse, *André Gill, l'impertinant* (Paris: Editions du Félin, 1991); Jean Frapat, ed., *André Gill, 1840–1885* (Paris: Musée de Montmartre, 1993).
2. On the contestability of popular culture, see Stuart Hall, "Notes on Deconstructing 'The 'Popular,'" in *Peoples' History and Social Theory*, ed. Raphael Samuel (London: Routledge and Kegan Paul, 1981), 229–239.
3. Arthur Rimbaud, *Oeuvres complétes* (Paris: Gallimard, 1972), 106 (my translation).
4. For related arguments, see Thomas Crow, "Modernism and Mass Culture in the Visual Arts," in *Pollock and After: The Critical Debate,* ed. Francis Frascina (New York: Harper and Row, 1985), 233–266.
5. On the Chat Noir and bohemianism in Paris, see Jerrold Seigel, *Bohemian Paris: Culture, Politics, and the Boundaries of Bourgeois Life, 1830–1930* (New York: Penguin, 1986), 215–241. See also Mariel Oberthür, ed., *Le Chat Noir* (Paris: Editions de la Réunion des Musées Nationaux, 1992); André Velter, *Les Poètes du Chat Noir* (Paris: Gallimard, 1996).
6. On the *montmartrois* cabarets, see Anne de Bercy and Armand Ziwès, *A Montmartre, le soir* (Paris: Grasset, 1951); Michel Herbert, *La Chanson à Montmartre* (Paris: La Table Ronde, 1967); Maurice Donnay, *Autour du Chat Noir* (Paris: Grasset, 1926). On artistic production in Montmartre, see Phillip Denis Cate and Mary Shaw, eds., *The Spirit of Montmartre: Cabarets, Humor, and the Avant-Garde, 1875–1905* (New Brunswick,

NJ: Rutgers University Press, 1996); Sylvie Buisson and Christian Parisot, *Paris-Montmartre: les artistes et les lieux* (Paris: Editions Pierre Terrail, 1996); John Grand-Carteret, *Raphaël et Gambrinus* (Paris: E. Dentu,1888).

7. On dance halls, see Georges Montorgueil, *Paris dansant* (Paris: Théophile Belin, 1898) and André Warnod, *Les Bals de Paris* (Paris: Editions Georges Crès, 1922).

8. For a comprehensive history of nineteenth-century Montmartre, see Louis Chevalier, *Montmartre du plaisir et du crime* (Paris: Editions Robert Laffont, 1980).

9. Gill's picture was sold into private ownership in 1883. The *enseigne* in this photograph (ca. 1900) is an anonymous fin-de-siècle copy of the original.

10. See, for example, the entry on "casserole" in Charles Virmaître, *Dictionnaire d'argot fin-de-siècle* (Paris: A. Charles, n.d.).

11. See Edouard Fournier, *Histoire des enseignes de Paris* (Paris: E. Dentu, 1884); see also the entry on "enseigne" in *Le Grand Larousse du XIXe siècle*.

12. On the production of *imagerie populaire* in France, see Denis Martin, *Images d'Epinal* (Québec: Editions de la Réunion des Musées Nationaux, 1995).

13. To invoke "carnival" and the "carnivalesque," of course, is to refer to Mikhail Bakhtin's *Rabelais and His World*, trans. H. Iswolsky (Cambridge, MA: The MIT Press, 1968) as well as the ongoing critical discourse it has spawned. For an excellent summary, see Peter Stallybrass and Allon White, *The Politics and Poetics of Transgression* (Ithaca, NY: Cornell University Press, 1986), 1–26.

14. For a discussion of disobedience in the context of French cafés, see Susanna Barrows, "Parliaments of the People: The Political Culture of Cafés in the Early Third Republic," in *Drinking: Behavior and Belief in Modern History,* ed. Susanna Barrows and Robin Room (Berkeley and Los Angeles: University of California Press, 1991), 87–97.

15. *Le Rappel*, April 6, 1897, 1.

16. On the political aftermath of the Commune, see Jean T. Joughin, *The Paris Commune in French Politics, 1871–1880*, 2 vols. (Baltimore, MD: Johns Hopkins University Press, 1955).

17. It is noteworthy that Fontane's 1927 biography contains a "facsimile" of Gill's *enseigne* drawn "from memory" (in the absence of the original), in which the rabbit wears a red, white, and blue sash. It is also noteworthy that when the picture was rediscovered after fifty years of private ownership, it turned up in the collection of the socialist critic Adolphe Tabarant—who presumably would never have confused the color red for the tricolor red, white, and blue. See Fontane, *Un Maître de la caricature*, I:121.

18. The denizens of the frying pan in this instance are the symbolic figureheads of monarchism, Bonapartism, and the conservative Republic. See *Le Père Duchêne*, 17 Frimaire an 87 (November-December 1878).

19. Cited in Warnod, *Les Bals de Paris*, 22 (my translation).

20. This last observation is Jean-Claude Lebensztejn's, whose *Chahut* (Paris: Hazan, 1989) is the most thoroughgoing and provocative study of the painting. For comprehensive studies of Seurat, see Meyer Schapiro, "Seurat," *Modern Art, 19th and 20th Centuries: Selected Papers* (New York: George Braziller, 1979), 101–109; Richard Thomson, *Seurat* (Oxford: Phaidon Press, 1985); Robert L. Herbert, *Georges Seurat, 1859–1891* (New York: Abrams/The Metropolitan Museum of Art, 1991); Paul Smith, *Seurat and the Avant-Garde* (New Haven and London: Yale University Press, 1997).

21. Paul Signac [Un Impressionniste Camarade], "Impressionnistes et Révolutionnaires," *La Révolte* June 13–19, 1891, 3–4 (my translation). Seurat's *L'Esthétique* (unfinished drafts of a letter the artist wrote, but never sent, to Maurice Beaubourg) exists in four versions, the last of which (Fig. 6.13) I reproduce here. The term "synthèse" appears in the following lines: "Etant admis les phénomènes de la durée de l'impression

lumineuse. . . . La synthèse s'impose comme résultante." On Seurat's *L'Esthétique*, see Herbert, *Seurat, 1859–1891*, 372–373, 381–383.

22. E. Littré, *Dictionnaire de la langue française* (Paris: Hachette, 1873). See the entry on "synthèse" (my translation). In the context of fin-de-siècle Paris, of course, the term "synthèse" could mean many things, particularly among artists (Paul Gauguin, Emile Bernard, the Nabis) more closely aligned than the Neo-Impressionists to the Symbolist movement. For detailed analyses, see Michael Marlais, *Conservative Echoes in Fin-de-siècle Parisian Art Criticism* (University Park: Pennsylvania State University Press, 1992), 72–76; H. R. Rookmaker, *Gauguin and Nineteenth-Century Art Theory* (Amsterdam: Swets and Zeitlinger, 1972), 176–186.

23. For a reevaluation of Seurat's "scientific" sources, see John Gage, "The Technique of Seurat: A Reappraisal," *Art Bulletin* 69:3 (1987): 448–454.

24. Clement Greenberg's, of course, are among the most often cited foundational texts of modernism's formalist trajectory. See, for example, "Modernist Painting," in Clement Greenberg, *The Collected Essays and Criticism*, 4 vols., ed. John O'Brian (Chicago: University of Chicago Press, 1986).

25. Daniel Halévy, *Pays parisiens* (Paris: Grasse, 1932), 65 (my translation).

26. Gustave Kahn, "Seurat," *L'Art moderne*, April 5, 1891, 107–110 (my translation).

27. On Seurat and Chéret, see Robert L. Herbert, "Seurat and Jules Chéret," *Art Bulletin* 40:1 (1958): 156–158. See also Ségolène LeMen, *Seurat et Chéret: Le peintre, le cirque, et l'affiche* (Paris: CNRS Editions, 1994).

28. Yvanhoé Rambosson, "Psychologie des Chéret," *La Plume*, November 15, 1893, 499–501 (my translation).

29. Ibid.

30. This same quotient of social instability was underscored by Georges d'Avenel, who described the typical *chérette* as "la représentation d'un femelle aux traits chiffonnés, moitié princesse de féerie et moitié 'gigolette.'" See Georges d'Avenel, "Le Mécanisme de la vie moderne: la publicité," *Revue des Deux Mondes*, February 1, 1901, 659.

31. For a diagramatic interpretation of the linear system at work in *Chahut*, see William Innes Homer, *Seurat and the Science of Painting* (Cambridge, MA: The MIT Press, 1964), 225.

32. Emile Verhaeren, "Georges Seurat" (1891), in *Ecrits sur l'art (1881–1892)*, ed. Paul Aron (Brussels: Editions Labor et Musée de la littérature, 1997), 424 (my translation).

33. Charles Baudelaire, "De l'essence du rire" (1855), *Oeuvres complètes*, vol. 2 (Paris: Editions Gallimard, 1976), 543 (my translation). For related arguments, see Paul de Man, "The Rhetoric of Temporality," in *Blindness and Insight: Essays in the Rhetoric of Contemporary Criticism* (Minneapolis: University of Minnesota Press, 1983), esp. 208–228.

Portrait of the Artist
as a Louis XIII Chair

MICHAEL L. J. WILSON

Montmartre has, throughout its long history, attracted artists, composers, and writers. Members of the art world have been interested for centuries in Montmartre's panoramic views and picturesque character; beginning in the mid-nineteenth century they were also drawn by the inexpensive housing and studio space Montmartre afforded. Alerted to the neighborhood's charms by the Impressionists, the naturalist writer Paul Alexis in 1881 noted that Montmartre was rapidly becoming "the new Latin Quarter."[1] What he could not have predicted was that by the mid-1880s Montmartre would become a center of bohemian life more vibrant and important than the Latin Quarter.

"Bohemia" is generally understood to be a subculture common to modern Western societies but with a distinctly French origin. Bohemia is a self-chosen community, loosely associated with marginality, youth, poverty, devotion to art, and rebellious behaviors and attitudes. In the 1830s, when bohemia was first identified and celebrated as a precinct of artistic life, observers felt it was not just a French phenomenon but a uniquely Parisian one. In the words of its most famous chronicler, Henry Murger, "Bohemia only exists and is only possible in Paris."[2] Murger devotes five pages of the preface to the *Scènes de la Vie*

de Bohème to detailing an illustrious genealogy for bohemia, one beginning with Rabelais and Villon and continuing through the canonical figures of French literature. Bohemia, in this rendering, is a central part of the national patrimony.

By the fin de siècle, the history of bohemian Paris, a tradition as often literary as social, formed a complex inheritance, and a new generation of aspiring writers, artists, and musicians in Montmartre self-consciously drew upon and transformed this tradition. This generation of bohemians established their own cafés and cabarets, many of which published their own journals. These publications promoted the work of the artists who frequented the establishments as well as the cafés themselves, trying to attract a public for both. The newspapers were a crucial forum in which bohemian Montmartre constructed its image and identity for itself and for a wider, perhaps unknown audience. Central to this community's self-image was the claim by its inhabitants that they were the true heirs of a Gallic culture—earthy, festive, and vital—that had been corrupted by modern bourgeois life.

The history of Montmartre's bohemian community demands our attention for several reasons. First, we can observe in Montmartre an important episode in the making of mass culture. Bohemian Montmartre is remarkable for its attempt to appropriate the tools of the nascent commodity culture—advertising, newspapers, commercial leisure—in order to represent social and artistic rebellion. Second, the bohemians' use of mass culture suggests some important things about the ways in which social identities in modern society can be constructed and represented, about who one might be under the conditions of modernity. More particularly I am interested in the ways in which identities are propped up—not just by what cultural theorists term the performative (the imperative to embody, enact, and rehearse our selves), but propped up by physical objects and by selective use of the national past.

Lest such formulations remain abstract and forbidding, I'd like to demonstrate the staging of bohemian life by telling a few stories from the annals of *la vie de bohème*, by pursuing one of its favorite myths. The tale of the Louis XIII chair is a story of rivalry between two cabarets and their owners, but underlying that story is a contest between two visions of what it meant to be bohemian, to be an artist in modern society. The collective life of bohemian Montmartre was organized around *cabarets artistiques*, commercial spaces owned and controlled by bohemians and dedicated to the presentation of their artistic labors. The first and most famous of these institutions was the Chat Noir, opened by Rodolphe Salis in 1881. Housed in a small, dark, former postal station, the original Chat Noir was furnished in a deliberately unfashionable manner for cafés, a style Salis

labeled "Louis XIII," deliberately invoking medieval France. The furniture was rough and the decoration consisted of the clutter, plaster casts, and old metal-ware typical of the atelier. Emile Goudeau, an early regular at the Chat Noir, offers the best description of the cabaret's interior:

> A cat hanging from a bracket, a cat on the stained-glass window, wooden tables, massive and solid square seats (sometimes weapons against aggressors), enormous nails, called "spikes of the Passion" (whose Passion, oh Louis XIII most pure?), tapestries extending the length of the walls over diamond-patterned panels torn out of old cupboards (which Salis had collected since his tender youth), a tall fireplace, whose destiny it was, it later seemed, never to be lit because it sheltered on its mantel and bore on its andirons all sorts of odds and ends: a bedwarmer, gleaming as if Chardin had painted it, an authentique death mask (Louis XIII perhaps), gigantic pitchers—a jumble; but of kindling, none at all.[3]

This decor, a clear rejection of contemporary standards of "good taste," would come to signify bohemian Montmartre. The Chat Noir's reproduction of the atelier's castoffs and clutter links bohemia to artistic tradition. At the same time, the "medieval" furnishings evoke the Gallic popular culture of Rabelais and Villon, in particular the slightly disreputable class-mingling social space of the traditional cabaret. In short, the Chat Noir's decor itself purports to embody the same aspects of French culture invoked by Murger in his genealogy of bohemia.

The Chat Noir was filled with Louis XIII chairs, and the attribution of so ancient and exalted a provenance to such humble furnishings is of a piece with the cabaret's collective forms of satiric subversion, which they named *fumisme*. Fumisme—which might be roughly translated as "blowing smoke"—can be seen as a more subtle outgrowth of *la blague*, the joking hyperbole and buffoonery of the artist's studio. Goudeau in his memoirs describes fumisme as "a sort of disdain of everything, an inward contempt for being and things," born out of frustration.[4] Like la blague, though, the bohemians' fumisme gains its power by forgoing direct attacks and cloaking its scorn in a genial manner. Take, for example, the earliest advertisement for the cabaret, published in the first issue of its journal, *Le Chat Noir*:

> LE CHAT NOIR
> Cabaret Louis XIII
> Founded in 1114 by a fumiste
> 84 Boulevard Rochechouart, 84

These four lines, like the misattribution of the decor, rely on an audience's recognition of the gap between discourse—especially "official" discourse—and

its referent. Here the parody is even more pointed, for though the Chat Noir's advertisement is patently false, its dissimulation makes it faithful to its model because advertising always lies.

The fumisme of this advertisement pervaded not only the cabaret's journal but also its nightly entertainments. Evenings at the Chat Noir, at first informal gatherings, quickly developed a set format: Salis served as master of ceremonies, introducing the poets and songwriters who would perform their own work (Fig. 7.1). Salis's patter was one of the cabaret's great attractions, for he would improvise fanciful monologues about his cabaret and its regulars, addressing the audience with mock deference:

> Yes, handsome and valiant wayfarers of the Milky Way, yes, you will achieve just as much as Alexander, Hannibal, Caesar, and Pompey! . . . And you will achieve still more! Because if the glory of these illustrious Toulousians Hannibal, Caesar, and Bonaparte has illuminated with lightning flashes the somber cloud that hangs over the Ocean of the Ages, you have, you yourselves, conquered Montmartre, navel of the world! . . . Montmartre of which the Butte and the Chat Noir cabaret are the breasts of Paris, of Paris where reign the virtues of [President] Grévy the Jussasic—order and economy! Always hold these theological virtues if you wish to possess a heart of bronze and a gullet of steel worthy of receiving, here, for your earthly happiness, oh my dignified gentlemen, the miraculous mead which, upon your request and depending on several scattered *sous*, will be poured into the most pure crystal by Picard, my faithful and diligent cupbearer![5]

Salis's monologue is marked by fumisme's teasing hyperbole and has the same simultaneously inflating and deflating effect. So exaggerated are Salis's claims for the importance of his audience of outsiders that they parody the self-important manners of the bourgeoisie. The monologue, by lampooning the diction and values of official culture, creates a common sense of superiority among those who can see through such pretensions. This select audience shares as well a recognition of the truth within Salis's parodic boasting: though not acknowledged by society as such, these *are* "dignified gentlemen," the descendants of "illustrious Toulousians," meeting at the "navel of the world." Similarly, as the Chat Noir attracted more customers, the small rear room, separated by the zinc counter and a curtain, was reserved for bohemian habitués and dubbed the "Institute." This title both mocks the inflated self-regard and entrenched power of the real Institut de France, and accurately describes what the Chat Noir had become for its "elite" regulars: a place where representatives of all four arts could meet.

The carnivalesque displacement of Paris by Montmartre, of the Institut de France by the "Institute" of the Chat Noir, turns on the evocation of an older,

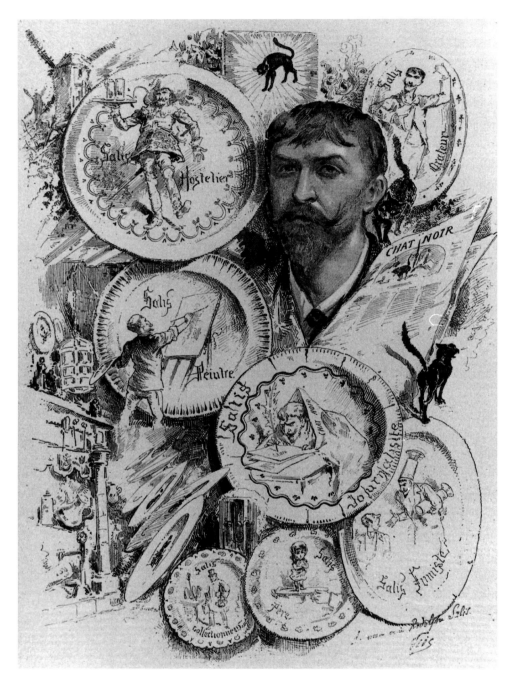

Figure 7.1 Uzès (pseudonym of J. Lemot), "Rodolphe Salis," *Le Chat Noir*, November 24, 1883. Jane Voorhees Zimmerli Art Museum, Rutgers, The State University of New Jersey. Acquired with The Herbert D. and Ruth Schimmel Museum Library Fund.

more authentic France. Montmartre is central *because* it is marginal: on the fringes of the city proper, largely untouched by Haussmannization, a traditional pleasure ground, home to the "popular classes." The regulars at the Chat Noir declared themselves to be *montmartrois*, not Parisian. For example, the masthead of *Le Chat Noir* is dominated by a drawing by Henri Pille (Fig. 7.2). It shows a black cat wandering the highest ground in Montmartre, silhouetted against sketchy rooftops and the two old windmills that at that time still dominated the Butte. This is a specific evocation of Montmartre, stressing its distance from Paris, its quasi-rural, pre-industrial character, and its reputation as a traditional site of popular entertainment (one windmill is labeled "Moulin de la Galette"). Articles in the early issues of *Le Chat Noir*, such as Jacques Lehardy's "Montmartre," extol the neighborhood in precisely these terms:

> We read in Genesis that Noah's ark dropped anchor on Mount Ararat.
> What could this mean, Mount Ararat?
> Read: Montmartre! . . .
> Therefore, Montmartre is the cradle of humanity. . . .
> Therefore, Montmartre is the center of the world. . . .
> It was in Montmartre that humans built the first city.
> At first, the descendants of Noah lived in the caverns which are still visible
> today. . . . Then they built a windmill and made pancakes. Next they
> spread out over the world.[6]

Here, as in Salis's monologue, Montmartre itself thus becomes the rhetorical ground for claims to the French tradition of festivity and creativity.

The varieties of performance and discourse at the Chat Noir are thus unified by a common emphasis on rebellious sensibilities, by a refusal of "modern" and "bourgeois" society. These sensibilities are as easily exhibited through parody, carnivalesque humor, or testing the limits of language and sense as through traditional artistic and literary production. Indeed, the former is much more prominent than the latter. This same loose constellation of bohemian attributes— "irregularity," festivity, camaraderie, rebelliousness—had since Romanticism also been associated with the figure of the artist.[7] The Chat Noir insisted that "artist" and "bohemian" are identical, united not by cultural production but by the attitudes and behaviors that place bohemia outside bourgeois society. As Maurice Donnay, a Chat Noir regular in the 1890s, asserted,

> In 1881, in a Louis XIII cabaret in Montmartre, this word "artist" could
> contain youth, gaiety, audacity, lyricism, imagination, a feeling of not giving
> a damn, poverty, certitude in the uncertainty of tomorrow, subversive
> theories, *fumisterie*, the mists of glory, the smoke of tobacco, thirst, beards,
> and long hair.[8]

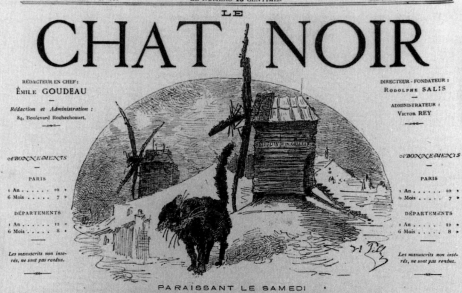

PREMIÈRE ANNÉE. — N° 12. LE NUMÉRO 15 CENTIMES SAMEDI 1ᵉʳ AVRIL 1882

LE CHAT NOIR

RÉDACTEUR EN CHEF :
ÉMILE GOUDEAU

Rédaction et Administration :
84, Boulevard Rochechouart.

DIRECTEUR - FONDATEUR :
RODOLPHE SALIS

ADMINISTRATEUR :
VICTOR REY

ABONNEMENTS

PARIS

1 An 10 »
6 Mois 7 »

DÉPARTEMENTS

1 An 12 »
6 Mois 8 »

Les manuscrits non insérés, ne sont pas rendus.

ABONNEMENTS

PARIS

1 An 10 »
6 Mois 7 »

DÉPARTEMENTS

1 An 12 »
6 Mois 8 »

Les manuscrits non insérés, ne sont pas rendus.

PARAISSANT LE SAMEDI

L'ASSAUT DE MONTMARTRE

Aujourd'hui, 1ᵉʳ avril, à quatre heures pour le quart du matin, une tentative d'assaut a été faite contre Montmartre.

Au mépris des promesses les plus solennelles, Léon Gambetta, à la tête des troupes de la Chaussée-d'Antin, a pénétré dans le pays Montmartrais par les rues Lepic, Coustou et Houdon.

Le rappel a sonné sur la montagne ; le Moulin de la Galette a été mis en état de défense ; les soldats du Sacré-Cœur sont consignés dans leur église.

Les ambassadeurs A'Kempis et Jacques Lehardy ont été rappelés, malgré les protestations de M. de Freycinet, qui a immédiatement mobilisé l'armée Parisienne. Cette armée va occuper les boulevards extérieurs. Elle est commandée en chef par l'illustre général Langlois (de Seine-et-Oise).

Le député Margue commande l'artillerie.

L'armée Montmartraise opérera sa jonction avec les divisions parisiennes par les places Pigalle et Blanche, en même temps, les batteries du Moulin écraseront la cavalerie ennemie, commandée par Spuller.

Du 1ᵉʳ Avril 1882, 10 heures matin.

Officiers, sous-officiers et soldats,

La patrie Montmartraise n'est pas en danger, elle est tout simplement menacée. Les suppôts de la tyrannie veulent saper dans leur base nos buttes immémoriales.

Non !

La vigueur, l'élasticité des muscles des autochtones de la montagne des Martyrs sont les garants des futurs succès de nos armes.

Tous debout !

Le général en chef du camp retranché de la place Saint-Pierre,
CHANOUARD.

ORDRE DE MOBILISATION

PLACE DE MONTMARTRE
Etat-Major

1ᵉʳ Avril, 11 heures, pour la demie.

Que naturellement les hommes généralement susceptibles d'appartenir à une classe à peu près quelconque sont convoqués dans tous les terrains vagues qui ne seront pas ultérieurement désignés.

Qu'ils se rendront à leur destination sans emprunter le secours des chemins de fer.

Que rendus, à cet endroit, ils seront incorporés dans les phalanges ou cohortes qui leur sont susceptibles.

Sont seuls exemptés les hommes des 17ᵉ, 21ᵉ et 69ᵉ légions de la classe 1848, les proscrits de Décembre et les Polonais de la section, en ce qui concerne leurs infirmités.

P. O. de la Place
Le chef d'état-major général,
SCHLING DU METATARSE.

DERNIÈRES NOUVELLES

6 heures 1⁄4.

Une vague escarmouche a eu lieu aux avant-postes, près de la Grand'Pinte ; à peine trois hommes tués, plus un ecclésiastique ennemi.

A'Kempis et Lehardy sont arrivés. Ils vont prendre le commandement de la vieille garde Montmartraise.

Un certain mouvement de panique se manifeste dans les camps ennemis.

Dure journée que celle du 1ᵉʳ avril.

Figure 7.2 *Le Chat Noir*, April 1, 1882. Jane Voorhees Zimmerli Art Museum, Rutgers, The State University of New Jersey. Acquired with The Herbert D. and Ruth Schimmel Museum Library Fund.

In this sense of the word bohemians are *all* artists. Perhaps the most iconic formulation of this vision of bohemia is Adolphe Willette's images of Pierrot, the character from commedia dell'arte (Fig. 7.3). This, though, is not the traditional Pierrot. In Willette's words, Pierrot "has become an artist, that is to say a poet scorned by serious people."[9]

Bohemian identity, as acted out in the Chat Noir and as represented in *Le Chat Noir*, is a state of being, a manner of expressing one's self which reveals that self to be alienated from society. Such a state of being is most easily expressed, then, in the company of others who are similarly alienated and who recognize and reinforce its importance and value. Transgressive creativity forms the basis for a new model of masculinity, one not available to bourgeois or working-class men. It necessarily excludes women as active participants, degendering those who were artists.[10] Of course, such a homosocial community also raises the specter of homosexuality, as in Abel Truchet's drawing of a cabaret artistique. Truchet depicts clearly the fear that, if bohemia is the inheritor of the creative camaraderie of the stoa, it may also have inherited a penchant for "Greek love" (Fig. 7.4). In response, the bohemians proclaimed their heterosexuality to excess, though, as Elizabeth Menon suggests, the bohemians can see women only as figures in whom pleasure and danger are uneasily mixed. Finally, the community of artists, in breaking with modern bourgeois society, recovers not only a "true" self but also the true France. Donnay, in his memoirs, declares that the Chat Noir "was not only the spirit of Paris but the spirit of France in Paris between 1880 and 1900."[11] The emphasis on spontaneity, bodily pleasure, and carnivalesque humor at the Chat Noir makes the montmartrois the true inheritors of the culture of Villon and Rabelais: "Gallic and classical."[12]

However, the ability of the Chat Noir's coterie to mount their critique of modernity was threatened by the cabaret's very success. The Chat Noir became a tourist destination and its audience increasingly bourgeois; *Le Chat Noir* claimed a circulation of 20,000 by 1884. As the distinction between the cabaret's customers and its performers grew more pronounced, and as Salis treated the regulars less as comrades and more as employees, disaffection grew among those who had frequented the Chat Noir in its early days. Many left the Chat Noir to found their own cabarets and journals. Among the most popular and long-lived of the cabarets were the Divan Japonais (The Japanese Divan), opened in 1888, the Ane Rouge (The Red Ass), opened by Salis's brother Gabriel in 1890, and the Quat'z'Arts (The Four Arts), opened in 1893. These venues generally reproduced the Chat Noir's décor, its forms of entertainment, its community-building ambitions, and its sponsorship of a newspaper.

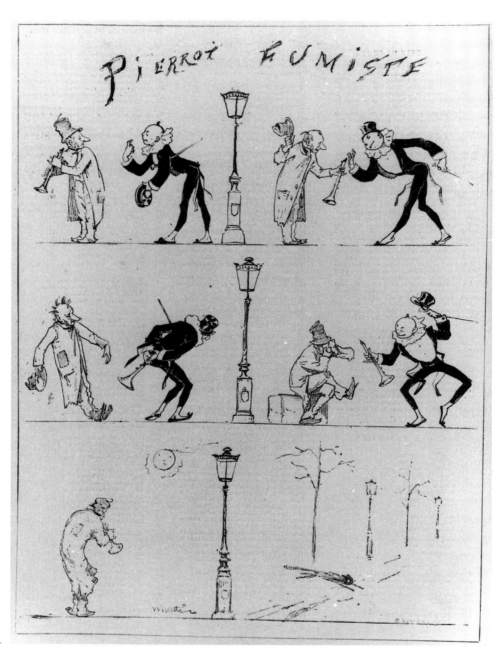

Figure 7.3 Adolphe Willette, "Pierrot fumiste," *Le Chat Noir*, March 18, 1882. Jane Voorhees Zimmerli Art Museum, Rutgers, The State University of New Jersey. Acquired with The Herbert D. and Ruth Schimmel Museum Library Fund.

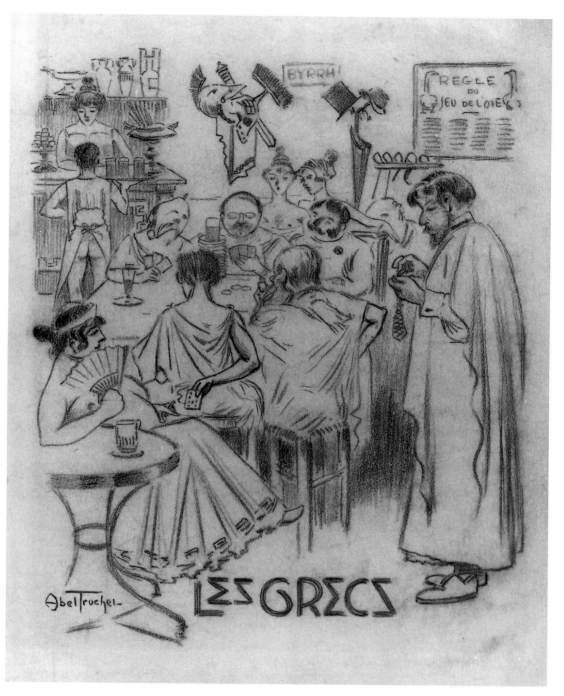

Figure 7.4 Abel Truchet, *Les Grecs* (*The Greeks*), ca. 1895. Jane Voorhees Zimmerli Art Museum, Rutgers, The State University of New Jersey. David A. and Mildred H. Morse Art Acquisition Fund.

In 1885 Salis moved the Chat Noir to larger and more luxurious quarters nearby. The new Chat Noir deployed the same architectural and decorative semiotics as the old, but on a larger, more elaborate, and more luxurious scale. It, too, was filled with "medieval" furnishings—though of more expensive manufacture—and the profusion of bric-a-brac which characterized the first Chat Noir (Fig. 7.5). In 1886 and again in 1888, the cabaret published a *Chat-Noir Guide,* which described in fumiste detail the putative origins of many of the most prominent elements of the décor (Fig. 7.6). The second Chat Noir introduced the famed shadow theater, discussed by Elena Cueto-Asín; a fine art publication, the *Album du Chat Noir;* and the collections of *Contes du Chat Noir*

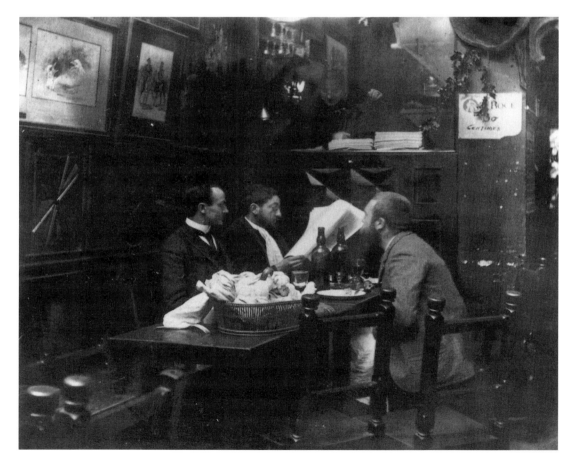

Figure 7.5 Unidentified, *Intérieur du Chat Noir* (*Interior of the Chat Noir*), ca. 1885–86. Jane Voorhees Zimmerli Art Museum, Rutgers, The State University of New Jersey. David A. and Mildred H. Morse Art Acquisition Fund.

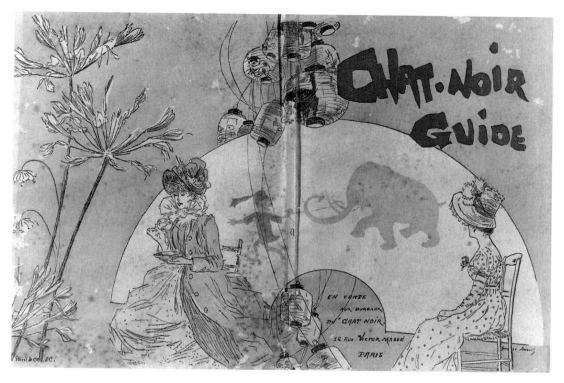

Figure 7.6 George Auriol, cover of *Chat-Noir Guide* (Paris, 1887). Jane Voorhees
Zimmerli Art Museum, Rutgers, The State University of New Jersey.
Gift of Sara and Armond Fields.

analyzed by Janet Whitmore. All these developments served to integrate the
Chat Noir more firmly in the world of Parisian commercial entertainment and
to undermine the cabaret's ties to its original bohemian clientele.

When Salis vacated the first Chat Noir, the space was rented by one of the
cabaret's songwriters, Aristide Bruant. Bruant had written the "Ballad of the
Chat Noir" with its well-known refrain:

> We are seeking fortune
> Around the Chat Noir
> By the light of the moon
> In Montmartre after dark![13]

Unlike most members of the Chat Noir circle, Bruant had had a limited educa-
tion and direct experience of downward social mobility, manual labor, and
poverty. Bruant had depended on this difference, and the air of authority it con-
ferred upon him, to claim his position in bohemian Montmartre. Bruant built a

reputation at the Chat Noir with his eccentric costume of corduroy suit, high boots, broad-brimmed black hat, and red scarf, and with his songs about the Parisian underworld. These songs narrated the lives of the poor, of criminals, pimps, and prostitutes, and they were usually cast in the first person and made liberal use of Parisian argot. Bruant renamed his cabaret "Le Mirliton," the word signifying both a reed pipe and, in argot, doggerel. This name emphasized the cabaret's ties to popular culture and, at the moment of the Chat Noir's highly visible embourgeoisement, seemed to claim for Bruant the rebellious spirit of the original Chat Noir. The Mirliton, with its "low-life" atmosphere, provided an equally theatrical but more rough-hewn alternative to Salis's establishment and proved to be the Chat Noir's strongest competition.

The Mirliton was not, however, an imitation of the Chat Noir. Bruant did nothing after Salis's departure to reconstruct the Chat Noir's Louis XIII decor; in fact, he did nothing to the empty boutique but install a piano, tables, and chairs. Only gradually were the walls hung with paintings—often of Bruant—by regulars such as Henri de Toulouse-Lautrec and Théophile-Alexandre Steinlen, and with plates, swords, and other bric-à-brac. Salis, though, when moving, had forgotten one of his chairs. Bruant refused to return the chair and instead suspended it from the ceiling, attaching to it the following poem:

> Ah! ladies, one is at one's ease,
> When seated on the chair of Louis XIII.
>
> It belongs to Rodolphe! But,
> To sit upon it you must go to Bruant,
> To the Cabaret of the Mirli-
> To the Cabaret of the Mirli-
> Of the Mirli-ton-taine and ton-ton,
> Of the Mirliton.[14]

This refrain mocks Salis, his pettiness, materialism, and embourgeoisement. By showing Salis's "Louis XIII chair" for what it actually was, Bruant declares himself the more honest and direct. By hanging the Louis XIII chair Bruant enacted the social distance separating the two cabarets: if the new Chat Noir was to be the site of Parisian "high life," the Mirliton would be the home of the "low." Of course, this declaration of disaffiliation also seems to have been quite good advertising for Bruant's own enterprise (Fig. 7.7).

An evening's entertainment at the Mirliton was also in decided contrast to that at the Chat Noir—in many ways as deliberate an inversion as that of the chair. The experience was carefully produced and orchestrated in both venues, but at Bruant's cabaret it was directed toward quite different effects. Le Mirliton

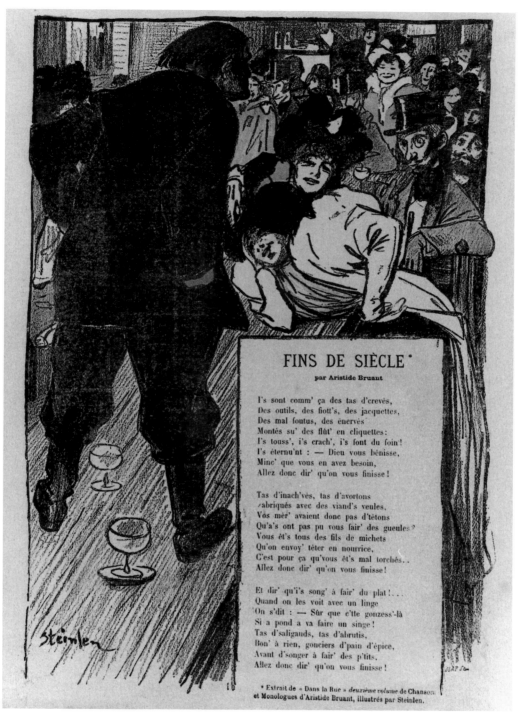

Figure 7.7 Théophile-Alexandre Steinlen, "Fin de siècle," *Gil Blas Illustré*, February 24, 1895. Jane Voorhees Zimmerli Art Museum, Rutgers, The State University of New Jersey. Norma B. Bartman Purchase Fund.

was open only very limited hours: from 10:10 p.m. to midnight, later to 2:00 a.m. To gain entry customers had to knock conspiratorially at the door and request admission. Once inside, visitors were roughly directed by Bruant to a seat, told to squeeze together, and forced into uncomfortable proximity to the other patrons. Newcomers were routinely greeted by an insulting refrain:

> Oh! là! là! That mug! That face!
> Oh! là! là! What a mug he has!

In contrast to Salis's mockingly hyperbolic politeness, Bruant's customers were subjected to a continuing stream of insults:

> Attention, gentlemen, here come the girls! Some whores, some beauties! In God's name, this time it's not the bidet slops; we have the trollop of choice, the deluxe courtesan, with her three stars! These gentlemen following behind on foot, they are surely pimps or ambassadors.[15]

The sole beverage available at the Mirliton was beer, though its price could vary from customer to customer and all were regularly inveigled to order more. Bruant's performance of his songs and monologues was interspersed with constant demands by the performer for additional contributions and insistence that customers purchase his song sheets and the cabaret's journal, *Le Mirliton*. Those patrons who chose to leave, at whatever point in the evening, were the targets of special invective:

> Attention, someone's leaving! Goodbye, sire, are these two virgins yours? Ah well, my piglet, no one gets shit on in your family. The gentleman screws two bottoms! Probably to be even more sure of being cuckolded. Good night, ladies, make him happy. To him the honors. To us the chorus:
> (Everyone sings, all together)
>> All the customers are pigs,
>> La fari dondon, la fari dondaine,
>> Especially those who go away,
>> La fari don daine, la fari don don![16]

The festive life of Le Mirliton was thus concerned less with the invocation of a specific French past than the reproduction of a present many of its customers would find unfamiliar, both exotic and slightly threatening. Bruant's songs aspire to form a prosopography of the Parisian lower orders, depicting lives of grinding poverty, forced criminality, and little hope. The titles of these songs chart a social geography of Paris: "Montmartre," "Belleville-Ménilmontant," "A Saint-Lazare," "A la Bastille," "A Montparnasse." Bruant positions himself in his work as the intermediary between two worlds: providing a voice for those socially marginal

characters who would otherwise have none, and introducing his bourgeois public to the "hidden" experiences of the popular classes. At the Mirliton the experience of the "popular" was defined by rough speech, playful verbal abuse, and the use of argot; by physical discomfort and lack of personal space; by frank talk about sexuality and the undisguised demand for money. Richard Sonn is undoubtedly correct to challenge the accuracy of this image and point out the ways in which this sort of entertainment reinforced social identities and class privilege;[17] but the power of Bruant's spectacle lay in its clear rejection of those values termed bourgeois, in its effort to show the "real" Paris.

In *Le Mirliton*, though, a much more explicit link is forged between the popular classes, the *chansonnier populaire,* and the French past. Alongside Bruant's songs we find in *Le Mirliton* an attempt to document the popular culture of an earlier, pre-industrial France. Under the rubric "Old Songs," the journal printed in each issue the lyrics to a traditional folksong. These texts are generally concerned with drinking, relations between men and women, soldiers, and the exploits of outlaws. A similar range of activities, supplemented by scatological humor, is covered by the "Old Jokes" and "Old Tales" also printed in each issue. All these texts are valued within *Le Mirliton* not for their faded charms or benign amusement, but for being old, the traces of rural folk culture. This invocation of premodern France is also present to some degree in *Le Chat Noir*; but here the representation of the traditional culture is more extensive, and in this different context it appears to have a rather different meaning.

These fragments of popular culture are juxtaposed in *Le Mirliton* not only to Bruant's songs, but also to a range of written texts that depict the misery of life for members of the popular classes and that decry and ridicule the indifference and hypocrisy of the bourgeoisie. The visual contributions to *Le Mirliton* take on a special importance in this regard. They extend Bruant's vision of social realities, not only by graphically rendering the contents of his songs, but also by further elaborating the themes established in them. The constant juxtaposition of the traditional and the marginal suggests a narrative, one in which folk culture becomes the prehistory of the popular classes (Fig. 7.8).[18] It plots a trajectory by which the popular classes become the inheritors of "true" French culture. Those qualities celebrated in nineteenth-century representations of the "popular"— frankness, festivity, sensuality, spontaneity—are thus rendered peculiarly French. Within the pages of *Le Mirliton*, then, Bruant's songs become situated as the contemporary incarnation of traditional French culture. By speaking the "popular," Bruant becomes (as he insistently pronounced himself) the new Villon, and so the voice of the French.[19] Let me point out in passing that Bruant's

Figure 7.8 Henri de Toulouse-Lautrec, "Le Dernier Salut," *Le Mirliton*, March 1887. Jane Voorhees Zimmerli Art Museum, Rutgers, The State University of New Jersey. Acquired with The Herbert D. and Ruth Schimmel Museum Library Fund.

cabaret also had its imitators. In 1896, Bruant's assistant, Alexandre Leclerc, left the Mirliton to open his own cabaret, Boisterous Alexander's Cabaret, where he insulted clients in slang and performed Bruant's repertoire while wearing a copy of Bruant's famous attire. Bruant sued Leclerc for unfair competition and won. We may see in the suit Bruant's efforts to reassert the authenticity of his self-expression against the mere performance of "popular" entertainment. The implication of the lawsuit is that, without Bruant's intervention, an ignorant public might not be capable of differentiating between the true voice of bohemia and crude commercial mimicry.

It would be easy to see the tale of the Louis XIII chair as simply a matter of style, as a superficial difference between those who sought to outrage and enter-tain the bourgeoisie by calling an ordinary chair a precious antique and those who sought to do so by calling a chair a chair. Both the Chat Noir and the Mir-liton were, after all, commercial establishments that made their reputations by staging mildly exotic and ultimately tame versions of life "outside" bourgeois culture. When the Mirliton made Bruant a highly successful entrepreneur—when he became, in fact, a star of the café-concert—he was just as easily and just as often accused of pretension, insincerity, and avarice as Salis had been. More-over, both cabarets strove to bolster their claims to authenticity by grounding their entertainments in highly selective and dubious constructions of the French past: the Chat Noir by imagining an essential Gallic spirit reincarnated in the festive nightlife of Montmartre, the Mirliton by casting Bruant as a poet-outlaw, following in the tradition of Villon in speaking the truth about the lives of ordinary people.

There is, I think, more to be considered here, though. Underlying the sty-listic differences between the Chat Noir and the Mirliton, and belying their shared strategy of commodifying marginality, are two rather distinct models of bohemia and its relation to the larger society. The Chat Noir imagines bohemia to be an elite fellowship of like-minded men, artists in spirit and behavior. In contrast, the Mirliton figures the artist—particularly the popular artist—as simply one member within the larger social grouping of the marginalized. While the first model regards the bourgeoisie as the center of society, and bohemia as marginal to that dominant class, the second model sees society as a whole as the center from which *all* bohemians have been excluded. As models of community, both notions of identity are not without their conceptual, not to mention social difficulties. What comprises the identification and commonality between bohemians is constantly in doubt and must continually be reaffirmed; the place of the artist or writer within the community of the marginalized is similarly

always in question. Finally, the claim of both models that bohemia represents and embodies what is truly, genuinely French must always contend with the indifference (if not hostility) of the bulk of French society toward its activities.

Let me complicate my own model, though, by introducing a third Montmartre cabaret: Taverne du Bagne or Jailhouse Tavern, an establishment opened in 1885 by Colonel Maxime Lisbonne, a former Communard who had been exiled (Fig. 7.9). While the Chat Noir purported to be a "cabaret Louis XIII," the Jailhouse Tavern took the Paris Commune as its theme and was decorated to resemble a prison. As Howard Lay demonstrates, the Commune has a complex and powerful afterlife within French culture and very specific ties to Montmartre. The Jailhouse Tavern played on many of these associations. The cabaret occupied a crudely constructed condemned building and customers were made to wait on the street until Lisbonne cried, "Bring in a new batch of convicts!" The interior of the cabaret was furnished simply and the walls decorated with paintings of the heroes and events of the Commune. Waiters were dressed as prisoners, down to the ball and chain. Once finished with their visit, customers

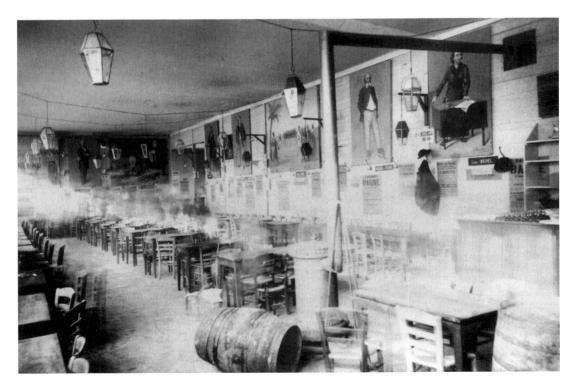

Figure 7.9 Interior, Taverne du Bagne. Courtesy of the Musée de Montmartre.

were advised that the "freemen can proceed to the court clerk and leave," and then paid their bill to a cashier dressed as a prison guard.

The commodified experience marketed by the Jailhouse Tavern clearly deploys a central bohemian strategy. At the Chat Noir, customers could make an imaginary entry into bohemian life and join in an evening of artistic festivity; at the Mirliton, they could similarly go slumming amid the demimonde. The Jailhouse Tavern presented the same opportunity for a momentary escape from the quotidian, but the fantasy it offered was of a much more specific, bounded, and political variety. The cabaret was a deliberate provocation, but a provocation whose purpose is unclear. On the one hand, the Jailhouse Tavern confronted a largely bourgeois public with a particularl reality, the traumatic beginnings of the Third Republic. Having a political prisoner serve customers who, while dining, must face depictions of torture and martyrdom does stress the experiential gulf between the conflict's victors and its vanquished. On the other hand, the theatricality of this structured experience must have distanced the customers emotionally from the events on display. Political life becomes a diversion, the meaning of its events inevitably trivialized.

These uncertain relations between sending up and celebrating the Commune are even more pronounced in the cabaret's newspaper, the *Gazette du Bagne* (The Jailhouse Gazette). The paper contains only two sorts of contributions: promotions for the Jailhouse Tavern and first-person accounts by Communards. The articles are signed not with names but with prisoner identification numbers. These memoirs are impassioned efforts to delineate the cruelty and injustice suffered by the Communards despite their inherent nobility and the rightness of their cause. All of these texts are openly partisan, the only writing with a self-consciously *revolutionary* spirit to be found in bohemian discourse. The representation of the cabaret takes only a very few forms. On the masthead of every issue a member of the staff is pictured in a convict's or guard's uniform; all receive a straightforward biographical sketch later in the issue. The *Gazette du Bagne* also reprinted articles from Parisian, provincial, and foreign newspapers that discuss the Jailhouse Tavern. At the center of critical reaction is the figure of Colonel Lisbonne, for the spectacle of the Jailhouse Tavern was as dependent on his authentic political experience as the Mirliton was on Bruant's experiences of poverty. How, the articles asked, could a man who had suffered imprisonment and exile fashion out of that past a past attraction? Was it merely "a simple *fumistererie*, invented by citizen Lisbonne to earn his living by rapid means" or was it "his revenge against the bourgeoisie?"[20] Both those who would forget the Commune and those who would enshrine it were thus forced by Lisbonne's

cabaret to consider the event in an unfamiliar light. This shock effect was ephemeral—as was the cabaret's success—but it raises questions of what politics expresses and how political memory can be expressed.

The uneasy mixture of politics and entertainment at the Jailhouse Tavern foregrounds the contradictions underlying both models of bohemian identity and community. It also highlights the forces leading to bohemian Montmartre's fragmentation and dissolution as a community in the late 1890s. One of the most powerful of these forces was politics itself, easily the most frequent object of bohemian lampoons. Rodolphe Salis in 1884 mounted a mock electoral campaign, the poster for which parodies the Abbé Siéyès's pre-Revolutionary tract, "What is the Third Estate?" by asking "What is Montmartre?" (Fig. 7.10). Bohemians conducted similar mock candidacies frequently in the following years. However, during moments of national crisis, the bohemians took up an ideological position quite at odds with their usual dismissal of politics. During the Boulanger Affair, for example, Adolphe Willette ran a failed campaign as an anti-Semitic candidate (Fig. 7.11). During the Dreyfus Affair the artists of Montmartre became the chief visual propagandists on both sides of that political battle.[21]

The community was simultaneously transformed by the forces of commercialization. The wealth generated by their cabarets allowed Salis and Bruant the luxury of withdrawing from bohemian life and both became prominent landowners. Many other bohemians were less fortunate and foundered in obscurity and poverty. Bourgeois audiences favored those cabarets featuring performers who sang humorous and topical songs, limiting opportunities for less accessible artists. Moreover, the success of the cabaret artistique led to the proliferation of attractions in Montmartre inspired by but repulsive to the bohemians. Colonel Lisbonne briefly ran the Brasserie des Frites Révolutionnaires, and entrepreneurs opened nightclubs taking ancient Greece, Rabelais, even court proceedings as their theme. Particularly reviled were the "afterlife" cabarets named Heaven and Hell, where waiters were dressed as angels and devils. Bohemian critics labeled these establishments examples of "shameful mercantilism,"[22] but even at the time observers wondered how different they were from the Mirliton, which, after 1895, was without the presence of Aristide Bruant, or a third Chat Noir mounted without the participation of any of the original Chat Noir members.

The stories of the Chat Noir, the Mirliton, and the Taverne du Bagne suggest the risks and the difficulty of any critical staging of identity under the conditions of modernity. These three cabarets and their imitators constitute brief

XVIIIᵉ Arrondissement — Quartier Montmartre

ÉLECTEURS

Qu'est-ce que Montmartre? — Rien !

Que doit-il être? — Tout!

Le jour est enfin venu où Montmartre peut et doit revendiquer ses droits d'autonomie, contre le restant de Paris.

En effet, dans sa fréquentation avec ce qu'on est convenu d'appeler la capitale, Montmartre n'a rien à gagner que des charges et des humiliations.

Montmartre est assez riche de finances, d'art et d'esprit pour vivre de sa vie propre. Électeurs !

Il n'y a pas d'erreur !

Faisons claquer au vent de l'indépendance le noble drapeau de Montmartre.

" La Butte ", cette mamelle où s'allaitent la fantaisie, la science et tous les Arts vraiment Français avait déjà son organe " Le Chat Noir". A partir d'aujourd'hui, elle doit avoir son représentant, un représentant digne de ce nom.

Rodolphe SALIS, qui, depuis trois ans, dirige, avec l'autorité que l'on sait, le Journal qui est la joie de Montmartre, nous a paru apte à cette mission.

Montmartre mérite d'être mieux qu'un arrondissement.

Il doit être une cité libre et fière.

Aussi notre programme sera-t-il court et simple :

1° La séparation de Montmartre et de l'État ;

2° La nomination par les Montmartrois d'un Conseil Municipal et d'un Maire de la Cité Nouvelle ;

3° L'abolition de l'octroi pour l'Arrondissement et le remplacement de cette taxe vexatoire par un impôt sur la Loterie, réorganisée sous la régie de Montmartre, qui permettrait à notre quartier de subvenir à ses besoins et d'aider les dix-neuf arrondissements mercantiles ou misérables de Paris ;

4° La protection de l'alimentation publique. La protection des ouvriers nationaux.

LE COMITÉ :

WILLETTE (Pierrot), 20, rue Véron.
POUSSARD (R. P. La Cayorne), 84, bᵃʳᵈ Rochechouart.
CHOUBRAQUE, rue Ramey, 58.
LEFÈVRE, rue Ramey, 58.
MARION, 26, rue Letort.
MARCEL-LEGAY, 92, boulevard de Clichy.
GÉRAULT-RICHARD, 44, rue des Abbesses.
DE SIVRY, 82, rue des Martyrs.

Pn. CATTELAIN, 27, rue du Ruisseau.
RANDON, 82, rue des Martyrs.
COQUELIN (cadet), 84, boulevard Rochechouart.
JULES JOUY id. id.
ALPHONSE ALLAIS, id. id.
Léon BLOY, id. id.
Cn. LEROY, homme de lettres, 23, bouleᵛᵈ Barbès.

Vu et Approuvé : Rodolphe SALIS.

ÉLECTEURS,

Ce programme sera défendu avec une énergie farouche. — Je suis de ceux qui meurent plutôt que de se rendre.

Si je descends dans l'arène vous jugerez si ma devise, SÉRIEUX QUAND MÊME, est justifiée.

Électeurs, pas d'abstention. La postérité nous attend.

Vive Montmartre !

RODOLPHE SALIS

84, Boulevard Rochechouart.

Candidat des Revendications Littéraires, Artistiques et Sociales.

252. Imprimerie Charles BLOT, rue Bleue, 7. — Paris.

Figure 7.10 Rodolphe Salis's notice for the Montmartre municipal election, 1884. Jane Voorhees Zimmerli Art Museum, Rutgers, The State University of New Jersey. David A. and Mildred H. Morse Art Acquisition Fund.

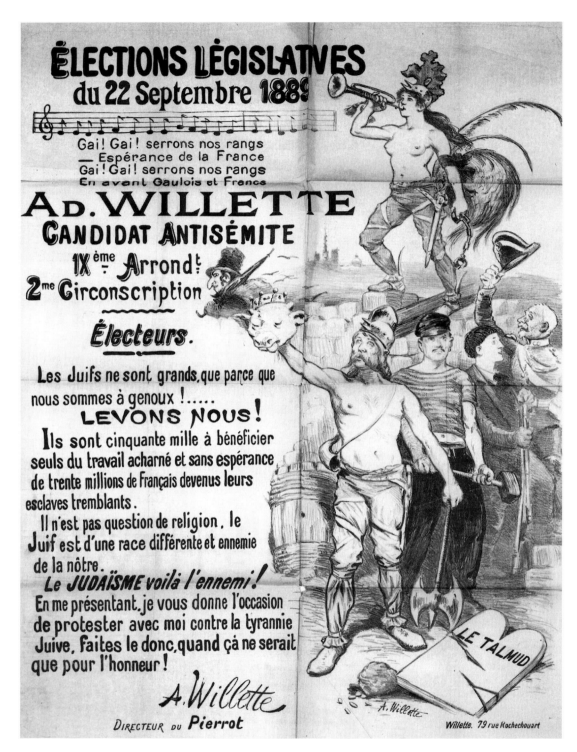

Figure 7.11 Adolphe Willette, *Poster for Municipal Election*, 1889. Reproduced by permission of the Houghton Library, Harvard University.

moments in the longer history of French social contestation, and they added something to the repertoire of gestures of refusal and strategies of subversion. But these sorts of gestures are ephemeral and their effects short-lived. This is especially true of efforts like bohemian Montmartre's attempts to market rebellion. The ground on which transgression is posited—whether genius, marginality, authenticity, political protest, or Frenchness—is constantly shifting and the signs by which such transgressions are enacted are not themselves stable. The tale of the Louis XIII chair reminds us that mass culture has proven to have a voracious appetite for self-styled rebels and that they are more likely to be tamed by the market than successful at subverting it.

NOTES

1. Paul Alexis, "Le nouveau quartier latin," in *"Naturalisme pas mort": Lettres inédites de Paul Alexis à Emile Zola*, ed. B. H. Bakker (Toronto: University of Toronto Press, 1971), 469.
2. Henry Murger, *Scènes de la Vie de Bohème* (Paris: Michel Lévy Frères, 1861), 6.
3. Emile Goudeau, *Dix ans de Bohème* (Paris: La Librairie Illustrée, 1888), 255–256.
4. Ibid., 95.
5. Adolphe Willette, *Feu Pierrot, 1857–19—?* (Paris: H. Floury, 1919), 143–145. On Willette and Pierrot fin-de-siècle, see Marcus Verhagen, "Refigurations of Carnival: The Comic Performer in Fin-de-Siècle Parisian Art" (Ph.D. diss., University of California at Berkeley, 1994), chapter four.
6. Jacques Lehardy, "Montmartre," *Le Chat Noir*, January 14, 1882.
7. Alain Rey, "Le Nom d'artiste," *Romantisme* 55 (1987): 10–22.
8. Maurice Donnay, *Autour du Chat Noir* (Paris: Bernard Grasset, 1926), 15.
9. Willette, *Feu Pierrot*, 128.
10. Michael Wilson, "Sans les femmes, qu'est-ce qui nous resterait: Gender and Transgression in Bohemian Montmartre," in *Body Guards: The Cultural Politics of Gender Ambiguity*, ed. Julia Epstein and Kristina Straub (New York: Routledge, 1991), 195–222.
11. Donnay, *Autour du Chat Noir*, 44.
12. Jules Lemaître, "Préface," *Gaîtés du Chat Noir* (Paris: Ollendorff, 1894), vii.
13. Aristide Bruant, "Ballade du Chat Noir," *Le Chat Noir,* August 9, 1884.
14. Alexandre Zévaès, *Aristide Bruant* (Paris: Editions de la Nouvelle Revue Critique, 1942), 35–36. The ritual surrounding Salis's chair is documented in Toulouse-Lautrec's 1886 painting *Le Refrain de la Chaise Louis XIII au Cabaret d'Aristide Bruant*, originally hung in the Mirliton and now in a private collection.
15. Jacques Castelman, "Cinq minutes chez Bruant," in *Belle Epoque* (Paris: Librairie Académique Perrin, 1962), 105.
16. Ibid., 106.
17. Richard Sonn, *Anarchism and Cultural Politics in Fin-de-Siècle France* (Lincoln: University of Nebraska Press, 1989), 129–137.
18. This narrative can be seen strikingly in the paper's images of contemporary carnival. See Caillou [Steinlen], "Roi d'un jour," *Le Mirliton*, April 3, 1886; Caillou [Steinlen], "Souvenir de la Mi-Carême," *Le Mirliton,* April 19, 1886; and "La Fête foraine de Montmartre," *Le Mirliton,* October 1886.

19. Bruant's insistence upon being identified with Villon is taken up by all subsequent commentators on his work. See Sonn, *Anarchism*, 129–130.
20. "Albert Wolff et Maxime Lisbonne," *Gazette du Bagne,* November 15, 1885.
21. Phillip D. Cate, "The Paris Cry: Graphic Artists and the Dreyfus Affair," in *The Dreyfus Affair: Art, Truth and Justice*, ed. Norman L. Kleeblatt (Berkeley and Los Angeles: University of California Press, 1987).
22. Jean-Emile Bayard, *Montmartre hier et aujourd'hui* (Paris: Jouve et Cie., 1925), 156.

Absurdist Humor in Bohemia

J A N E T W H I T M O R E

On any given evening at the Chat Noir cabaret, the casual visitor might well have encountered such cultural luminaries as Emile Zola, Stéphane Mallarmé, Adolphe Willette, Henri Rivière, or Théophile Steinlen, not to mention a host of other less famous, but no less important artists of the time. At the center of this activity was Rodolphe Salis, the founder and guiding spirit of the Chat Noir. Salis opened the Chat Noir in November of 1881. Within a month, he launched the first of the cabaret's publications—*Le Chat Noir*—which served as a promotional vehicle for the cabaret.[1] This newspaper eventually became the foundation for two other Chat Noir publications—the *Contes du Chat Noir* and the *Album du Chat Noir*—neither of which have been studied to date.[2]

Before examining the *Contes du Chat Noir* and the *Album du Chat Noir*, it is important to explore the common features of all three publications. First, the overall tone of these works is one of parody, satire, and, occasionally, outrageous commentary on current events. The humor runs the gamut from political satire to absurdist black humor to stinging social critiques of contemporary life. Very few sacred cows are left untouched by the acute and often antic observations of *Le Chat Noir* contributors—not even jolly old St. Nicholas.

Second, the Chat Noir publications provided a forum for both artists and writers to express their ideas and display their talents. A wide variety of graphic artists such as Henri Rivière, Théophile Steinlen, and Adolphe Willette were actively involved in many of these publications, while writers such as Emile Zola, Emile Goudeau, and Théodore de Banville also contributed from time to time. Third, the literature of the Chat Noir represents a thoroughly collaborative effort among writers and visual artists, providing a fresh cross-fertilization of ideas. This type of cooperative creativity engendered both "tabletop" exchanges in which the lighthearted banter at the cabaret was inscribed on random pieces of notepaper, and the more serious illustrated poetry, which grew out of the simultaneous development of verse and drawings.

Finally, all of the publications produced under the auspices of the Chat Noir were intended to be part of a promotional strategy for both the cabaret and the artists who frequented it. Salis clearly understood the commercial value of creating an image for his cabaret and of making it the center of artistic activity in Montmartre. *Le Chat Noir* served as the initial vehicle for transmitting information about activities at the cabaret, and as a forum for airing the political and social concerns of Salis and his colleagues. Its distribution throughout Montmartre not only ensured that the community knew exactly what events were scheduled at the cabaret, but also developed a specific image of the Chat Noir and the people who frequented it.

While *Le Chat Noir* is widely recognized as a satirical community newspaper, largely because of its association with the avant-garde artists of fin-de-siècle Montmartre, the other publications of the Chat Noir are relatively unknown to contemporary audiences. Printing records are not available nor are circulation figures, which makes it difficult to determine how widely the *Contes du Chat Noir* and the *Album du Chat Noir* were distributed. This lack of specific data suggests several possibilities. One is that the print runs were short and that the printer was a small, neighborhood business that did not keep extensive records or archives. This would be in keeping with the community base of the cabaret as well as *Le Chat Noir,* both of which were intimately tied to the neighborhood of Montmartre. The paucity of reception documents concerning the publications also suggests that they were marketed directly to a targeted Chat Noir audience. It would not be surprising to discover that Salis simply presented his new, and highly specialized, publications through the forum of the cabaret itself. Like *Le Chat Noir,* the *Contes du Chat Noir* and the *Album du Chat Noir* may well have been for sale at the Chat Noir to patrons who already had a taste for the satirical, offbeat humor that Salis and his cronies offered. It might also have

seemed a waste of time, not to mention contrary to the anarchic spirit of the Chat Noir, to solicit a literary review from the bourgeois critics of daily Paris newspapers. The Chat Noir publications, like the cabaret, were an acquired habit that appealed to audiences with an absurdist sense of humor and a willingness to accept, if not endorse, socially outrageous behavior. They were hardly the conventional fare for late nineteenth-century critics.

Many issues remain open in regard to the Chat Noir publications. Did they serve the desired goal of promoting the cabaret and its artists successfully? Did they make a profit, or were they, like other "artistic" publications such as *La Revue Blanche,* a continual financial loss? How far did the influence of the publications reach? Most important of all, who read them? Some of these questions are unlikely to be answered with any factual responses, but it is possible to examine the context of the texts themselves, and to draw some conclusions about the authors' and artists' intentions.

Contes du Chat Noir

With the success of the cabaret and *Le Chat Noir,* Salis began to consider broadening his publishing efforts, and in 1888 published the collection of short stories known as the *Contes du Chat Noir.* The first edition was printed in the winter of 1888 and consists of fifteen stories by Salis, all of which had previously been published in *Le Chat Noir.*

The first of these tales, actually a prologue to the collection, presents us with the unlikely meeting of the devil and St. Nicholas as they stroll along a beach (Fig. 8.1). The devil is disguised as Rodolphe Salis. Willette's illustrations of the encounter between St. Nick and the devil indicate that, in spite of the devil's protruding tail, the good St. Nick does not recognize him. In fact, after a short conversation, the unsuspecting saint agrees to accompany the devil to a cabaret for a drink. St. Nick then proceeds to complain about the Parisians being *fumistes,* a word that means both "joker" and "chimney sweep" as well being a reference to the fumiste artists associated with the Chat Noir.[3] The devil responds that St. Nicholas is something of a fumiste himself since he comes into people's homes through the chimney. St. Nick concedes the point, but argues that neither chimneys nor children are what they used to be, and that he is thoroughly depressed about the modern world. As this conversation continues, the devil pours more and more wine in St. Nick's glass and gradually trades all of his clothes for those of the saintly bishop. By the end of the story, the devil announces his plans to return to Paris and the Chat Noir, leaving St. Nick to sleep it off in a drunken

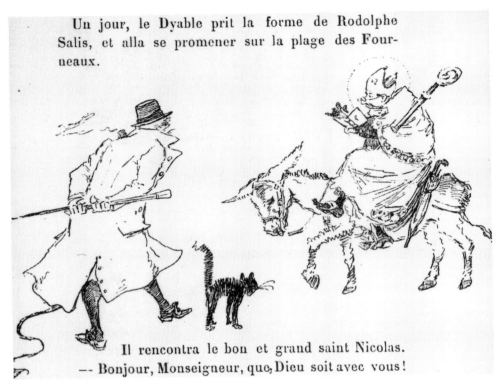

Un jour, le Dyable prit la forme de Rodolphe Salis, et alla se promener sur la plage des Fourneaux.

Il rencontra le bon et grand saint Nicolas.
–– Bonjour, Monseigneur, que, Dieu soit avec vous!

Figure 8.1 Adolphe Willette, *"Bonjour, Monseigneur, que Dieu soit avec vous!"* (*"Good Day, Monsignor, God Be with You!"*), 1888. Image from *Contes du Chat Noir*. Photo courtesy Bibliothèque Historique de la Ville de Paris.

stupor (Fig. 8.2). The black cat who had been ingratiating itself with St. Nick remains behind and transforms itself into a female demon as the drunken saint sleeps. Just as he is about to be seduced by the *chat noir*, a host of heavenly angels arrives to rescue him. The black cat disappears and the angels chide St. Nicholas, saying, "St. Nicholas, what have done with your halo? You've been drinking with the devil."[4]

This is typical of Salis's humor. It's full of wordplay and gentle but pointed satire on well-established bourgeois values. It is also a comment on the prevalence of alcohol in late nineteenth-century society and its effect on far too many people, even a revered religious figure like St. Nicholas. Further, the depressed mood expressed by St. Nick is a reflection of the anxiety of the Church at this time—and even St. Nicholas is at a loss as to what to do about it.

The other stories in the *Contes du Chat Noir* are handled somewhat differently. All are written in an archaic form of French, reminiscent of medieval tales

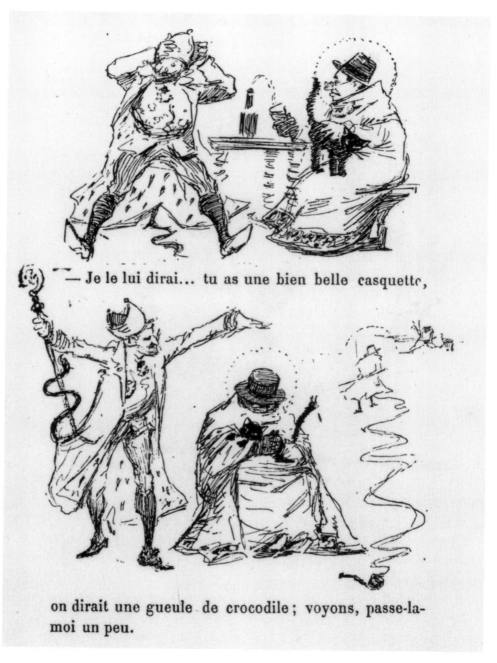

Figure 8.2 Adolphe Willette, *"Je le lui dirai . . . tu as une bien belle casquette,*
on dirait une gueule de crocodile; voyons, passe-la-moi un peu."
("I Will Tell Him . . . You Are Wearing a Beautiful Cap, It Looks Like a
Crocodile Jaw'; Let's See, Hand It Over"), 1888. Image from *Contes du*
Chat Noir. Photo courtesy Bibliothèque Historique de la Ville de Paris.

and the works of the Renaissance writer François Rabelais.[5] Rabelais was of par-
ticular interest to the Chat Noir artists because, like them, he saw the humor in
daily life and expressed it through outrageous exaggerations.[6] These stories are
also filled with stock characters loosely based on the tradition of the commedia
dell'arte, a popular form of theater rather than the official style of the French
Academy. Much of the humor would now be considered slapstick, although it,
too, is based on commedia traditions. There is the corrupt and lustful cleric, the
wily servant, the brawny but stupid military man, and the canny woman who
outsmarts them all; each of these characters can be found in traditional com-
media plays.[7] Both the form of the language and the use of these stock charac-
ters allow Salis to create a sense of detachment from the content of these
stories. Although he is clearly satirizing the contemporary Church, for example,
he is also implying that the hypocrisy of lustful, greedy clerics has a very long
history.

In one of the tales, we meet a curate named Louis Portelance, who lusts after
a local farmer's wife.[8] She is thoroughly annoyed with his advances and devises a
plan whereby she tricks him into believing that she will succumb to his desires if
he gives her some excellent wine as well as money. Louis believes the ruse; how-
ever, just when the farmer's wife has most of his clothes off, her husband appears.
As a respectable cleric, Louis then climbs a tree to escape detection, leaving the
farmer's wife alone to explain the situation to her supposedly angry husband. In
the end, the farmer and his wife enjoy themselves beneath the tree where Louis
is now trapped (Fig. 8.3). As they leave, they toss his clothes away and he must
make his way back to the monastery in only his underwear (Fig. 8.4).

There is a strong element of social satire in these stories as well as an ener-
getic interest in deflating hypocrisy of any kind, a quality that is characteristic
of both the cabaret and the Chat Noir publications. The illustrations are typi-
cally line drawings that support key moments in the story and often provide an
additional visual commentary on the situation, a reflection of the collaboration
between artists and writers who frequented the Chat Noir cabaret. Scheduled for
publication on a quarterly basis, with one edition appearing each season, the
Contes du Chat Noir provided a regular showcase for the artists involved and evi-
denced Salis's entrepreneurial skills in promoting his cabaret. By linking the suc-
cess of the individual contributors to their association with the cabaret, Salis
implemented a cross-marketing strategy that enhanced the Chat Noir's reputa-
tion, introduced new artists and writers to a larger public, and underscored the
appeal of already established artists and writers to an audience interested in
bohemian culture.

Figure 8.3

Oswald Heidebrinck, *Louis Portelance*,
1888. Image from *Contes du Chat Noir*.
Photo courtesy Bibliothèque Historique
de la Ville de Paris.

Figure 8.4

Oswald Heidebrinck, *Louis Portelance*,
1888. Image from *Contes du Chat Noir*.
Photo courtesy Bibliothèque Historique
de la Ville de Paris.

Album du Chat Noir

The *Album du Chat Noir* was an even more ambitious undertaking. Designed as a collection of images and texts, this publication was aimed at an audience wealthy enough to consider the purchase of several luxury editions. On the cover of the *Album* is a list of three deluxe categories that buyers could order: one for 100 francs, one for 200 francs, and one for 500 francs. The price categories reflect different production values, particularly in the varying grades of paper, ranging from vellum to fine imported Japanese papers. Clearly, Salis perceived a market for a deluxe printing of the *Album*, an indication that the reputation and cachet of the Chat Noir extended beyond the modest residents of Montmartre. Like the other Chat Noir publications, the *Album* was vigorously promoted in the *Chat Noir*. In one promotional ad Salis assures the reader that "this album of drawings and verse improvised on the corner of a table by all the artists who come to the Chat Noir is absolutely unique in all the world."[9] The *Album* becomes yet another tool to promote the cabaret, to display the works of artists and writers, and to create a collaborative publication. The *Album* was first published in October 1885 and consists of eight editions that appeared during the late 1880s and the early 1890s.

The *Album* is equally notable as a prototype for *La Revue Blanche,* which began publication in December 1889. Initially published as a four-page pamphlet, *La Revue Blanche* expanded to forty-eight pages by October 1891, with a subscriber list of 200-300 people and a print run of 1,300 copies.[10] Although less outrageous in tone and humor, *La Revue Blanche* clearly took inspiration from the publications of the Chat Noir and like the *Album*, it combined prints, drawings, and text from a variety of avant-garde artists and writers. Although its stated goal was to be "open to all opinions and all schools," it was most closely associated with the Symbolist poets and playwrights as well as the young artists known as the Nabis.[11] Many of these artists and writers were also regulars at the Chat Noir cabaret, and undoubtedly were well acquainted with both *Le Chat Noir* and the *Album*.[12]

From an economic perspective, the financial structure of *La Revue Blanche* provides some clues about the commercial aspects of the Chat Noir *Album*. The audience for *La Revue Blanche* is known to have been "relatively well-off, well-educated people who lived in Paris for the most part. *La Revue Blanche* was one of a number of small journals, with circulation in the thousands, which were read by a group of people who went to openings of exhibitions and to the theater and liked to feel a part of the scene."[13] In other words, the audience for *La*

Revue Blanche was very much the same group that Salis was targeting with the *Album* and the *Contes du Chat Noir.* What distinguishes the Chat Noir publications, however, is that the financial backing came from the cabaret profits, whereas *La Revue Blanche* was funded by the personal fortune of the Natanson brothers, who served as publisher, editor, and business manager. When it was dissolved in 1903, records indicate that *La Revue Blanche,* in fact, had never made a profit.[14] Salis did not have the luxury of continuing to publish works that drained his capital; for that reason the eight editions of the *Album* had to be vigorously promoted as highly desirable and unique publications.[15]

The cover of the *Album* (Fig. 8.5) incorporates the standard Chat Noir motifs: the Moulin de la Galette on top of the hill, the Parisian lamppost to one side, and in the center of it all, the larger-than-life black cat looking quizzically at a young woman who reaches out for the Chat Noir publication. The distorted scale of these images in relation to each other emphasizes that this is a world of fantastic and perhaps troubling encounters, that this spider web–filled world of the Chat Noir may not be entirely comfortable for a fashionable Parisian woman. Although clearly intrigued, there remains an element of trepidation as the woman looks into this somewhat eerie and disconcerting environment.

The Chat Noir *Album* is dedicated to the memory of the late medieval poet François Villon, who was an early advocate of writing about the reality of daily life, with full attention to both its ridiculous and painful qualities.[16] Villon is presented to the Chat Noir reader as a "worker poet," dressed in medieval peasant clothing; in the upper left corner of the page, a small drawing of a skeleton hanging from a gallows refers to Villon's best-known poem "Ballade des pendus" (Fig. 8.6). In Villon's poem, the desiccated bones of the skeleton speak directly to the reader, reminding him of the harsh reality of life and asking for compassion for man's common human plight. This combination of unpretentious reality and supernatural events is a frequent element in the Chat Noir publications, a reflection of the cabaret patrons' down-to-earth satire in alliance with a keen sense of the absurdity of life.

Another characteristic image (Fig. 8.7), this one from the fifth edition of the *Album*, is an example of the "tabletop" exchanges that Salis described in his promotional material. The drawing by Willette depicts a shadowy world filled with bats flying out at twilight as a vaguely demonic figure watches from the balcony of a rooftop across the page. In the lower portion of the drawing a large, sketchy cross stands beside a dark lake where the setting sun is reflected.

The text is an exchange between the poets Léon Bloy and Maurice Rollinat, both of whom were regulars at the Chat Noir. On the top of the page, Bloy

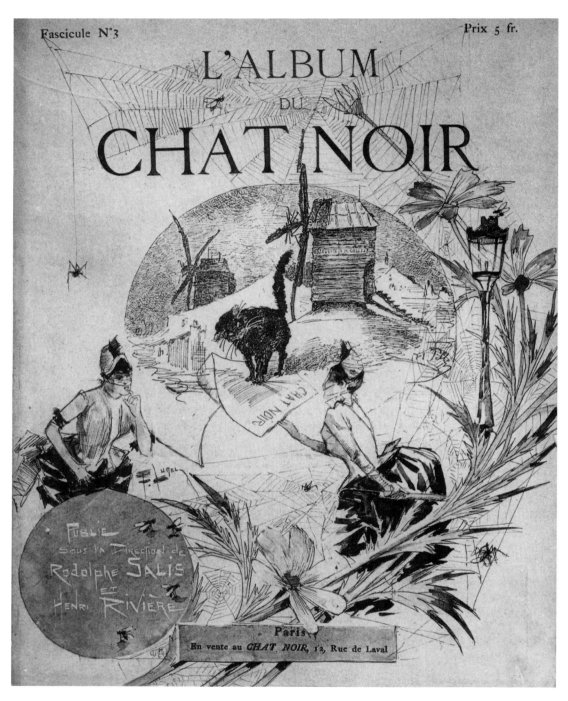

Figure 8.5　Ferdinand Lunel and Henri Pille, cover for *L'Album du Chat Noir*, no. 3, 1885. Courtesy Bibliothèque Historique de la Ville de Paris. Photo Jean-Loup Charmet.

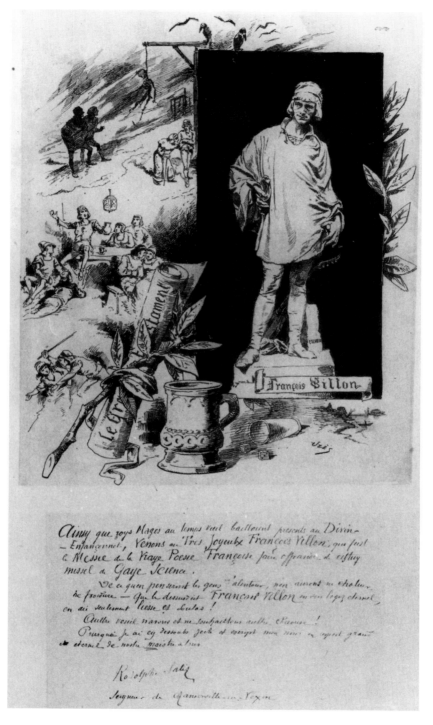

Figure 8.6 Uzès (pseudonym of J. Lemot), *Homage to François Villon*, *L'Album du Chat Noir*, 1885. Courtesy Bibliothèque Historique de la Ville de Paris. Photo Jean-Loup Charmet.

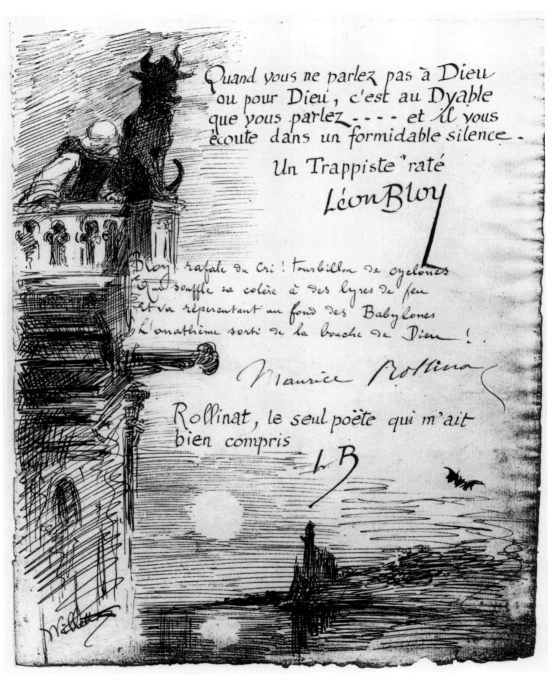

Figure 8.7 Adolphe Willette, image illustrating poems by Léon Bloy and Maurice Rollinat, *L'Album du Chat Noir*, 1885. Courtesy Bibliothèque Historique de la Ville de Paris. Photo Jean-Loup Charmet.

writes, "When you don't speak *to* God or *for* God, you're speaking to the devil—and he listens to you with an awful silence." Signed "an ineffectual Trappist monk" by Bloy, it refers not only to the silence of the Church as exemplified by the Trappists, but also to Bloy's own inability to remain silent about what he sees around him.[17] Rollinat's response indicates this clearly when he describes Bloy in the next part of the text as "a burst of cries, a swirling cyclone who blasts his anger on lyres of fire" that reveal the "curses that come from the mouth of God." Bloy's answer is a tribute to Rollinat, saying that he is "the only poet who truly understands me."

This kind of exchange, half in jest but deadly serious at the same time, is characteristic of the Chat Noir albums, intimating that the dark-edged world first introduced on the cover of the *Album* is an environment where humor and shadow work together to make the reader think about the world around him. Bloy's charge about the silence of the Church is a clear condemnation as well as a call to arms for people to speak up about the pervasive problems of society. If the Church is in the service of the devil, then perhaps the "ineffectual Trappists" of the world are the only ones left who can provide a balance.

An entirely different tone is set in Maurice Rollinat's parody of a Romantic or Symbolist love poem, published in the second edition of the *Album* (Fig. 8.8). In this poem, written in ballad form, the author laments his love of an unattainable wax mannequin who haunts him, but who of course remains inhuman. He stares at her in the store window, lavishes praise on her figure, her eyes, her dress—suffering all kinds of anguish over her indifference. He ends with a plea to Satan, that ancient king of perversity, to show him grace and send this woman of wax to his room.

Clearly, this is a spoof on the Romantic archetype of the suffering young genius who is caught up in his own fantasy world of impossible love. And just in case there's any doubt about that, Willette's illustration shows us the iconic figure of the tormented young man in his garret apartment. Light streams in through the tiny attic window as the tortured lover covers his ears with his hands to block out his demon thoughts. In contrast, the mannequin is shown on the opposite side of the text, aloof and alluring in her fashionable dress and spotlighted by the lamps in the store window. Striking a seductively contorted pose, she glances flirtatiously over her shoulder at the viewer.

This plate from the *Album* clearly demonstrates the integration of text and image. The agitated lines of the illustration that bleed into the poem at several points and the energetic swirls at the bottom of the mannequin's image emphasize and reinforce the increasingly anguished language as the author describes

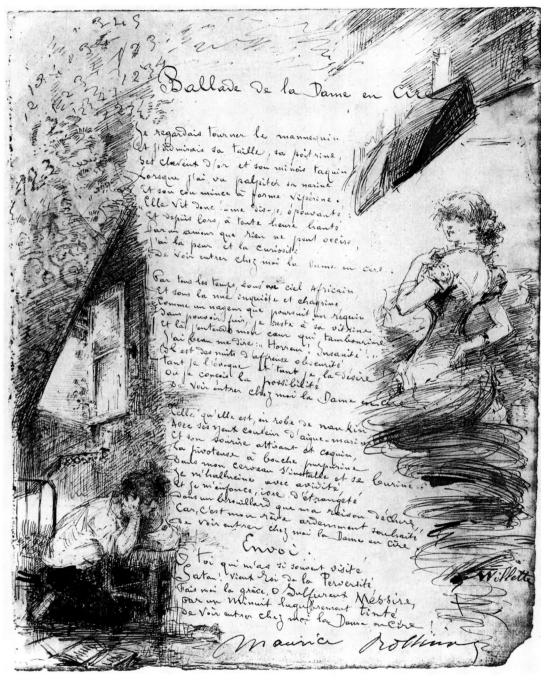

Figure 8.8 Adolphe Willette, image illustrating "Ballade de la dame en cire," poem by Maurice Rollinat, *L'Album du Chat Noir*, 1885. Courtesy Bibliothèque Historique de la Ville de Paris. Photo Jean-Loup Charmet.

the young man's desire as "a fog that has shattered his reason."[18] This type of spoof, emphasizing the ridiculous absurdity of yearning for a wax mannequin, would have been immediately understandable to an audience familiar with the overblown and occasionally obsessive verse of earlier Romantic poets such as Baudelaire or Gerard de Nerval.

The *Album* also contained more serious writing that focused on the social context of contemporary Paris. A poem by Louis Marjolleau from the fifth edition illustrates this clearly (Fig. 8.9).[19] A contemporary memento mori for the empty lives of the Parisian bourgeoisie, the text addresses itself to the free birds of the forest and fields, pointing out that they are able to enjoy the flowering of spring, the months of love-making, and the joy of singing their songs openly, just as the artistic community surrounding the Chat Noir relishes its free-wheeling lifestyle in the less constricted environment of Montmartre. Marjolleau concludes by asking these joyfully free birds to think sometimes of the birds that are caged, all alone, in the depths of the fashionable sections of Paris without joy or love.

Théophile Steinlen's accompanying illustration depicts a cozy group of birds perched in pairs on the branches of an old tree. They appear to be tucked in for the night while the evocative light of the moon glances off the gravestones of the cemetery below. The flower-covered grave in the foreground suggests a newly buried soul who has finally come to rest in a peaceful natural environment. Only in death do the "caged birds" of Paris achieve the freedom that the birds of the forest enjoy each day.

Again we see the close integration of text and image, the artistic interplay of different media unified in a collaborative whole. In particular, the text here functions almost as an oversized gravestone created by the reflection of the moonlight on the page. Straggling branches of the tree stretch across the text as they might across a gravestone in the cemetery beneath the tree. In this plate we can understand the bond with the poet Villon most clearly. Like the balladeer Villon, Steinlen and Marjolleau offer a melancholy compassion for the emptiness of life, in this case the life lived in a "cage" of bourgeois values that refuse to make space for freedom and joy.

Returning again to the characteristics described earlier, it is clear that the literature of the Chat Noir consistently reflects the values of both Rodolphe Salis and the artists associated with the cabaret. Both the *Contes du Chat Noir* and the *Album du Chat Noir* take a humorous approach to contemporary life, sometimes in a delightfully amusing tone and often in a darker, more satirical mode. Their

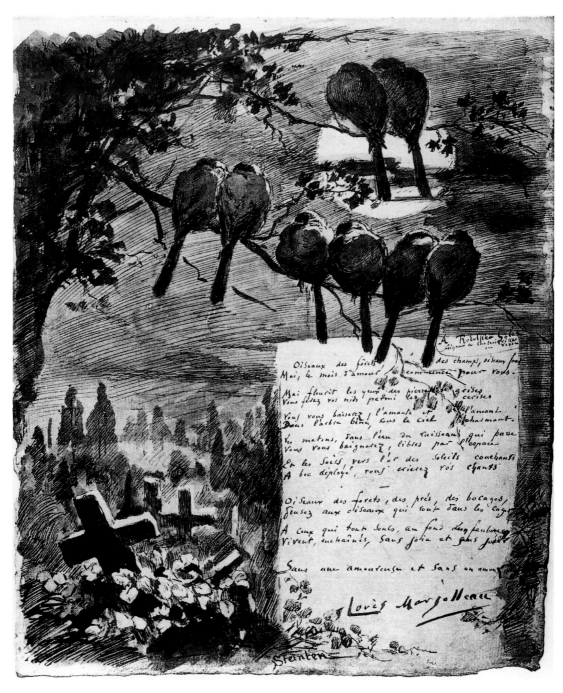

Figure 8.9 Théophile-Alexandre Steinlen, image illustrating a poem by Louis
Marjolleau, *L'Album du Chat Noir*, 1885. Courtesy Bibliothèque
Historique de la Ville de Paris. Photo Jean-Loup Charmet.

choice of Villon and Rabelais as historic predecessors reflects the two ends of this spectrum: Rabelais as the creator of outrageous exaggerated humor that allows room for satirical commentary and Villon as the poet of a darker, harsher perception that permeates the reality of daily life.

Central to these publications is the role of the creative artist as the social conscience of a world run amok. Visual artists and writers alike had a forum in the Chat Noir publications for articulating their perceptions and for convincing their readers of the relevance of their observations. The intimate collaboration between writers and artists further stands as a testament to the possibilities created through cooperation. Together, they created work that made a point while raising a smile, which is in sharp contrast to the Romantic notion of the solitary artist who creates only out of suffering and grief.

Finally, it must be remembered that the literature of the Chat Noir represents a commercial venture as well as an artistic one. The publications were clearly intended as promotional tools for both the cabaret and the artists associated with it. Questions remain about the distribution and sales of the *Contes* and the *Album*, but there is no doubt that these publications provided a model for other fin-de-siècle publishing ventures. Salis's gift for entrepreneurship was unparalleled in his time and must be considered in any discussion of the importance of the Chat Noir literature. To promote a new business and create a vibrant center for artistic activity is no small accomplishment, especially when it's done with humor and style.

NOTES

1. Phillip Dennis Cate and Mary Shaw, *The Spirit of Montmartre: Cabarets, Humor and the Avant-Garde, 1875–1905*, (New Brunswick, NJ: Rutgers University Press, 1996), 24.
2. The history of the Chat Noir cabaret is detailed in Cate and Shaw, *The Spirit of Montmartre*. The cabaret was originally located in two rooms at 84, boulevard Rochechouart in an old post office building. The space held approximately thirty people at maximum capacity. In June 1885, the Chat Noir moved to larger quarters at 12, rue de Laval where it remained until closing in February 1887, one month before Rodolphe's Salis's death. Ibid., 34–39.
3. *Fumisme* is characterized by skepticism and an often macabre sense of humor. The goal was to reveal and ridicule the hypocrisy of bourgeois culture and to encourage independent thinking. The definition of *fumisme* is discussed in depth in Cate and Shaw, *The Spirit of Montmartre*, 23.
4. Rodolphe Salis, *Les Contes du Chat Noir* (Paris: Librairie Dentu, 1888).
5. Garnier Frères published a new edition of Rabelais's *Gargantua and Pantagruel* in 1873 in two folio volumes with illustrations by Gustave Doré. Another edition, undated, appeared shortly after the 1873 publication with several of the original illustrations deleted. See *Doré's Illustrations for Rabelais* (New York: Dover Publications, 1978).

6. Barbara Bowen discusses Rabelais's use of specific comic techniques in *The Age of Bluff, Paradox, and Ambiguity in Rabelais and Montaigne* (Chicago: University of Illinois Press, 1972). Pointing out that "Rabelais' primary purpose was to disconcert his reader," Bowen notes that the author makes use of a variety of comic strategies, including ambiguity, bluffs and double bluffs, paradox, and the blurring of distinctions between reality and fantasy. For an English translation of Rabelais's writing, see *The Histories of Gargantua and Pantagruel*, trans. J. M. Cohen (Harmondsworth, England: Penguin Books, Ltd., 1986).

7. *Commedia dell'arte* plays traditionally depend on the use of stock characters and improvisational acting within the parameters of a script outline. Although *commedia* gave rise to a large number of stock characters, the most familiar are the arrogant military man, the duplicitous clergyman, the clever (and often disguised) servant, the young lovers, and the cunning older woman. For a general discussion of the development of *commedia* within the history of theater, see Oscar G. Brockett, *History of the Theatre* (Needham Heights, MA: Allyn & Bacon, 1999).

8. Rodolphe Salis, *Les Contes du Chat Noir*.

9. *Le Chat Noir*, October 3, 1885.

10. Brett Waller and Grace Sieberling, *Artists of La Revue Blanche*, ex. cat. (Rochester, NY: Memorial Art Gallery of the University of Rochester, 1984), 8. See also Georges Bernier, *La Revue Blanche, Paris in the Days of Post-Impressionism and Symbolism*, ex. cat. (New York: Wildenstein and Co., 1983), 24.

11. Waller and Sieberling, *Artists of La Revue Blanche*, 3.

12. Félix Fénéon, who became editor of *La Revue Blanche* in 1895, was actively involved in *Le Chat Noir* in the early 1890s. His experience at *Le Chat Noir* cannot have failed to be of considerable influence on his work at *La Revue Blanche*.

13. Waller and Sieberling, *Artists of La Revue Blanche*, 28.

14. Ibid., 12.

15. It is worth noting that *La Revue Blanche* also made a foray into satirical humor in 1893–95 with two supplements to the publication: *Le Chasseur des Chevalures (1893–1894)* and *NIB* (1895) with texts by Tristan Bernard and illustrations by Toulouse-Lautrec. See Waller and Sieberling, *Artists of La Revue Blanche*.

16. Twentieth-century Villon scholarship began with a focus on historical and biographical interpretations of his poetry. In the last few decades, scholars have turned their attention to an examination of the texts without particular reference to the biographical and historical context, distinguishing the "poetic persona from the man, François Villon," as David A. Feine explains in *François Villon Revisited* (New York: Twayne Publishers, 1997). It should be noted that Villon's total work consists of only 3,000 lines of poetry, a fact which has in no way diminished interest in his work over the centuries. In the twentieth century alone, two major poets, Galway Kinnell and William Carlos Wiliams, both worked on translations of Villon's work; Williams wrote the Introduction to the translation by Anthony Bonner, *The Complete Works of François Villon* (New York: David McKay, 1960); and Kinnell did his own translation, *The Poems of François Villon* (Boston: Houghton Mifflin, 1977).

17. Léon Bloy was an early advocate for Church reform in France. As Kurt F. Reinhardt points out in *The Theological Novel of Modern Europe* (New York: Frederick Ungar, 1968), "Bloy reproaches the Church and certain members of the clergy for their crass materialism and for their soft, sentimental piety. . . . [He] was one of the first to call attention to the weakening of religious faith in France, especially among the working class and the peasantry" (79).

18. *Album du Chat Noir* 2 (n.d.).

19. Ibid.

The Chat Noir's Théâtre d'Ombres

Shadow Plays and the
Recuperation of Public Space

ELENA CUETO-ASÍN

The fiftieth anniversary of the opening of the famous Montmartre cabaret, the Chat Noir, was commemorated in 1932. That same year, Paul Jeanne, in his book *Les Théâtres d'ombres de Montmartre,* lamented the fact that the celebrations were highlighted by the revival of songs and poems associated with the locale but without any mention of the shadow theater that made it famous. He wrote: "They didn't go beyond presenting the hors-d'oeuvre and forgot the main dish."[1] Almost seventy years later in the context of this collection of essays on the rise of mass culture and Montmartre at the turn-of-the-century, it is my turn to ensure that the work of the Théâtre d'Ombres is not forgotten again.

The Théâtre d'Ombres theater company of Montmartre was active in various Paris cabarets between 1887 and 1914. During this time the company produced some forty shadow plays of diverse styles and themes that ranged from the satirical and the comical to the lyrical and the historical were produced. These performances in shadow have enjoyed lasting recognition as they figured among the most highly appreciated and popular spectacles of the theatrical avant-garde of Paris of their time. The popularity of the shows also extended beyond the confines of the capital, through tours of various provinces of France

and abroad. In 1893 the company even crossed the Atlantic to participate in the World Columbian Exposition in Chicago. Given all of this and in spite of the general lack of critical studies of the company's activities, the Théâtre d'Ombres and its shadows play are still considered treasures of the Symbolist drama of the final decades of the nineteenth century.

My study of the Théâtre d'Ombres is not principally concerned with its aesthetic attributes, the configuration of the shadows, or their evolution and variations, nor will I study this theater from a literary perspective. Instead, my interest in the work of the Théâtre d'Ombres company centers on the genesis of the spectacle of shadows itself as a social phenomenon and a form of public entertainment that reflects the cultural anxieties of the time.

Recent work in the field of cultural history has been responsible for raising interest in the consideration of popular and mass culture by recovering certain areas of art that have traditionally been ignored in the canonical study of high culture. This new interest in popular and mass art forms retreats from the analysis of individual works by immersing them in their socio-historical contexts and by examining their importance as objects produced for consumption, their technological strategies, their modes of distribution, and their spaces of production. Much of the work in this field of investigation originates in the study of the early modern period. It places special emphasis on the nineteenth century as the point from which almost all contemporary discourses of modernity emerge when cultural forms of industrial capitalism are forged. One of the essential points of this theoretical framework has been the recognition of the importance of including the receiving public as a significant part of the genesis of any given cultural production. This inclusion is reflective of the shifting ground of culture in the age of industrial revolution and underlines the necessity of incorporating the receiver or buyer into the mechanisms of producing public or mass entertainment. Moreover, part of this incorporation involves the designation of specific spaces or locations for the reception of these new forms of entertainment. This process becomes more accentuated in the second half of the nineteenth century as the spaces for public diversion are systematically stratified.

This stratification can only be understood as paralleling a new idea of urbanization, exemplified by Baron Haussmann's vast replanning of Paris, which resulted in the isolation of the middle and upper classes in an exclusive area of the city, distancing them from the rest of society. Among the many who have studied this phenomenon, Richard Sennett, in his book *The Fall of Public Man*, studies the conventions of the bourgeoisie in the context of the changing cityscape of the second half of the nineteenth century.[2] He analyzes the middle

class's retreat from the open and spontaneous space of the street and how this group sought to reaffirm itself through the adoption of a distinguished and introspective attitude based on silence and discretion. Following this separation, the street became a theatrical space where appearances and the image of dignity were to be maintained. Amid the hustle and bustle the individual observed with discretion at the same time he or she was observed and qualified as genuinely belonging to the class he or she purported to represent. Paris, referred to by Walter Benjamin as "the capital of the nineteenth century," emerges as the model for the diffusion of these tendencies throughout Europe.[3] Roger Shattuk, in his famous book, *The Banquet Years*, reiterates this theatrical image of the French capital, referring to it as "a stage, a vast theater for herself and the world" where "living had become increasingly a special kind of performance presided over by fashion, innovation, and taste."[4] Those areas of the city and those individuals that failed to obey these established norms of fashion and social composure were automatically excluded as undignified, and associated with the lower classes, immoral licentiousness, and political subversion. As a result of these rigid social conventions, a neighborhood's respectability was gauged by the absence of street vendors, pubs, taverns, and other places of social gathering.

The world of show business also succumbed to this reorganization of urban space and the underlying social norms that accompanied it. Outdoor venues and those free to the general public disappeared and locales with any capacity for staging performances were divided and categorized. Legal measures were imposed to differentiate drinking and eating establishments like taverns and café-concerts from theaters and opera houses. Added to the increasing commercialization of theatrical productions, these changes accentuated an increasing emphasis on the differentiation and categorization of genres and theater professionals, and resulted in the emergence of new architectural spaces that crystallized a rigid hierarchical reorganization of ticket pricing and seating. This rigidity would remain in place, practically unmodified, until the advent of the cinema.

The Théâtre d'Ombres at the Chat Noir developed in the midst of the consolidation of these transformations under the bourgeois order of the Third Republic. The appearance of this unique form of entertainment also occurred at a critical moment in the evolution and history of the spectacle given that the advent of motion picture technology was but a few years away. Artistically speaking, the shadow theater is framed within the Symbolist movement and can be considered a part of what John A. Henderson called "the first avant-garde" that formed the bases for the activity of radical change and renovation that has

defined drama in the twentieth century.[5] On the one hand, we can observe that the Théâtre d'Ombres, in the context of the Parisian cabaret, is a clear manifestation of the avant-garde spirit that sought to escape and maintain a critical distance from the reigning bourgeois mentality. On the other hand, this initiative, like so many others, contradicted its own principles through its close association with the intellectual exclusivity of the Chat Noir and its lucrative ends.

Of the many Paris locales with which the Théâtre d'Ombres was associated, without a doubt the most important and most emblematic of these was the Chat Noir. It was in this Montmartre cabaret that the theater was born and functioned until 1896. The company presented its show in other venues like Le Lyon d'Or, La Boudinière, and Les Quat'z'Arts, La Boîte à Fursy, and La Lune Rousse until as late as 1914, and during the First World War in La Chaumière café. Yet in no other locale did the shadow theater enjoy as much success and as much popularity as it did on its first stage at the Chat Noir.

The Chat Noir was the most successful cabaret of the many that opened earlier in the nineteenth century; it was modeled after La Grande Pinte, founded on the idea of offering an environment for an intellectual and artistic clientele that differed from the established locales of the Latin Quarter. Due to the success of its many activities the cabaret quickly outgrew its space, causing its owner, Rodolphe Salis, to move the Chat Noir to its definitive locale on the rue Victor Massé (rue Laval today). There the cabaret became one of the most popular nightspots of the city, not only among artists and intellectuals but also among a curious bourgeois and tourist crowd anxious to be admitted to the busy locality to rub elbows with the extravagant world of bohemia.

Salis, a man of great talent and personality, played an important role as the master of ceremonies of his own cabaret. Familiar with the idiosyncrasies of Paris, he was always able to foresee its fickleness and ephemeral tastes so as not to allow his business to become passé as often happened. To this end he continuously renewed the artistic program and updated literary circles and was always receptive to the original ideas of his patrons. The Théâtre d'Ombres, along with many of the cabaret's other unique activities, owes its existence to Salis's initiative and confidence in the cabaret's regulars.

The idea for a shadow show cropped up one night in 1887, springing from artists Henry Somm's and George Auriol's simple marionette theater, which was part of the nightly repertoire. Henry Rivière, editor of the *Le Chat Noir*, was inspired to experiment on his own shadow show by placing a napkin over the opening of the puppet theater and making several cutouts representing municipal policemen. By illuminating the figures from behind, the shadows on the nap-

kin were made to accompany the *chansonnier* Jouy's rendition of a popular song entitled "Sergot" or "The Cop." This improvisation was so applauded (by all except Jouy) that it was repeated. Little did Salis know that this experiment would give rise to one of the Chat Noir's most popular attractions.

Henry Rivière can be considered the master and creator of the Théâtre d'Ombres, but in reality the artistic contribution of the company was the fruit of the collaboration of a dedicated group of artists, illustrators, writers, musicians, and other accompanists. The artistic activity of these productions extended to other aesthetic expressions, which have been preserved, the most important of which are the posters advertising the plays and the company's tours and the programs designed by Steinlen, Auriol, and Rivière (Figs. 9.1 and 9.2). Another manifestation can be found in books inspired by several of the most popular shadow plays, published by Flammarion and Enoch & Cie (Fig. 9.3). These volumes were in a horizontal format that replicated the shape of a screen and contained lithographs and the music that accompanied the plays.

The basic mechanisms for the production of the shadow plays were extended and developed over time and resulted in a highly sophisticated technical apparatus (Fig. 9.4). The first figures, simple cardboard cutouts, gave way to detailed zinc silhouettes. The screen was enlarged to occupy an entire wall of the locale to make its decorative circular opening the center of attention. Lighting techniques were perfected with the addition of colored lenses and other shading devices. The images were accompanied by an array of sound and other special effects that emerged from the box of the theater (five yards deep and nine yards high), which had been extended into a patio behind the cabaret to allow several technicians to work simultaneously (Fig. 9.5). In just a short time, the shadow shows produced by the Théâtre d'Ombres at the Chat Noir reached a marvelous degree of complication without losing their bohemian qualities and avant-garde principles.

Armond Fields has noted that "the old Chat Noir was a tavern for artists and writers; the new Chat Noir was a theater for the people."[6] The literary cabaret of the late nineteenth century was a hybrid locale that brought together the elitist seventeenth-century literary salon, highly intellectual or political in tone and completely removed from society, and the café-concert, dedicated to song and other popular forms of music and entertainment. In this new eclectic space literary discourse intermingled with popular theater and other leisure activities in the context of food, drink, and the possibility of conversation and spontaneous amusement. The literary cabaret was an offensive response to the stratification occurring beyond the limits of the locality in greater Paris. Uniting in one place

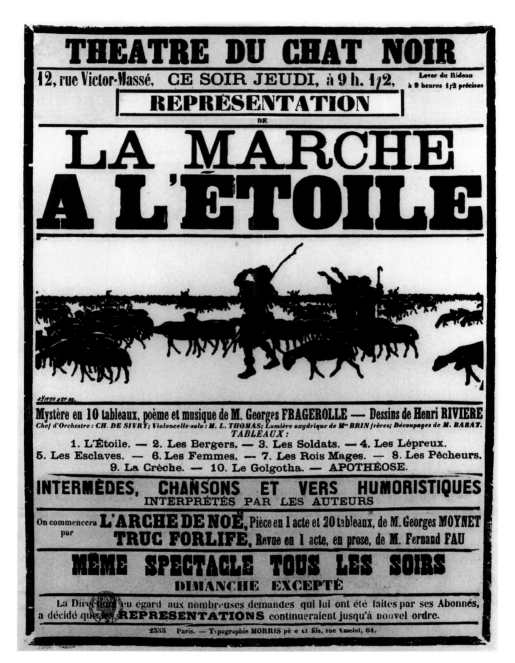

Figure 9.1 J. Vitou, *La Marche à l'étoile*, 1890. Poster advertisement for a performance at the Chat Noir. Lithograph with hand coloring, 23 7/8 x 16 5/8" (60.7 x 42 4 cm). Santa Barbara Museum of Art. Gift of Sara and Armond Fields.

Figure 9.2 George Auriol, program for the Chat Noir Théâtre d'Ombres performance of *Héro et Léandre*, 1893. Stencil-colored photorelief, 13 x 9 3/4" (33.1 x 24.8 cm). Santa Barbara Musuem of Art. Museum purchase with funds provided by Sara and Armond Fields and Deaccessioning.

the business of the intellectual elite with the social activities of the lower classes was an attempt to recuperate public space by excluding or alienating the middle class that had imposed itself and its values of exclusivity on the social order at large.

The Théâtre d'Ombres takes this project of recuperating public space to its most sophisticated expression. The formula of the shadow play lent itself to this intention given that it was a mode of representation historically linked to other forms of popular and traveling entertainment. The re-creation of the Middle Ages was an important attribute of the Symbolist aesthetic. Like the Romantics before them, the Symbolists were attracted to this period because it represented a precapitalist state, free from Enlightenment rationality and free from the predominance of the concrete over the symbolic and allegorical. This tendency was echoed in the Chat Noir, in the design of its interior and in the additional aesthetic elements produced by the artists who congregated there and who enthusiastically participated in the recovery of that period. This was not done without

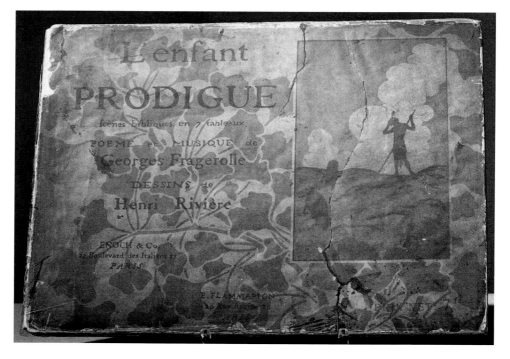

Figure 9.3 Henri Rivière, image from a picture book based on the shadow play *L'Enfant prodigue* (*The Prodigal Son*),1895. Pen and ink on silk, 9 3/4 x 12 3/4" (24.8 x 32.4 cm). Santa Barbara Museum of Art. Gift of Sara and Armond Fields.

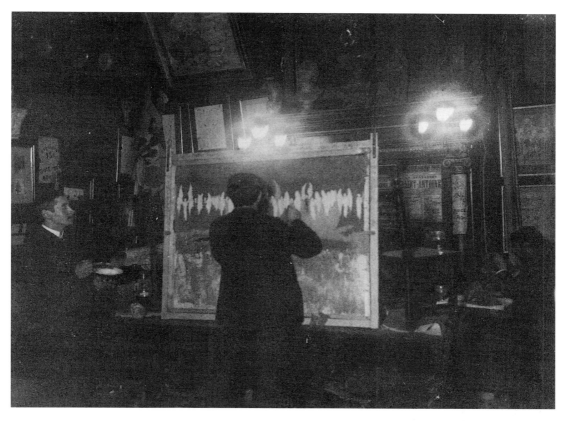

Figure 9.4 Henri Rivière, photograph of scenery being painted for *Ste. Geneviève*, 1893. Musée d'Orsay, Paris.

a certain degree of banality: the walls of the cabaret were covered with cobwebs and the drinking cups of Charlemagne, Rabelais, and Villon (the patron saint of the Chat Noir) were displayed. These elements aside, the least evident but most relevant allusion to the Middle Ages for my discussion is found in the spatial distribution of the cabaret and its activities. The organization of the Chat Noir reproduced the essential coordinates of the public place prior to its privatization in the modern period which was exemplified by the medieval town square or plaza. This space was idealized as a center for literary and theatrical activities where the boundaries between spectacle and spectator were not fixed architecturally and the separation of the performing arts (theater, poetry, and music) was nonexistent. In this context, the work of art composed by the troubadour or the itinerant artist was combined with the spontaneity of the moment and the active participation of the public. The performance in the open plaza had to accommodate itself to the rhythm and pace of the myriad of other activities that

were going on simultaneously around it. It was a place where the full range of human social activities and interactions were joined with the creative endeavors of the artist.

In spite of their originality, Henri Rivière and his associates in no way can be credited with introducing the idea of a shadow theater in France. In fact when their Théâtre d'Ombres at the Chat Noir became the talk of the town, the Parisian audience was already familiar with this type of performance, and considered it to be second rate.

The origins of this mode of representation are found in the Far East, where it had been common since the early Middle Ages in China, India, and Java primarily. In these countries, the illusory and abstract qualities of the silhouette evoke a spiritual dimension related to epic, philosophy, and religion that was not incompatible with a popular form of entertainment. In Western culture the projection of shadows has quite a different story. From the earliest vestiges of

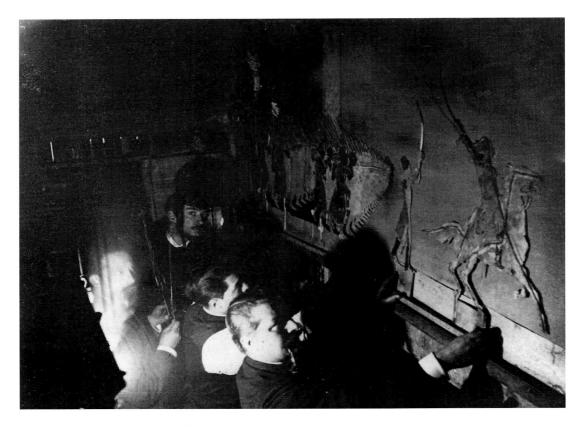

Figure 9.5 Henri Rivière, photograph of shadow puppet operators behind the screen at the Chat Noir, ca. 1890. Musée d'Orsay, Paris.

the Western tradition the shadow was used as a scientific tool to measure such things as the height of pyramids or the sun's daily trajectory. Later the silhouette formed an essential part of advances in the areas of optics and reflexology and the development of such devices as the magic lantern (targeted by the Catholic Church for being necromancy).

Not until the eighteenth century when the shadow's playful character was discovered and was deprived of its scientific utility did it come to be valued as a form of entertainment. During this time silhouette portraits and landscape scenes cut from black paper became fashionable. Early in this century shadow performances with human figures also became common in the salons. This form of entertainment was popularized by individuals such as the famous Séraphin who began his career presenting his show in the gardens of Versailles and who even enjoyed success following the Revolution with his company, the Théâtre des Vrais Sans Culottes, in Paris. Following the death of Séraphin in 1800 his theater survived, although in a progressive state of decline. By the middle of the nineteenth century many such theater companies had been established in the city's center, but many of these never enjoyed more than a marginal draw as magic shows featuring hand shadows. Outside of the theater the silhouette was popularized as a decoration for weather vanes and as a form of journalistic caricature. It was also commercialized in the form of miniature theaters designed for family entertainment. All of these forms give evidence that the silhouette became an important part of the proliferation of visual spectacles in the entertainment industries of the late nineteenth century. Mariel Oberthür observes, "Then the public demanded entertainment. And moreover, they loved when they were given images."[7]

Artistically speaking the Théâtre d'Ombres at the Chat Noir claimed a connection to the Asian tradition by giving its silhouettes the same spiritual, transcendent, and stylized dimension proper to its oriental predecessors. This was also perfectly in line with the group's Symbolist aesthetic preoccupations. The dramatic adaptation of the shadow within this tendency was based on the duality of this effect of light. On the one hand it clearly pertained to physical reality and had the ability to represent concrete figures. On the other hand, the shadow's capacity to disappear or to be transformed by simple changes in lighting, or to be combined with another opaque and transparent body, simultaneously linked it with qualities that distanced it from materiality. The trait of intangibility made it easy to liken the shadow to the form of the soul and other spiritual elements. As Carlos Angloti notes in his book *Comics, títeres y teatros de sombras*, the shadow offers "the possibility of revealing something without seeing it, of insinuating,

of deforming reality and giving it characteristics that by any other means would be very difficult to achieve."[8] While not totality incompatible with this search for the spiritual in art, the Théâtre d'Ombres as an avant-garde project also sought to echo the banality of the silhouette's use by reclaiming its popular manifestations. All of these aesthetic considerations must also be linked to the fact that Henri Rivière, along with his colleagues, was deeply affected by the popularity of Japanese art and a renewed interest in lithography and engraving following the 1883 Exposition d'art japonnais in Paris. The result was a combination between high and low culture that allowed for the broad range of thematic possibilities reflected in the titles of the company's many productions and in the varied styles of the silhouettes produced for them. This variety accounted for the wide appeal of the Théâtre d'Ombres and made it possible for works as different as *L'Epopée* (1886), *La Marche à l'étoile* (1890), and the *Pierrot pornographe* series (1893) to enjoy the same level of success.

In general the plays were drawn from existing sources. *L'Epopée,* together with *La Conquête d'Algérie* (1889) and *Le Roi débarque* (1894), belong to the part of the repertoire inspired by historical and patriotic themes. This latter play represented the Napoleonic campaign in twenty military scenes and was accompanied by a complex juxtaposition of sounds ranging from cannon blasts to screams of victory. Free from political commentary, the patriotic subject matter was among the most successful. Nevertheless, the largest number of plays were based on literary themes that reflect more clearly the company's underlying Symbolist sensitivities. The most successful of these performances were: *La Tentation de Saint Antoine* (1887), after Flaubert's narrative; *L'Éléphant* (1886), inspired by oriental legends; and *Ailleurs* (1891), from a poem by Maurice Donnay. Apart from sophisticated and suggestive lighting effects, these works were accompanied by music and poetry recitations. Along these same lines were the religious and biblical themes: *La Marche à l'étoile* (Fig. 9.6), *Ste. Geneviève* (1893), and *L'Enfant prodigue* (Fig. 9.3). Among the comic productions the most famous were those that featured the adventures of Pierrot like the *Pierrot pornographe* series and *L'Age d'Or* (Figs. 9.7 and 9.8). These spectacles also included farces and *soties* (fourteenth-century farce) reflecting contemporary events like *L'Honnête gendarme* (1896). Oberthür notes in her study that *La Nuit des temps* (1889) was the only entirely original play created by the company (Figs. 9.9 and 9.10).[9] This work, which anticipates later science fiction writing, is about medieval time travelers, transported to the present by means of a magical potion.

In addition to the eclecticism of themes, sources, and artistic media that characterized the Théâtre d'Ombres's recovery of public space, another funda-

mental aspect of the shadow plays was the simultaneous interaction between various literary genres. This interaction revolved around the figure of Salis and his presentation and spontaneous explanation of the works as they were being projected. Each evening the cabaret was witness to a succession of various numbers or performances alternating with music, song, and recitals. This format reflects the absence of professional divisions and the brevity and variety of mass forms of entertainment. Although Jody Berland, in her article "Cultural Technologies and Production of Space," comments on the early television variety show, her remarks are pertinent to the cabaret's variété formula in that she sees this format as fundamentally "facilitating the creation of a newly capitalized

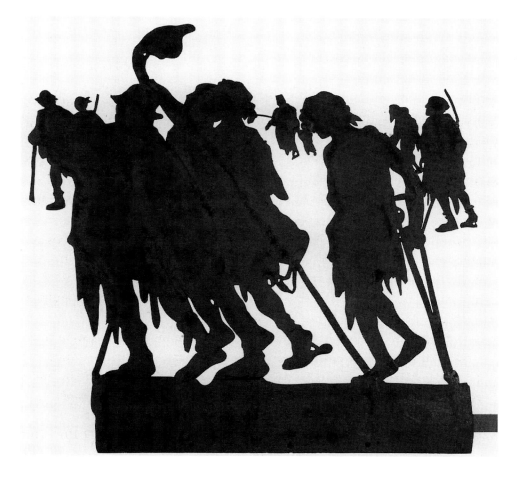

Figure 9.6 Henri Rivière, *Les Lépreux* (*The Lepers*), zinc-cut figure for *La Marche à l'étoile*, 1890. Musée des Arts Decoratifs, Paris. Photo Laurent-Sully Jaulmes.

and centralized entertainment industry."[10] This was a formula that, at a specific moment in time, at the end of the nineteenth century, would transcend the realm of popular culture championed by bohemia and would be converted into the mainstay of commercialized mass culture. This transition, as we will see, occurs at the Chat Noir in the rise of its famous theater of shadows.

The shadow play as a composite form based on various genres was the realization of the Symbolist ideal of the theatrical performance as poetry in motion. With the advance of the nineteenth century, poetry and theater were progressively segregated in the process of stratification that coincided with the rise of the bourgeoisie. Drama and theater spaces came to be associated with this class and its values, so Symbolist intellectuals rejected this genre entirely. Instead they developed a strong identification with poetry as a literary form, free of class associations and as occupying the realm of pure creativity and free-spiritedness.

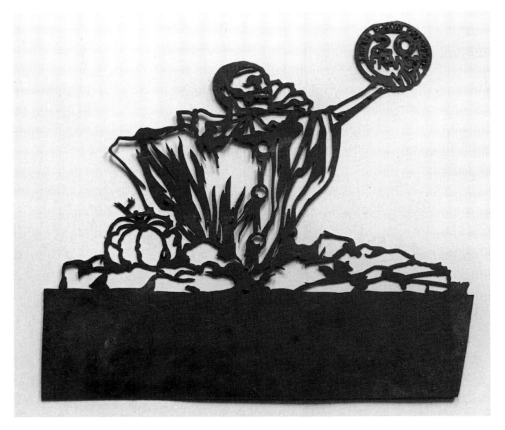

Figure 9.7 Adolphe Willette, *Pierrot*, zinc-cut figure for *L'Age d'Or*, 1889. Hôtel Sully–Musée Municipal de Châtellerault, Châtellerault, France.

According to the poet Stéphane Mallarmé, it was only through poetry, by means of the symbol and the concept, that the hidden interior reality of the human being could be expressed. By contrast, in the theater pure expression was individualized and thus destroyed by the mediation of the actor. Other theoreticians of the movement like Maurice Maeterlink, Gordon Craig, or Adolphe Appia

Figure 9.8 Adolphe Willette, *Columbine*, zinc-cut figure for *L'Age d'Or*, 1889, Hôtel Sully–Musée Municipal de Châtellerault, Châtellerault, France.

sought to solve this problem in the theater by substituting for the actor a puppet or a shadow that is unable to use dialogue and whose movements merely accompany the music or the poetic expression. In the end, however, the only spectacle that the Symbolist groups admitted, apart from the Wagnerian opera, was that of the Théâtre d'Ombres, which was associated with the literary cabaret's eclectic space.

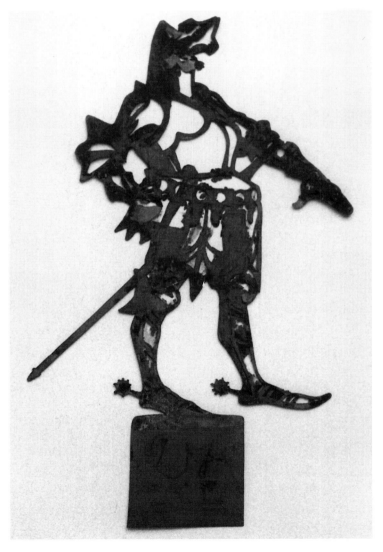

Figure 9.9 Albert Robida, *Guerrier du Moyen Age* (*Warrior from the Middle Ages*), zinc-cut figure for *La Nuit des temps*, 1889. Hôtel Sully–Musée Municipal de Châtellerault, Châtellerault, France.

Frantisek Deak in *Symbolist Theatre* proposes that the relation between poetry and the theater as spectacle "is both structural and historical."[11] The tradition of acting out a poetic text goes back to the Middle Ages and the songs of the bard, the troubadour, the *saltimbanque*, and the variety of other itinerant actors whose performances were based on the monologue as a form of entertainment to capture the public's attention. Among these manifestations was the

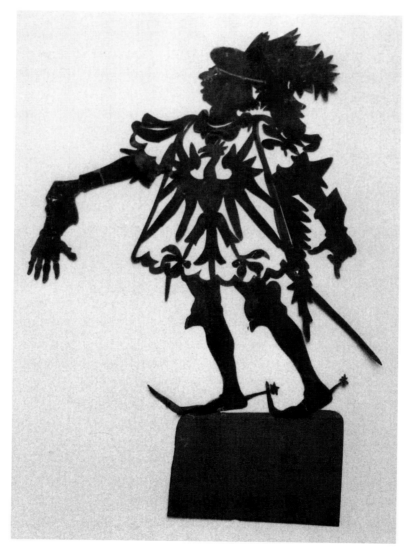

Figure 9.10 Albert Robida, *Guerrier du Moyen Age* (*Warrior from the Middle Ages*), zinc-cut figure for *La Nuit des temps*, 1889. Hôtel Sully–Musée Municipal de Châtellerault, Châtellerault, France.

song of the blind man or the cripple who told stories of strange and extraordinary events and crimes of passion from memory with the aid of vignettes accompanied by music or his own gabbiness. In all of these early forms of theater, the division between the audience and the space reserved for the actor was a vague notion detached from any sort of physical barriers or conventions that regulated entry, exit, price, or behavior. Although the works of many of these performers persisted well into the nineteenth century, as we have seen, they were increasingly restricted to rural zones and marginal areas on the outskirts of the city. One exception to this decline was the sudden popularity of the circus that shared the hillside of Montmartre with the cabarets. The remnants of popular itinerant theater and the figures associated with it proved especially attractive to innovative artists, inspiring not only the Symbolists and Parnassians but also the Naturalists. Apart from the organization of public space that surrounded these individuals' performances, the bohemian artist also copied the figures themselves.

In one of Paris's most stylish and most frequented nightclubs Salis ventured to reproduce these obsolete and base forms of entertainment. The host of the Chat Noir took on the role of minstrel not only by introducing the shadow show but also by forming an integral part of the spectacle, narrating and commenting on the images projected on the screen. To this end, the master of ceremonies would appear in various guises, some evenings dressed as a medieval knight and others donning the medals of the Legion of Honor. Following a triumphal entrance, Salis would circulate throughout the cabaret, move up and down the stairs chatting with his clients, making jokes with them and about them or spontaneously reciting a poem. One of Salis's stock formulas for such entertainment was the *pièce bonimentée*, which consisted in accompanying the programmed shadow play or other show with musical improvisation and biting satirical commentaries. The interpretation of the story would be twisted to take advantage of current events, of the latest news story or public scandal or the popularity of a particular public personality who happened to be in the audience that evening. Salis also took this formula on the road, and when the company was touring in France and abroad, he always sought out the details of the latest local dispute or crude story so as to insert them into his commentaries and heighten the provincial audience's entertainment.

Paul Jeanne, Dominique Bonnaud, and other writers who frequented the Théâtre d'Ombres performances and later wrote about them, lamented the fact that Salis's interpretations and commentaries and those of his followers at the Chat Noir and other cabarets were never recorded. Like the literature of the min-

strels and troubadours of the Middle Ages, these performances belong to that history of oral literary tradition that only with great difficulty can be reconstructed. We are left only with the descriptions of those who witnessed these productions and a very few critical reviews that appeared in the newspapers of the period. Jeanne described in the following way Salis's enormous capacity for improvisation: "Salis found material for his commentaries by constantly renewing his improvisations and avoiding implied meanings that might be misunderstood. He always knew just the right word to give his audience but never flattered them. He juggled metaphors, antitheses, and anachronisms on purpose, throwing himself blindly into long monologues without any idea of how they might turn out."[12]

No one has studied the symbiotic relationship between the actor of the popular theater and the avant-garde artist as Jean Starobinski did in his book *Portrait de l'artiste en saltimbanque*. According to Starobinski, the identification between the modern artist and the figure of the jester was not simply a visual or poetic strategy. Rather more importantly it was a "circuitous and parodic way to pose the question of art."[13] For the bohemian, the attitude of the clown transcended the stage and infiltrated real life, constituting an ironic interpersonal relationship vis-à-vis bourgeois behavior. From this disposition we can trace the evolution of another form of social theatricality such as dandyism, an attitude embodied in personalities of the period like Oscar Wilde, Charles Baudelaire, and Alfred Jarry.

The audience was an integral part of this project of recuperation that made the success of the minstrel or clown and his theater possible. Who were the clients of the Chat Noir and the audience for the Théâtre d'Ombres? We know that the public for these evenings of entertainment was quite large and was responsible for spreading the fame of these activities beyond the limits of the avant-garde circuit. It is also evident that it was a not a group comprised of marginal intellectuals of radical and antibourgeois persuasions. The audience in attendance did not necessarily reciprocate the attitudes that permeated the artists' ideas and performances. On weekends, and in particular on Friday evenings, enormous crowds gathered at the entrance to the Chat Noir to get in to see the most popular of the Théâtre d'Ombres's representations, readily paying outrageous prices for consumption just as they did at other fashionable Parisian locales. The company very soon after its inception lost the aura of a bohemian or marginal spectacle. Salis owed the success of his business to a regular monied clientele that, in principle, should have been hostile to the bohemian position of the cabaret and its entertainment offerings since both were founded with the intention of mocking the very values for which this public stood.

How exactly this symbiosis between the cabaret space and a wealthy middle-class audience came about at the Chat Noir and in the context of the Théâtre d'Ombres productions is connected to the very process of stratification that seemingly made the two incompatible. Sennett points out that the demise of public culture in 1880s and 1890s Paris, while a very real phenomenon, is often difficult to discern on the surface of many visual and written testimonials of the period that by contrast reflect an urban space alive with constant activity. From a sociological standpoint this is often the result of a tendency to confound genuine social practice with the creation of representations or forms of public entertainment designed to have a sudden yet short-lived impact on the masses. The great urban centers of fin-de-siècle Europe were spectacles unto themselves and represented a fixed attraction for the well-to-do, and especially for the men, who felt the need to observe the world around them even if the greater part of it was prohibited and beyond their reach. As Sennett writes, "He clung to the belief that outside the home, in the cosmopolitan crowd, there were important experiences for a person to have."[14] This potential explorer/spectator desired to escape the rigidity of family life and its middle-class surroundings to gain access to the realm of fantasy that his daily existence lacked and to abate the frustrations caused by the limitations imposed on him by society. On the street, as I noted earlier, the respectable city dweller took on the characteristics of an actor. To be seen and observed while engaged in daily activity and to participate in certain events on the street were integral parts of the creation of a new public persona. Peter Bailey, in *Music Hall: The Business of Pleasure*, defines this practice as a first attempt to "reconcile an invitation to indulgence with the newer forms of orderly consumption."[15] In this new activity "the crowd were as much producers as consumers of a form of social drama."[16] Thus, to attend the latest and most stylish cabaret was not necessarily linked to any real interest or understanding of its activity. Instead, the visit to Montmartre was more frequently an excursion, a superficial voyage of sorts into those prohibited and unknown regions of the urban geography. Among the well-to-do regulars were also artists who had frequented the cabaret early in their careers and who by then were renowned figures, for example, Claude Debussy and Erik Satie.

Salis ably took advantage of this superficial spirit, which deep down he must have despised, to build his business. He was willing to ignore some of his own intellectual principles to fill his cabaret and to promote the Théâtre d'Ombres. The cabaret owner was as famous for his creative and ingenious verbosity as he was for the rude and contemptuous manner in which he treated his clients. The latter were received at the entrance of the cabaret with a shower of insults and

these playful attacks continued throughout the shadow performances as part of the *pièce bonimentée*. Salis's demeanor was considered by the public part of the ritual of going to the Chat Noir and the patrons accepted it as part of the extravagant show they were paying to see there. Jeanne wrote that Salis:

> had, deep down, the greatest disdain for those people who brought him their money. While he addressed them as "Your Lordships and Your Electoral Excellencies," they accepted the attacks he launched on them without saying a word. Especially on Friday nights, the most fashionable evening, when they paid a *louis* to sit on a hard wooden seat to see La *Marche à l'étoile* or *Sainte Geneviève*, Salis would be most impertinent with his clients. Friday was a day for aggressiveness. He would crush the bank, the parliament, high society, the *demi-monde*, everyone![17]

The formula of the insult was successful due to its novelty, and other cabaret proprietors like singer Aristide Bruant at his Le Mirliton soon copied it. As Shattuk comments: "No one had tried such a 'democratic' enterprise before, and the snobs loved it."[18] The innovation was nothing less than the inversion and erasure of the boundary between the spectators and the actor, between the entertainer and the consumers. The patrons paid a very high admission fee only to allow themselves to be humiliated; they turned upside down the fundamental principle of the capitalist system that reserved the position of power for the one who pays.

The acceptance of this abuse and this inversion of privilege on the part of the cabaret-goers can be explained in part by the convention of silence that the bourgeois system imposed on itself and that became an essential part of accepted behavior in the realm of entertainment. Among the many protocols that regulated the newly stratified space of the late nineteenth-century theater, Sennett cites with special emphasis that the restriction of emotional reaction to performances was seen as another fundamental distinction among the classes. He notes, "To sneer at people who showed their emotions at a play or a concert became 'de rigeur' by the mid-nineteenth century."[19] The self-discipline of silence also came to be considered a distinctive phenomenon of all that was cosmopolitan, differentiating the audiences of the capital from those of the provinces who were more likely to react out loud and to make noise at a performance. Nevertheless, it would be wrong to say that the upper-class audiences of the capital discarded all of their capacity to react to what they perceived to be scandalous or improper. This is evidenced by the fact that the various avant-garde movements of the late nineteenth and early twentieth centuries continued to focus much of their creative energy on provoking the outbursts of

this otherwise reserved public. And yet this need to provoke, to *épater les bourgeois*, was a reaction to a tendency created over an entire century in which the public was educated to see without response and to respect and appreciate whatever was deemed to be art, regardless of whether they understood it or not. An anxiousness to become cultured and a fear of being ridiculed in front of others for a lack of class brought on this passivity. In this way, silence was "the song of a profound self-doubt."[20] To abstain from reaction, and to repress and dissimulate feelings were signs of invulnerability that made one immune to accusations of weakness or insecurity in the process of social and cultural education. Such was the power of this process that by the end of the century this self-discipline and other modalities of behavior associated originally with the grand theaters and opera houses had begun to infiltrate the popular playhouses and even the cabarets.

Salis was well aware of his audience and even delighted in the fact that this feeling was heightened by a general sense of disorientation vis-à-vis the unique and eclectic distribution of space inside the Chat Noir. In one sense the public found itself vulnerable and trapped between the dictates of snobbish fashion and the necessity to foster a favorable public image. Surely few were able to come up with a quick response to Salis's disparaging attitude. The master of ceremonies was able to direct the public's enthusiasm and even win their favor by capitalizing on the anxiety with which these individuals entered a world lacking rigid conventions. In his memoirs Maurice Donnay described how Salis was able to excite the audience to the point of being carried away by the emotion and patriotism of a shadow play like *L'Epopée* so that applause and yells were heard in the streets of Montmartre.[21]

Looking at this phenomenon from a different perspective we might ask to what extent did the audience of the Théâtre d'Ombres at the famous cabaret know that brushing off the humiliation of insult with a smile was the price to be paid for entering the bohemian exclusivity of this space? By the same measure, we might also consider that the packing of the Chat Noir to admire its shadow theater was just as much a triumph for the public as it was for its promoters. Indeed, those members of the upper-middle-class public who managed to get into the cabaret were awarded with the privilege of being able to boast of having penetrated and conquered a space originally designed to exclude them. In addition to the practical explanations given above it is also possible that Salis's ill humor was a reflection of an overall sense of bitterness, of frustration with himself and with a market system of commercialized entertainment to which his artistic endeavor had finally succumbed. As occurred with other inno-

vative artistic undertakings of the turn of the century, the commercial success of the Théâtre d'Ombres and its space of performance, resulted in its being appropriated by the middle classes as an object of mass consumption. This outcome can be linked to Theodor Adorno's observations on how the work of art, in the context of advanced capitalism, is destined to be converted into an "absolute commodity" or a "fetish against commodity fetishism" when it cannot escape the logic of the dominant ideology even though it was originally conceived in opposition to it.[22]

The failure as a bohemian project does not eliminate the original aesthetic qualities of the Théâtre d'Ombres performances that even today retain their status as precious works of art. The creation of shadow plays and the creation of the space for which they were conceived deserve equal attention in terms of their importance as phenomena of performance that had as their goal the recuperation of an almost obsolete dramatic form.

NOTES

1. "On s'est borné à présenter les 'hors-d'oeuvre' on oubliant le plat de résistance." Paul Jeanne, *Les Théâtres d'ombres à Montmartre de 1887 à 1923* (Paris: Les Éditions des Presses Modernes au Palais-Royal, 1937), 11.
2. Richard Sennett, *The Fall of Public Man* (New York: W. W. Norton, 1992).
3. Walter Benjamin, *Illuminations,* trans. H. Zohn (New York: Schocken Books, 1969).
4. Roger Shattuk, *The Banquet Years* (New York: Vintage, 1968), 6.
5. John A. Henderson, *The First Avant-Garde, 1887–1894: Sources of the Modern French Theatre* (London: G. G. Harrap, 1971).
6. Armond Fields, *Le Chat Noir: A Montmartre Cabaret and Its Artists in Turn-of-the-Century Paris* (Santa Barbara, CA: Santa Barbara Museum of Art, 1993), 31.
7. "Or le public demande des divertissements. De plus, il aime qu'on lui propose des images." Mariel Oberthür, *Le Chat Noir, 1881–1897* (Paris: Réunion des Musées Nationaux, 1992), 40.
8. "Las posibilidades de mostrar sin dejar ver, de insinuar, deformar la realidad y dotarla de unas caraterísticas en otros medios sería muy díficil de conseguir." Carlos Angloti, *Comics, títeres y teatros de sombras* (Madrid: Proyecto Didáctico Quirón, 1990), 82.
9. Oberthür, *Le Chat Noir, 1881–1897,* 49.
10. Jody Berland, "Cultural Technologies and Production of Space," in *Cultural Studies,* ed. Lawrence Grossberg, Cary Nelson, and Paula Treichler (New York: Routledge, 1992), 44.
11. Frantisek Deak, *Symbolist Theater: The Formation of an Avant-Garde* (Baltimore, MD: Johns Hopkins University Press, 1993), 25.
12. Salis trouvait matiére à commentaires,—avec des improvisations toujours renouvelées,—sans sous-entendus équivoques, sachant avoir le terme juste qui porte sur l'auditoire,—qu'il ne flattait cependant jamais,—jonglant avec les métaphores, les antithèses, les anachronismes volontaires, se lançant aveuglément dans des périodes oratoires dont on ne savait,—et lui tout le premier,—comment il pourait s'en tirer." Jeanne, *Les Théâtres d'ombres à Montmartre,* 21.

13. "Une façon parodique et indirecte de poser la question de l'art." Jean Starobinski, *Portrait de l'artiste en saltimbanque* (Geneva: Editions d'Art Albert Skira, 1970), 9.

14. Sennett, *The Fall of Public Man*, 195.

15. Peter Bailey, *Music Hall: The Business of Pleasure* (Milton Keynes: Open University Press, 1986), 8.

16. Ibid., 17.

17. "Avait, au fond, le plus grand mépris pour tous ces gens qui lui apportaient leur argent et, tout en les appelant: 'Vos Seigneuries et Vos Altesses Electorales', –il leur envoyait des brocards qu'ils encaissaient sans broncher. C'était surtout le vendredi, qui était le jour chic, et où le spectateur payait sa rude chaise de bois un louis pour voir la Marche à l'Etoile ou Sainte Geneviève, que Salis se montrait le plus impertinent avec sa clientèle; le vendredi, il avait la parade agressive; il flétrissait la haute banque, le parlementarisme, le grand monde, le demi-monde, tout le monde!" Jeanne, *Les Théâtres d'ombres à Montmartre*, 38.

18. Shattuk, *The Banquet Years*, 22.

19. Sennett, *The Fall of Public Man*, 206.

20. Ibid., 205.

21. Jeanne, *Les Théâtres d'ombres à Montmartre*.

22. Theodor W. Adorno, *Aesthetic Theory*, trans. Robert Hullot-Kentor (Minneapolis: University of Minnesota Press, 1997), 236.

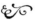
Discovering Sites

Enervating Signs for the Spanish *Modernistas*

G A B R I E L P . W E I S B E R G

When Santiago Rusiñol and Miguel Utrillo returned from a trip to Barcelona early in 1891, they headed for their rooms in Montmartre, taking along their belongings and a series of recent canvases (Fig. 10.1). Although they had lived periodically in Paris, they were now determined to continue their allegiance to bohemian artistic creativity, as suggested in the drawings made by their friend Ramon Casas. In his large, sprawling script at the base of one drawing, Casas announced that they had all returned. By early in the next year the friends had found a new apartment close to the Moulin de la Galette.[1] Once they settled in, they maintained their systematic program of absorbing the atmosphere of each locale in Montmartre as they looked for places that could serve as inspiration for ideas and their work. They, like so many others, were well aware of bohemian artistic culture and the freedom that it allowed the artist. All three men were eager to experiment with new concepts. Paris, as the recognized mecca of the art world, was the best city in which to learn about new art and ideas. In effect, from their first sojourn in Paris and through the 1890s, Rusiñol and his friends regarded their mission in Paris as one of experimentation and assimilation, one that would culminate in their bringing ideas and artworks from Montmartre to

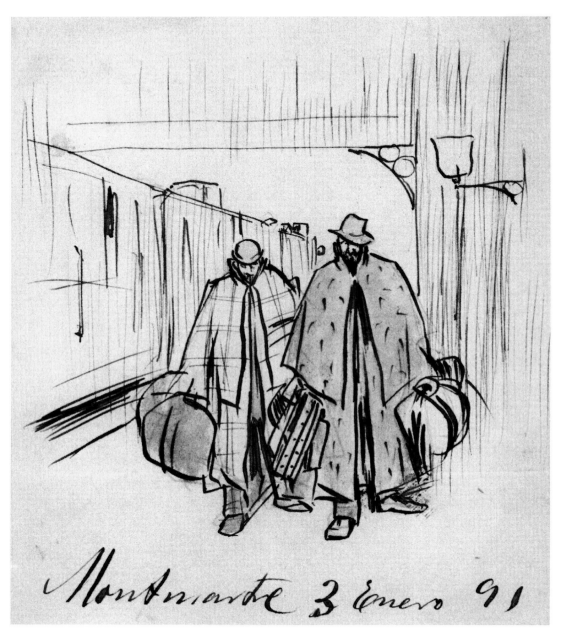

Figure 10.1 Ramon Casas, *Montmartre 3 Enero 91* (*Montmartre, January 3, 91*), 1891.
Ink drawing. Charles Deering McCormick Library of Special Collections,
Northwestern University Library, Evanston (Illinois).

Barcelona. They hoped to encourage a contemporary renaissance that would affect all the visual arts in their Spanish homeland.

They were eager to learn, even though they were young artists from another culture and lacked much firsthand exposure to issues associated with "modernity." While they undoubtedly remained "outsiders" due to their limited skills with the French language, they were recognized by natives as part of the growing Spanish community of the butte, which within a few years would attract the young Pablo Picasso.[2] They had also arrived at Montmartre at a time of great change and contrast. The dismal effects of the Franco-Prussian War and the Commune were lessening, although politicians of the Third Republic still controlled some ideas. Many segments of the population were down on their luck, while other people flaunted their prosperity and flocked to the city's "hot spots." Even so, artistic creativity abounded in Montmartre. The artists from Barcelona cut quite a fine figure. Being independently wealthy, they dressed as fashionable dandies (especially Rusiñol) and made it clear that, while they sided with bohemia, they themselves were not bereft of position, finances, and social standing.

Montmartre itself was changing at this time. To the old picturesque sites of narrow, winding streets and lengthy stairways stretching to the top of the hill—locations recorded by etchers who were eager to please a bourgeois public—was added the new construction of the Church of the Sacré-Coeur. The Sacré-Coeur exerted a mystical influence on the inhabitants of Montmartre and, by implication, on all of Paris. It was massive, dominant, and all-inclusive. The Catholic Church constructed it as a way to regain control over a section of the city that Church leaders felt had become too aberrant, too secular, and too morally indulgent.[3] The Spanish painters, seeing the church rise from the ground during their initial stays in Montmartre, were undoubtedly amazed by the huge edifice. They could not hide from this monstrous building, which had become, by the end of the century, the principal monument on the butte. It symbolized the role of religion in daily life, and yet it also contrasted with the aberrance and creative license that defined the lives of many.

In this heady atmosphere, Rusiñol and Casas produced drawings of what they saw, recording images of their friends and the nightlife of Montmartre that was so different from what they had known in Spain (Fig. 10.2).[4] Images evolved into an album of types and a record of significant sites, each with their own mood and approach to popular culture and mass entertainment. Their naturally conceived drawings and paintings were easily understandable, and they helped to transfer similar strategies to Barcelona. By spreading contemporary

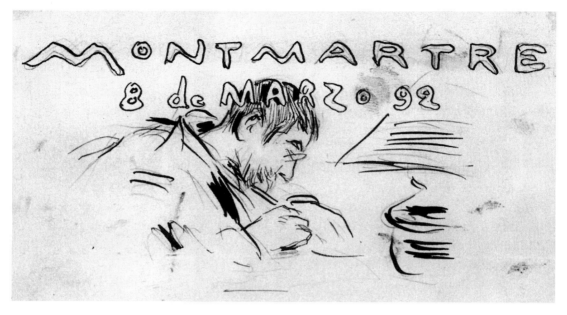

Figure 10.2 Ramon Casas, *Montmartre 8 de Marzo 92* (*Montmartre, March 8, 92*), 1892. Ink drawing. Charles Deering McCormick Library of Special Collections, Northwestern University Library, Evanston (Illinois).

experimental mass culture to Spain, Rusiñol and Casas were in effect helping to turn Barcelona into a satellite of Montmartre.[5]

On the Butte

Rusiñol and his colleagues were daily exposed to poverty in Paris, yet they had the financial means to escape from the butte whenever necessary. Similar to the bourgeois visitors who frequented the nightclubs of Montmartre, Rusiñol was financially independent enough to escape the city. From 1889 onward, he returned to Barcelona every year to replenish himself, to discuss his discoveries, and to exhibit his Parisian paintings in the Pares Gallery and other public sites. With his family money he built a large villa on his estate at Sitges, about twenty-five miles from Barcelona, where he held "modernist festivals" beginning in 1892.[6] These events, which included a folk opera one year, elevated the most mundane material to the status of modern art. In France, Rusiñol had seen a similar interest in "rustic" ironwork and folk ceramics as well as in making art more accessible to the public through performances, modern festivals, and popular art forms.

In Paris, Rusiñol was bombarded by images of the miserable conditions of the poor in Montmartre. Artists frequently turned to the theme of the daily drudgery experienced by workers, many of whom were dispossessed.[7] During the early 1890s numerous paintings and countless prints were produced that showed the Montmartre district, located at the outskirts of the city, as a place inhabited by the bereft. Many viewers believed that vagabonds and those who were simply down on their luck gravitated to the area because there they were not so closely watched by the police. One painting, shown at the 1894 Salon and reproduced in the widely distributed *L'Europe Artiste,* focuses on a lonely vagabond, his bottle at the ready.[8] A work by Henri Royer (1869–1938), a painter of Breton scenes, conveys the same sense of misery and destitution among the lower classes. Royer often traveled to Paris—he taught at the Académie Julian in the city's center—and frequented nightclubs in the district. His depiction of a solitary figure staring into space (Fig. 10.3) underscores the feelings of uselessness and emptiness that plagued those without hope. In an 1891 portrait of a young woman seated on the butte, he employs the scene's barrenness as a metaphor for her nomadic life. Clearly, Royer believed that the downtrodden, linked by their common bond of destitution, congregated in this section.

Rusiñol was not blind to his surroundings, although he did not dwell on the infirm. In *La Morfina (The Morphine Addict)* (Fig. 10.4) he looks sympathetically at the controversy surrounding the use of drugs. Most likely he was examining his own addiction to morphine as well.[9] Other artists were keenly aware of the morphine craze that victimized women, and particularly prostitutes. The Swiss artist Eugène Grasset, for one, produced the print *La Morphinomane (The Morphine Addict)* (Fig. 10.5) to document the morbid fad.

The poor on the butte eventually played lesser roles in his compositions as he focused instead on the environment of the craggy hill or selected a few wooden buildings as a backdrop for a lovers' meeting (Fig. 10.6). He repeatedly attempted to situate the region's unique features into the traditional landscape format. In one scene, the encroaching shadow caused by the construction of the Sacré-Coeur looms over the ramshackle huts and small parcels of land that dominate the foreground (Fig. 10.7). Using an impressionistic palette, Rusiñol concentrates on the dingy huts that provide shelter to the unseen inhabitants. Other artists who painted scenes of the Moulin de la Galette also included these hovels to emphasize the sharp contrast between the reported gaiety of the area and its reality.

In his study of the small, nearby cemetery (Fig. 10.8), Rusiñol found an unusual angle and theme, with tombs in the background and a construction site

Figure 10.3 Henri Royer, *Sur la Butte* (*On Montmartre Hill*), 1891. Oil on canvas,
28 3/8 x 23 5/8" (72 x 60 cm). Rio de Janeiro, Museu nacional
de belas artes.

and workers' huts in the foreground. Although it is suggested obliquely, mortality remains an underlying theme in the midst of new buildings being erected in the quarter. Rusiñol and his Spanish colleagues soon turned their attention to the heart of bohemian creativity, replacing misery and landscapes in the works with scenes of Montmartre nightlife. By studying, analyzing, and decoding what they saw, they hoped to understand and then transfer selected aspects of Montmartre back to Spain. An astute observer of life, Rusiñol became a playwright and a novelist in addition to being an artist committed to oil painting. In this way he interrelated all the arts and made them a guiding theme for his own creativity.

Into the Performance Centers

Even though their own paintings remained rooted in an earlier style, Rusiñol, Casas, and Utrillo gained insight into the challenging "new art" of live performances—situational readings of poetry, comedy skits, and the elevation of caricature

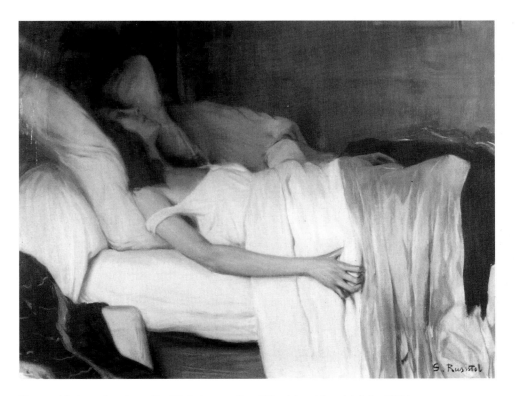

Figure 10.4 Santiago Rusiñol, *La morfina* (*The Morphine Addict*), 1894. Oil on canvas, 34 3/8 x 45 2/8" (87.5 x 115 cm). Museum Cau Ferrat (Consorcio del Patrimonio de Sitges), Spain.

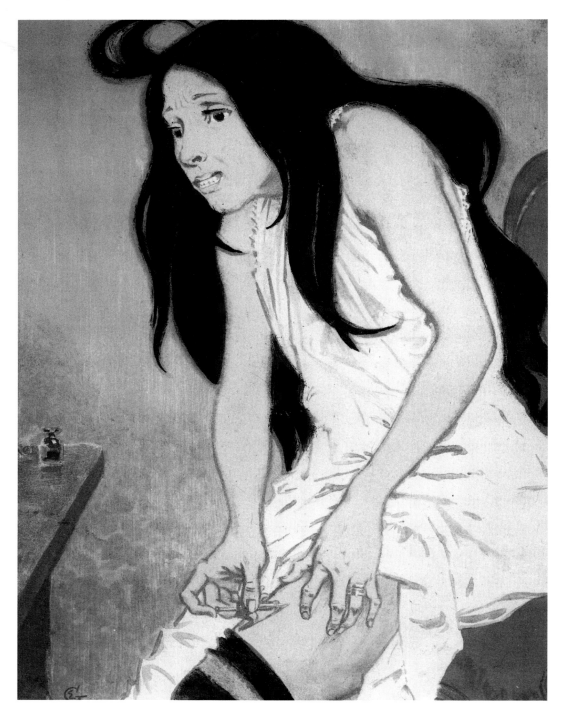

Figure 10.5 Eugène Grasset, *La Morphinomane* (*The Morphine Addict*) (from *L'Album d'estampes originales de la Galerie Vollard*),1897. Seven-color lithograph, 16 1/4 x 12 1/4". Jane Voorhees Zimmerli Art Museum, Rutgers, The State University of New Jersey, "Friends" purchase.

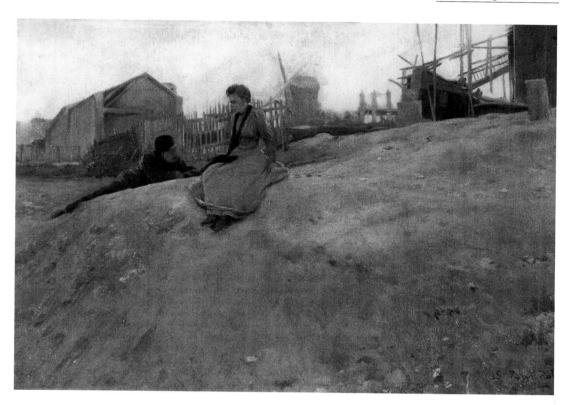

Figure 10.6 Santiago Rusiñol, *En Campaña* (*On the Mound*), 1891. Oil on canvas, 17 7/8 x 28 3/8" (48.5 x 72 cm). Museu d'Art Modern del MNAC, Barcelona. Bequest of Martí Estny, 1943.

to an art form—that were popular in cafés and cabarets.[10] These newer tendencies did not follow the hierarchical approach to artistic training fostered by art schools and public Salons. Instead, art was popular and open. (Inspired by outlandish costume balls in Paris, Rusiñol and his friends staged similar "happenings" in Sitges.) By attending these "art performances," this trio of Spanish painters gained both a greater understanding of the meaning of life in Montmartre and more breadth in their art. Rusiñol's painted scenes of many of the Montmartre clubs have a documentary as well as a symbolic edge.

The number of cafés and cabarets in Montmartre had grown considerably since the early 1880s. Some were quite small, with only enough room for a few customers, while others were dance halls crammed each evening with revelers in search of sensual abandon. Almost all of the long-lasting cabarets had a specialty: the Chat Noir boasted a shadow puppet theater, the Moulin de la Galette put on vigorous performances of contemporary dances, and the Café des Incohérents

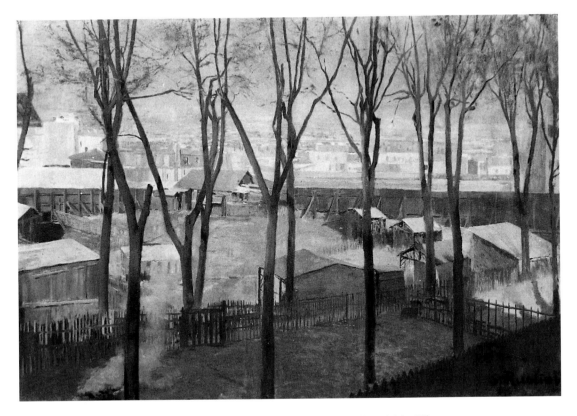

Figure 10.7 Santiago Rusiñol, *La Butte* (*Montmartre Hill*), 1892. Oil on canvas,
29 1/8 x 39 3/4" (74 x 101 cm). Museu d'Art Modern del MNAC,
Barcelona. Purchased in 1932.

held satirical exhibitions and performances that were later seen as forerunners
of Dada experiments.[11] On the walls of these spaces the leading writers, poets,
and playwrights were celebrated in amusing caricatures.

The Café des Incohérents specialized in bringing together unusual and dis-
parate elements, as if the owners were trying to underscore the contrasts that
existed in "visual culture." In Rusiñol's depiction of the site (Fig. 10.9), we see
on one wall of the café's interior a model of the Eiffel Tower, one of the most
discussed extravagances of "modern" engineering. Elsewhere are hung Asian
masks and an ever-changing display of small, new paintings by young artists.
(Exhibitions of these works were advertised in small pamphlets. These unso-
phisticated "throwaway" publications replaced the voluminous Salon cata-
logues and were themselves carefully collected.) Other cafés opened in the area
and adopted innovations introduced by the Café des Incohérents, such as its
rustic interior with rough wooden beams. Rusiñol includes his friends in his

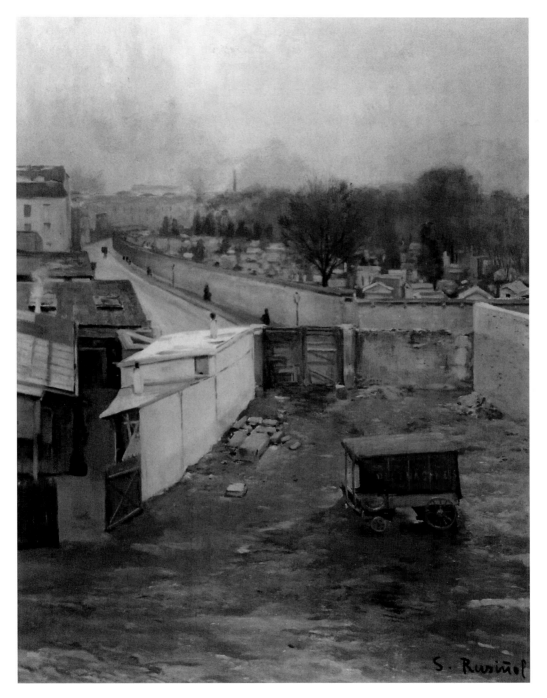

Figure 10.8 Santiago Rusiñol, *Cementerio de Montmartre* (*Montmartre Cemetery*),
1891. Oil on canvas, 39 3/8 x 29 1/2" (100 x 75 cm). Museu Cau Ferrat
(Consorcio del Patrimonio de Sitges), Spain.

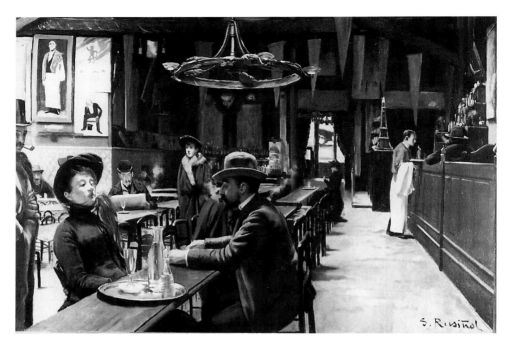

Figure 10.9 Santiago Rusiñol, *Café de los Incoherentes* (*Café des Incohérents*), 1890. Oil on canvas, 31 1/2 x 45 6/8" (80 x 116 cm). Colección Museu de Montserrat. Gift of J. Sala Ardiz.

painting of the café's interior (Fig. 10.9). Utrillo is in the background reading a paper, and Casas sits in the foreground at a long, wooden table, mesmerized by the young woman opposite him. When this canvas was exhibited in Barcelona, as were many of Rusiñol's works, it proved that Spanish artists were actively involved in the most modern temples of French art and were well prepared to share their experiences with their colleagues. Indeed, they were as deeply familiar with Montmartre's local hangouts as were the French natives. Curiously, however, the Spanish artists also seem uncomfortable with this environment. They played at being bohemians and retained their ability to step back from their life in France whenever they wanted. Their frequent trips back to Spain underscore this sense of detachment.

The Moulin de la Galette

Living near the Moulin de la Galette gave the Spanish painters the opportunity to visit not only the dance hall but also the restaurant and the small park nearby at any time they wanted, even in the off-hours. Memories of the previous

evening's gaiety contrasted sharply with the desolation of the same location in the gray light of morning.

In one instance, Casas painted a dreary view of the dance hall's interior (Fig. 10.10). Women select their dance partners while stern onlookers remain seated, glaring from beneath an overhang that supports a tiny orchestra. This view conveys little of the fabled energy of the dance floor. The lack of customers and the cold light suggest that certain aspects of the legendary reputation of the Moulin de la Galette were the products of good publicity. Casas shatters a popular illusion by providing a disquieting vision of local entertainment that was probably much closer to the truth than were the lively advertisements for the cabaret that were produced by other artists. He presents a drab view of urban existence by showing a few idle customers in a joyless atmosphere.

Rusiñol also saw the Moulin de la Galette differently than many artists. He depicted the area around the dance hall in his painting *El Parque del Moulin de la Galette* (*The Park at the Moulin de la Galette*) (Fig. 10.11), a work he created in 1891 and exhibited in Barcelona that same year. The scene, suggestive of a view from an open window, shows the dance hall's famed windmill at the distant horizon. The sense of desolation, heightened by the leafless trees and the abandoned carousel in the foreground, verifies the artist's ability to see this site in a way that broke with public perceptions. There is no life in this park, only melancholic isolation. Rusiñol depicted the Moulin de la Galette in several works, perhaps attracted by this dichotomy between reputation and reality. His works range from an intimate scene of a solitary figure sitting at a table to a landscape with the recognizable windmill looming over nearby rooftops, as if to suggest that the Moulin de la Galette exerted a dominating presence much as the Sacré-Coeur did—but it was intended to attract an entirely different audience.[12]

In another work, Rusiñol depicted his friend Miguel Utrillo near the entrance to the park of the Moulin de la Galette (Fig. 10.12). A dedicated aesthete and a frequent visitor to the nightclubs of Montmartre, Utrillo had become a special devotee of Rodolphe Salis's cabaret Chat Noir, where he was thoroughly absorbed by the shadow puppet theater.[13] His casual stance, his dark good looks, his fashionable dress, and the way he holds his cane all contribute to make this a portrait of an aesthete who is apparently detached from the pressures of a bohemian lifestyle. It is not unusual that Rusiñol chose to depict Utrillo, his friend and a longtime resident of the quarter, in front of the Moulin de la Galette. What is unsettling is the realization that the garden is empty and practically devoid of any sense of gaiety (a string of Japanese lanterns dangles behind the figure). It is as if Rusiñol is seeing both the site and his colleague

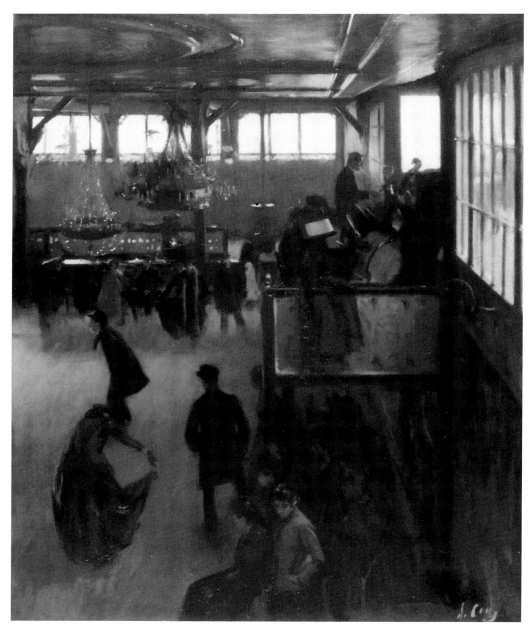

Figure 10.10 Ramon Casas, *Danza en Moulin de la Galette* (*Dance at the Moulin de la Galette*), 1890. Oil on canvas, 39 3/8 x 32 1/8" (100 x 81.5 cm). Museu Cau Ferrat (Consorcio del Patrimonio de Sitges), Spain.

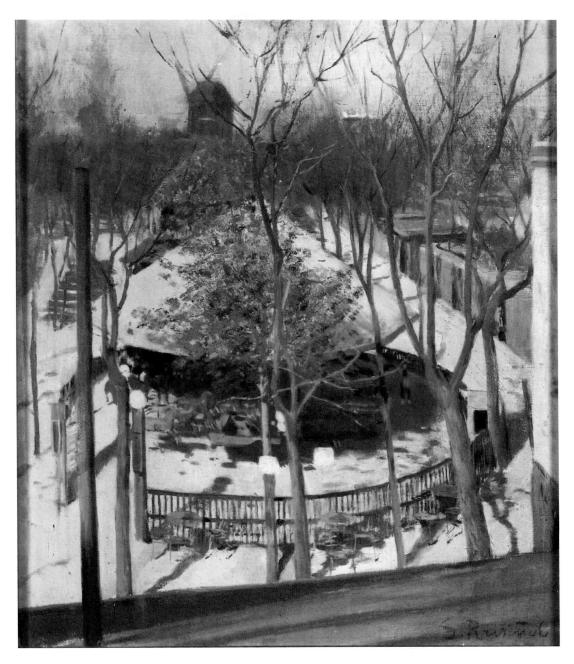

Figure 10.11 Santiago Rusiñol, *El Parque del Moulin de la Galette* (*The Park at the Moulin de la Galette*), 1891. Oil on canvas, 24 x 19 5/8" (61 x 50 cm). Museu Cau Ferrat (Consorcio del Patrimonio de Sitges), Spain.

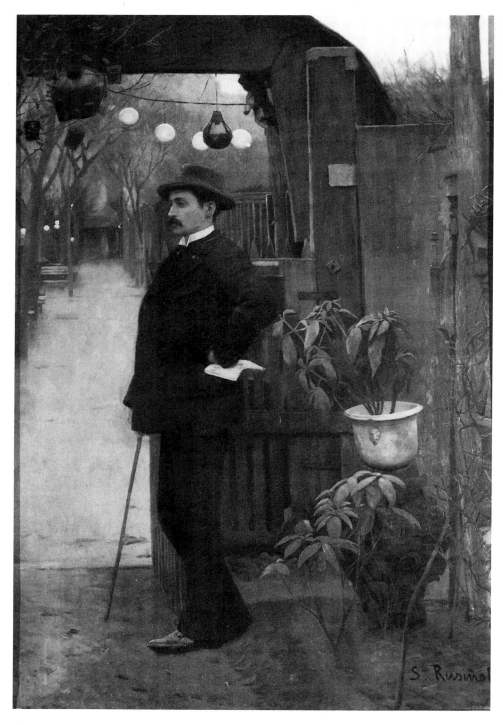

Figure 10.12 Santiago Rusiñol, *Retrato de Miguel Utrillo* (*Portrait of Miguel Utrillo*),
1890/91. Oil on canvas, 77 5/8 x 59 3/8" (222.5 x 151 cm).
Museu d'Art Modern del MNAC, Barcelona.

with a melancholic, intellectual detachment, an air similar to the ways in which these Spanish artists were viewing their experiences in Paris in the early 1890s.

The Bohemian Context

While the Spanish artists were certainly aware of bohemia and could recognize its manifestations throughout the quarter, they managed to remain above it and often outside it. Only on a few occasions did Rusiñol document the sexual pitfalls of Montmartre. He was certainly aware of the prostitutes who prowled the area in search of customers and how they formed the basis of many artists' work. *Interior of a Café* (Fig. 10.13), for example, recalls similar themes explored by Edgar Degas while it also conveys the sense of assignation and loneliness that distinguishes some of Rusiñol's paintings of the Moulin de la Galette.[14] In this image, young women assume provocative poses as they drink away the hours and wait for customers. Rusiñol, however, was not easily seduced by the bohemian existence and the pursuit of sensual pleasure. Instead, he viewed the bohemian presence as something to be assessed and tried in Spain, an attitude that he put to his own advantage in Barcelona.

Young artists, writers, and musicians in Montmartre could develop their personal sense of creativity and independence by dedicating themselves to the arts. They spent hours in the cafés, conversing with friends and enjoying the area's unrestrained freedom. Eager to know this bohemian culture, Spanish artists sought out the friendship of their French neighbors, including Rodolphe Salis, director of the Chat Noir cabaret; art dealer Siegfried Bing, who hosted an exhibition of Rusiñol's paintings at his Galerie d'Art Nouveau in 1899; and music critic and composer Erik Satie.[15] Rusiñol depicted Satie on several occasions, such as when he worked as a piano accompanist in Utrillo's shadow puppet theater.[16] In another instance, he also showed the solitary musician surrounded by books in a room decorated with posters of Montmartre. A single cot occupies the corner of the room. Judging from this image, it appears that Rusiñol felt that the life of a struggling creator was one of deprivation and continual striving to achieve personal goals.

It was Ramon Casas, however, who created the most revealing images of Satie. In one caricature he shows an emaciated Satie wandering the quarter—note the windmill of the Moulin de la Galette in the background—and passing by two men, perhaps Rusiñol and Utrillo, whose identities are hidden by their bowler hats and their mackintosh raincoats (Fig. 10.14). Satie carries a closed umbrella, seemingly oblivious to the inclement weather. This bumbling, comical impression

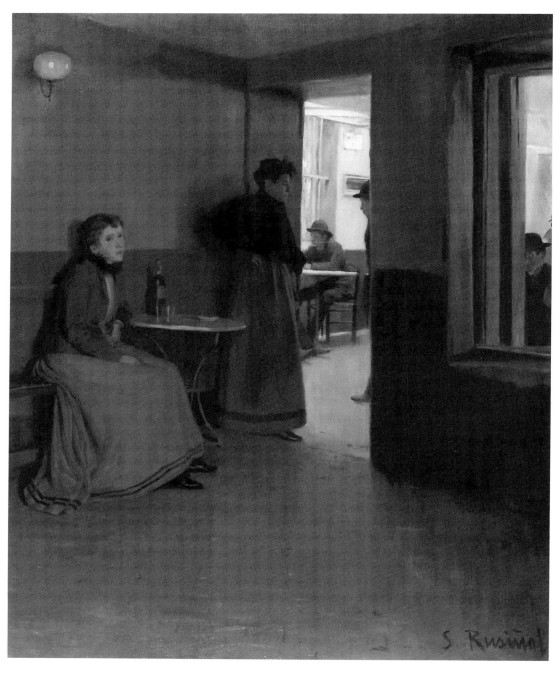

Figure 10.13 Santiago Rusiñol, *Interior of a Café*, 1892. Oil on canvas, 39 1/2 x 32" (100.3 x 81.3 cm). The John G. Johnson Collection, Philadelphia Museum of Art.

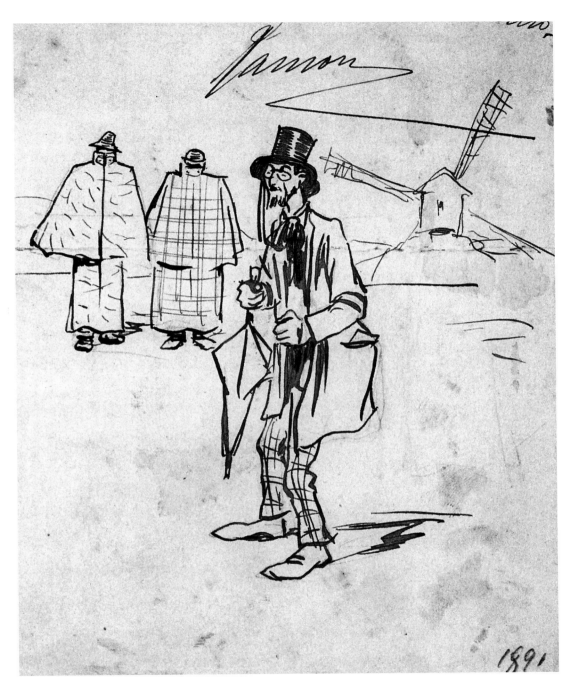

Figure 10.14 Ramon Casas, *Portrait of Erik Satie*, 1891. Ink drawing, Charles Deering McCormick Library of Special Collections, Northwestern University Library, Evanston (Illinois).

is in keeping with Casas's view that his friend was frequently lost in his own thoughts. The artist creates a similar effect in a large oil painting of Satie in which he wears a top hat and a black coat (Fig. 10.15). Here, the musician has the air of a slightly mystified wanderer, whose dress and dreamlike expression, while not as comical as in the caricature, draw attention to his inner creative life. Satie later gained considerable fame in the world of contemporary experimental music, but at the time of this portrait he was still struggling to find his own way.

By positioning Satie on the boulevards of Montmartre, Casas casts the musician as one who has been seduced by the liberating and sometimes hallucinatory effects of bohemian nightlife. This metaphorical construction is apt because it underscores the concept that one could achieve a measure of personal satisfaction by following the path of bohemian creativity. In addition, in the early 1890s Satie began showing an interest in the Rosicrucian otherworldly religious group that formed around the Sar Péladan, its self-appointed leader. Satie's own air of self-contemplative mysticism suggests his movement toward the occult.[17] He seems to be preoccupied with an awareness of a "higher reality" that may well have been stimulated by his creative surroundings and his association with mystical groups.

Another painting by Rusiñol explores Satie's significant role as a musician. In this case Rusiñol depicts Satie at work, playing the piano. Here he is a vigorous performer of considerable talent. His hair falls loosely about his face like a true bohemian, but his disciplined attitude at the keyboard points to the serious strain that runs beneath this guise. His demeanor, his dress, and even his haircut (or lack thereof) are simply the stuff of artifice. The composer's personal interest in mysticism, however, remained a guiding force throughout the 1890s.

By the mid-1890s, when Satie's portrait (now lost) by the Symbolist artist Georges de Feure was exhibited at the Salon of the Société Nationale des Beaux-Arts, some people objected to the musician because Satie had elevated art in general to the rank of religion. To Satie and others in his circle, the composer had founded the Metropolitan Church, which essentially celebrated the love of art.[18] People could worship art in Satie's church, which was located on the butte of Montmartre. (While this might sound impressive, Satie's office in his church was so small that he was forced to sit on the windowsill to accommodate visitors there.) Whether it was real religion or imaginary, Satie greatly influenced his Spanish colleagues by showing them that art could be treated like a religion with blessed followers. His Spanish friends absorbed this new attitude and soon came to see the "cult of art" as something they could take back to their homeland and transplant in Barcelona or, if not there, then in Sitges.

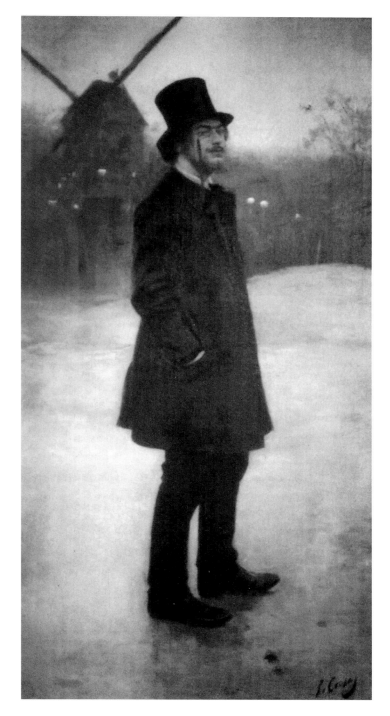

Figure 10.15 Ramon Casas, *The Bohemian (Portrait of Erik Satie)*, 1891. Oil on canvas, 78 1/8 x 39 2/8" (198.9 x 99.7 cm). Charles Deering McCormick Library of Special Collections, Northwestern University Library, Evanston (Illinois).

The New Art Transplanted: Sitges and Barcelona

Rusiñol frequently returned to Sitges throughout the years he worked in Montmartre. In 1892, 1893, and again in 1894, he attracted the highest levels of Barcelona's artistic community to his "modernist" festivals in honor of art. For the event held on November 9, 1894, he adopted ritualistic practices from the city's holiday celebrations. (One journalist called the festival a "spectacle of civic religion.")[19] The local inhabitants of Sitges prepared for the event as if it were a serious Catholic festival. People along the procession route went so far as to decorate their balconies. Rusiñol organized a parade in which artists and city officials were united in their concerted effort. Among the effigies carried in the procession were ones honoring El Greco, an artist whose works were then being rediscovered by Rusiñol and others.[20] The day's most significant event was the ceremony held on the beach at Sitges. There, before 150 writers and artists, Rusiñol gave an enthusiastic speech, coupled with poetry readings. Known by then as a writer and a budding playwright as well as an artist, Rusiñol attacked the region's old traditions and the dominance of the aristocracy. He expounded on the need to create a new art, one that combined enthusiasm with religious insight.[21] Rusiñol seems to have been putting into practice the mystical statements that he had heard in Montmartre and the beliefs he had learned from Satie and others. In this regard, Rusiñol was planting contemporary French attitudes toward art and religion in the receptive soil of Spain.[22]

Unfortunately, Sitges was missing a main "cathedral" for the new art. Since it was located so far from Barcelona, Sitges required a gathering space much like the places where Rusiñol, Casas, and Utrillo met their friends in Montmartre. For this purpose they organized the Four Cats café in Barcelona and hired Père Rameu to assist Utrillo in running it.[23] The cabaret not only became the central meeting place for the Modernista group, but with its combination of facilities— beer hall, meeting place, puppet theater, art gallery, symbolic setting—it also reflected many aspects of similar establishments in Montmartre. Much can be made of the name and its ties with the Chat Noir, but other sites in Paris were equally important influences on the evolution of the Four Cats.

Central to the successful operation of the Four Cats was maintaining the shadow puppet theater developed by Miguel Utrillo from what he had seen at the Chat Noir in Paris. These Spanish artists recognized it as a popular art form that blended illusion and sound in a way that approximated the old street theater (and presaged early cinema).[24] This integrated art form allowed the viewer to become involved in the total experience by suspending disbelief and enter-

ing a hallucinatory realm. By emulating what they had seen in Paris, Utrillo and his friends created a theater of total visual impact, one that moved shadow plays into a purely sensory realm. The achievement was electric. This introduction of modern creativity sparked a demand for experimental culture among the younger generation in Spain.

Artists in Montmartre were being pulled in many creative directions, and often at the same time. Curiously, these trends did not cancel out one another but instead added to the intrinsic attraction of the area. The Spanish artists and writers who lived in Montmartre absorbed the quarter's idiosyncracies and yet managed to filter out what they could not utilize from what was significant to their own creative development. Instead of accepting the commercial aspects of certain sites, Rusiñol and his colleagues chose to focus on the sense of experimentation and their willingness to liberate themselves from traditional biases by seeing art as a new religion. In Montmartre, they realized, the seeds were planted that would allow materialist values to give way to bohemian ideas and lifestyles which would be of considerable value to future generations of Spanish and French artists. As revealed in his later studies exhibited in Paris in 1899, Rusiñol found in Montmartre a personal view of isolation, detachment, and melancholy that he could later apply to Spanish settings. These atmospheric works, based on his early years in Paris, eventually secured Rusiñol's reputation and catapulted him to a preeminent position in the international Symbolist movement.

NOTES

1. Some dispute surrounds the date of Rusiñol's first arrival in Paris. For reference to an early date, see *Dictionari Biographic*, vol. 4 (Barcelona: Editorial Albert, 1970), 172–173, which gives 1878 as the first date. Apparently Rusiñol and his Spanish colleagues arrived in Paris in time for the Exposition Universelle of 1889. After studying with the academic painter Henri Gervex, Rusiñol lived in several different locations in Montmartre. By 1891 he was living in an apartment with Ramon Casas and Miguel Utrillo not far from the Moulin de la Galette. Like Rusiñol, Casas and Utrillo were financially secure and had independent means of existence.
2. On Picasso's first years in Montmartre, see John Richardson, *A Life of Picasso, 1881–1906*, vol. 1 (New York: Random House, 1991). The number of Spanish artists who worked in Montmartre has not been tabulated, but it must have been considerable. Enclaves of "other" unassimilated groups from cultures far distant from France were also found in Montmartre. These groups often remained closely knit due to language barriers and for the sake of sharing artistic ideas.
3. While Montmartre's religious history is difficult to chart, the site for the Sacré-Coeur was clearly selected because the Catholic Church wanted to regain control over an undisciplined section of the city. See Jacques Benoist, *Le Sacré-Coeur de Montmartre: Spiritualité, Art et Politique (1870–1923)* (Paris: Editions ouvrières, 1991); and Jacques

Benoist, ed., *Le Sacré-Coeur de Montmartre: Un voeu national* (Paris: Délégation à l'action artistique de la Ville de Paris, 1995). The construction of the Sacré-Coeur was also initiated at a time when a strong Catholic revival was spreading throughout France as a way to dominate or even eliminate tendencies that could not be controlled by traditional religious means.

4. On Rusiñol's practice of reporting what he saw, see Temma Kaplan, *Red City, Blue Period: Social Movements in Picasso's Barcelona* (Berkeley and Los Angeles: University of California Press, 1992), 40–41. Acting much like an "artist-reporter," Rusiñol produced images that the popular periodicals could use in place of photographs. This was a well-respected tradition in the nineteenth century, and Rusiñol's activity was not considered unusual or unique. For his part, Rusiñol was eager to see his images used in Spain, where they would bring French visual culture to viewers in Barcelona.

5. Ibid., 40. In effect, Rusiñol became Catalonia's prophet for new art. Many of his colleagues and press reports in Spanish journals in the 1890s referred to him this way.

6. On the nature of these festivals, see ibid., 40–41. Also interested in the traditional crafts of the region, Rusiñol bought numerous pieces and placed them throughout his villa. He was inspired by the idea of a popular-based art, and he held "performance" festivals that the local inhabitants carried out under his watchful eye.

7. The dispossessed as a viable artistic theme had emerged earlier in the century with the works of Jean-François Raffaelli. Since some of his own works focused on rag-pickers at the city's outskirts, it is understandable that Raffaelli would inspire others during the 1890s. See Barbara Schinman Fields, "Jean-François Raffaelli (1850–1924): The Naturalist Artist" (Ph.D. diss., Columbia University), 1978. Among those artists who viewed Montmartre as a center of destitution were Edgar Chahine and Théophile-Alexandre Steinlen. (Jill Miller extensively examines Steinlen in her essay in this volume.)

8. For reference to this painting see "Sur la Butte Montmartre (Salon du Champs de Mars)," *L'Europe Artiste,* May 20, 1894, 1. The painting bears the signature of A. Koetscher. While it might seem unusual that a working-class theme based in Montmartre was reproduced in a high-society publication such as *L'Europe Artiste*, it actually was not an unusual occurrence, for the magazine reported extensively on all aspects of Montmartrian night life. Through this publication artists throughout Europe came to realize that some of the most creative efforts in the world of performance art were being created amidst profound poverty.

9. See Richardson, *Picasso,* 115. Rusiñol apparently had a kidney ailment, and he may have been given morphine to quell the pain. Gradually he became addicted to the drug, which required him to receive treatment for the addiction rather than for the original malady. Morphine became plentiful, fashionable, and desirable following the Franco-Prussian War (1870). By 1892 it was a plague. See Eugen Weber, *France, Fin de Siècle* (Cambridge, MA: Harvard University Press, 1986), 31.

10. For further discussion of these aspects, see Charles Rearick, *Pleasures of the Belle-Epoque: Entertainment and Festivity in Turn-of-the-Century France* (New Haven, CT: Yale University Press, 1985).

11. See Mariel Oberthür, *Le Chat Noir, 1881–1897* (Paris: Réunion des Musées Nationaux, 1992). Also see Emily Rovetch, "The Chat Noir and the Mirliton: Creating the Myth of Montmartre" (Paper submitted to the Committee on the Degree in History and Literature, Harvard/Radcliffe College, March 1982). Rovetch's study carefully elucidates the ways that cabarets were designed to entice bourgeois clients into understanding the varied nuances of creativity.

12. On these paintings, see *Santiago Rusiñol 1861–1931*, ex. cat. (Barcelona: Museu d'Art Modern, 1997), cat. no. 31 and the images reproduced on pages 21 and 23. Rusiñol's

paintings, with their desolate spaces set in Spain or Paris, have inspired some highly political interpretations. His "abandoned gardens" have been linked to the theme of Spanish decay, while his use of similar scenes in Paris have been connected to larger aspects of the Symbolist movement. See Patricia Leighton, *Re-ordering the Universe: Picasso and Anarchism, 1897–1914* (Princeton, NJ: Princeton University Press, 1989), 24. Rusiñol's recent linking with the Symbolist movement has provided another way to interpret his works. See *Lost Paradise: Symbolist Europe*, ex. cat. (Montreal Museum of Fine Arts, 1995). The painting by Rusiñol in that exhibition was *The Morphine Addict*.

13. *Lost Paradise: Symbolist Europe.* For more information on Utrillo's role in Paris see Kaplan, *Red City, Blue Period*, 43–44. He was particularly enthralled with puppet shadow plays, and he eventually transferred this idea to Barcelona. His relationship with Suzanne Valadon is well known.

14. For reference to another painting by Rusiñol that is set within the Moulin de la Galette and is dominated by a mood of loneliness, see *Santiago Rusiñol 1861–1931*, cat. no. 31.

15. Miguel Utrillo became closely associated with Salis at the Chat Noir. His careful study of several Chat Noir shadow plays greatly influenced his own career. In previous years Utrillo had served as a journalist for *Vanguardia* in Barcelona. When Rusiñol first met Siegfried Bing remains unknown, although the press did cover the Spanish artist's private exhibition in Bing's galleries in 1899. See Charles Saunier, "Petite Gazette d'art, Santiago Rusinol," *La Revue Blanche* 20 (1899), 463. Bing did not sell any works by Rusiñol from his private painting collection that year. See *Collection Bing, Catalogue de tableaux modernes.* Oeuvres de Besnard, Cottet, Thaulow, Brang-wyn, Maurice Denis, etc. dont la vente aural lieu Hôtel Drouot, May 17, 1900 (Paris, 1900). As his association with Bing demonstrates, Rusiñol had the ability to connect with influential dealers who were outside the realm of bohemia.

16. On this and Satie's early career, see Steven M. Whiting, "Erik Satie and Vincent Hyspa: Notes on a Collaboration," *Music and Letters* 77:1 (February 1996): 64–91. Whiting notes that Satie began his musical career as an accompanist at the Chat Noir, where he was associated with Rodolphe Salis from 1889 to around 1892.

17. Ibid., 65. According to Whiting, Satie pursued connections with "two Rosicrucian sects." This led to Satie's heightened effects of esotericism while he continued his vehement opposition to the Academy and the traditions of the Institut. On religious unease and the evolution of occultism, see Jean Pierrot, *The Decadent Imagination, 1880–1990* (Chicago: University of Chicago Press, 1981), 100–118. The high point of occultism occurred between 1890 and 1895.

18. On this relationship and the influence of Georges de Feure's paintings see Ian Mill-man, *Georges de Feure: Maître du Symbolisme et de l'Art Nouveau* (Paris: ACR Edition, 1992), 68. The church that Satie discussed was most likely an imaginary construction with mystical and occult connections. Satie was obviously drawing parallels with his mystical church and the actual construction of the Sacré-Coeur.

19. On this development, see Kaplan, *Red City, Blue Period*, 40–41.

20. On this aspect, see ibid., 41. Ignacio Zuloaga was one of the artists who participated in the rediscovery of El Greco. For reference to his work see *Ignacio Zuloaga, 1870–1945*, ex. cat. (Paris: Pavillon des Arts, 1991).

21. Rusiñol's political activism is of considerable importance to this period, although the precise time it began is open to dispute. His writings were recognized in the early 1890s, while his prose poems and his plays with social overtones were better known from 1897 onward. His radical social and political views could have been well established during the time he was traveling between Montmartre and Barcelona. See Leighton, *Re-ordering the Universe*, 24–26.

22. Whether this can be considered a part of the Art Nouveau aesthetic that was then in full swing in Europe or whether it must remain linked with the Modernista movement in Spain is open to further discussion. His ideas connect Catholic revivalism with Art Nouveau ideology. For a variant of this construct, see Gabriel P. Weisberg, "Albert Besnard at Berck-sur-Mer: Decorative Art Nouveau Painting in Public Buildings," *Apollo* (May 2000): 52–58, where some of Besnard's church murals reveal the need of creating a new world through religious dedication.

23. For an excellent discussion of the café and its habitues, see Richardson, *Picasso*, 129–141. Picasso's ties to the location and his creation of imagery linked to the space are examined at some length.

24. Kaplan, *Red City, Blue Period*, 42. In reality, the shadow theater in Barcelona was supplanted by an early interest in the cinema, which was slowly emerging by 1900.

Selected Bibliography

Adhémar, Jean. *Toulouse-Lautrec: His Complete Lithographs and Drypoints.* New York: Abrams, 1964.

Adorno, Theodor W. *Aesthetic Theory.* Translated by Robert Hullot-Kentor. Minneapolis: University of Minnesota, 1997.

Agulhon, Maurice. "Paris: A Traversal from East to West." In *Realms of Memory: The Construction of the French Past,* vol. 3: *Symbols,* edited by Pierre Nora. Translated by Arthur Goldhammer. New York: Columbia University Press, 1998.

Alexis, Paul. *"Naturalisme pas mort": Lettres inédites de Paul Alexis à Emile Zola.* Edited by B. H. Bakker. Toronto: University of Toronto Press, 1971.

Amalvi, Christian. "Bastille Day from *Dies Irae* to Holiday." In *Realms of Memory: The Construction of the French Past,* vol. 3: *Symbols,* edited by Pierre Nora. Translated by Arthur Goldhammer. New York: Columbia University Press, 1998.

Angloti, Carlos. *Comics, títeres y teatros de sombras.* Madrid: Proyecto Didáctico Quirón, 1990.

Arrivé, René. *Influence de l'alcoolisme sur la population.* Paris: Jouve et Boyer, 1899.

Ary-Leblond, Marius. "Les Peintures de la femme nouvelle." *La Revue* 39 (1901): 275–276.

Avenel, Georges d'. "Le Mécanisme de la vie moderne: la publicité." *Revue des Deux-Mondes,* February 1, 1901, 659.

Babcock, Barbara. *The Reversible World: Symbolic Inversion in Art and Society.* Ithaca, NY: Cornell University Press, 1978.

Bailey, Peter. *Music Hall: The Business of Pleasure.* Milton Keynes: Open University Press, 1986.

Bargiel, Réjane, and Christophe Zagrodzki. *Steinlen affichiste. Catalogue raisonné.* Lausanne: Editions du Grand Pont, 1986.

Barrows, Susanna. "After the Commune: Alcoholism, Temperance, and Literature in the Early Third Republic." In *Consciousness and Class Experience in Nineteenth-Century Europe,* edited by John M. Merriman. New York: Holmes and Meier, 1979.

———. "Nineteenth-Century Cafés, Aromas of Everyday Life." In *Pleasures of Paris: Daumier to Picasso,* edited by Barbara Stern Shapiro. Boston: Museum of Fine Arts, 1991.

———. "Parliaments of the People: The Political Culture of Cafés in the Early Third Republic." In *Drinking: Behavior and Belief in Modern History,* edited by Susanna Barrows and Robin Room. Berkeley and Los Angeles: University of California Press, 1991.

Bayard, Jean-Emile. *Montmartre hier et aujourd'hui*. Paris: Jouve et Cie, 1925.

Le Bel héritage: Th. A Steinlen Rétrospective 1885–1922. Montreuil: Musée de l'Histoire Vivante–Centre des Expositions, 1987.

Benjamin, Walter. *Illuminations*. Translated by H. Zohn. New York: Schocken Books, 1969.

Benoist, Jacques. *Le Sacré-Coeur de Montmartre: Spiritualité, Art et Politique (1870–1923)*. Paris: Editions ouvrières, 1991.

———. *Le Sacré-Coeur de Montmartre de 1870 à nos jours*. 2 vols. Paris: Editions ouvrières, 1992.

———. *Le Sacré-Coeur de Montmartre: Un voeu national*. Paris: Délégation à l'action artistique de la Ville de Paris, 1995.

Bercy, Anne de, and Armand Ziwès. *A Montmartre . . . le soir*. Paris: Bernard Grasset, 1951.

Berland, Jody. "Cultural Technologies and Production of Space." In *Cultural Studies*, edited by Lawrence Grossberg, Cary Nelson, and Paula Treichler. New York: Routledge, 1992.

Berlanstein, Lenard. *The Working People of Paris, 1871–1914*. Baltimore, MD: Johns Hopkins University Press, 1984.

Bernheimer, Charles. *Figures of Ill Repute: Representing Prostitution in Nineteenth-Century France*. Cambridge, MA: Harvard University Press, 1989.

Bernier, Georges. *La Revue Blanche. Paris in the Days of Post-Impressionism and Symbolism*. New York: Wildenstein and Co. , 1983.

Bordat, Jean, and Francis Boucrot. *Les Théâtres d'ombres*. Paris: Hachette, 1990.

Bowen, Barbara. *The Age of Bluff. Paradox, and Ambiguity in Rabelais and Montaigne*. Chicago: University of Illinois Press, 1972.

———. ed. *Rabelais in Context. Proceedings of the 1991 Vanderbilt Conference*. Birmingham, AL: Summa Publications, 1993.

Brockett, Oscar G. *History of the Theatre*. Needham Heights, MA: Allyn and Bacon, 1999.

Cate, Philip Dennis. *The Graphic Arts and French Society, 1871–1914*. New Brunswick, NJ: Rutgers University Press, 1988.

———. "The Paris Cry: Graphic Artists and the Dreyfus Affair." In *The Dreyfus Affair: Art, Truth and Justice*, edited by Norman L. Kleeblatt. Berkeley and Los Angeles: University of California Press, 1987.

Cate, Philip Dennis, and Susan Gill. *Théophile-Alexandre Steinlen*. Salt Lake City: Gibbs Smith, 1982.

Cate, Philip Dennis, and Mary Shaw, eds., *The Spirit of Montmartre: Cabarets, Humor, and the Avant-Garde, 1875–1905*. New Brunswick, NJ: Rutgers University Press, 1996.

Chelini, Jean. *Les Chemins de Dieu; histoire des pèlerinages chrétiens des origines à nos jours*. Paris: Hachette, 1982.

Chevalier, Louis. *Laboring Classes and Dangerous Classes in Paris during the First Half of the Nineteenth-Century*. New York: H. Fertig, 1973.

———. *Montmartre du plaisir et du crime*. Paris: Laffont, 1980.

Cholvy, Gérard, and Yves-Marie Hilaire. *Histoire religieuse de la France contemporaine, vol 1: 1800–1880*. Paris: Privat,1985.

Collins, Irene. *The Government and the Newspaper Press in France 1814–1881*. Oxford: Oxford University Press, 1959.

Cooper, Richard. "Le véritable Rabelais déformé." In *Editer et traduire Rabelais à travers les âges*. Amsterdam: Rodopi, 1997.

Corbin, Alain. *L'Avènement des loisirs, 1850–1960*. Toulouse: Privat, 1995.

———. *Women for Hire: Prostitution and Sexuality in France after 1850*. Translated by Alan Sheridan. Cambridge, MA: Harvard University Press, 1990.

Crauzat, Ernest de. *L'Oeuvre gravé et lithographié de Steinlen*. Paris: Société de propagation de livres d'art, 1913.

Crespelle, Jean-Paul. *La Vie quotidienne à Montmartre au temps de Picasso, 1900–1910*. Paris: Hachette, 1978.

Dansette, Adrien. *Histoire religieuse de la France contemporaine: l'Eglise catholique dans la mêlée politique et sociale.* Paris: Flammarion,1965.

Darzens, Rodolphe. *Nuits à Paris. Illustrations by Willette.* Paris: E. Dentu, 1889.

Deak, Frantisek. *Symbolist Theater: The Formation of an Avant-Garde.* Baltimore, MD: Johns Hopkins University Press, 1993.

Des Etrivières, Jehan. *Les Amazones du siècle.* Paris, 1882.

Dolléans, Edouard. *La Police des moeurs.* Paris: Librairie de la Société du Recueil Général des Lois et des Arrêts, 1903.

Donnay, Maurice. *Autour du Chat Noir.* Paris: Bernard Grasset, 1926.

Doré, Gustave. *Doré's Illustrations for Rabelais.* New York: Dover Publications, 1978.

Dubois, E. T. *Portrait of Léon Bloy.* London: Sheed and Ward, 1950.

Eade, John, and Michael J. Sallnow, eds. *Contesting the Sacred: The Anthropology of Christian Pilgrimage.* London and New York: Routledge, 1991.

Fauchon, Dr. "La Tuberculose: maladie du peuple." *Le Magasin Pittoresque* 3:2 (September 1906): 392–394.

Fein, David A. *François Villon Revisited.* New York: Twayne Publishers, 1997.

Fontane, Charles. *Un Maître de la caricature: André Gill, 1840–1885.* 2 vols. Paris: Editions de l'Ibis, 1927.

Foulon, J. A. [Monsignor, Archevêque de Lyon]. *Histoire de la vie et des oeuvres de Mgr. Darboy, archevêque de Paris.* Paris: C. Poussielgue, 1889.

Fourastié, Jean. *Des loisirs, pourquoi faire?* Tournai: Casterman, 1977.

Fournier, Edouard. *Histoire des enseignes de Paris.* Paris: E. Dentu, 1884.

Fox, John. *The Poetry of Villon.* London: Thomas Nelson and Sons Ltd., 1962.

Frank, Thomas. *The Conquest of Cool: Business Culture, Counterculture, and the Rise of Hip Consumerism.* Chicago: University of Chicago Press, 1997.

Frerebeau, Mariel. "What is Montmartre? Nothing! What should it be? Everything!" *Artnews* 76:3 (1977): 60–62.

Fuchs, Rachel G. "Morality and Poverty: Public Welfare for Mothers in Paris, 1870–1900." *French History* 2:3 (September 1988): 288–311.

Gage, John. "The Technique of Seurat: A Reappraisal." *Art Bulletin* 69:3 (1987): 448–454.

Gaultier, Paul. "La Crise de la charité." *Revue Bleue* 4 (August 5, 1905): 187–191.

Gill, Susan. "Théophile-Alexandre Steinlen: A Study of His Graphic Art, 1881–1900." Ph.D. diss., City University of New York, 1982.

Goudeau, Emile. *Dix ans de Bohème.* Paris: La Librairie Illustrée, 1888.

Grand-Carteret, John. *La Femme en culotte.* Paris: E. Flammarion, 1899.

Grave, Jean. "Les Enfants." *La Plume,* May 1, 1893, 209–210.

Guillemen, Julien. *Protection des enfants du premier âge: dépopulation de la France.* Paris: Giard et Brière, 1901.

Haine, W. Scott. *The World of the Paris Café: Sociability among the French Working Class, 1789–1914.* Baltimore, MD: Johns Hopkins University Press, 1996.

Hamon, Auguste. *Histoire de la dévotion au sacré-coeur de Jésus,* 5 vols. Paris: Gabriel Beauchesne, 1923–1939.

Harrison, Charles, and Paul Wood, eds. *Art Theory, 1815–1900: An Anthology of Changing Ideas.* Oxford: Blackwell, 1998.

Harvey, David. "Monument and Myth: The Building of the Basilica of the Sacred Heart." In *Consciousness and the Urban Experience. Studies in the History and the Theory of Capitalist Urbanization,* edited by David Harvey. Baltimore, MD: Johns Hopkins University Press, 1985.

Henderson, John A. *The First Avant-Garde, 1887–1894: Sources of the Modern French Theatre.* London: G. G. Harrap, 1971.

Heppenstall, Rayner. *The Double Image. Mutations of Christian Mythology in the Work of Four French Catholic Writers of To-Day and Yesterday.* London: Secker and Warburg, 1947.

Herbert, Michel. *La Chanson à Montmartre*. Paris: La Table ronde, 1967.

Homodel. "Les Marges de l'histoire du cabaret à la brasserie." *La Vie Parisienne*, July 13, 1895, 404.

Hourdin, Georges. *Une civilisation des loisirs*. Paris: Calmann-Lévy, 1961.

Hyp. "Les Statues qu'elles aiment." *La Vie Parisienne*, January 7, 1899, 6–7.

Irvine, William D. *The Boulanger Affair Reconsidered: Royalism, Boulangism, and the Origin of the Radical Right in France*. New York: Oxford University Press, 1989.

Jeanne, Paul. *Les Théâtres d'ombres à Montmartre de 1887 à 1923*. Paris: Les Éditions des Presses Modernes au Palais-Royal, 1937.

Joughin, Jean T. *The Paris Commune in French Politics, 1871–1880*. 2 vols. Baltimore, MD: Johns Hopkins University Press, 1955.

Kaplan, Temma. *Red City, Blue Period: Social Movements in Picasso's Barcelona*. Berkeley and Los Angeles: University of California Press, 1992.

Kermode, Frank. "Loïe Fuller and the Dance Before Diaghilev." *Theatre Arts* (September 1962): 9.

Laligant, Pierre [Abbé]. *Montmartre. La Basilique du Voeu national du Sacré Coeur*. Grenoble: B. Arthaud, 1933.

Lebensztejn, Jean-Claude. *Chahut*. Paris: Hazan, 1989.

Leighton, Patricia. *Re-ordering the Universe: Picasso and Anarchism, 1897–1914*. Princeton, NJ: Princeton University Press, 1989.

Lemaître, Jules. *"Préface." Gaîtés du Chat Noir*. Paris: Ollendorff, 1894.

Lesourd, Paul. *Montmartre*. Paris: Editions France-Empire, 1973.

Levin, Miriam R. *Republican Art and Ideology in Late Nineteenth-Century France*. Ann Arbor, MI: UMI Research Press, 1986.

Lista, Giovanni. *Loïe Fuller. Danseuse de la Belle Epoque*. Paris: Somogy, 1994.

Loeb, Lori Anne. *Consuming Angels*. New York: Oxford University Press, 1994.

Lombroso, Ferrero. *La Femme criminelle et prostituée*. Paris: F. Alcan, 1896.

Loyer. François. "Le Sacré-Coeur de Montmartre." In *Les Lieux de mémoire*, vol. 3: *Les France,* edited by Pierre Nora. Paris: Gallimard, 1992.

McLaren, Angus. *Sexuality and Social Order: The Debate over the Fertility of Women and Workers in France, 1770–1920*. New York: Holmes and Meier, 1983.

Maillard, Léon. "I. Femme du monde; II. Bourgeoisie; III. Femme du peuple; IV. La Balance." *La Plume,* May 1, 1891, 151.

Mallarmé, Stephane. *Oeuvres complètes*. Edited by Henri Mondor and Jean Aubry. Paris: Galimard, n.d.

Mann, Paul de. "The Rhetoric of Temporality." In *Blindness and Insight: Essays in the Rhetoric of Contemporary Criticism*. Minneapolis: University of Minnesota Press, 1983.

Marc-Aurèle. "L'Hiver à Paris: Un dispensaire d'enfants à Montmartre." *Le Monde Illustré,* December 20, 1890, 528.

Martin, Denis. *Images d'Epinal*. Québec: Editions de la Réunion des Musées Nationaux, 1995.

Mauclair, Camille. "La Femme devant les peintures modernes." *La Nouvelle Revue* 1 (1899): 190–213.

———. "Steinlen." *L'Art et les Artistes* 5 (April-September 1907): 300.

Menon, Elizabeth K. "Fashion, Commercial Culture, and the Femme-Fatale: Development of a Feminine Icon in the French Popular Press." *Analecta Husserliana. The Yearbook of Phenomenological Research* 53 (1998). Reprinted in *The Reincarnating Mind or the Ontopoietic Outburst in Creative Virtualities,* edited by Anna-Teresa Tymieniecka. Dordrecht: Kluwer Academic Publishers, 1998.

———. "Henry Somm: Impressionist, Japoniste, or Symbolist?" *Master Drawings* 33:1 (Spring 1995): 3–29.

Meyer, Philippe. *The Child and the State: The Intervention of the State in Family Life.* New York: Cambridge University Press, 1977.

Millman, Ian. *Georges de Feure: Maître du Symbolisme et de l'Art Nouveau.* Paris: ACR Edition, 1992.

Mollier, Jean-Yves. *L'Argent et les lettres. Histoire du capitalisme d'édition 1880–1920.* Paris: Librairie Artheme Fayard, 1988.

Monneret, Sophie. *L'Impressionisme et son époque: dictionnaire international.* Paris: Laffont, 1987.

Montorgueil, Georges. *Paris dansant.* Paris: Théophile Belin, 1898.

Moses, Claire Goldberg. *French Feminism in the Nineteenth Century.* Albany: State University of New York Press, 1984.

Mourey, Gabriel. "Steinlen." *Revue Illustrée,* October 1, 1900, 36–47.

Murger, Henry. *Scènes de la vie de Bohème.* Paris: Michel Lévy Frères, 1861.

Nicolet, Claude. *L'Idée républicaine en France (1789–1924): Essai d'histoire critique.* Paris: Gallimard, 1982.

———. *La République en France: Etat des lieux.* Paris: Seuil, 1992.

Nolan, Mary Lee, and Sidney Nolan. *Christian Pilgrimage in Modern Western Europe.* Chapel Hill: University of North Carolina Press, 1989.

Nord. Philip. *Paris Shopkeepers and the Politics of Resentment.* Princeton, NJ: Princeton University Press, 1968.

———. *The Republican Moment: Struggles for Democracy in Nineteenth-Century France.* Cambridge, MA: Harvard University Press, 1995.

Oberthür, Mariel. *Le Chat Noir, 1881–1897.* Paris: Réunion des Musées Nationaux, 1992.

Offen, Karen. "Depopulation, Nationalism, and Feminism in Fin-de-Siècle France." *American Historical Review* 89 (1984): 648–676.

Paguelle de Follenay, J. [abbé]. *Vie du cardinal Guibert, archevêque de Paris.* 2 vols. Paris: C. Poussielgue, 1896.

Parent-Duchâtelet, A.J.B. *De la prostitution dans la ville de Paris.* Paris: Baillière, 1837.

Parkhurst, Priscilla Ferguson. *Paris as Revolution: Writing the Nineteenth-Century City.* Berkeley and Los Angeles: University of California Press, 1994.

Pierrot, Jean. *The Decadent Imagination, 1880–1990.* Chicago: University of Chicago Press, 1981.

Pitts, Jesse R. "Continuity and Change in Bourgeois France." In *In Search of France,* edited by Stanley Hoffmann. Cambridge, MA: Harvard University Press, 1963.

Poole, Mary Ellen. "Chansonnier and Chanson in Parisian Cabarets Artistiques, 1881–1914." Ph.D. diss., University of Illinois at Champaign/Urbana, 1994.

Rabelais, François. *The Histories of Gargantua and Pantagruel.* Translated by J. M. Cohen. Harmondsworth, England: Penguin Books Ltd., 1986.

Rambosson, Yvanhoé. "Psychologie des Chéret." *La Plume* November 15, 1893, 499–501.

Rearick, Charles. *Pleasures of the Belle-Epoque: Entertainment and Festivity in Turn-of-the-Century France.* New Haven, CT: Yale University Press, 1985.

Reinhardt, Kurt F. *The Theological Novel of Modern Europe.* New York: Frederick Ungar, 1968.

Rey, Alain. "Le Nom d'artiste." *Romantisme* 55 (1987): 10–22.

Richardson, John. *A Life of Picasso, 1881–1906.* New York: Random House, 1991.

Rodenbach, Georges. "La Loïe Fuller." *Revue Illustrée,* May 1, 1893, 335–336.

Rollinat, Maurice. *Le Livre de la nature. Choix de poésies pour les enfants.* 3d ed. Paris: Librairie Ch. Delagrave, n.d.

———. *Oeuvres.* Paris: Lettres Modernes Edition, 1971.

Saint-Montan, Jeannette de. *Nos pèlerinages en 1900, 15 août–19 octobre; souvenirs intimes, lettres intimes.* Balan-Sedan: Imprimerie du Patronnage, 1901.

Santiago Rusiñol 1861–1931. Barcelona: Museu d'Art Modern, 1997.

Sauvage, Louis-Frédéric. "L'Oeuvre de Steinlen." *La Nouvelle Revue* 26 (1904): 91.

Schimmel, Herbert, ed. *The Letters of Henri de Toulouse-Lautrec*. Oxford: Oxford University Press, 1991.

Schwartz, Vanessa R. *Spectacular Realities: Early Mass Culture in Fin-de-Siècle Paris*. Berkeley and Los Angeles: University of California Press, 1998.

Screech, M. A. *Some Renaissance Studies: Selected Articles 1951–1991 with a Bibliography*. Geneva: Librairie Droz S.A., 1992.

Segel, Harold B. *Pinocchio's Progeny*. Baltimore, MD: Johns Hopkins University Press, 1995.

———. *Turn-of-the-Century Cabaret*. New York: Columbia University Press, 1987.

Seigel, Jerrold. *Bohemian Paris: Culture, Politics, and the Boundaries of Bourgeois Life, 1830–1930*. New York: Penguin, 1986.

Sennett, Richard. *The Fall of Public Man*. New York: W. W. Norton, 1992.

Shattuk, Roger. *The Banquet Years*. New York: Vintage, 1968.

Silverman, Debora L. *Art Nouveau in Fin-de-Siècle France: Politics, Psychology, and Style*. Berkeley and Los Angeles: University of California Press, 1989.

Silverman, Willa Z. *The Notorious Life of Gyp: Right-Wing Anarchist in Fin-de-Siècle France*. Oxford: Oxford University Press, 1995.

Sonn, Richard D. *Anarchism and Cultural Politics in Fin-de-Siècle France*. Lincoln: University of Nebraska Press, 1989.

Spector, Jack. "A Symbolist Antecedent of the Androgynous Q in Duchamp's L.H.O.O.Q." *Source: Notes in the History of Art* 18:4 (Summer 1999): 44

Springer, Annemarie. "Woman in French Fin-de-Siècle Posters." Ph.D. diss., Indiana University, Bloomington, 1971.

Stallybrass, Peter, and Alton White. *The Politics and Poetics of Transgression*. Ithaca, NY: Cornell University Press, 1986.

Starobinski, Jean. *Portrait de l'artiste en saltimbanque*. Geneva: Editions d'Art Albert Skira, 1970.

Steinlen, Théophile-Alexandre. *Dans la vie*. Paris: Sevin and Rey, 1901.

Stone, Judith F. *Sons of the Revolution: Radical Democrats in France 1862–1914*. Baton Rouge: Louisiana State University Press, 1996.

Strauss, Paul. "L'Enfance abandonnée." *La Revue Bleue* 22 (August 1891): 252–254.

Sussman, George. *Selling Mother's Milk: The Wet Nursing Business in France, 1715–1914*. Urbana: University of Illinois Press, 1982.

Tardivaux, René. "La Loïe Fuller." *Gil Blas Ilustré*, December 18, 1892, 2–3.

Le Temps de Toulouse-Lautrec. Paris: Réunion des Musées Nationaux, 1991.

Téry, Gustave. *Les Cordicoles*. Paris: E. Cornély, 1902.

Théophile Steinlen (1859–1923). Geneva: Musée du Petit Palais, 1993.

Traverse, Dr. Paul. *Etude sur les dispensaires pour enfants malades à Paris*. Paris: G. Carré et C. Naud, 1899.

Le Triomphe des Mairies: Grands décors républicains à Paris 1870–1914. Paris: Musée du Petit Palais, 1986.

Uzanne, Octave. *La Femme à Paris. Nos contemporaines, notes successives sur les Parisiennes de ce temps dans leurs divers milieux, états et conditions*. Paris: Ancienne Maison Quantin, 1894 and 1910.

Verhagen, Marcus. "Refigurations of Carnival: The Comic Performer in Fin-de-Siècle Parisian Art." Ph.D. diss., University of California at Berkeley, 1994.

Villon, François. *The Complete Works of François Villon*. Translated by Anthony Bonner. New York: David McKay, 1960.

———. *The Poems of François Villon*. Translated by Galway Kinnell. Boston: Houghton Mifflin, 1977.

Waller, Brett, and Grace Sieberling. *Artists of La Revue Blanche*. Rochester, NY: Memorial Art Gallery of the University of Rochester, 1984.

Weber, Eugen. *France, Fin de Siècle*. Cambridge, MA: Harvard University Press, 1986.

Weir, David. *Anarchy and Culture: The Aesthetic Politics of Modernism*. Amherst: University of Massachusetts Press, 1997.

Willette, Adolphe. *Feu Pierrot, 1857–19—?*. Paris: H. Floury, 1919.

Willette, Luc. *Adolphe Willette. Pierrot de Montmartre*. Paris: Editions de l'Armançon, 1991.

Wilson, Michael. "Sans les femmes, qu'est-ce qui nous resterait: Gender and Transgression in Bohemian Montmartre." In *Body Guards: The Cultural Politics of Gender Ambiguity*, edited by Julia Epstein and Kristina Straub. New York: Routledge, 1991.

Zelizer, Viviana. *Pricing the Priceless Child: The Changing Social Value of Children*. New York: Basic Books, 1981.

Zévaès, Alexandre. *Aristide Bruant*. Paris: Editions de la Nouvelle Revue Critique, 1942.

Notes on Contributors

ELENA CUETO-ASÍN received her Ph.D. in comparative literature from Purdue University. She specializes in the study of modern literature and theater in Spain and France, and is the author of several articles on this topic. Currently, she works as an assistant professor in the Department of Romance Languages at Bowdoin College, Brunswick, Maine.

RAYMOND A. JONAS is a professor of history and an adjunct professor in French and Italian studies at the University of Washington, Seattle. He is the author of *France and the Cult of the Sacred Heart: An Epic Tale for Modern Times* (Berkeley: University of California Press, 2000) and *Politics and Industry in Rural France* (Ithaca, NY: Cornell University Press, 1994) as well as articles and essays published in France and the United States. His recent scholarship has focused on emblems, rituals, and architecture in the political culture of counterrevolution in France.

HOWARD G. LAY is an assistant professor of the history of art at the University of Michigan. He has recently published a study of the pictorial and rhetorical strategies informing the anarchist propagandist Emile Pouget's inflamatory journal, *Le Pere Peinard*. He is also co-editor of a special interdisciplinary issue of *Yale French Studies* entitled "Fictions of Revolution." His book, *Fictions of Dissolution: Essays in the Pictorial Rhetoric of Fin-de-Siècle Paris,* is forthcoming from Yale University Press.

KARAL ANN MARLING teaches popular art and material culture at the University of Minnesota. She is the author of *Merry Christmas! Celebrating America's Greatest Holiday* (Harvard University Press, 2000), *Norman Rockwell* (Abrams, 1997), *Designing Disney's Theme Parks: The Architecture of Reassurance* (Flammarion, 1997),

Graceland: Going Home with Elvis (Harvard University Press, 1996), *As Seen on TV: The Visual Culture of Everyday Life in the 1950s* (Harvard University Press, 1994) and many other books.

ELIZABETH K. MENON is an assistant professor of art history, Division of Art and Design, at Purdue University. Since receiving her doctorate from the University of Minnesota, Dr. Menon has published an essay in *The Popularization of Images: Visual Culture under the July Monarchy* (Princeton University Press, 1994) and numerous articles in *Gazette des Beaux-Arts, Master Drawings,* and *Art Journal.* She is currently completing a book entitled *Evil by Design: The Creation and Marketing of the Femme-Fatale in Nineteenth-Century France.*

JILL MILLER is an assistant professor of art history at Armstrong Atlantic State University in Savannah, Georgia. She received her Ph.D. in nineteenth- and early twentieth-century European art from the University of Minnesota. Miller is currently preparing manuscripts for an art and technology textbook, as well as for a book based on her dissertation, "Propaganda and Utopianism: The French Family and Visual Culture in the Early Third Republic, 1870-1905."

JOHN KIM MUNHOLLAND is a professor of history at the University of Minnesota, where he teaches modern European and French history. Among his publications is a book on Europe at the turn of the century, *Origins of Modern Europe 1890-1914,* and several articles on modern and contemporary French cultural and political history, including "Michaud's History of the Crusades" and the "French Crusade in Algeria under Louis-Philippe," in *The Popularization of Images: Visual Culture under the July Monarchy,* edited by Petra ten Doesschate Chu and Gabriel Weisberg. He is currently working upon the social, political, and cultural impact of the American presence in French New Caledonia during the Second World War.

RICHARD D. SONN is an associate professor of history at the University of Arkansas, where since 1987 he has taught modern French history and European social, cultural, and intellectual history. He is the author of two books: *Anarchism and Cultural Politics in Fin-de-Siècle France* (University of Nebraska Press, 1989) and *Anarchism* (Twayne, 1992).

GABRIEL P. WEISBERG is a professor of art history at the University of Minnesota. A recipient of Guggenheim and CASVA grants, and a former Regents Fellow, Smithsonian Institution at the National Museum of American Art, Weisberg has published widely in books, journals, and exhibition catalogues for over thirty years. Dr. Weisberg's *Beyond Impressionism: The Naturalist Impulse* was published in 1992 (Abrams). His recent *Overcoming All Obstacles: The Women of the Academy Julian* (Rutgers University Press, 1999) maintained his interest in curating timely exhibitions. In 2004 he will guest curate an exhibition on "From

Japonisme to Art Nouveau: The House of Bing" for the Rijksmuseum Vincent van Gogh, Amsterdam.

JANET WHITMORE is an instructor for the Minnesota State Colleges and Universities system. Recent appointments include Inver Hills Community College and Minnesota State University, Mankato. She is also a research fellow in the College of Architecture and Landscape at the University of Minnesota. She has written extensively for *Architecture Minnesota* and *Metropolitan Architecture*, and contributed several essays to the 1996 book *101 Places* published by the American Institute of Architects-Minnesota.

MICHAEL L. J. WILSON is an associate professor of history and humanities and associate dean for graduate studies at the University of Texas at Dallas. His essay is drawn from his forthcoming monograph, *Bohemian Montmartre: Art, Commerce, and Community in Fin-de-Siècle Paris*. He has also published articles on late nineteenth-century culture in *The American Journal of Semiotics*, *The Henry James Review*, and *Body Guards: The Cultural Politics of Gender Ambiguity*.

Acknowledgments

Montmartre and the Making of Mass Culture is the published realization of a symposium entitled "Montmartre and the Making of Mass Culture," which took place at The Minneapolis Institute of Arts on March 5 and 6, 1999. The speakers who participated in the symposium are the authors of the essays included in this book and their essays closely reflect their original presentations. As the brainchild of members of the Art History and History departments, University of Minnesota, and a member of the Art department, Minnesota State University, Mankato, the organization of the symposium benefited from the expert help of Janet Whitmore, a Ph.D. candidate in the Department of Art History, and several staff members at The Minneapolis Institute of Arts, including Susan Jacobsen and Matthew James of the Department of Public Programs. The symposium was enhanced by the presentation of an exhibition, "Toulouse-Lautrec and the Performers of Paris," held in the Prints and Drawings gallery at the museum. This exhibition was made possible through the sponsorship of Richard Campbell, head of the Department of Prints and Drawings, and the dedicated support of Lisa Michaux, curatorial assistant in the department. Dr. Evan Maurer, director of the museum, highlighted the importance of the symposium by welcoming speakers and conference attendees to the museum.

Ultimately, the symposium took place through the much-needed and highly appreciated financial contributions from Norwest Bank Corporation; the University of Minnesota CLA Special Events Fund; the Humanities Institute of the College of Liberal Arts, the Department of Art History, and the Department of History at the University of Minnesota; the John H. Stevens House Museum; and

the Minnesota Humanities Commission. The latter provided the organizers with an especially generous grant, which allowed the general public to readily attend the conference.

We gratefully acknowledge the support and assistance so graciously extended by all those mentioned above and by the many others who worked quietly behind the scenes.

Gabriel P. Weisberg
February 2001